# ABOVE THE WORLD

## STUNNING SATELLITE IMAGES FROM ABOVE EARTH

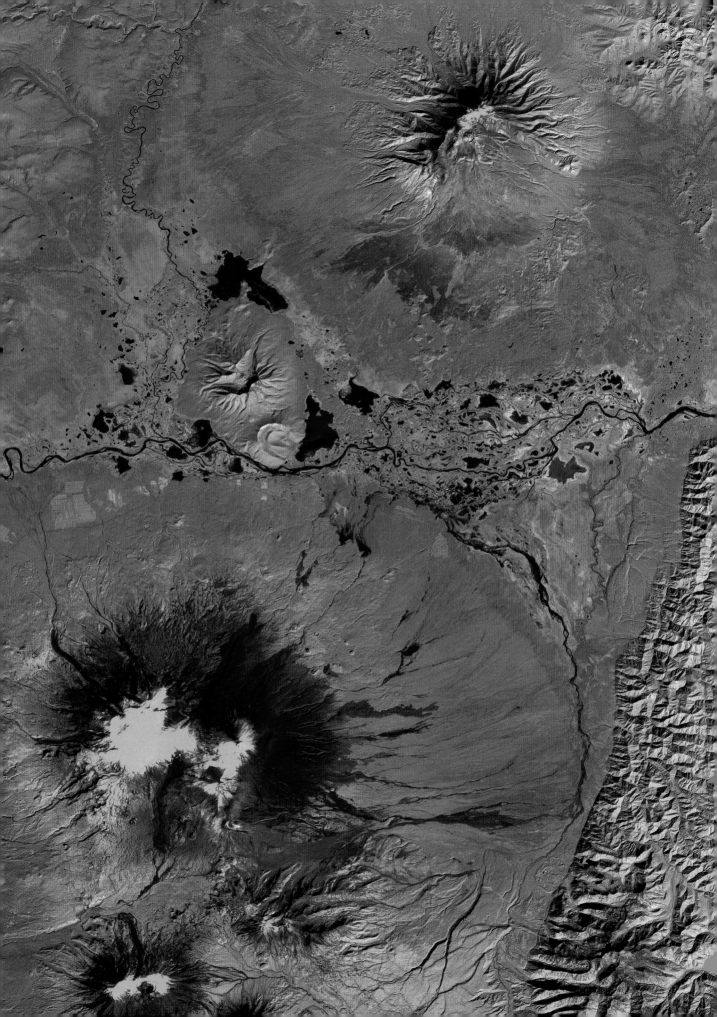

# ABOVE THE WORLD

## WORLD

### STUNNING SATELLITE IMAGES FROM ABOVE EARTH

A SELECTION OF SATELLITE IMAGES
COMPILED BY NPA GROUP

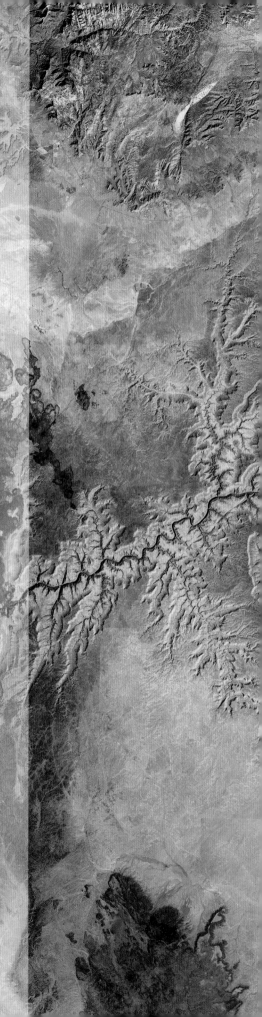

First published in Great Britain in 2005 by Cassell Illustrated,
a division of Octopus Publishing Group Limited
2-4 Heron Quays, London E14 4JP

This edition published in 2006 by Cassell Illustrated
Text and design copyright © 2004 Cassell Illustrated

Image preparation and selection by
Richard Chiles and Paul Karwinski (NPA)
Image interpretation by
Richard Chiles and Mike Oehlers (NPA)

A selection of satellite images compiled by NPA Group, Edenbridge, Kent, UK
www.npagroup.com   Tel: +44 1732 865023

All images other than those listed below are © NPA Group
pages 10-11, 52-53, 86-87, 126-127, 166-167, 200-201, 246-247, 284-285 © NPA Group (terrain
enhanced of imagery from NASA Goddard Space Flight Centre)
12-13, 54-55, 88-89, 128-129, 168-169, 202-203, 248-249 © NASA Goddard Space Flight Centre
pages 14, 84-85 Images courtesy Jeff Schmaltz, MODIS Land Rapid Response Team at NASA
GSFC/ pages 17, 24, 42, 191, 206 Images courtesy Jacques Descloitres, MODIS Land Rapid
Response Team at NASA GSFC
pages 12, 23,38-39, 68, 96, 106, 151, 151, 158-159, 183, 189, 197, 198-199, 220-221, 233, 237, 243,
252, 263 Satellite image courtesy of Space Imaging/pages 29, 37 Satellite image courtesy of
European Space Imaging/pages 60-61, 91, Satellite image courtesy of Space Imaging Middle East
page 36 Image courtesy NASA/GSFC/MITI/ERSDAC/JAROS, and the U.S/Japan ASTER Science
Team
pages 77, 81, 109, 125, 148, 161, 162, 215, 270 Image provided by the USGS EROS Data Center
Satellite Branch
pages 57, 70, 117, 145, 155, 231, 241 ©DigitalGlobe distributed by Eurimage

page 100-101 Image provided by Jeffrey Kargel, USGS/NASA JPL/AGU
page 123 Image by Jesse Allen, NASA Earth Observatory, based on expedited ASTER data
provided by the NASA/GSFC/MITI/ERSDAC/JAROS, and U.S./Japan ASTER Science Team
pages 204-205 Based upon images and data courtesy MODIS Snow and Ice Science Team
page 211 Data made available by NASA/GSFC/MITI/ERSDAC/JAROS, and U.S./Japan ASTER
Science Team
page 242 Courtesy of the NOAA Coastal Services Centre Hawaii Land Cover Analyst project
page 278 Image courtesy NASA/GSFC/MITI/ERSDAC/JAROS, and U.S./Japan ASTER Science
Team

Text by Thomas Cussans
Editor: Victoria Alers-Hankey
Designer: Austin Taylor

A CIP catalogue record for this book is available from
the British Library.

ISBN - 13: 978-1-844034-99-4
ISBN - 10: 1-844034-99-2
10 9 8 7 6 5 4 3 2 1

Printed in China

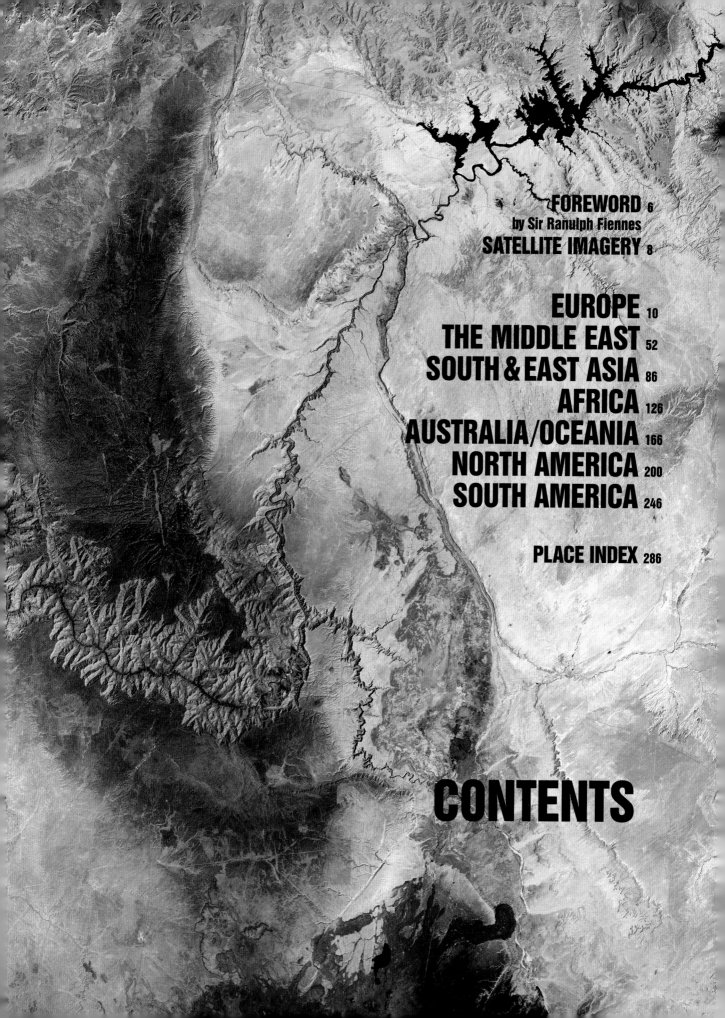

# CONTENTS

ABOVE THE WORLD IS A COLLECTION OF MORE than 200 brilliantly-coloured satellite images of the world arranged in continental groups. Each continent is shown as a whole then divided into countries, and then with tight focus on landmarks such as the Taj Mahal or Buckingham Palace as seen from space. This book is both an atlas and a work of art, and I can think of nothing more likely to hold even the most blasé of children mesmerized than the weird and wonderful shapes, patterns and contortions of our planet as photographed from space.

Remarkable gems of information are noted by each multicoloured image. Much of the information is threatening, but the overall impact is more one of fascination and general knowledge. A glance at the laborious zigzag tourist climb from Cuzco to Machu Picchu, an ant's trail clearly visible from space, would be enough to put off all but the confidently fit from ever attempting it. Asia, despite appearing largely vegetated from above, is home to 1,237 million humans in China and 984 million in India. Vietnam's Mekong Delta fans out to provide a lush silt-laden paddy plain, food basket to millions, the rice fields showing up as brilliant orange intersected by a million man-made canals. The Maldive isles in the Indian Ocean look like a string of translucent blue pearls. None of the 200 islets, with a population of 81,000, is more than 2m/6½ft above sea level.

On contemplating the vast hostile deserts of inner Australia, the mind boggles at the fortitude of the early explorers. There are no major river systems in the whole trackless waste, which stretches for thousands of kilometres. One image depicts a lake in the epicentre of an arid desert. It is called Lake Disappointment, for its explorers found it salty and undrinkable. Two meteorite strikes in the northern deserts show up clearly despite being 40 million years old. One has a 19km/12-mile diameter and struck Australia at one million times the impact of the Hiroshima atomic bomb.

Satellite imagery has a capacity to highlight features by exaggerating colours of selected rock types and formations. This makes for dazzling displays of 'modern art' images in mineral-rich zones such as Baluchistan and chequerboard patterns that clearly reveal where long-ago seismic surveys disturbed the earth during oil-company searches. The high-altitude volcanic tundra, riven by icy lakes, that straddles the borders of Chile, Argentina and Bolivia resembles what Mars must have looked like several million years ago.

Where the imagery uses a close-up lens, details become fascinatingly intricate as though some Canneletto disciple of fine detail was at work. The gaping cone of Vesuvius, for example, stands out in impressive third dimension above the plain of Naples. A new

eruption is expected at least of the force that destroyed Pompeii, yet clearly visible all about the crater, and stretching to the Bay of Naples, are the homes of some two million people.

Images of glaciers as far apart as the Himalayas and Patagonia show clearly an alarming rate of shrinkage due to global warming, while deforestation of jungles in Brazil is dramatically exposed by two images of the same rainforest, one taken in 1984, the other in 2001. Some 15,000sq km/5,800 sq miles are being slashed and burned every year.

Massive dam projects can be seen in most of the continents, many causing huge environmental damage. This is especially true in Brazil and China. Increased damming of the river Indus, Pakistan's principle source of fresh water for agriculture, has significantly reduced its flow and allowed saltwater encroachment from the sea. This has destroyed half the delta's once vast mangrove swamps and critically reduced their fish stocks. The cause and effect of such man-made problems are so much easier to follow through the multicoloured stories told by the satellite images.

One welcome healthy story is that of Hong Kong, which glows at the space cameras in the orange hue that denotes fertile vegetation because 75 per cent of its land is a strictly maintained conservation zone. This makes Hong Kong one of the most unspoilt cities in Asia, even though it is among the most densely populated.

# FOREWORD

WHEN THE SOVIET UNION LAUNCHED *SPUTNIK 1*, the first artificial Earth satellite, in October 1957, it began a process that would transform our knowledge of the world. By the 1960s, Earth-orbit space flights were almost routine, and Soviet cosmonauts and American astronauts were taking thousands of photographs of the Earth. After the launch in April 1960 of the American TIROS-1 satellite, equipped with television cameras to monitor weather patterns, ever larger numbers of satellites began to photograph the Earth.

During this giddy age of the Space Race, when permanent manned stations on the Moon and flights to Mars were confidently predicted, the image of Earth-rise over the Moon, captured by the crew of Apollo 8 in December 1968, summed up the new mood, promising a radically different understanding of our fragile planet. For the first time, humanity could see itself whole. Yet however memorable these photographs, they were just that – photographs. They may have been taken by probably the most expensive cameras in (or out of) the world, but they were recording what was visible only to the naked eye.

In July 1972 a new development occurred, much less trumpeted but ultimately more significant. This was the launch of the American satellite Landsat 1. For the transmission of conventional pictures it was equipped with three television cameras, which broke down almost at once. However, it also had a Multispectral Scanner, or MSS, on board. Though capable of recording in the visible spectrum – in other words what humans can naturally see – the MSS could also detect longer wavelengths of energy – electromagnetic radiation – that were invisible to the eye. The impact was immediate. In a vast range of disciplines – from volcanology to land management, geology to demography – the implications for the way we humans monitor and map the world have been immense.

All objects, whether natural or man-made, reflect electromagnetic radiation. In recording it, the MSS was able to produce an entirely new vision of the world. From the moment Landsat 1 began transmitting data, the images it provided were startlingly, almost shockingly different. Clear water, for example, typically reflects very little electromagnetic radiation. That's why in many of the images in this book it appears as black. Shallow or sediment-rich water, by contrast, reflects more energy and accordingly shows up lighter. Bare ground and buildings reflect a great deal of light, so they too show up as light, bright colours. Vegetation presents a particularly striking example. It absorbs most visible light but reflects much of the near-infrared light. As a result, it appears red – the healthier the vegetation, the brighter the red. Bare soils or sparse vegetation range from white in the case of sand to greens and browns, depending on moisture content.

Multispectral scanning is not only exceptionally efficient at distinguishing between these 'tell-tale electromagnetic signatures', but also, because the data it produces is digital, it can be manipulated almost infinitely, with colours enhanced – 'contrast stretched' – or suppressed to highlight particular features.

Refinements of the MSS technique followed. On later Landsat and other Earth-observation satellites, the range of spectral bands that the sensors could detect was gradually increased. Landsat 1 recorded in four such bands – three visible, one invisible – while Landsat 7, launched in 1999, does so in seven. 'Hyperspectral' satellites now have hundreds of spectral bands tracking precisely detailed spectral signatures. The quality of the data transmitted has also been consistently improved. The smallest object Landsat 1 could detect to form a single coloured dot or 'pixel' on an image was 79m/259ft across. Quickbird, launched in 2002, is able to depict objects no more than 60cm/2ft across as individual pixels. This is why a number of the close-up images in this book – of the Forbidden City in Beijing, for example, or of the pyramids – though taken from several hundred kilometres above the surface of the Earth actually look as if they might have been shot from an aeroplane flying at no more than a few thousand metres. That said, the majority of the images in this book were captured by Landsat satellites, orbiting about 705km/437 miles above the Earth and travelling at 27,000kph/16,750mph. They can record 16 million measurements a second, and can survey 33,670sq km/13,000 sq miles in less than 27 seconds.

Because Landsat and other Earth-observation satellites are in polar orbits, moving over the Earth from pole to pole, they keep time with the path of the Sun so that the local time of every point they cross is always broadly the same, between 9am and 11am. This means not only that lighting conditions are constant but also that atmospheric haze, at its lowest in the morning, is reduced. As a result, image clarity is improved.

In the words of NASA administrator James C. Fletcher, the result has been 'a new way to look'. On the whole, he understates the case.

# SATELLITE IMAGERY

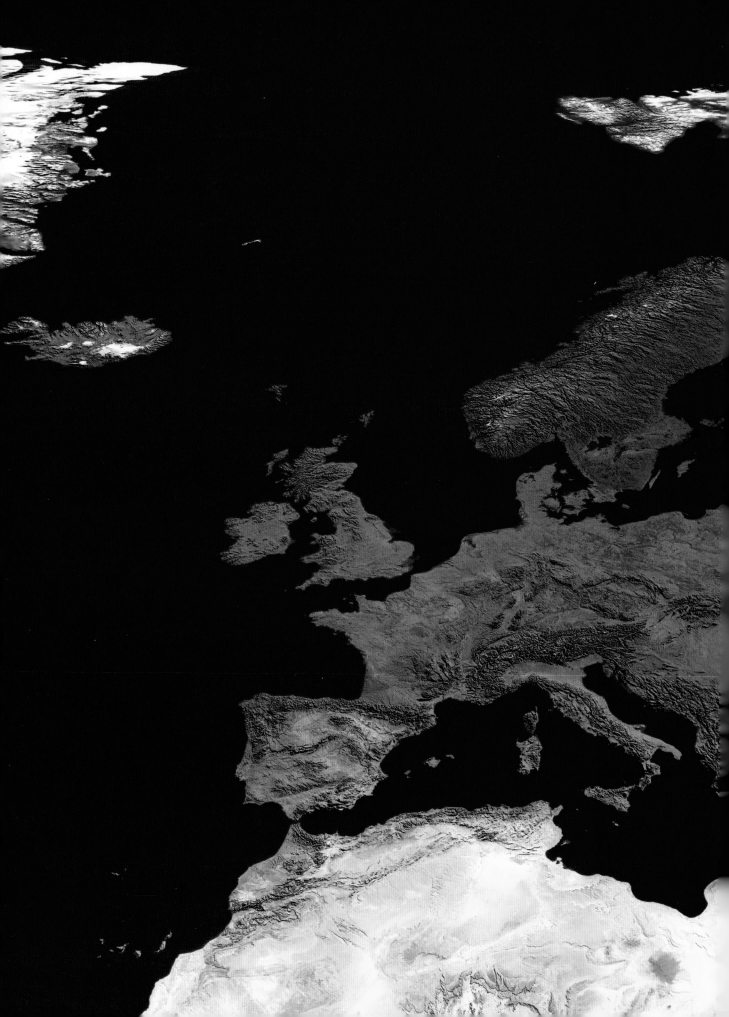

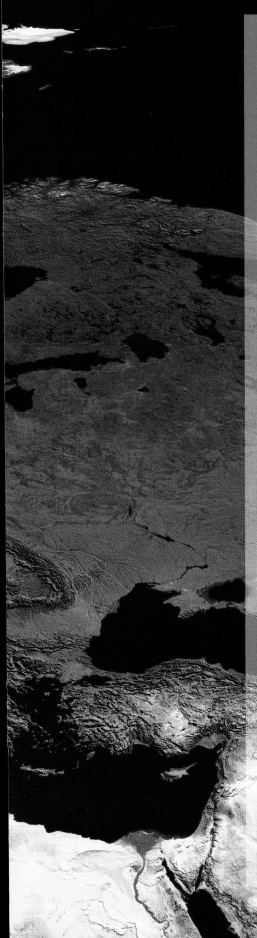

# EUROPE

Europe is the world's second smallest continent, ahead only of Australia/Oceania. At 10.4 million sq km/4 million sq miles it makes up one-fifteenth of the land area of the world. It is the world's second most densely populated area, with nearly 720 million people, one-seventh of the world's population. In its forty-four countries some 60 languages are spoken. Five of its countries are among the world's smallest: the Vatican City, Monaco, San Marino, Liechtenstein and Malta. Europe is also home to the second and fifth most urbanized countries in the world, Belgium and the Netherlands, at 97 per cent and 89 per cent respectively. Yet Paris, Europe's largest city, is not even in the world's top thirty in terms of population. Measured by GNP, Europe has five out of the ten richest countries in the world: the UK, Germany, France, Italy and Spain.

Despite having been recognized as a geographical entity since antiquity, Europe remains oddly hard to define. Its western half, from Scandinavia to the Mediterranean, constitutes a more or less clear-cut geographical unit. But to the east, Europe merges seamlessly into Asia. This eastern border has always been elastic, shifting in response to the prejudices and imperatives of those delineating it. Today, it is conventionally fixed at the Urals, deep in the Russian Federation.

Geographically, Europe divides broadly in three. To the north is a mountainous belt stretching from Scotland to western Scandinavia. South of it is a vast lowland area, the North European Plain, that includes most of England and northern France and runs eastward across the Low Countries, Denmark, northern Germany, Poland, the Baltic States and into Russia. To the south again, and with the exception of the valleys of the Ebro in northwest Spain, the Po in northern Italy and the Great Hungarian Plain, Europe is more mountainous. The Pyrenees, Alps and Carpathians do not just mark the division between northern and southern Europe but are also the western ends of a mountain chain that extends as far as the Himalayas.

Western Europe's climate, warmed by the Atlantic Ocean, is broadly temperate. To the east, however, the climate is much more variable, with cold winters and baking summers. Nonetheless, the major climactic difference is between the (warm) Mediterranean and the (cool) north.

Europe's irregular coastline extends for 38,000 km/24,000 miles, yet Europe has few other notable geographical features. Its longest river (the Volga, 3,685 km/2,290 miles long), its largest lake (Ladoga 17,680 sq km/6,826 sq miles) and its highest mountain (Elbrus), all in the Russian Federation, pale in comparison with those in other parts of the world.

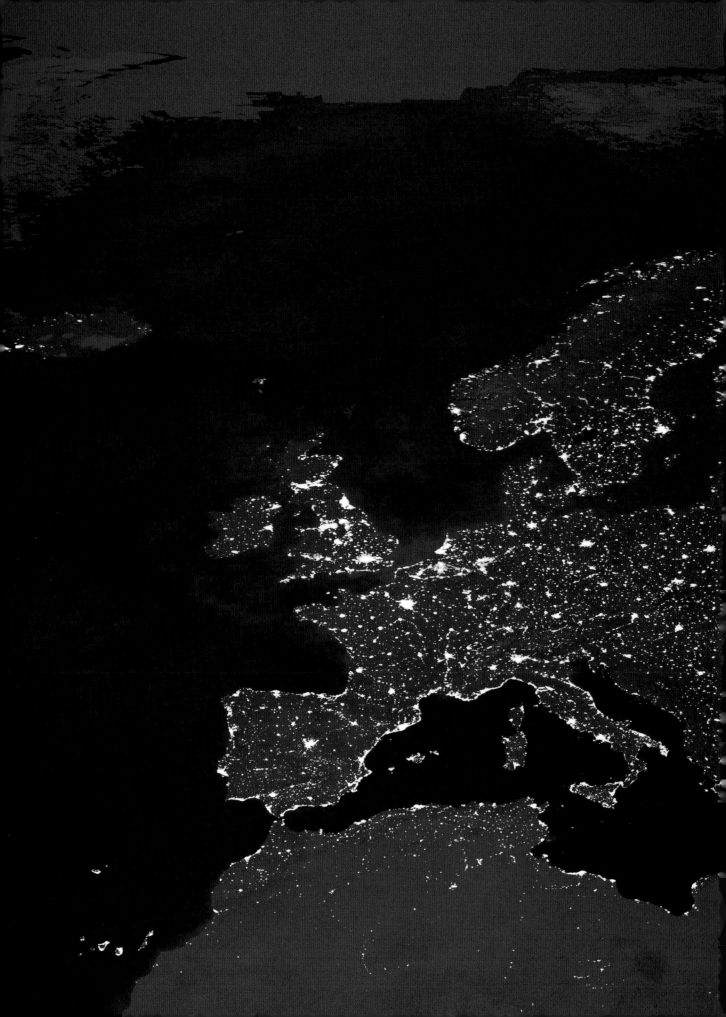

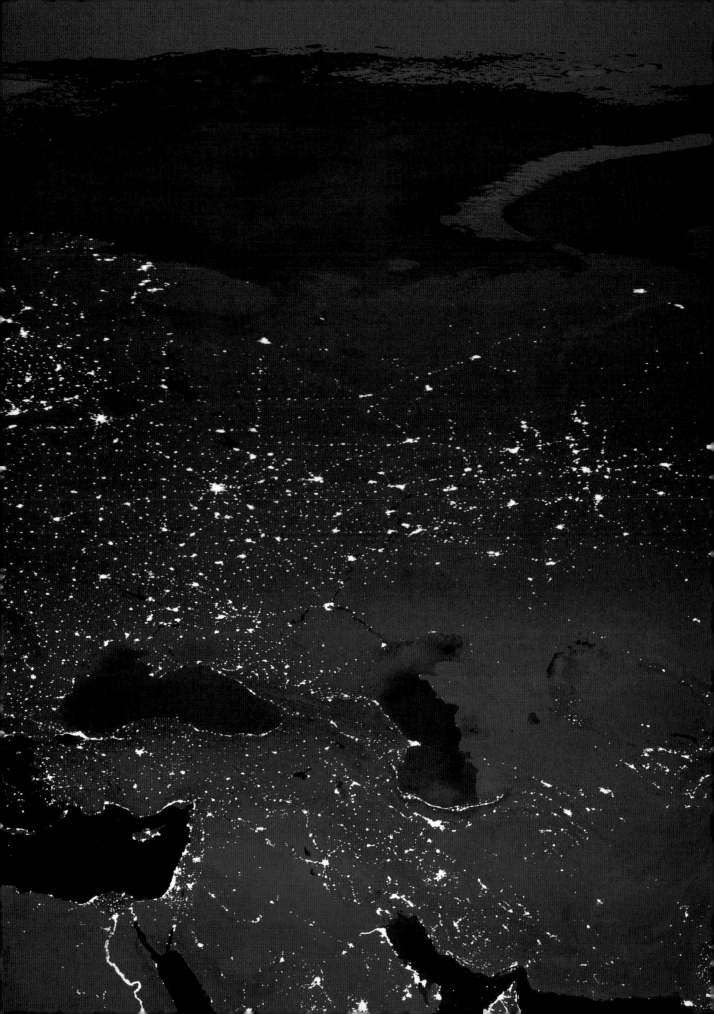

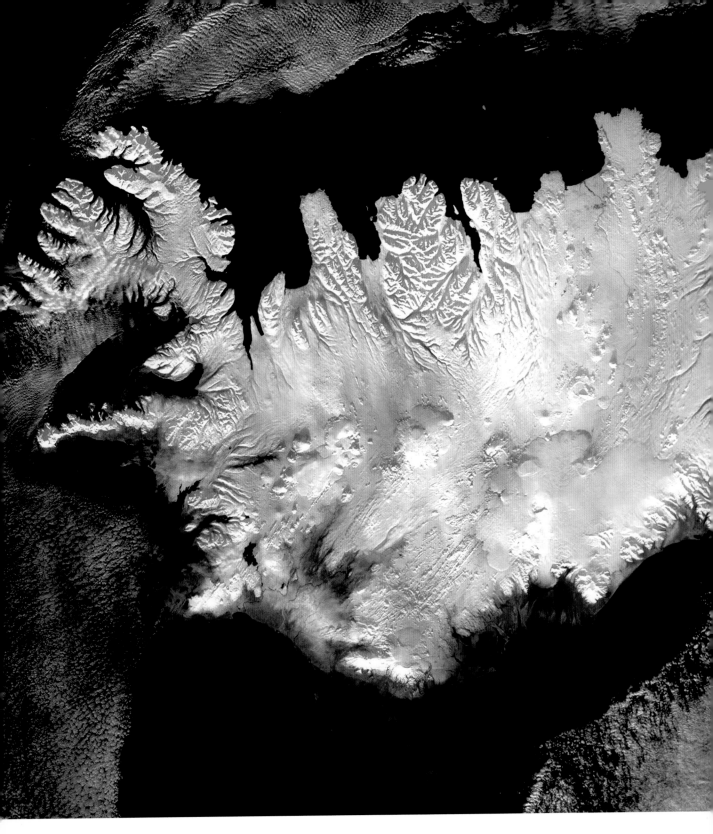

# Iceland

ICELAND IS THE MOST WESTERLY LANDMASS in Europe and, at 103,000 sq km/39,769 sq miles, the second largest island in Europe after Great Britain. Despite its name, its climate, other than in the extreme north, is relatively mild, warmed by the Gulf Stream. Nonetheless, most of the island is uninhabited Arctic desert, with dramatic volcanoes, hot springs, glaciers and waterfalls. It is the least densely inhabited country in Europe, with an average of only three people per sq km/one person per sq mile.

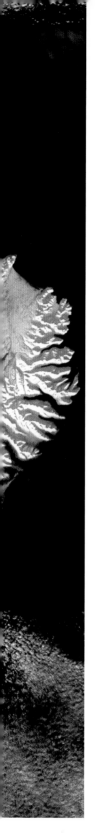

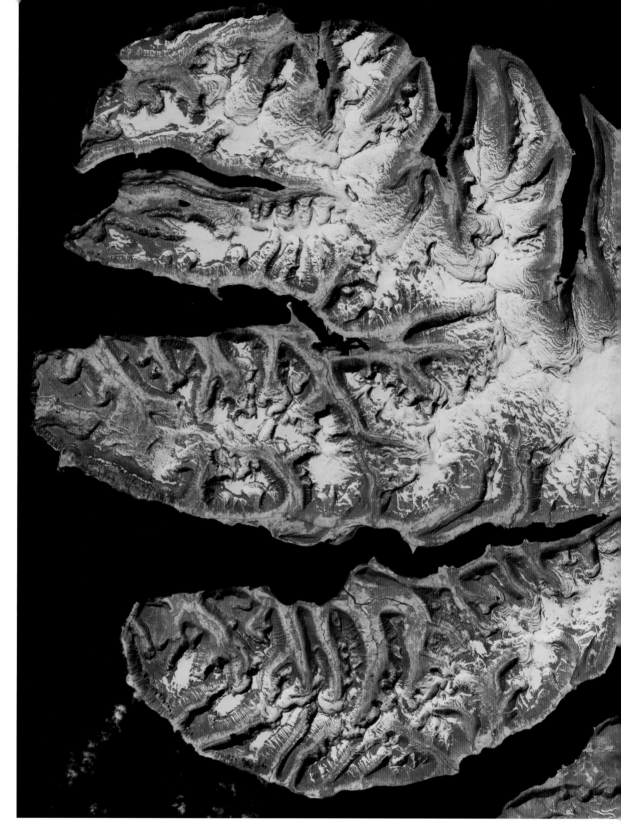

## Iceland: the Western Fjords

CONNECTED TO THE MAIN BODY OF ICELAND only by a narrow belt of land, the Western Fjords are a series of deeply eroded glacial peninsulas in the northwest of the island. This detail of one area covers approximately 50 km/30 miles from north to south. Though they represent less than one-eighth of Iceland's total area, their jagged, deeply intended perimeter accounts for more than half the island's total coastline.

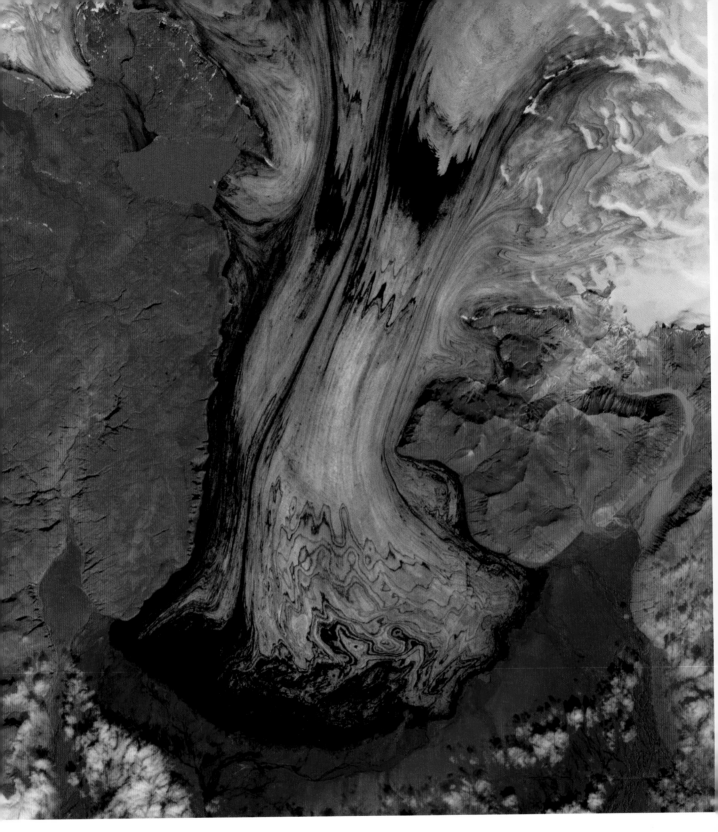

## Iceland: Vatnajökull Glacier

OF THE MANY GLACIERS THAT STUD ICELAND, the largest, in the southeast of the island and easily recognized in satellite images is the Vatnajökull Glacier. At 8,400 sq km/3,420 sq miles it is approximately the same size as all the glaciers in continental Europe combined. In parts, the ice is more than 0.8 km/0.5 miles thick. This close-up shows only a detail, approximately 32 km/20 miles from north to south. Global warming has seen a noticeable shrinking of Iceland's glaciers.

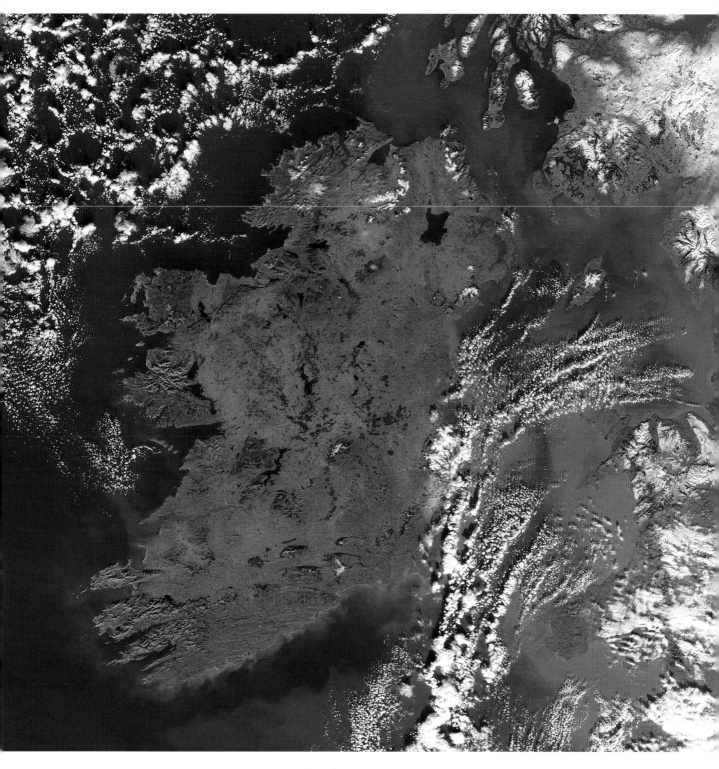

## Ireland

HILLY RATHER THAN MOUNTAINOUS – its highest point, Carrantuohill in Macgillycuddy's Reeks in the southwest is only 1,041m/3,414ft – much of Ireland consists of a central limestone plain with numerous bogs and lakes. The coast to the west, lashed by the Atlantic, is rugged and broken; that to the east much less dramatically weathered. Unusually, Ireland's population today – 3.9 million – is much smaller than it was in the nineteenth century, the result of successive waves of emigration.

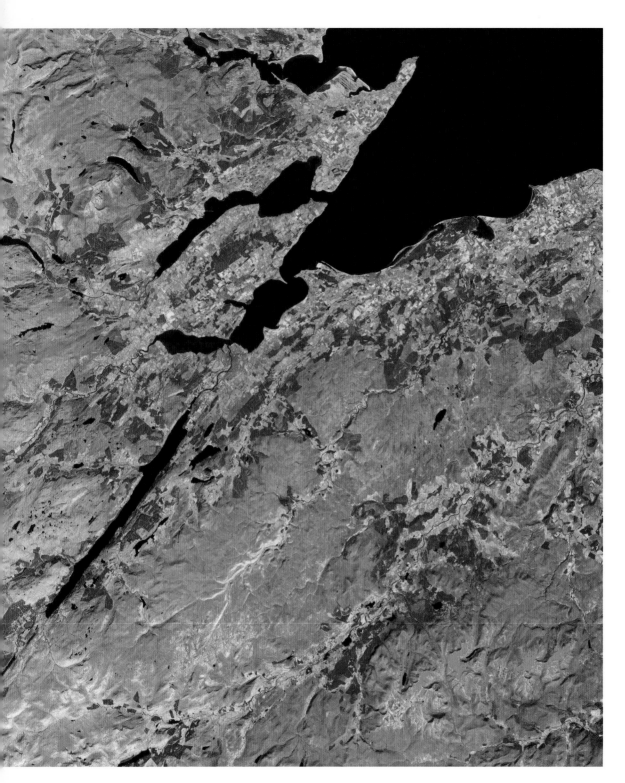

## Scotland: Loch Ness and the Northern Grampians

LOCH NESS, ITS WATERS SHOWN IN JET BLACK, runs diagonally from southwest to northeast for approximately 36 km/22 miles. It is the most northerly and largest element of the Great Glen, which extends from Fort William in the southwest to Inverness, Scotland's fourth-largest city, in the northeast. The vivid purple areas to the lower right of the image are the Cairngorms, site of the 1,309m/4,206ft Ben Macdui, Britain's second highest mountain.

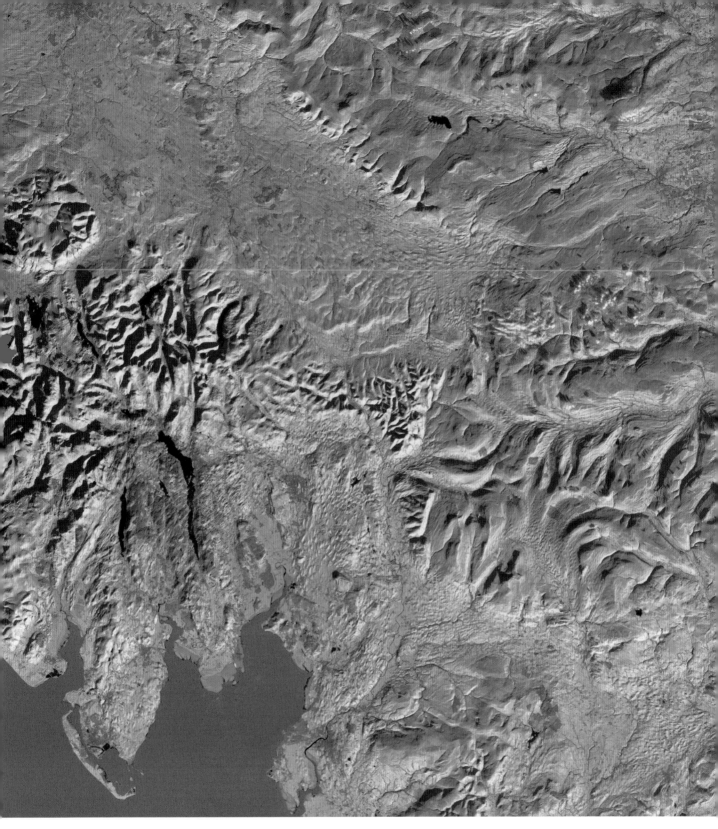

## England: The Lake District and Northern Pennines

THE LAKE DISTRICT, IN THE CENTRE-LEFT of this image, contains the largest mountains in England as well as most of the country's lakes. Much of the area consists of hard-wearing igneous rocks, carved into sharp peaks and steep-sided valleys during the last Ice Age, between 25,000 and 10,000 years ago. The Pennines, to the east, which run up the spine of England from the north Midlands, are typically lower and more eroded.

19

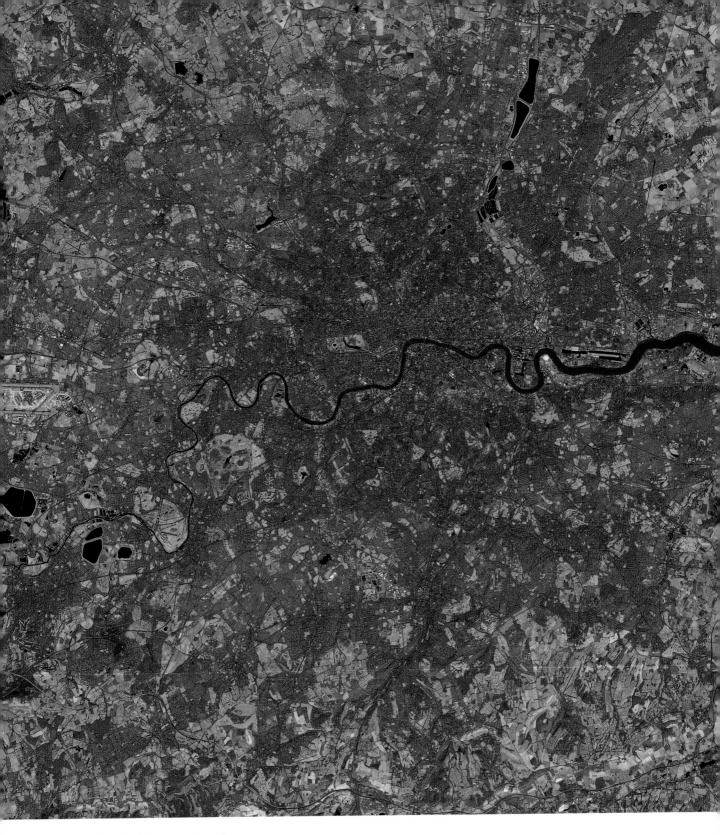

# England: Greater London

SHOWN IN VARYING SHADES OF PURPLE and bisected by the still deeper purple of the river Thames, London, with a population of 7.6 million, is by far the largest city in Britain and the third-largest in Europe. Greater London itself covers a total area of 1,579 sq km/609,000 sq miles. Just visible to the left of the image is Heathrow airport, the busiest international airport in the world, handling 60 million passengers a year.

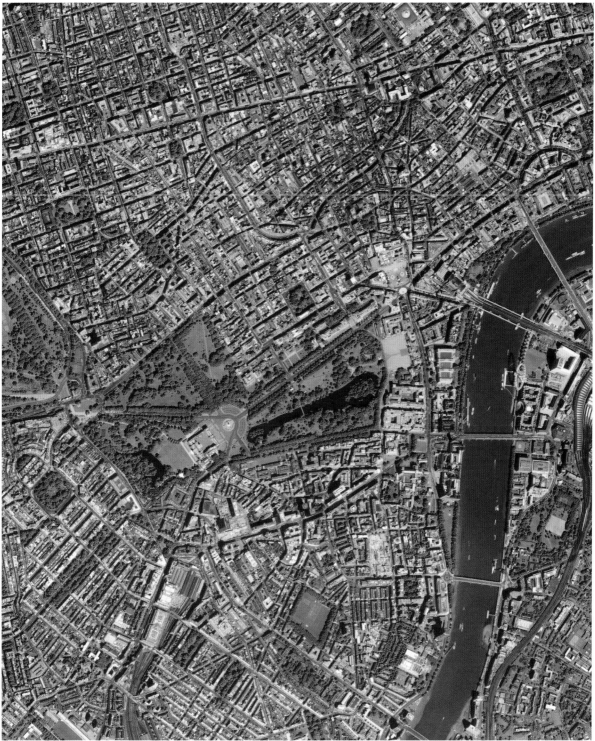

Satellite image courtesy of Space Imaging

# England: Central London

DOMINATING THIS IMAGE IS THE IMPOSING bulk of Buckingham Palace, sitting almost at the heart of an interconnecting series of parks, of which its own huge garden effectively forms one. To the east, facing the palace, is St James's Park; to the north is Green Park; to the northwest, Hyde Park. The distinctive green structure at the very top of the image is the dome over what was once the reading room of the British Museum.

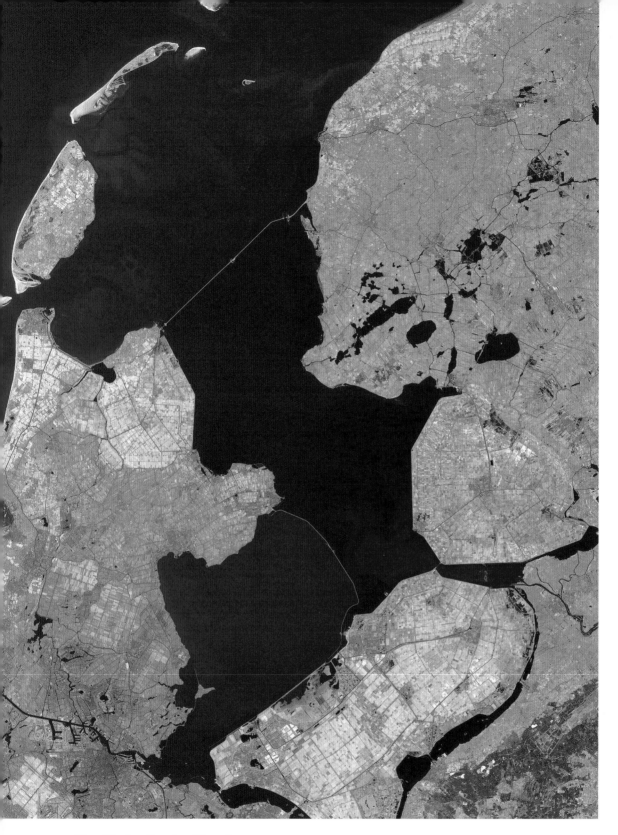

# The Netherlands: IJsselmeer

IJSSELMEER, A SHALLOW FRESHWATER LAKE in northern Holland, was created in 1932 with the completion of a 30 km/19-mile long dam, the Afsluitdijk, across the mouth of what was originally an inlet of the North Sea, the Zuiderzee. The dyke is clearly visible towards the upper half of this image as a thin line running southwest/northeast. To the south is a further dam, the Markerwaarddijk, completed in 1976, and enclosing a second lake, the Markermeer. Amsterdam, Holland's largest city, is in the lower left-hand corner of the image.

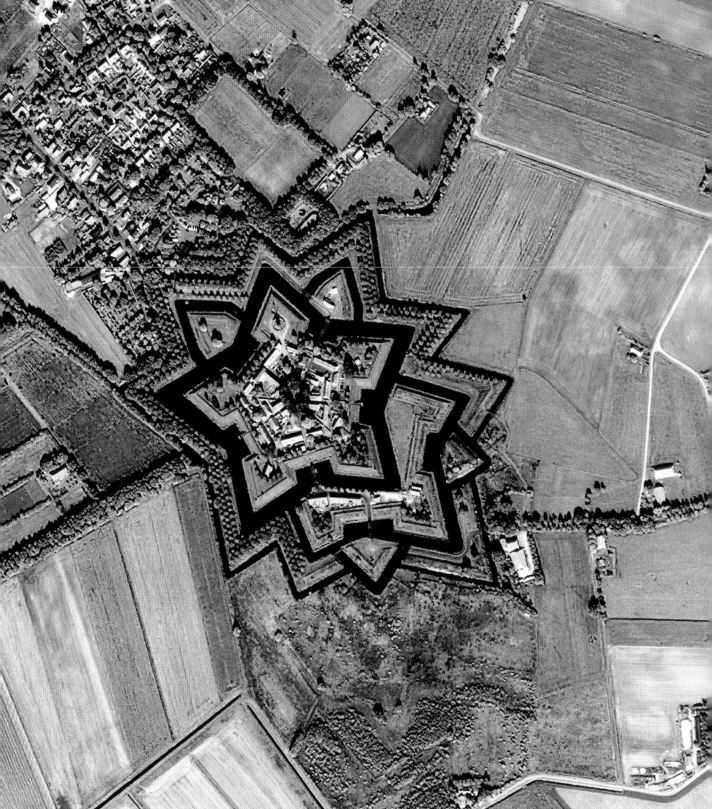

## The Netherlands: Bourtange

VESTING OR 'FORTRESS' BOURTANGE IN NORTHERN HOLLAND, close to the border with Germany, is a curious historical fake. The entire castle was demolished after 1850 but then rebuilt as a tourist attraction from 1964 onwards. The original fortress was constructed from about 1580 on the orders of Prince William of Orange. With modifications, it remained a fortress until the nineteenth century. Today's building, complete with highly elaborate star-shaped defensive works and moats, recreates the fortress as it was in 1742.

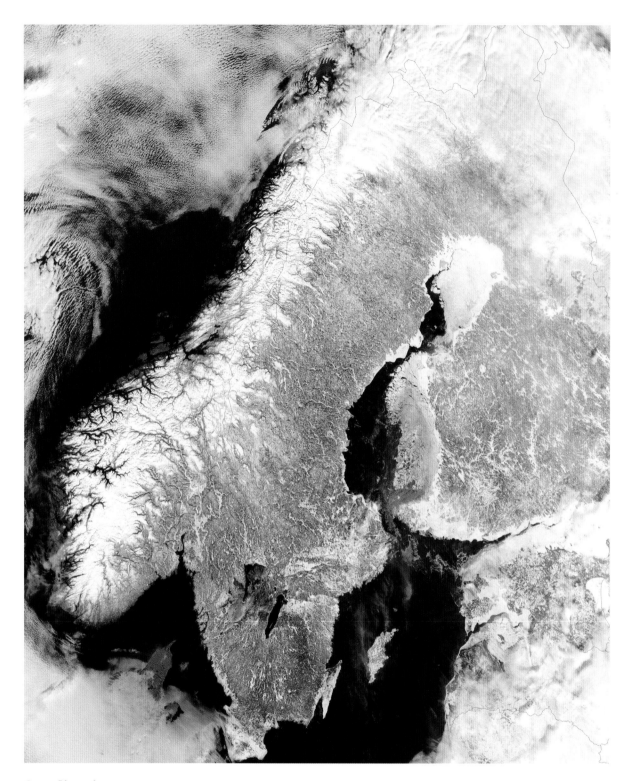

# Scandinavia

THE FOUR SCANDINAVIAN COUNTRIES – Denmark, Sweden, Finland and Norway – present a startling range of geographical contrasts. Finland, the most easterly has more than 56,000 lakes greater than a hectare in size. Sweden is a land of forests and lakes, its rocky Baltic coast on the Gulf of Bothnia studded with a series of islands. Norway, the most northerly country in Europe, is dominated by mountains and fjords. Its coastline is 2,400 km/1,500 miles long and has more than 45,000 islands.

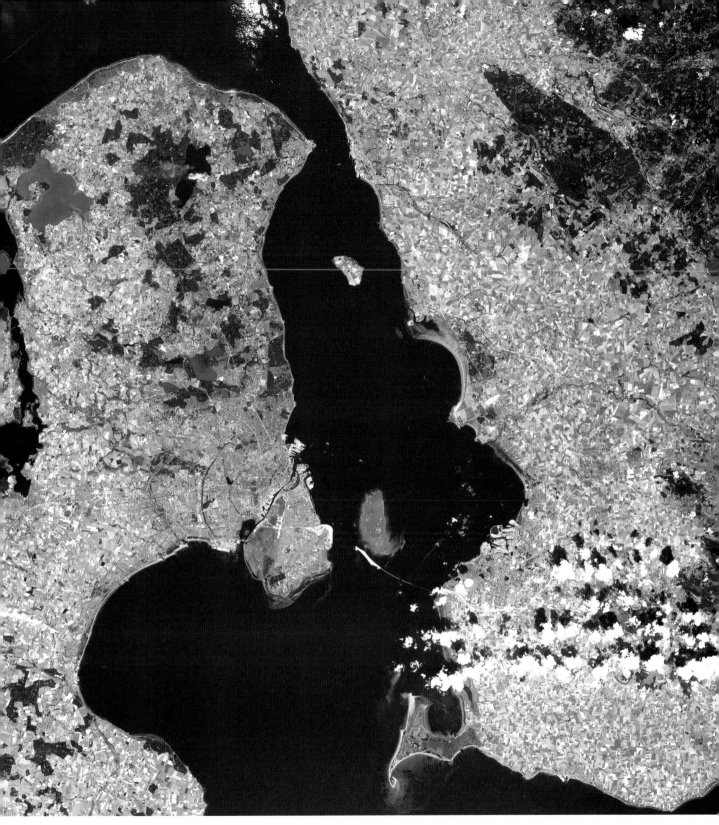

## Denmark and Sweden: Öresund Strait

THE ÖRESUND STRAIT, OR SIMPLY THE 'SOUND', separates Denmark, to the left, and Sweden, to the right. At its narrowest, to the north, it is a mere 5 km/3 miles wide. In July 2000, a huge bridge linking the Danish capital, Copenhagen, and Malmö was opened. It is visible on this image below the large island, Saltholm, at the southern end of the Strait. The two-tier bridge is part bridge and part tunnel and is 7.7 km/4.8 miles long. Its central span is 490m/1,608ft long.

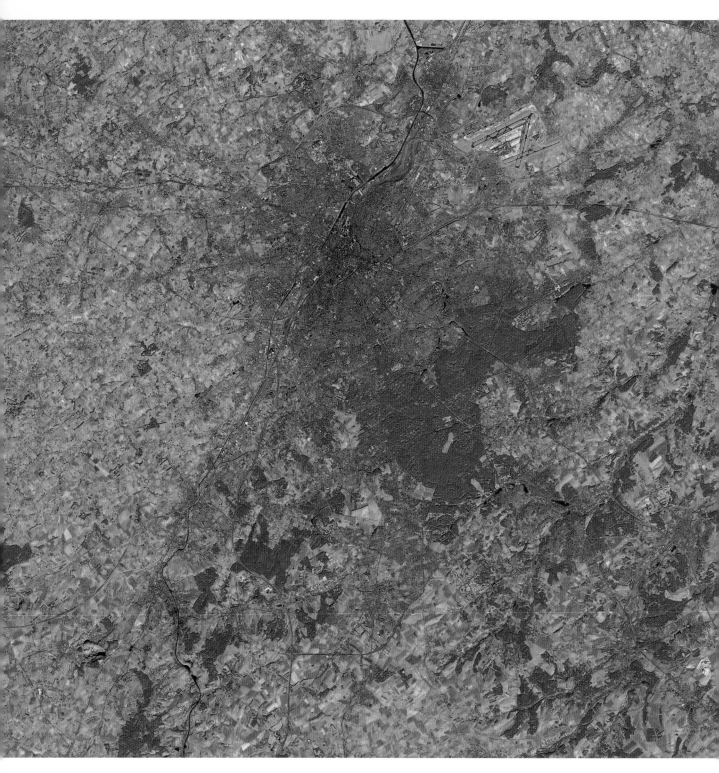

## Belgium: Brussels

BRUSSELS, CAPITAL OF BELGIUM, administrative centre of the European Union and home of
NATO, is small by the standards of Europe's leading capitals, with a population of no more
than 1.75 million. At least one-third of its residents come from overseas, which underlines
not just Belgium's cosmopolitan character but also its historic role as one of Europe's major
crossing points. Around the city are farms, highlighting the exceptional fertility of the region. The
large dark-red areas are forests.

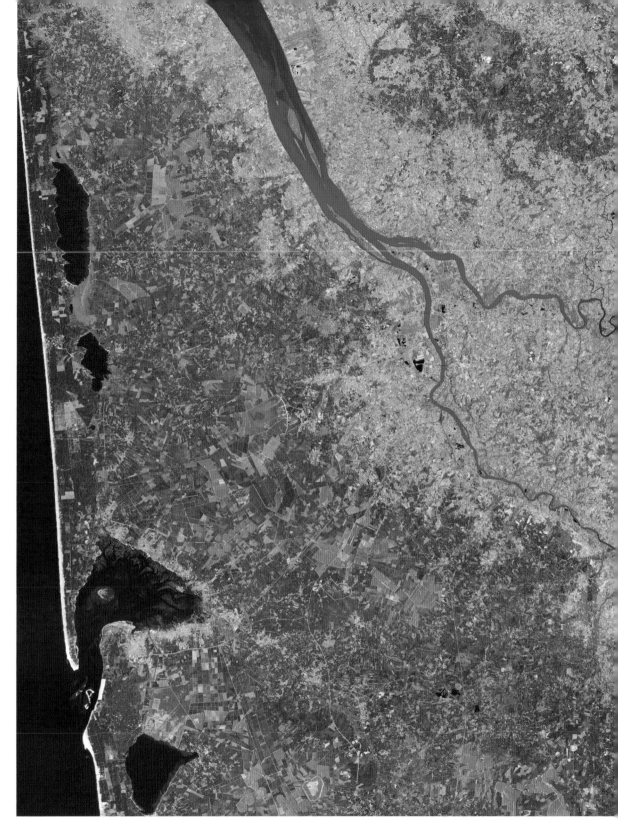

## France: Bordeaux, the Médoc and the Gironde

BORDEAUX, THE MOST CHIC OF FRANCE'S provincial cities, is the blue sprawl on the lower of the
two rivers that meet north of the city to form the Gironde, the largest estuary in Europe. The city
itself lies on the Garonne; the second river is the Dordogne. Southwest of Bordeaux is the large
bay of Arcachon, one of a series of lagoons that dot the sandy Atlantic coast. To the north is
the Médoc, the world's most celebrated wine-producing region.

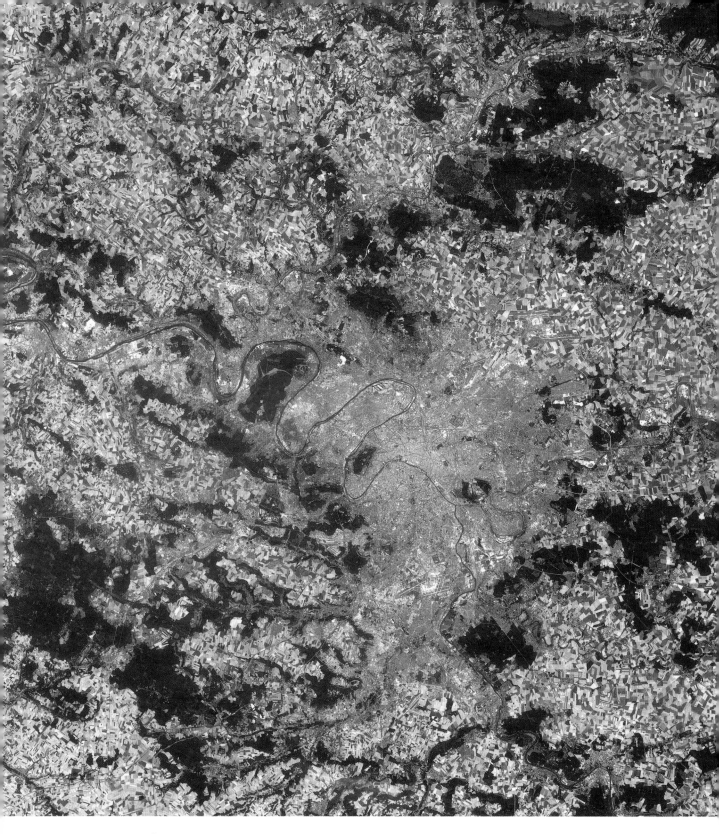

# France: Paris

WITH A POPULATION OF 10.5 MILLION, Paris, visible here as the grey mass in the centre of
the image, is not just the largest city in France as well as its capital, but is the largest in Europe.
It sits on generally low-lying land, part of the much larger North European Plain, astride the river
Seine. The river is clearly visible, snaking through the city from southeast to northwest before
meandering in a series of vast loops north to the Channel coast.

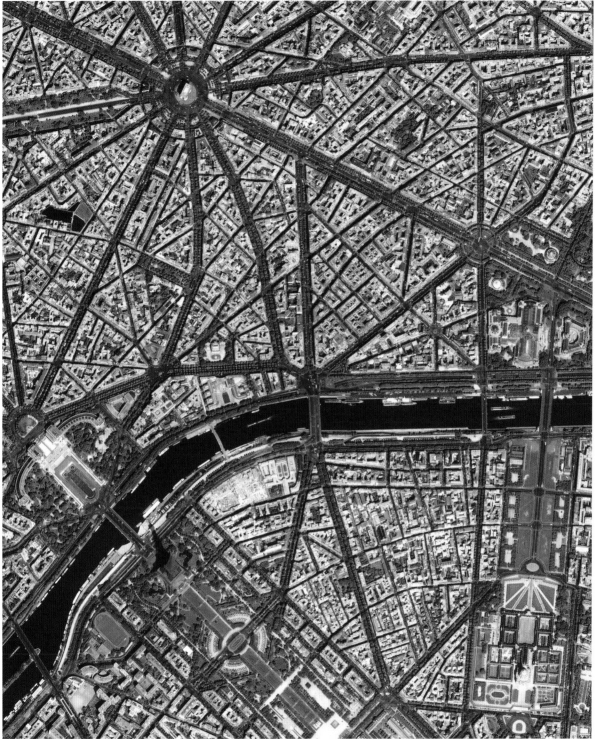

Satellite image courtesy of European Space Imaging

# France: Central Paris

THE FORMALITY AND GRANDEUR OF FRENCH town planning is immediately obvious. In the top left is the Arc de Triomphe, central point of a converging network of roads, of which the largest, the Champs Elysées, runs undeviatingly for more than two miles to the Place de la Concorde and the Louvre. On the left bank of the river a series of imposingly formal gardens lead to Louis XIV's church of the Invalides, the site of Napoleon's tomb. To its left is the Eiffel Tower.

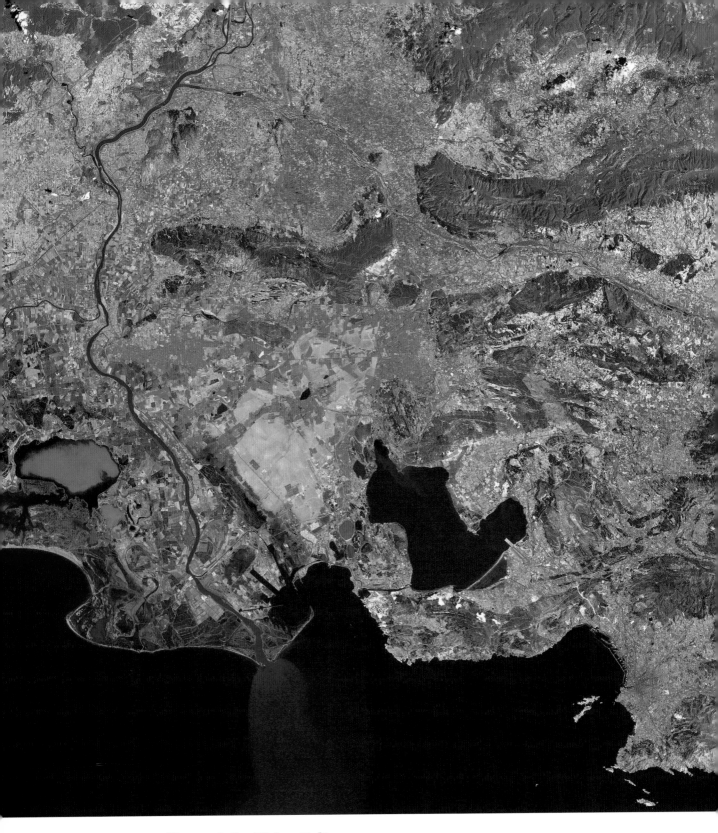

## France: Marseilles and the Rhône Delta

AS THE RHÔNE, EASILY VISIBLE ON THE LEFT of this image, nears the Mediterranean, it passes through an increasingly rocky landscape that then gives way to a series of interconnecting, saltwater lagoons, the Camargue. At the very mouth of the river lies one of the largest ports in Europe, Port-St-Louis-du-Rhône. Marseilles, the country's largest Mediterranean city, lies in the lower right of the image on a west-facing stretch of coast.

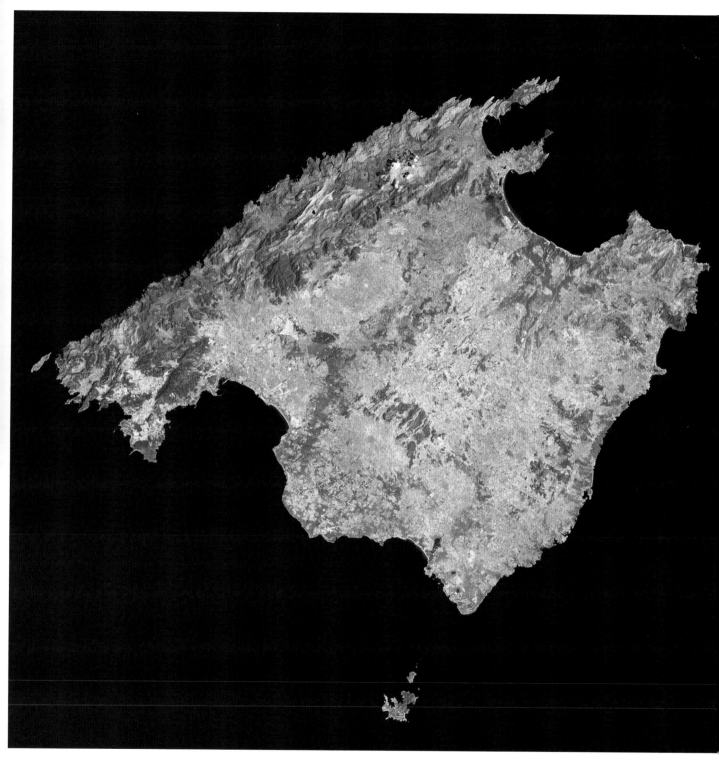

# Spain: Mallorca (Majorca)

IT IS AN UNMISTAKABLE MEASURE of the dominance of tourism on Mallorca's economy that at any given moment in the summer the island's permanent population of 581,000 is slightly outnumbered by the number of overseas visitors. In all, the island attracts about 9 million visitors a year. The majority cluster in and around the capital, Palma de Mallorca, at the western end of the large bay on the southwest coast. Much of the interior and rugged north coast remain surprisingly unspoilt.

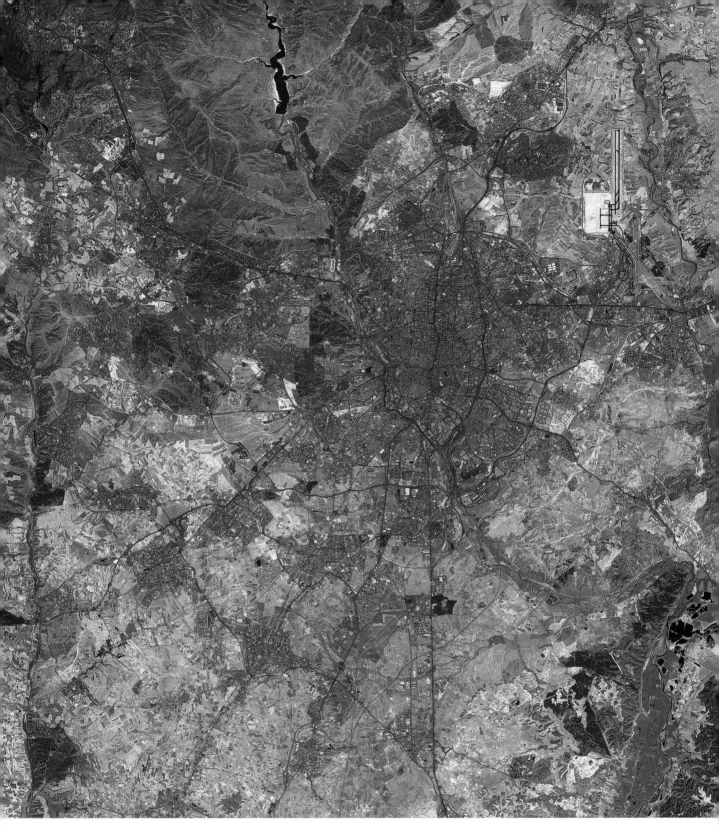

# Spain: Madrid

MADRID, THE CAPITAL OF SPAIN, lies at almost the exact geographical heart of the country.
It sits on the Meseta, the 610m/2,000ft-high central plateau that dominates the north and
centre of the country. As a result, while winters are often bitter and windswept, summers are
parchingly hot. Immediately to its north is the mountain range of the Sierra de Guadarrama.
With a population of 2.95 million, Madrid is by some way the largest city in the country.

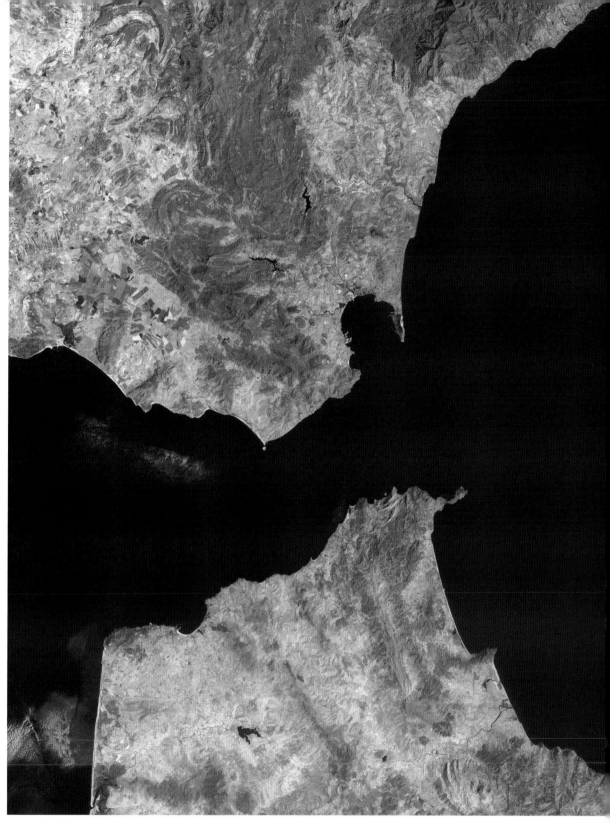

## The Straits of Gibraltar

THE STRAITS OF GIBRALTAR are one of the most historically significant geographical features of Europe. They not only mark the closest Europe comes to Africa but also, being only 15 km/9 miles wide at their narrowest, almost make the Mediterranean an inland sea. Though both Ceuta, the promontory projecting into the Mediterranean on the African shore, and Gibraltar itself dominate the straits, Gibraltar has by far the better harbour. For centuries, to control Gibraltar was to control the Mediterranean.

33

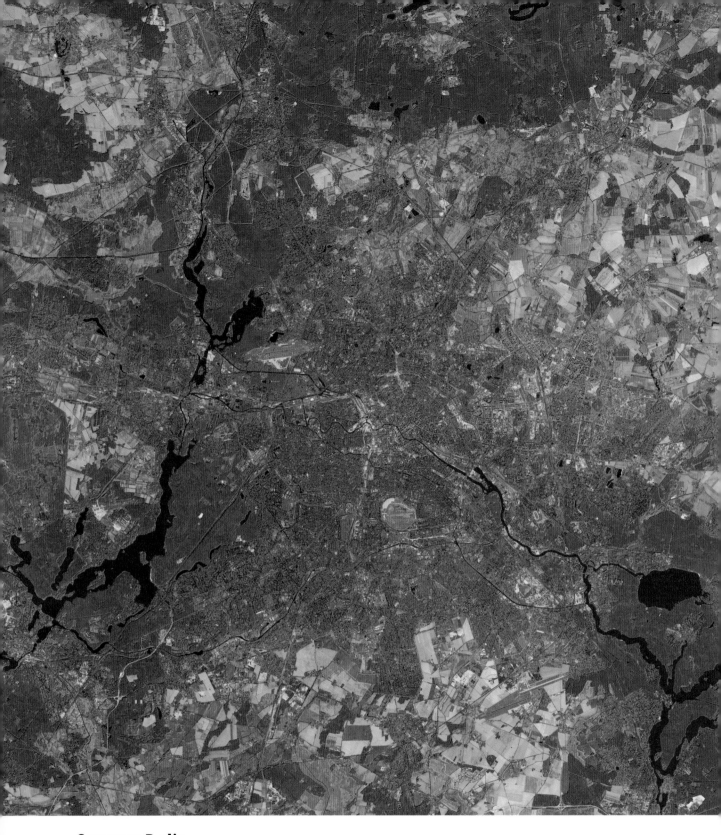

# Germany: Berlin

THE STRIKING SPLASHES OF RED in this image of Germany's capital are forests, clear evidence of the heavily wooded character of this area of the North European Plain. Also easily visible are the many lakes dotted around the city, themselves a favourite leisure destination for Berlin's 3.94 million inhabitants. The course of the river Spree, which runs through Berlin from right to left before heading north, is less easy to see. To the southwest is Potsdam.

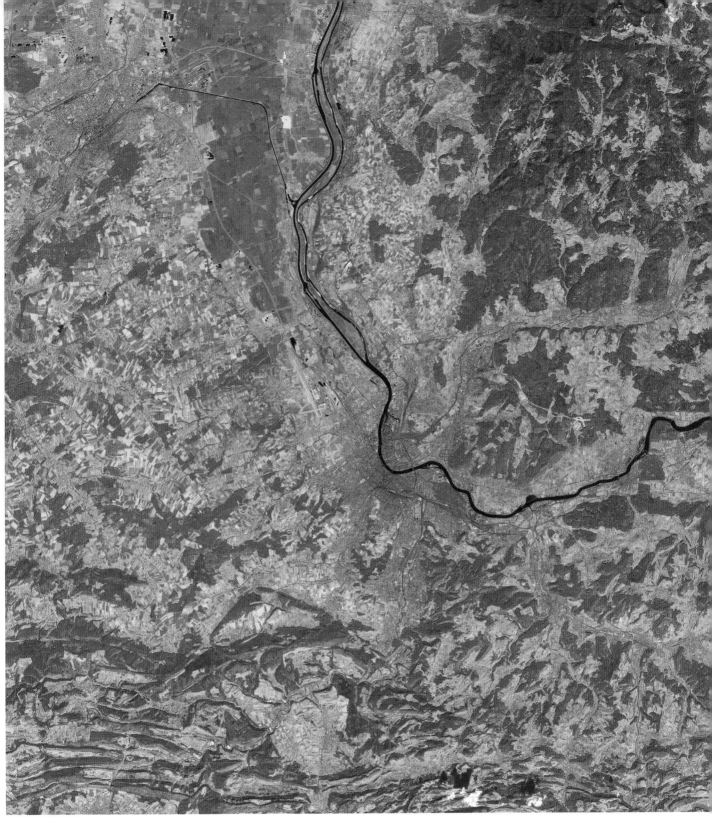

## Switzerland, France and Germany: Basel and the Rhine

THE RHINE, CLEARLY VISIBLE on this image, swings north to flow to the North Sea at Basel, which marks one of the great historic junctions of western Europe, the meeting point of Switzerland, Germany and France. Where the river flows west on this image, it forms the frontier between Germany, to its north, and Switzerland, to its south. Where it flows north, it forms the frontier between Germany and France. The French city of Mulhouse is visible in the upper-left-hand corner of the image.

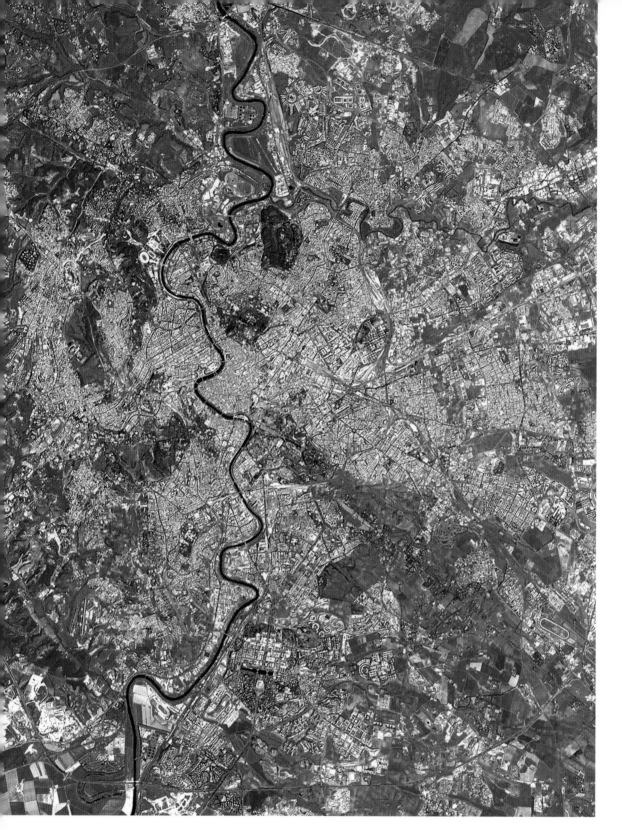
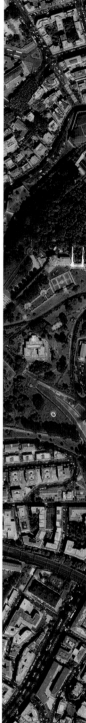

# Italy: Rome

THE ETERNAL CITY, TO WHICH ALL ROADS LEAD, may well have been the hub of the Roman Empire but it was only in 1870, nine years after most of the modern state of Italy had come into being, that Rome again found itself a capital. Even if its fabled seven hills are not easily visible on this image, the ancient heart of the city, huddled on the east bank of the Tiber, is readily apparent as a dense urban mass.

Satellite image courtesy of European Space Imaging

## The Vatican City

THE VATICAN CITY, ENTIRELY SURROUNDED BY ROME, is the smallest state in the world. It covers 44 ha/109 acres and has a population of 921, giving rise to the statistical absurdity of its being the third-most densely populated country in the world, with, extrapolated, 2,093 people per sq km/5,421 per sq mile. Vatican City is dominated by St Peter's, the world's largest church, and the immense curving piazza in front of it. The pope is its head of state; Latin is an official language.

37

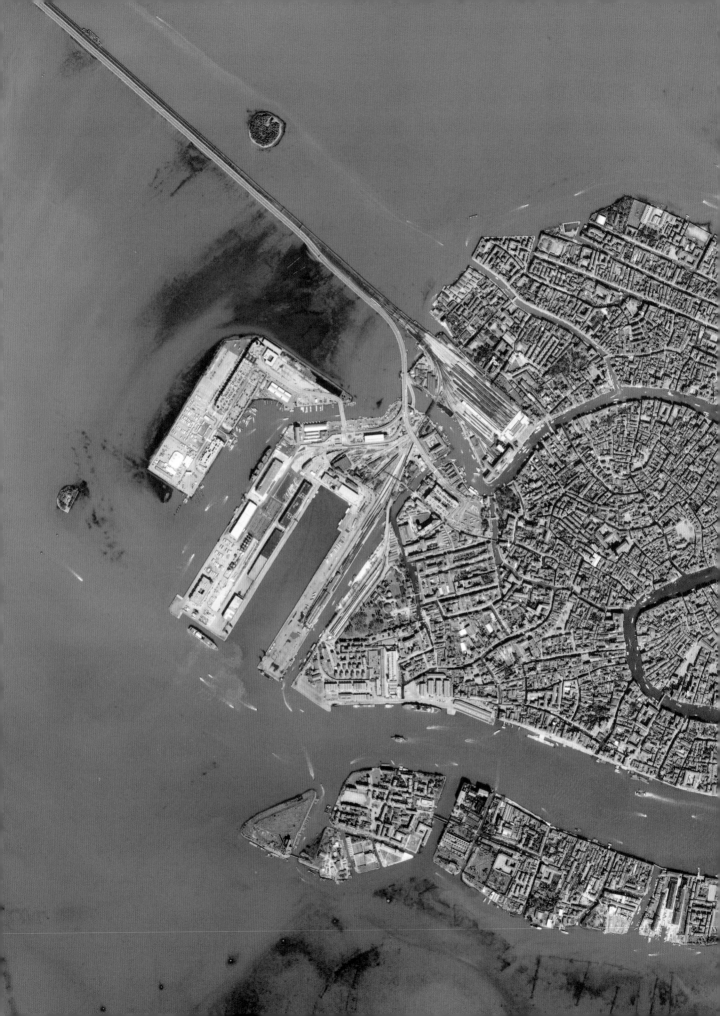

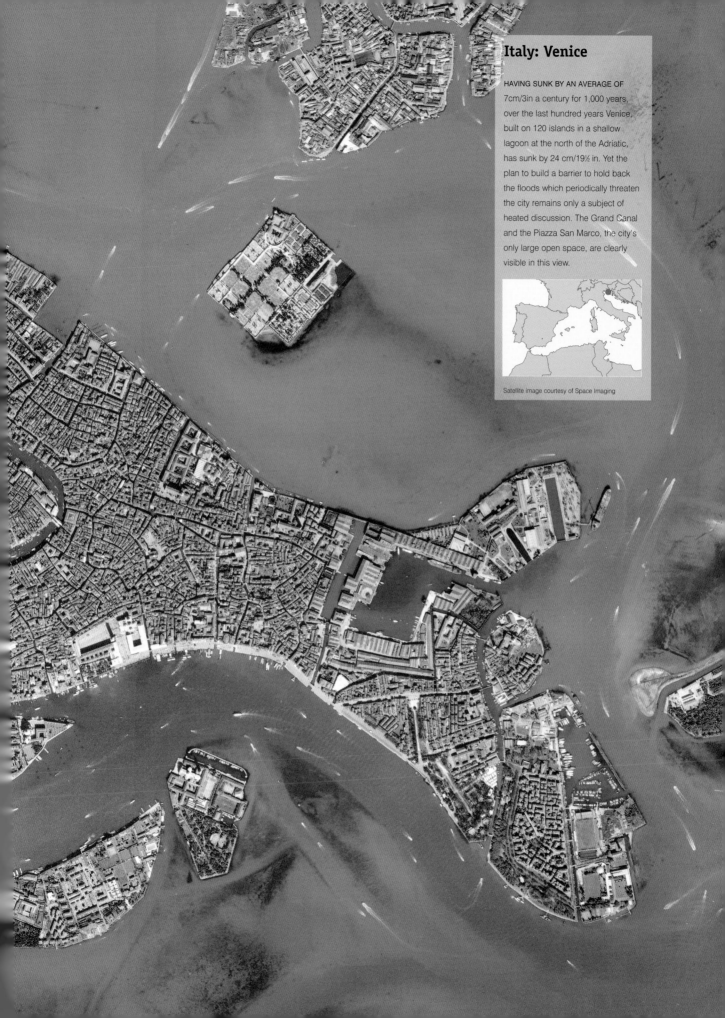

## Italy: Venice

HAVING SUNK BY AN AVERAGE OF 7cm/3in a century for 1,000 years, over the last hundred years Venice, built on 120 islands in a shallow lagoon at the north of the Adriatic, has sunk by 24 cm/19½ in. Yet the plan to build a barrier to hold back the floods which periodically threaten the city remains only a subject of heated discussion. The Grand Canal and the Piazza San Marco, the city's only large open space, are clearly visible in this view.

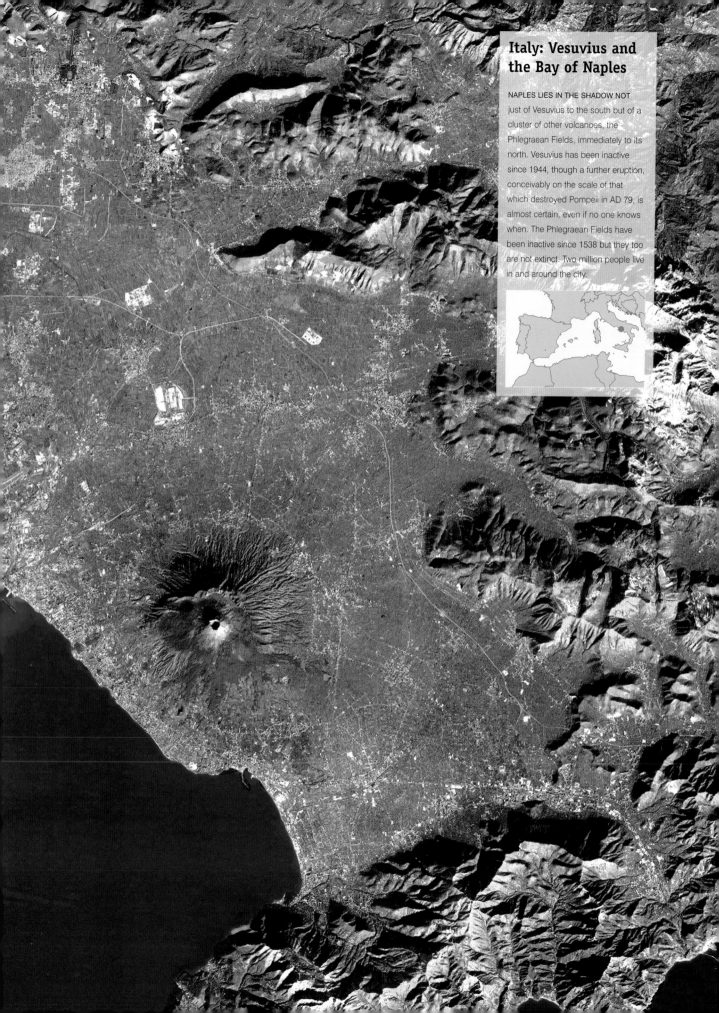

## Italy: Vesuvius and the Bay of Naples

NAPLES LIES IN THE SHADOW NOT just of Vesuvius to the south but of a cluster of other volcanoes, the Phlegraean Fields, immediately to its north. Vesuvius has been inactive since 1944, though a further eruption, conceivably on the scale of that which destroyed Pompeii in AD 79, is almost certain, even if no one knows when. The Phlegraean Fields have been inactive since 1538 but they too are not extinct. Two million people live in and around the city.

## Sicily: Mount Etna

MOUNT ETNA, 3,350M/11,000FT HIGH, lies on the east coast of Sicily and has been periodically
active since the mid-1950s, with volcanic activity increasingly marked since the 1980s. Today
it is in a state of semi-permanent activity. Like Vesuvius, it is one of the most intensely studied
volcanoes in the world. Satellite imagery plays a key part in the evolving science of
volcanology, in which the monitoring from space of gas emissions is crucial.

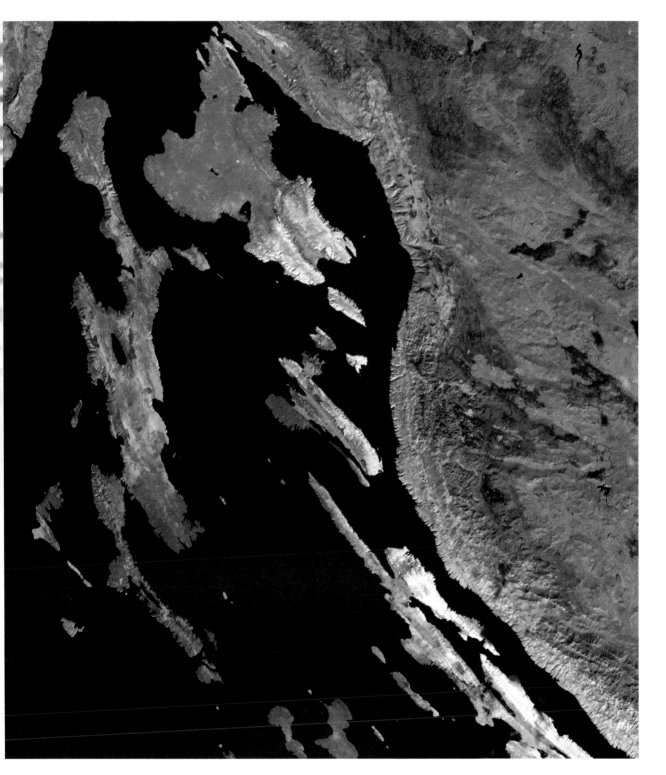

## Croatia: the Northern Dalmatian (Adriatic) Coast

CROATIA'S ADRIATIC COASTLINE IS among the most dramatically beautiful in Europe. Dozens of islands, large and small, stud the coast. The largest on this image, to the north, is Krk. To its west is the attenuated shape of Cres, both lying in the bay known as Kvarnericka Vrata. Inland from the rocky coast, the foothills of the Dinaric Alps, which stretch almost the full length of the country, are visible.

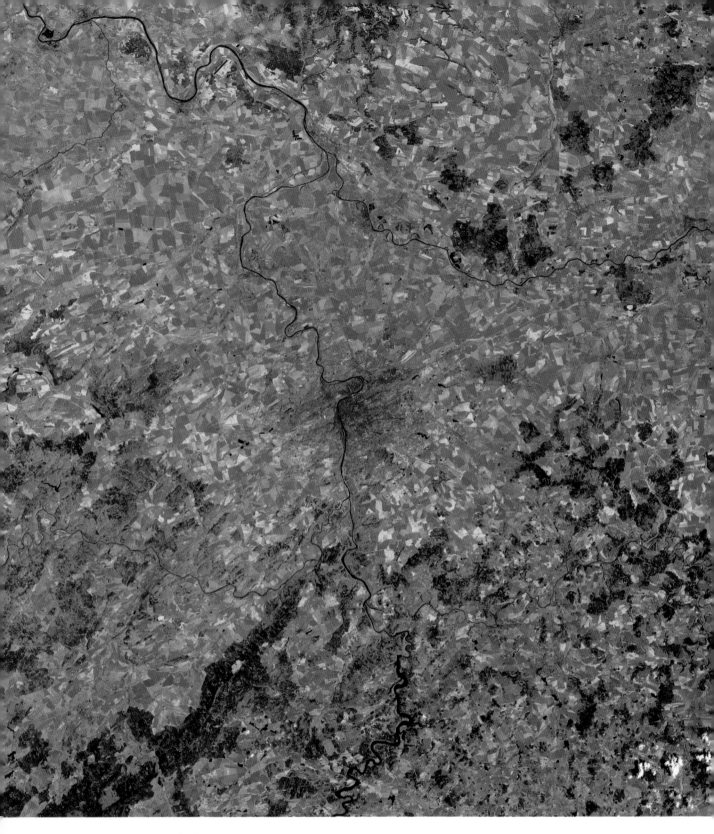

## The Czech Republic: Prague

PRAGUE, CAPITAL OF THE CZECH REPUBLIC, is in the centre of this image, which in total shows an area approximately 120 km/75 miles long from north to south. Vegetation is shown in red, its predominance making clear the agricultural nature of the region. The city lies on the Bohemian plateau, bounded on all sides by mountains and forests. Running through the city is the river Vltava, which flows to north to join the Elbe.

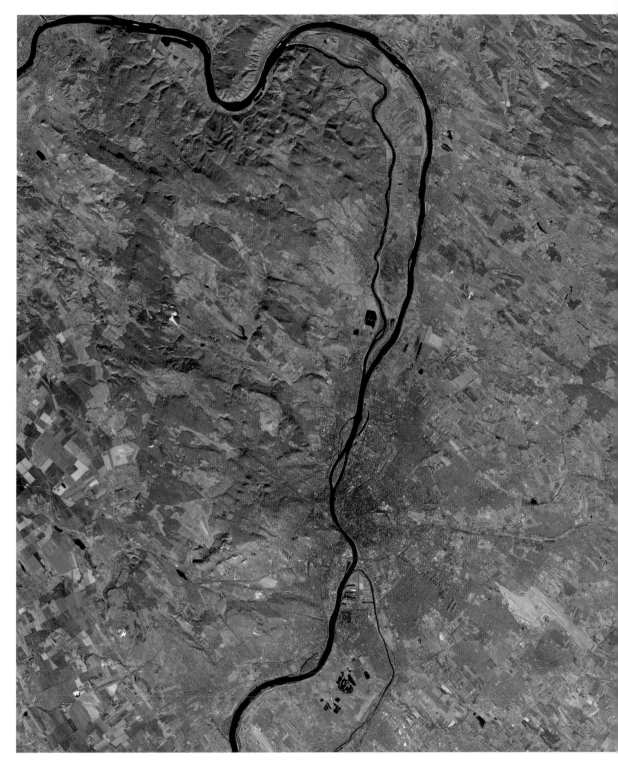

## Hungary: Budapest

BUDAPEST, THE CAPITAL OF HUNGARY, lies in the north of the Great Hungarian Plain. The Bakony Forest some kilometres north of the city, and adjacent to the Carpathian foothills, is clearly visible in red on this image, which shows an area of approximately 50 km/30 miles from north to south. Bisecting the city is the Danube, Europe's second longest river and its largest west to east flowing river.

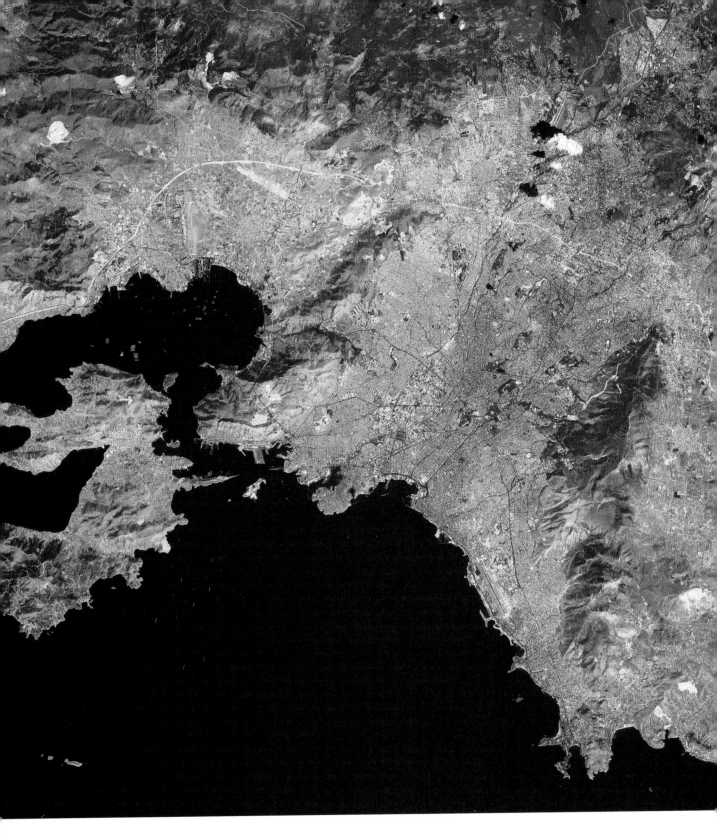

## Greece: Athens

ATHENS, CAPITAL OF GREECE and the country's largest city, lies on a plain that runs southwest to the island-studded Saronic Gulf. Mountains surround the city to the west, north and east. The greater metropolitan area of the city, including Piraeus, its port, is 427 sq km/165 sq miles. The population is three million. The city centre itself, site of ancient Athens, is 11 km/7 miles inland, and spreads outward from the 160m/525ft-high Acropolis, just visible in red on this image.

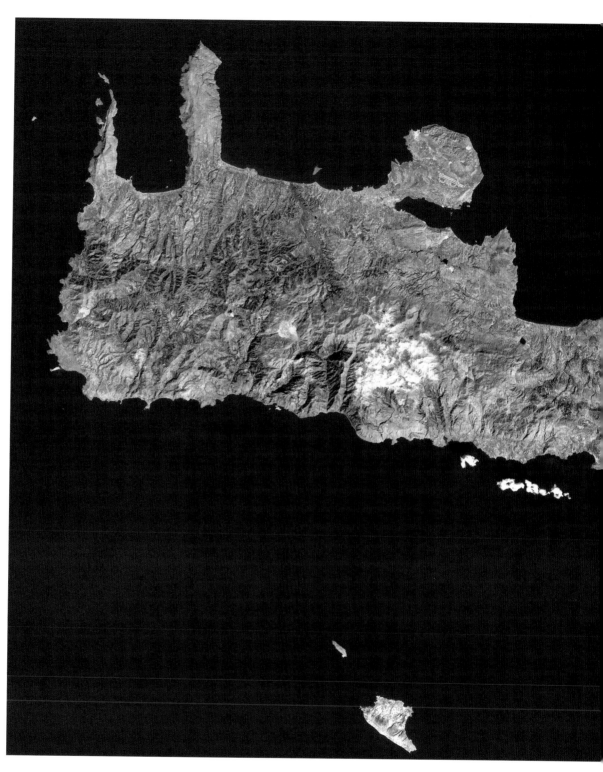

# Greece: Western Crete

CRETE, THE LARGEST GREEK ISLAND (and fifth largest in the Mediterranean), is 260 km/160 miles long and at its narrowest only 16 km/10 miles wide. Yet its coastline, part rocky, part sandy, is fully 1,000 km/620 miles long. At the west end of the island and protruding north from its mountainous spine are these three dramatic peninsulas. Although appearing to be snow covered, the White Mountains in the centre of this image are in fact named due to the particularly light limestone that forms this beautiful range.

47

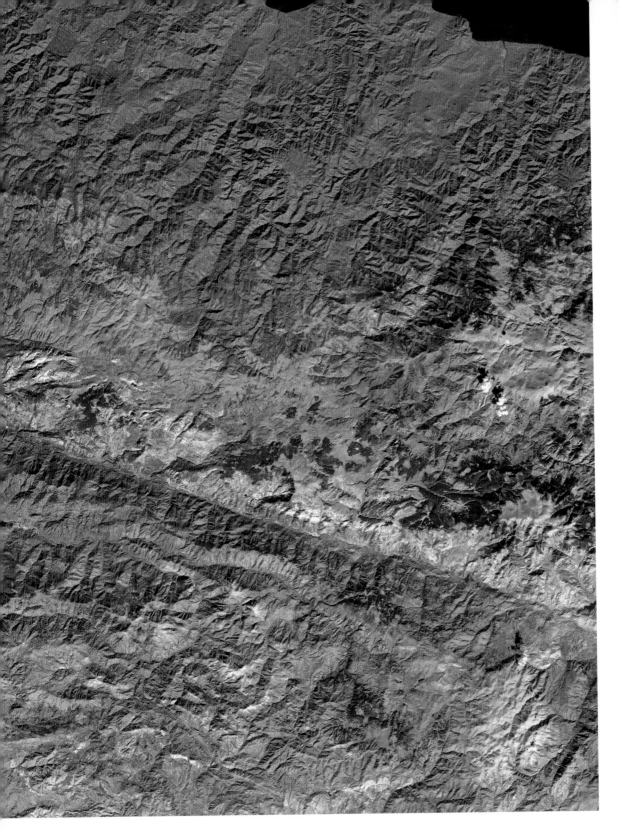

## Turkey: the Anatolian Fault

THE ANATOLIAN FAULT, of which about 100 km/60 miles is shown here, runs broadly east to west across Turkey for about 900 km/560 miles. There have been seven major earthquakes along it since 1939, all of which have progressively ruptured the fault from east to west. The most serious was near Izmit, close to Istanbul on the Sea of Marmara. It was in August 1999 and killed 18,000 people.

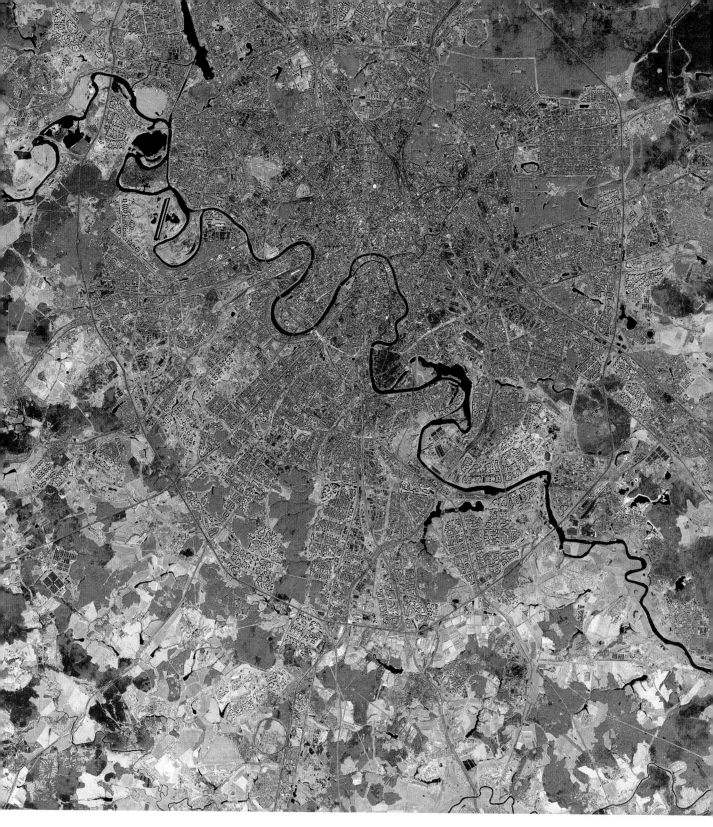

## Russia: Moscow

WITH A POPULATION OF 9.3 MILLION, Moscow, capital of Russia, is the country's largest city and
the second largest in Europe. It lies on the meandering Moskva (Moscow) river. The Kremlin,
the site of the first settlement, is just visible as an irregular red area immediately north of the
large, curving, slug-shaped island slightly to the right of the centre of the image. From north to
south, the image shows an area of approximately 58 km/36 miles.

49

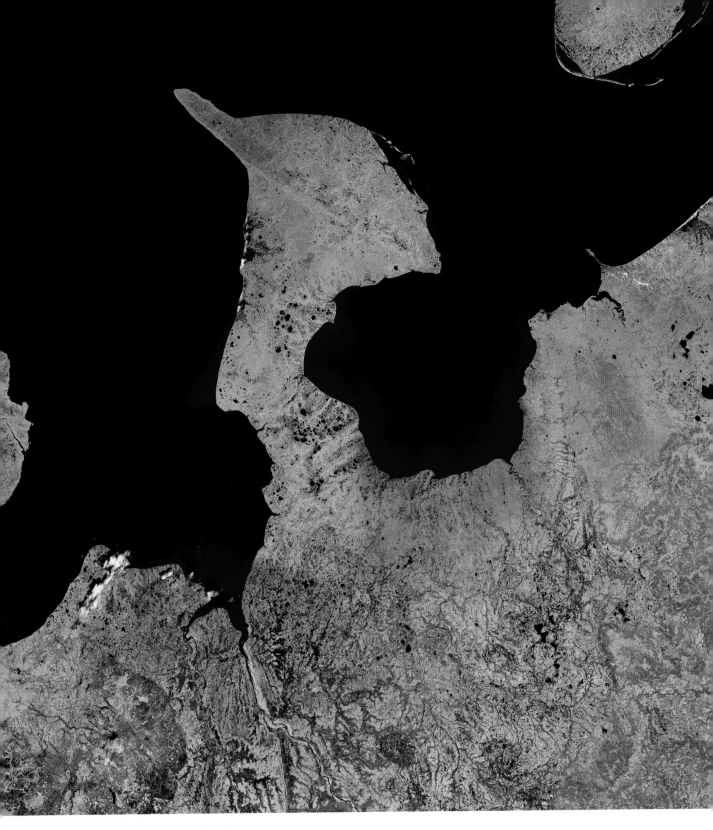

## Russia: Poluostrov Kanin

THE POLUOSTROV KANIN, or Kanin Peninsula, is in northwest Russia and projects starkly into the Barents Sea. To its west is the aptly named White Sea, to its east Cheshskaya Bay. With the entire peninsula lying north of the Arctic Circle, landscape and climate are extreme. The average January temperature is –17°C/1°F. Permafrost covers most of the peninsula, in places reaching a thickness of more than 275m/900ft. Its few hardy inhabitants live by hunting, fishing and raising reindeer.

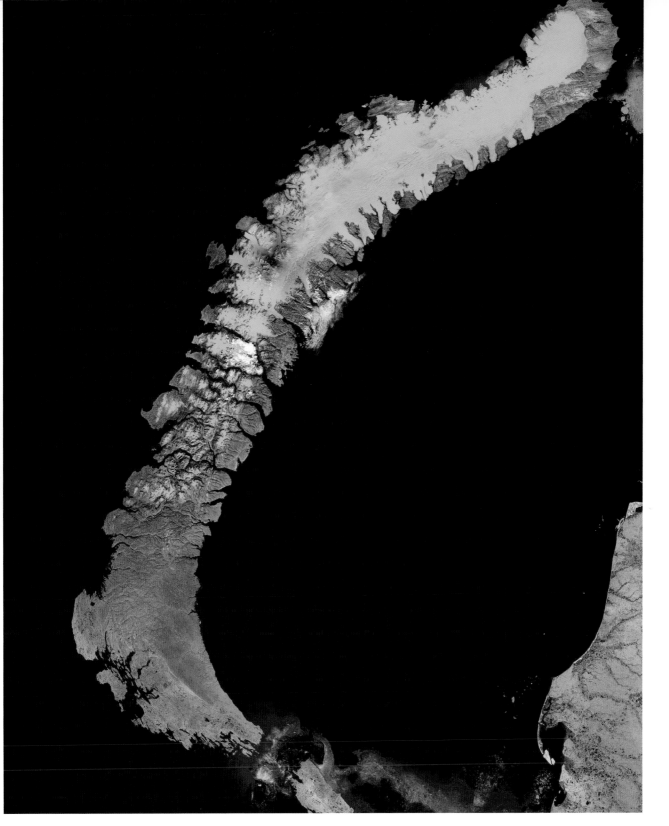

## Russia: Novaya Zemyla

NOVAYA ZEMYLA, OR 'NEW LAND', lies off the north coast of Russia and divides the Barents Sea in the west from the Kara Sea in the east. It consists of two principal islands, Severny and Yuzhny, as well as a host of smaller ones, the whole covering 90,650 sq km/35,000 sq miles. Geologically, it is a continuation of the Urals to the south, hence its mountainous character. Yuzhny, the southern island, is largely frozen tundra; Severny mostly glacial.

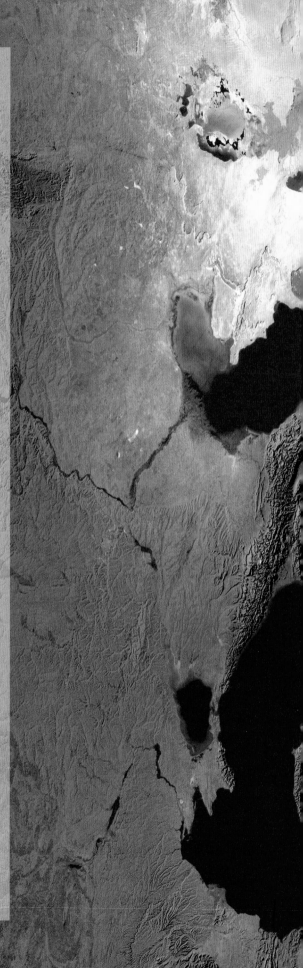

# THE MIDDLE EAST

Even more than Europe, the Middle East resists precise definition. Despite the great age of its civilizations – it was in Mesopotamia (modern Iraq) that the world's first cities emerged 5,000 years ago – this is a region that has always been less a discrete entity in its own right and more an important continuation of the wider and neighbouring Eurasian and North African worlds, a cultural as well as a geographical crossroads. The Fertile Crescent, arcing from Mesopotamia to Palestine and then south to Egypt, was one of the great highways of the ancient world, linking east and west.

The Anatolian mountains in Turkey and the Zagros mountains of Iraq and Iran form a rugged natural divide to the diverse environments of this region. To the north the landscape is dominated by three great inland water bodies (The Black, Caspian and Aral Seas). However, human activity and the limited water resource have combined to create a major threat to the environment of the arid Central Asian plains and the shallow waters of the Aral and north-

east Caspian Sea. To the south, the Arabian peninsula is covered by 3 million sq km/1.2 million sq miles of the Arabian and Syrian Deserts which contain more sand than the larger Saharan Desert. The aptly named Rub-al-Khali (Empty Quarter), in the south-east of the Arabian peninsula, contains sand dunes towering 330m/1100ft high, and with air temperatures up to 55°C/130°F and sand surface temperatures that can reach 80°C/175°F, this is a scorching habitat made even more forbidding by the presence of deadly snakes and scorpions.

Ancient Sumerians, Assyrians and Babylonians used oil from surface seeps, for lamps and treating wounds more than 6000 years ago. The modern oil era began in 1908 with the discovery of commercial quantities in southern Iran. This discovery in the Zagros mountains was followed by some of the world's largest oilfields under the sands of Saudi Arabia and Kuwait. Since then revenue generated from oil around The Gulf has been the core of The Middle East economies and sustained the world's petroleum industry. More recent giant discoveries around the Caspian will continue the development of this region.

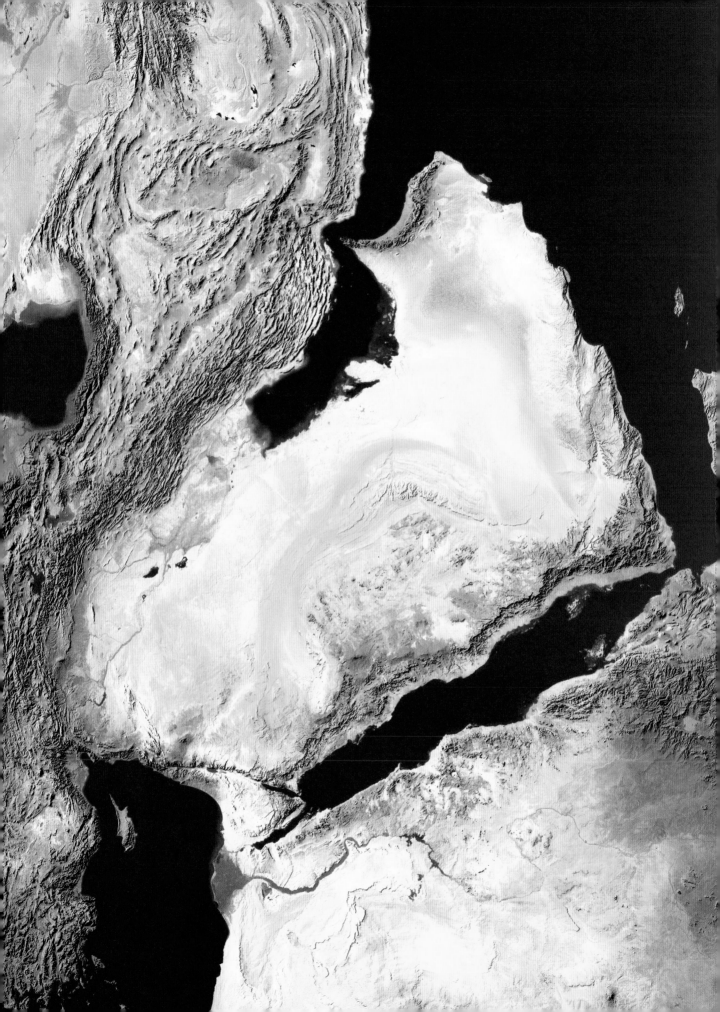

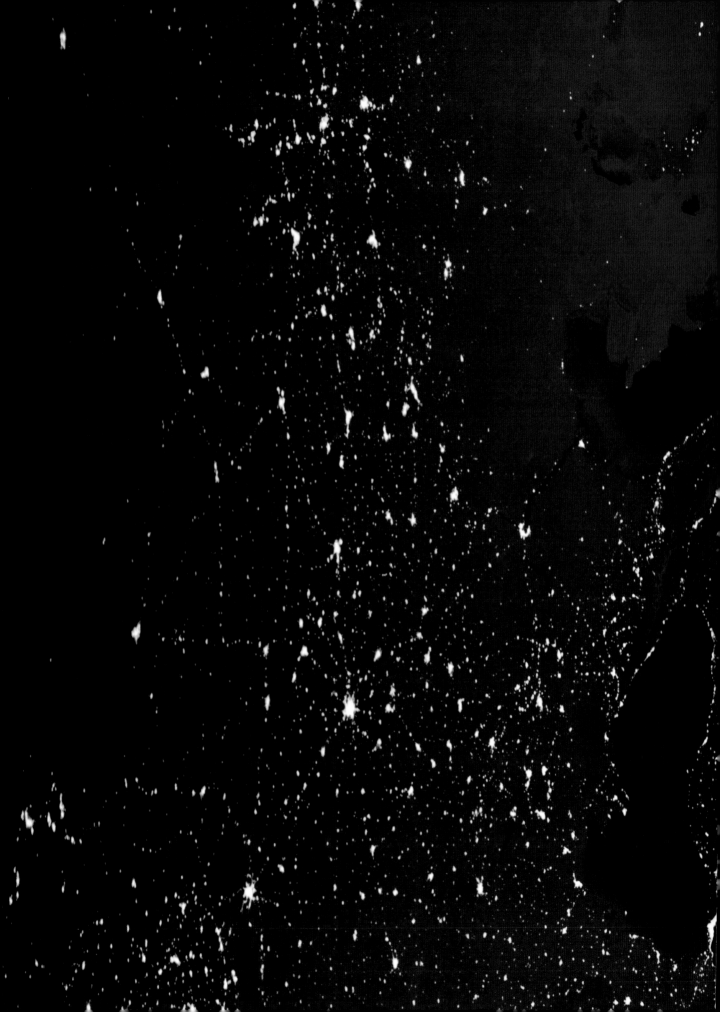

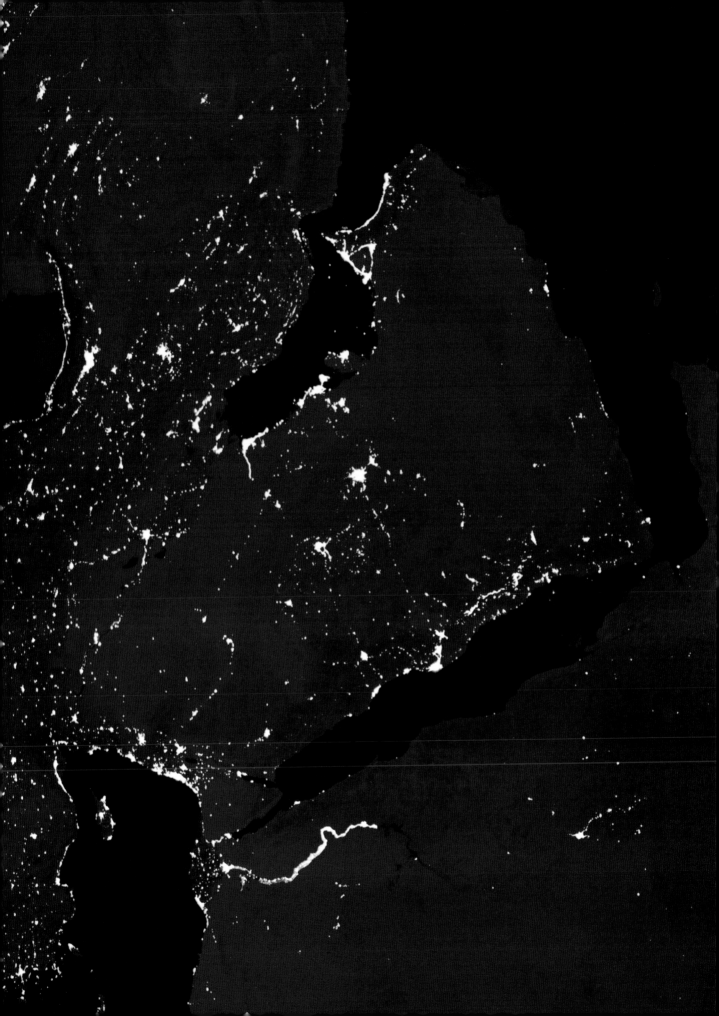

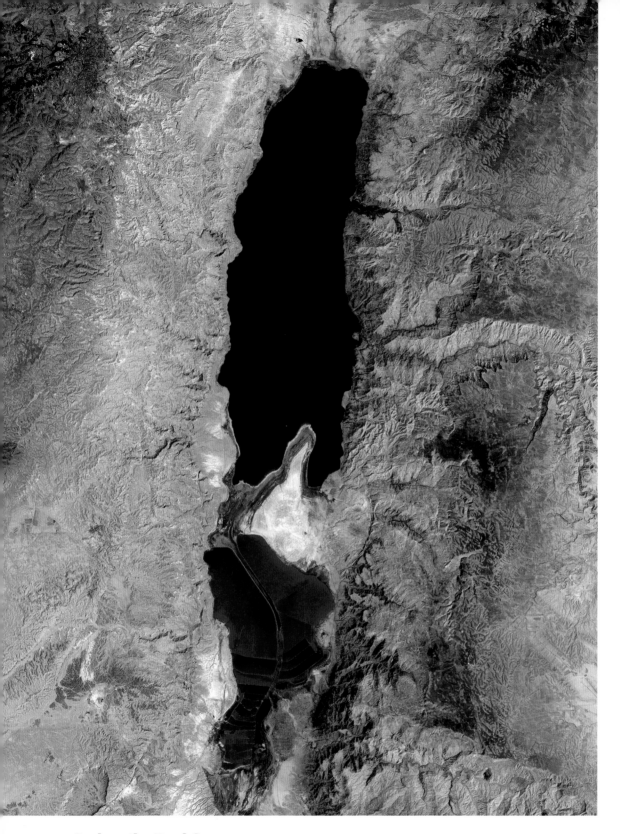

©DigitalGlobe

# Jordan: the Dead Sea

THE DEAD SEA, THE NORTHERNMOST extension of Great Rift Valley system, is a fault in the Earth's crust that runs north from Malawi and is aptly named. At 394m/1,292ft below sea level, it is the lowest point on the surface of the Earth. Approximately 70 km/44 miles from north to south, it is divided broadly in two: a larger northern basin and a much shallower southern basin. Its mineral-rich waters support no life at all. Fed from the north by the river Jordan, it has no southern outlet.

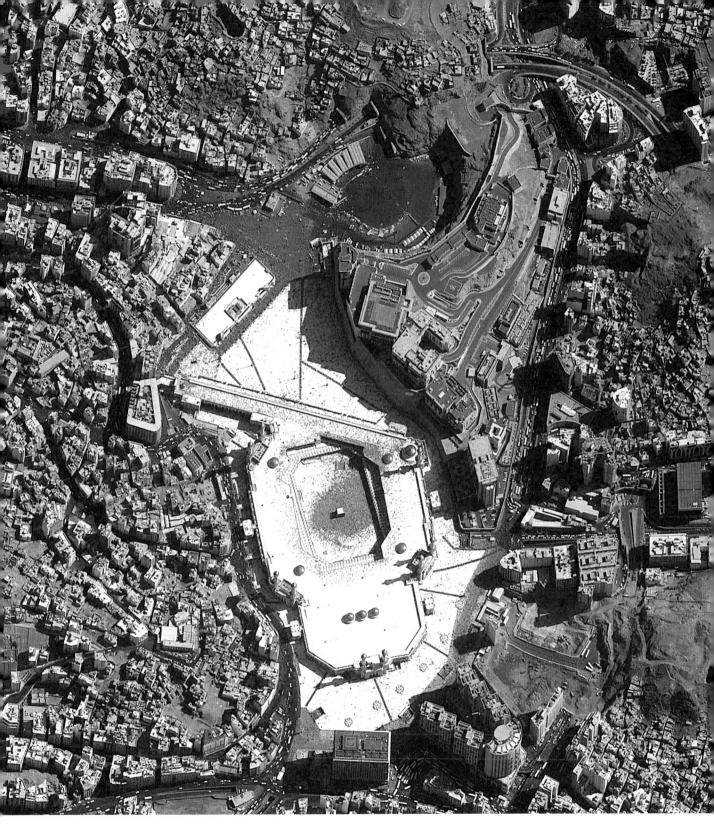

## Saudi Arabia: Mecca

THE GREAT MOSQUE IN MECCA, the Kaaba, in the centre of this image, surrounded by pilgrims is the focus of the world. It is 12m/40ft long, 10m/33ft wide and 15m/50ft high. Every year, millions of Muslims make a pilgrimage to worship there; every day, Muslims across the world face towards it to pray. At its heart is the holiest shrine in the Muslim world, the 'black stone'. It is said to have been brought by the Archangel Gabriel to Abraham while he was constructing the Kaaba.

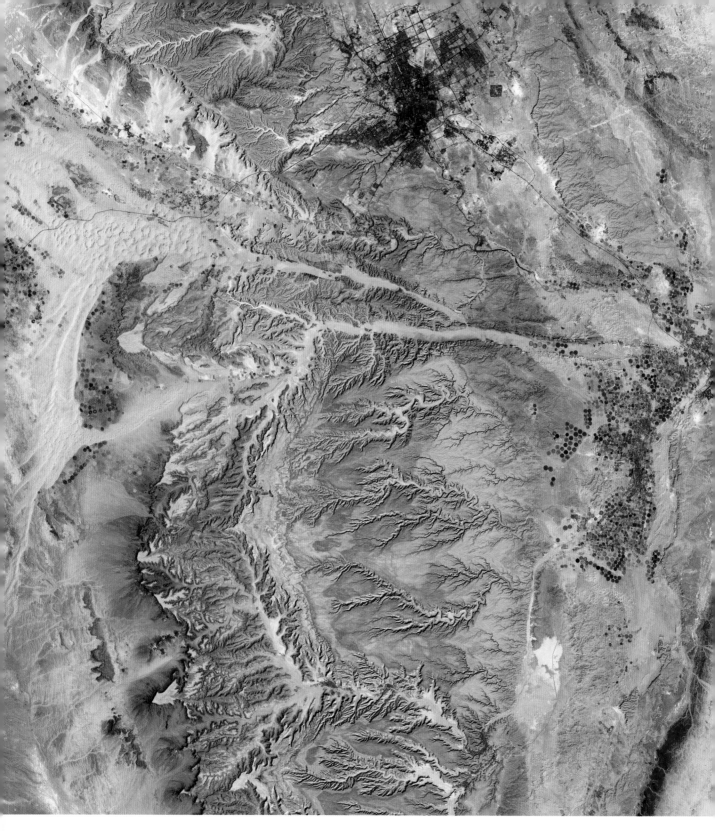

## Saudi Arabia: Riyadh

THE CAPITAL OF SAUDI ARABIA, Riyadh, lies in the Nejd, an elevated plateau 600m/1,970ft above sea level. It is in almost the exact geographical centre of the country. Riyadh is the largest city in Saudi Arabia and has a population of 1.8 million. The Nejd itself is a harsh, mostly uninhabited desert. Rainfall in the city averages 10cm/4in a year and is restricted to between January and May. The image shows an area approximately 200 km/120 miles from north to south.

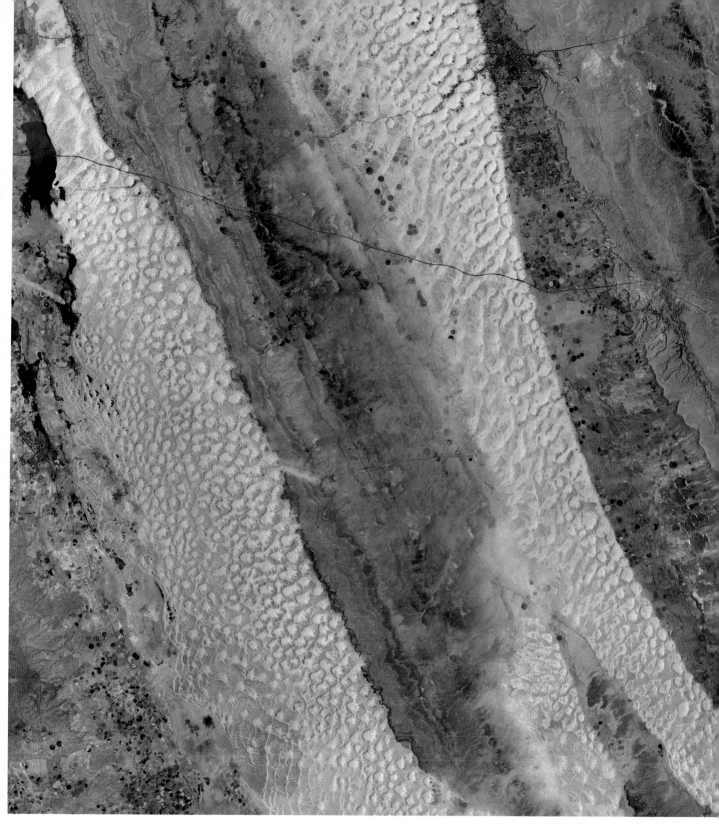

## Saudi Arabia: Az Zilfi

THE DESERTS OF CENTRAL AND NORTHERN Saudi Arabia are typical of the vast arid wastes of much of the country. It is one of the few regions of the world where summer temperatures in excess of 48°C/118°F are common and where there are no permanent lakes or rivers. Sand-storms are regular occurrences. As a result, Saudi Arabia has invested heavily in water-making plants to boost agriculture. The green circles are fields with centre-pivot irrigation systems.

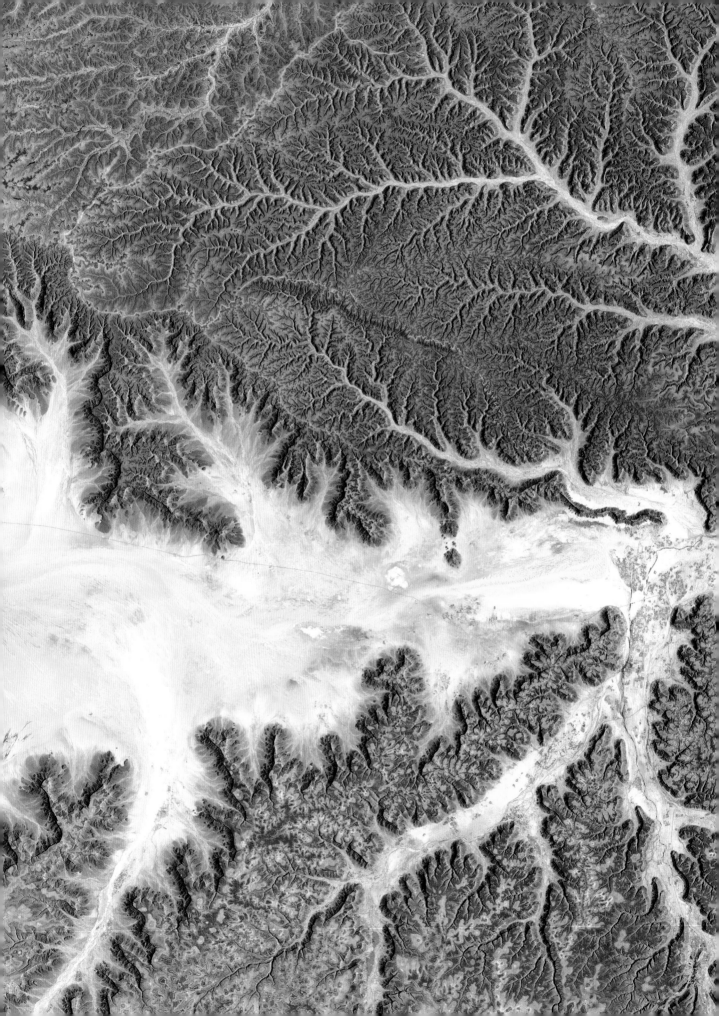

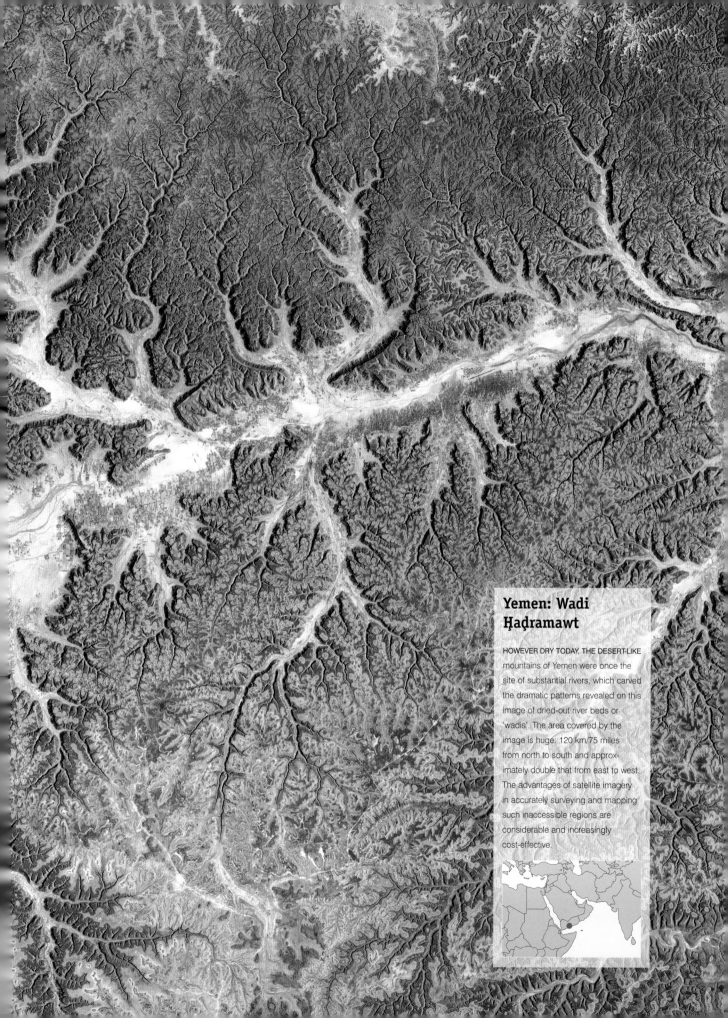

## Yemen: Wadi Ḥaḍramawt

HOWEVER DRY TODAY, THE DESERT-LIKE mountains of Yemen were once the site of substantial rivers, which carved the dramatic patterns revealed on this image of dried-out river beds or 'wadis'. The area covered by the image is huge: 120 km/75 miles from north to south and approx-imately double that from east to west. The advantages of satellite imagery in accurately surveying and mapping such inaccessible regions are considerable and increasingly cost-effective.

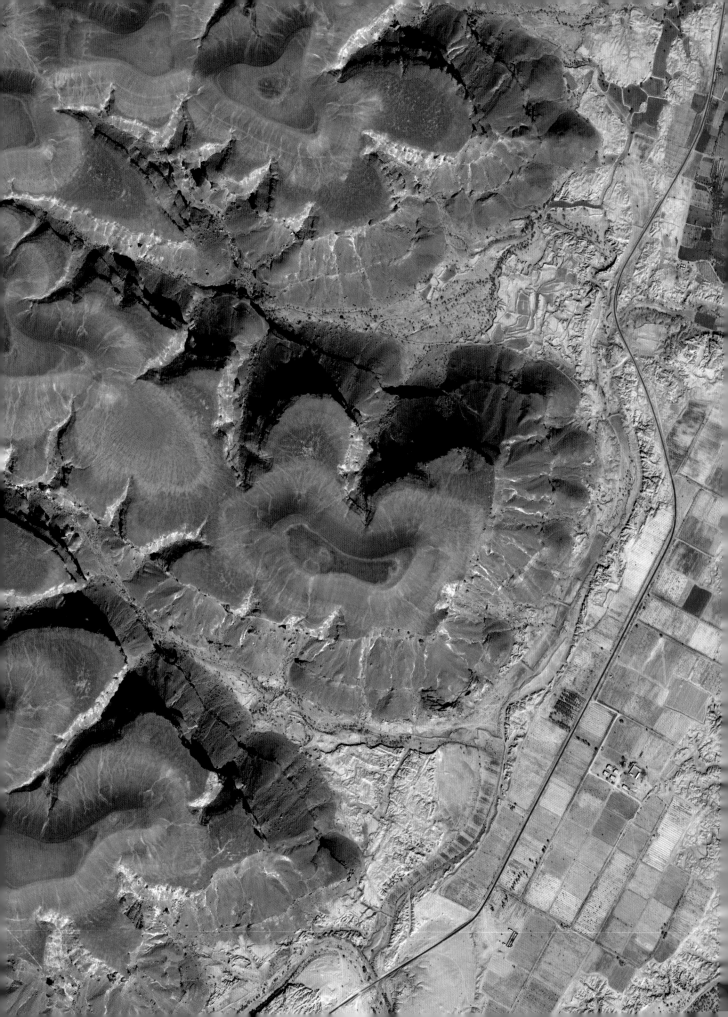

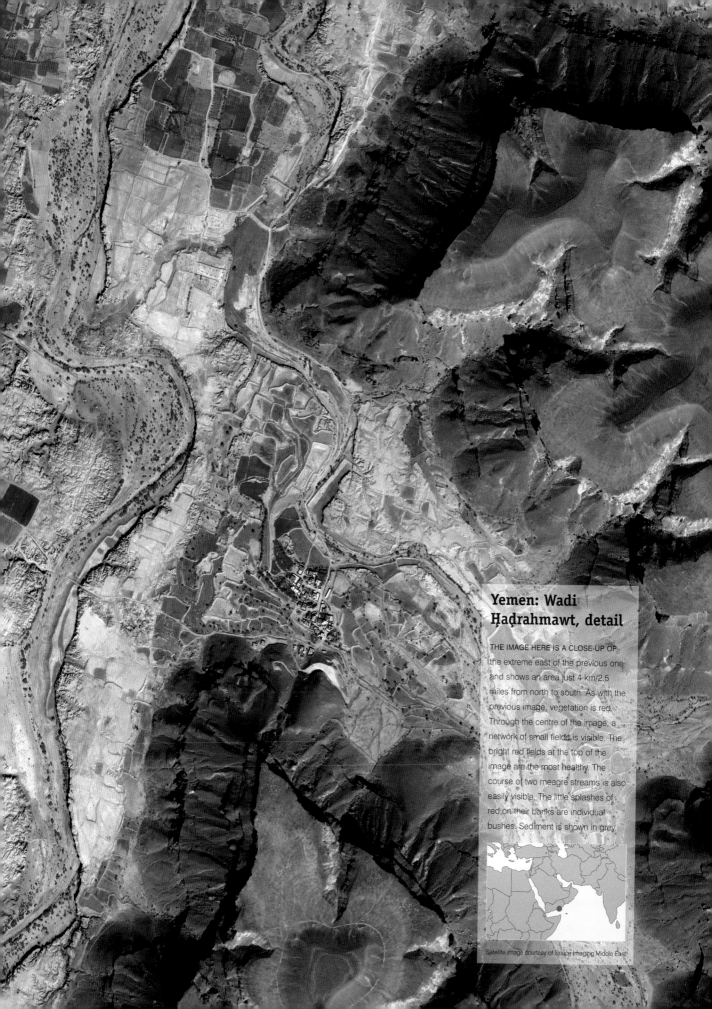

## Yemen: Wadi Ḥaḍrahmawt, detail

THE IMAGE HERE IS A CLOSE-UP OF the extreme east of the previous one and shows an area just 4 km/2.5 miles from north to south. As with the previous image, vegetation is red. Through the centre of the image, a network of small fields is visible. The bright red fields at the top of the image are the most healthy. The course of two meagre streams is also easily visible. The little splashes of red on their banks are individual bushes. Sediment is shown in grey.

# Oman: Umm as Samim

THE DRAMATIC CONTRASTS IN THIS IMAGE of northern Oman, approximately 120 km/75 miles from north to south, vividly illustrate the region's harsh terrain. The speckled yellow area to the lower left shows sand dunes, in fact the northeastern extremity of the Empty Quarter in neighbouring Saudi Arabia. To the upper right is an alluvial plain, comprising silt deposits created during the rare wet seasons. In the centre is a shallow 'ephemeral' lake, it, too, filled only periodically.

## Oman: Al Ḥajar al Gharbi and Aẕ Ẕahirah

IN CONTRAST TO THE FLAT WASTES of the rest of the country, the landscapes of north-central Oman, near the Gulf of Oman, are relatively mountainous. The image shows an area of approximately 175km/110 miles from north to south. The dark rocks in the centre and upper right-hand corner are fragments of oceanic crust, as are the interbedded green and orange rocks in the centre of the image. To the south are watercourses, created by flash floods.

65

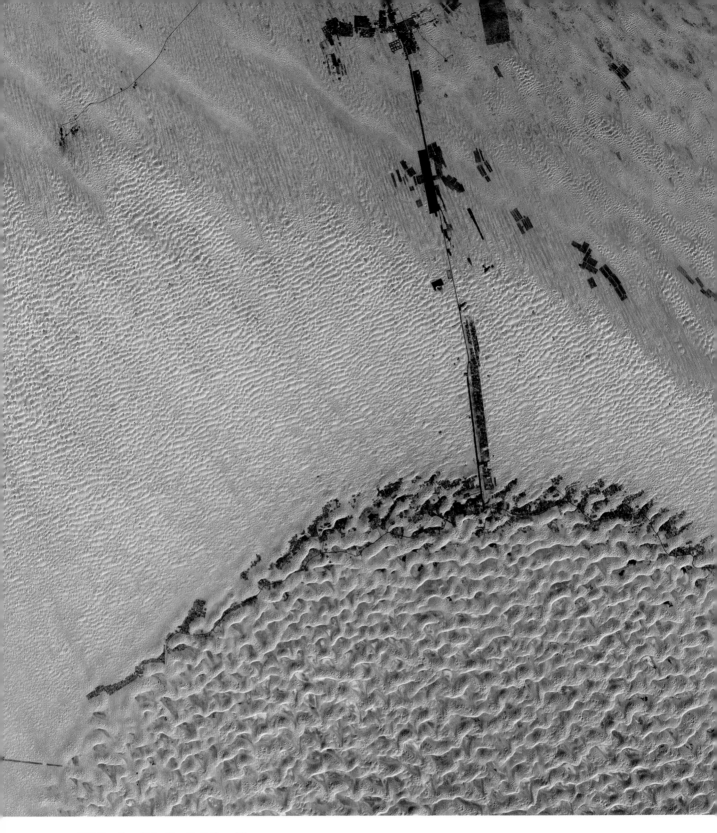

## UAE: the Bū Ḩasā Oilwells

THE DIFFERENCES IN TYPES OF SAND DUNE are highlighted here. The larger dunes in the
bottom half, a depression 20–50m/65–164ft lower than the top half of the image, are clearly
visible. The jewel-like blue areas between them are 'playas', clay basins in occasionally damp
interdune areas. To their north, they are fringed by a crescent of naturally occurring vegetation,
shown in green. Running north from this is a road leading to the coast. The oilwells themselves
are in the upper left-hand corner of the image at the end of a side-track running off this road.

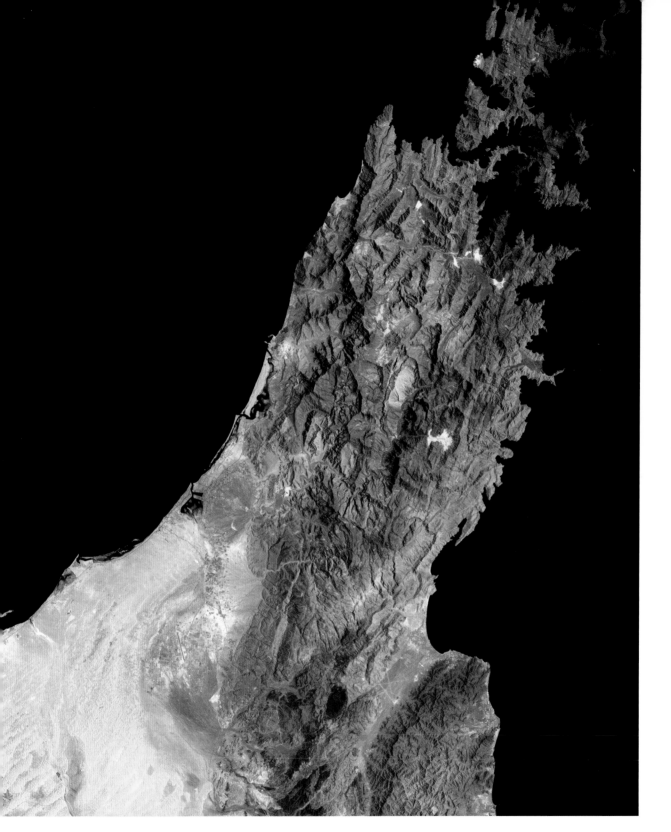

## Oman: the Musandam Peninsula

**THE MUSANDAM PENINSULA** is an Omani foothold surrounded by the UAE and projects dramatically into the Strait of Hormuz opposite Iran. The Strait itself, here only 50 km/31 miles wide, is one of the most strategically important in the world, through which 25 per cent of the world's oil passes. The peninsula, an extension of the Al Ḥajar al Gharbī Mountains, is forbidding and rugged, the jagged islands at its point reminiscent of Norway's fjords. The image shows an area approximately 120 km/75 miles from north to south.

67

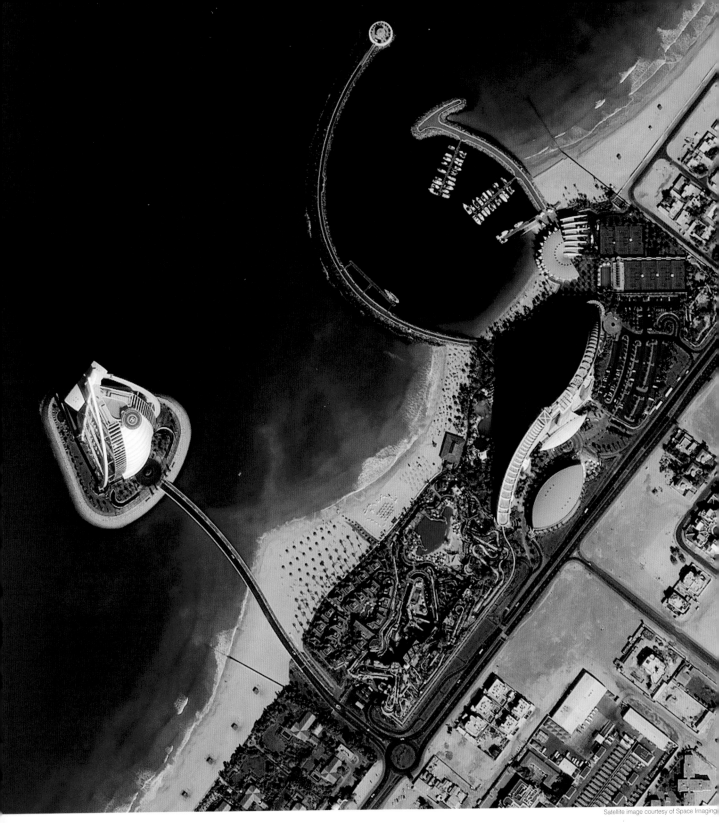

Satellite image courtesy of Space Imaging

# UAE: Burj Al Arab Hotel, Dubai

A MEASURE OF DUBAI'S DETERMINATION to rid itself of its dependency on oil alone is provided by the Burj Al Arab Hotel on the Persian Gulf 15 km/9 miles south of Dubai. Its central feature, clearly visible in the centre left of the image, is a dramatic sail-shaped tower that rises 321m/1,053ft above the sea. The hotel stands on a man-made island 300m/1,000ft offshore and linked to the mainland by a slender causeway.

68

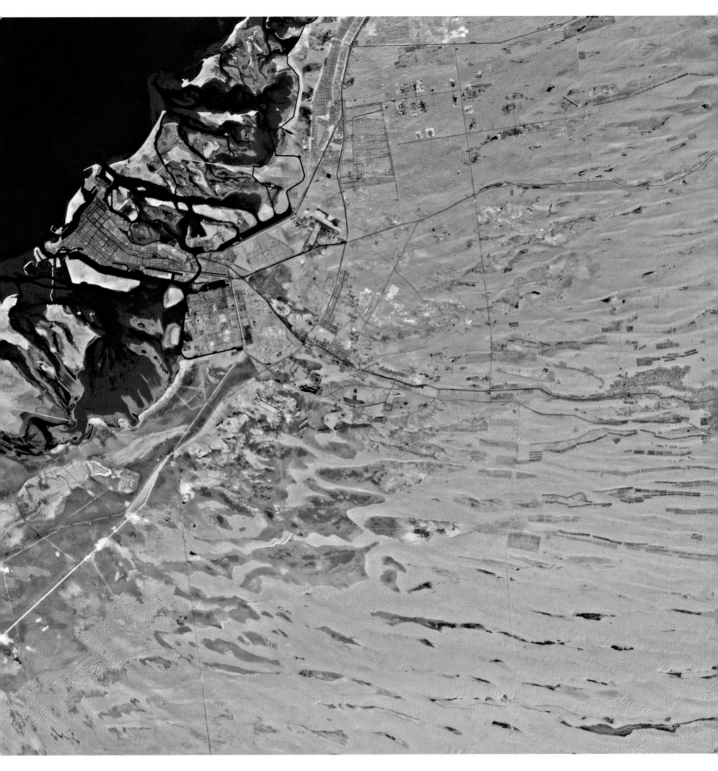

## UAE: Abu Dhabi

THE LARGEST OF THE SEVEN EMIRATES, the bulk of Abu Dhabi is desert which, to the west, merges with that of Saudi Arabia's Empty Quarter. Along the coast, however, extensive irrigation projects make a limited degree of agriculture possible, despite annual average rainfall of less than 130mm/5in. The city of Abu Dhabi, capital of the UAE, is visible to the upper left of this image. The small islands, shallow seas and reefs surrounding it are typical of the UAE's Persian Gulf coastline.

69

THE MIDDLE EAST

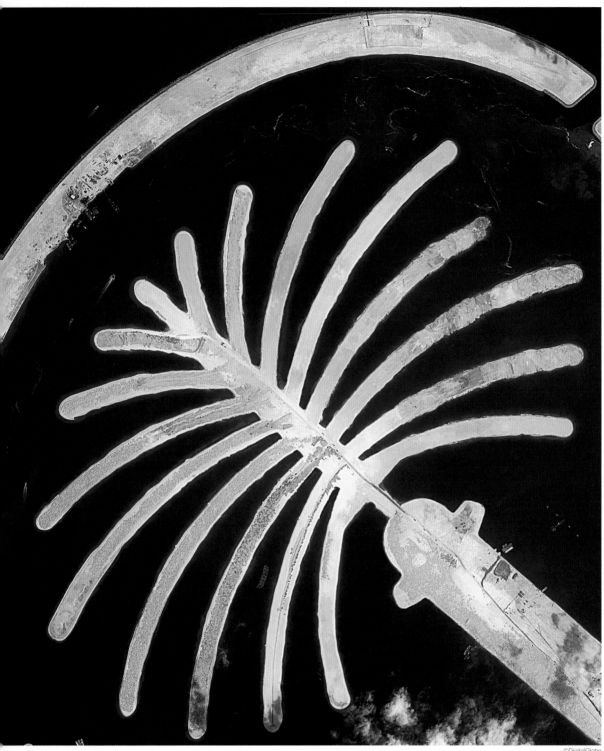

©DigitalGlobe

# UAE: Palm Island, Dubai

PALM ISLAND, BEING BUILT OFF THE COAST OF DUBAI, is one of the most ambitious construction projects in the world. It is a leisure and tourist resort constructed on artificial islands in the shape of a palm tree, the whole surrounded by a crescent-shaped concrete barrier. A second, even larger complex is also being built 21 km/13 miles down the coast. When complete, it is claimed both will be visible to the naked eye from space. This image of the first complex, Palm-Jumeirah, was taken in September 2003.

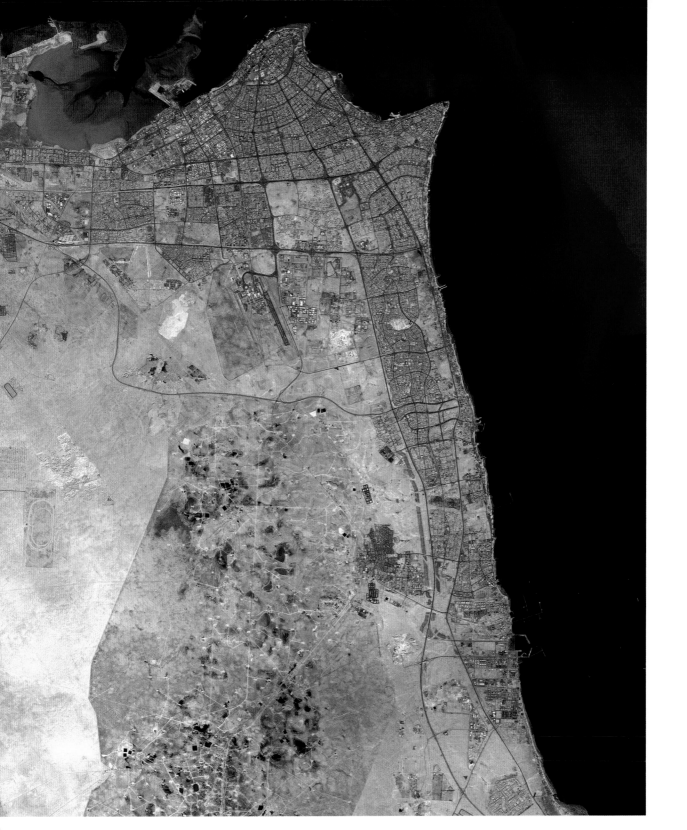

## Kuwait: Kuwait City

AT THE TOP OF THIS IMAGE IS KUWAIT CITY, capital of Kuwait, and, with a population of only 150,000, one of the world's smallest capitals. Immediately to its south are oilfields. Kuwait has proven oil reserves of 94 billion barrels, 10 per cent of the world total. The oilfields occur in slightly undulating desert, which extends across the whole country. Arable land makes up just 0.34 per cent of the total area of Kuwait.

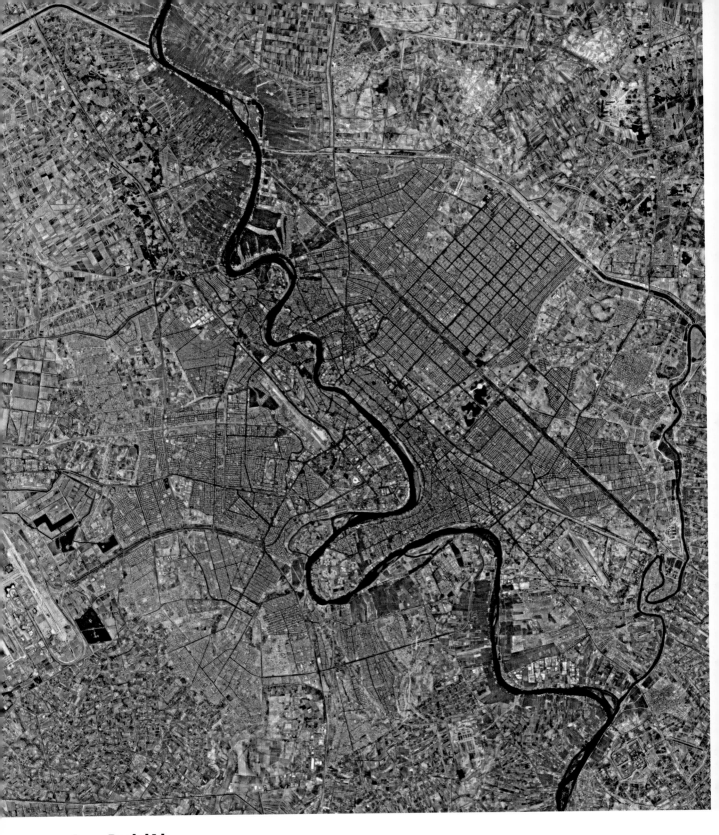

# Iraq: Baghdād

BAGHDĀD, CAPITAL OF IRAQ, sits astride one of the great arteries of the ancient world, the river Tigris. In contrast to much of the rest of the country, the flat alluvial plain through which the Tigris and Iraq's other great river, the Euphrates, run is fertile. The centre of the city is relatively small but huge suburbs sprawl around it. Baghdād suffered extensive damage in the 1990–1 Gulf War and again in 2003, when much of its infrastructure was destroyed.

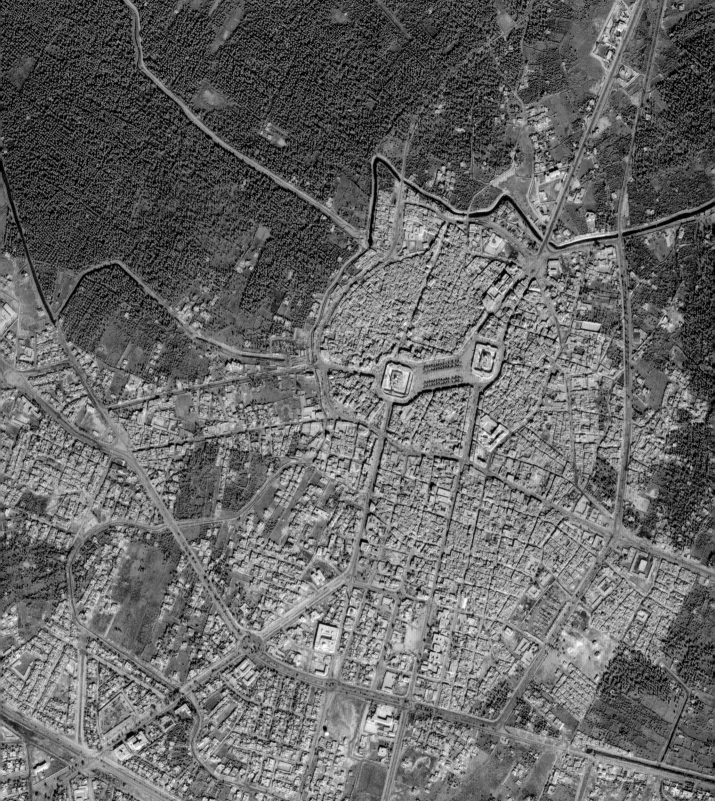

Satellite image courtesy of Space Imaging

# Iraq: Karbalā

KARBALA, CAPITAL OF AL KARBALA PROVINCE and located 100 km/60 miles southwest of
Baghdad, is not only one of the most ancient cities in the country but, to Shia Muslims, a holy
city third in importance only to Mecca itself and Najaf. It is the burial place of Husain, grandson
of the Prophet Muhammed. Karbala has more than a hundred mosques and also twenty-three
religious schools. Each year, more than a million pilgrims visit it.

73

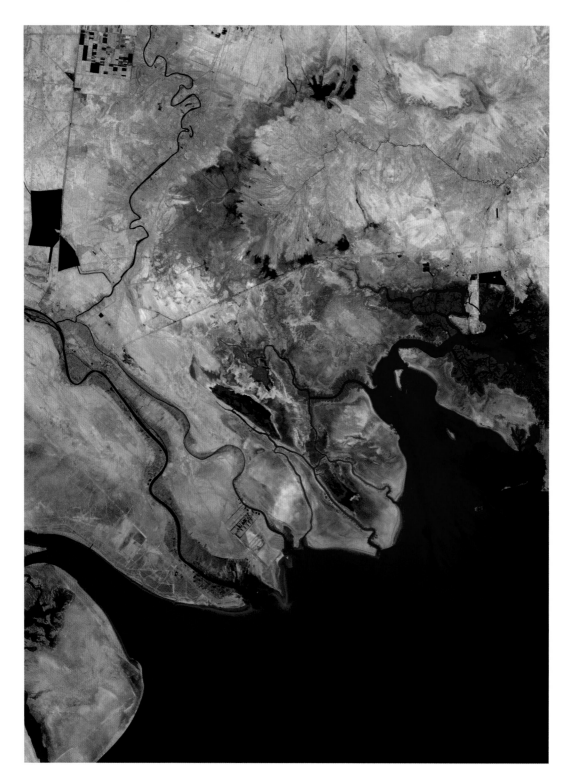

## The Persian Gulf: the Shaṭṭ al ʿArab

THE SHATT AL ARAB, IRAQ'S ONLY OUTLET to the sea, is the saltwater river created by the junction of the Tigris and Euphrates which flows southeast for 190 km/120 miles to the Persian Gulf. Control over this strategic point has been disputed between Iran and Iraq since 1935. It is navigable as far as Al Basrah, Iraq's principal port, though silt from its tributary, the Rūd-e Kārūn, which enters it from the northeast, is a persistent hazard to shipping.

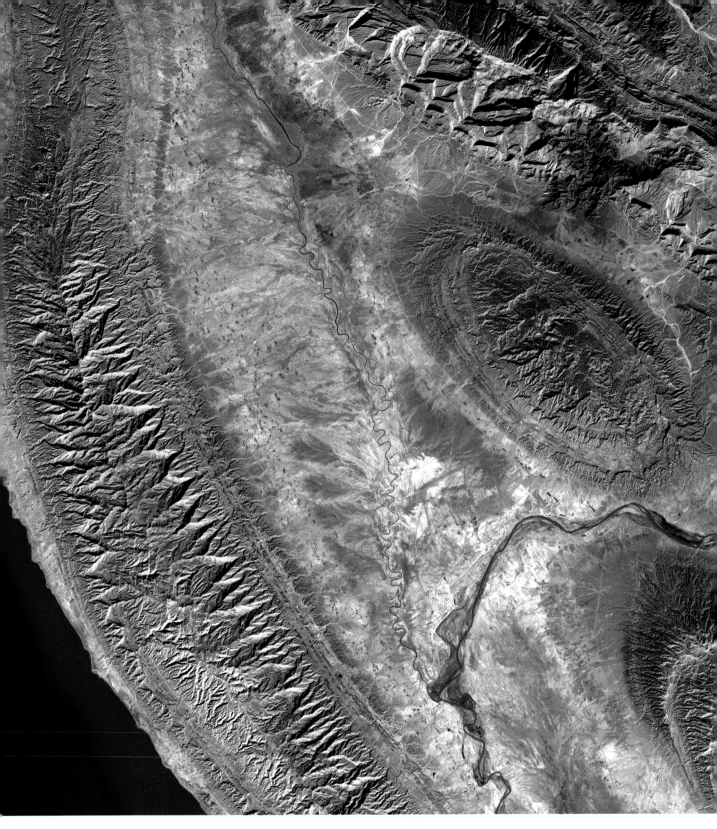

## Iran: the Western Zagros Mountains

THE ZAGROS MOUNTAINS IN WESTERN IRAN were created when Arabia, to the southwest, collided with the Eurasia landmass to the northeast. The striking feature to the left, running parallel to the Persian Gulf, with inward-pointing saw-tooth-like rocks, is an 'anticline', formed as the land was compressed and folded. Looping round in the lower right-hand corner is the river Mand, fed by a tributary that runs from the upper left-hand corner. The image shows an area approximately 70 km/43 miles from north to south.

75

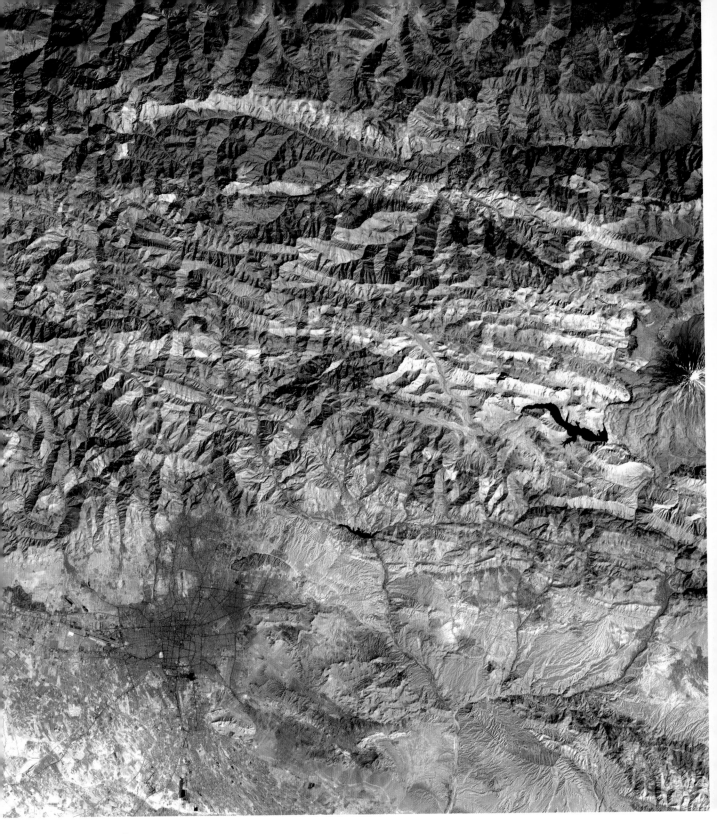

# Iran: Tehran

IN THIS IMAGE, TEHRAN, CAPITAL OF IRAN, is dwarfed by the sharply eroded peaks of the Elburz
Mountains to its north. The city itself, which lies at an altitude of 1,100m/3,500 ft, is located
towards the lower left-hand corner of the image, its road network clearly visible. With a
population of more than 11 million, it is easily the largest city in the country. The image
shows an area of approximately 120 km/75 miles from north to south.

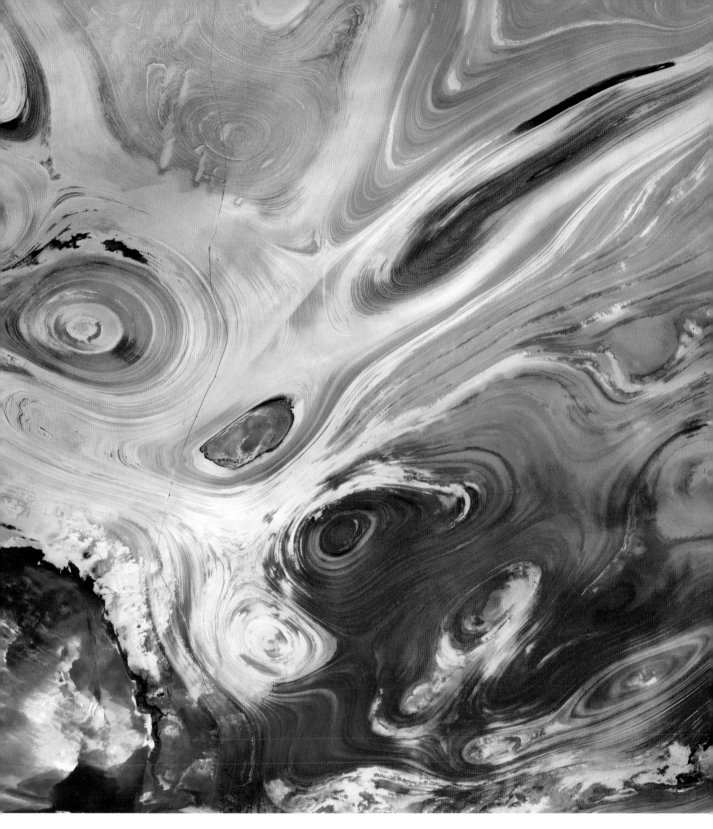

## Iran: the Great Salt Desert

THE GREAT SALT DESERT, or Dasht-e-Kavir, is actually the more northerly arm of a vast trackless waste that extends for more than 800 km/500 miles across eastern Iran. It is the largest desert in Iran. The startling swirls and loops of this image are folded rocks that entrain mud and salt marshes (playas). The region's crusts of salt are important in protecting the small amounts of moisture from evaporating completely. The image shows an area of approximately 60 km/37 miles from north to south.

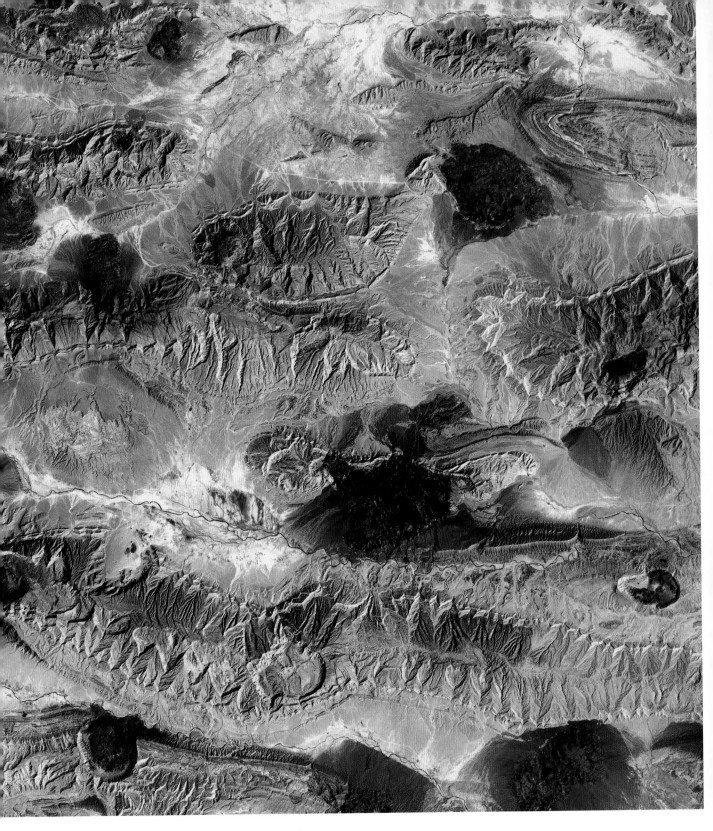

# Iran: the Southern Zagros Mountains

**78**   THE BLOTCHY, PREDOMINANTLY DARK RED patches on this image of a southwestern section of Iran's Zagros Mountains are 'diapirs', areas of viscous salt rock which have pierced through the brittle surface rock. The presence of salt is important: it disturbs layers or rock, forming potential oil traps. In remote areas of this kind, satellite imagery plays an important role in locating such diapirs and so help in the search for further oil deposits. The image shows an area approximately 120 km/75 miles from north to south.

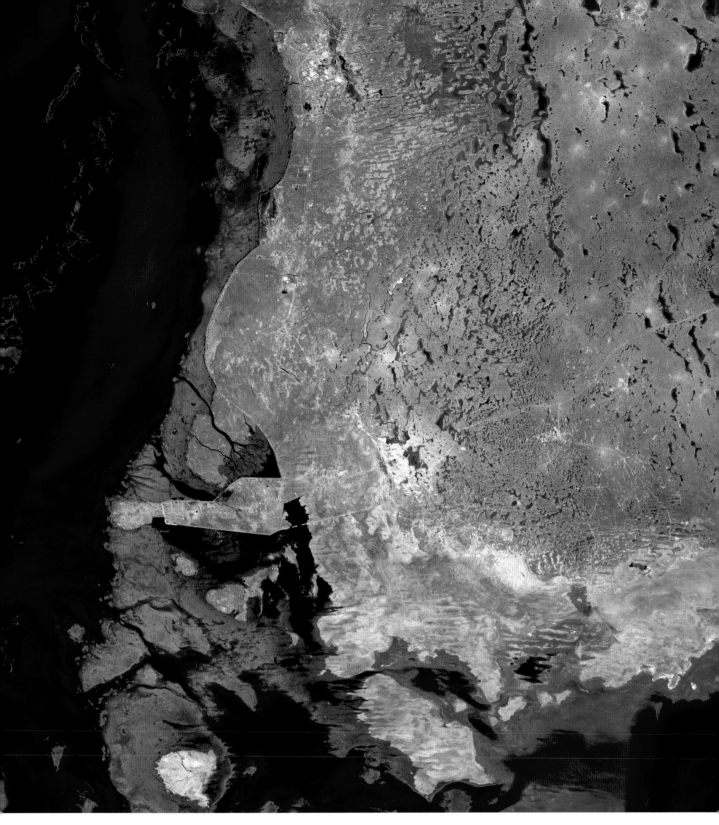

## Kazakhstan: the Caspian Sea

MUCH OF THE NORTHERN AND EASTERN SHORES of the Caspian Sea, including this view of its northeast corner, lies an average of 30m/100ft below sea level. Reed beds, shown in greenish blue, extend almost the length of the shallow coastal waters and, in places, offshore. The region is an important oil-producing area. The angular peninsula projecting west is reclaimed land, the site of the Prorva oilfield. The largest settlement is Karaton, built around the little bay, highlighted in pale green, at the centre top.

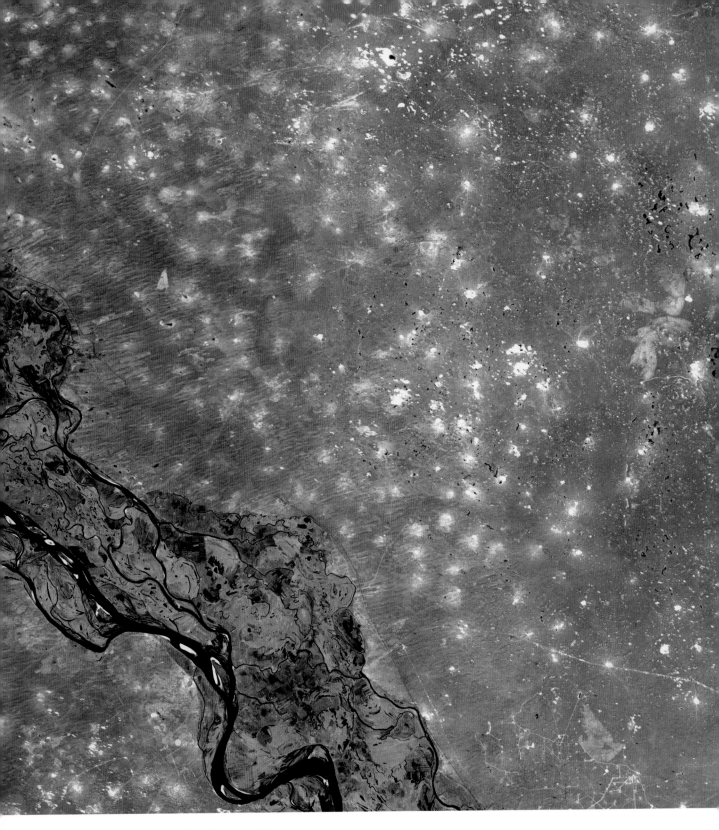

# Russia: the Caspian Depression

80 LOOKING RATHER LIKE THE SURFACE OF THE MOON, the white pockmarks on this image of the Caspian Depression, the low-lying area that extends north and south of the Volga Delta, are a legacy of environmental damage from human activity. They represent a variety of large-scale projects, chiefly the search for oil, in which top soil has been removed, creating widespread soil erosion. The Volga itself runs diagonally across the lower left corner.

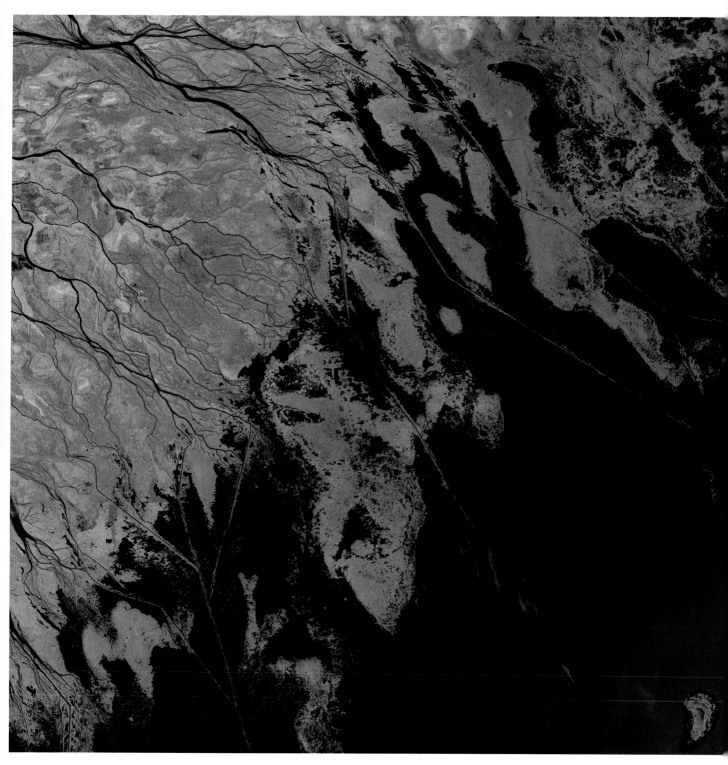

## Russia and Kazakhstan: the Volga Delta

AS IT FLOWS ACROSS THE FLAT CASPIAN Depression and nears the Caspian Sea, the world's largest inland sea, so the Volga divides and subdivides into more than 500 channels, some major, most minor. It is one of the most complex wetland ecosystems in the world, home to millions of birds as well as the site of the most productive fishing grounds in Eurasia. Satellite imagery provides an invaluable tool in monitoring such delicate natural habitats.

81

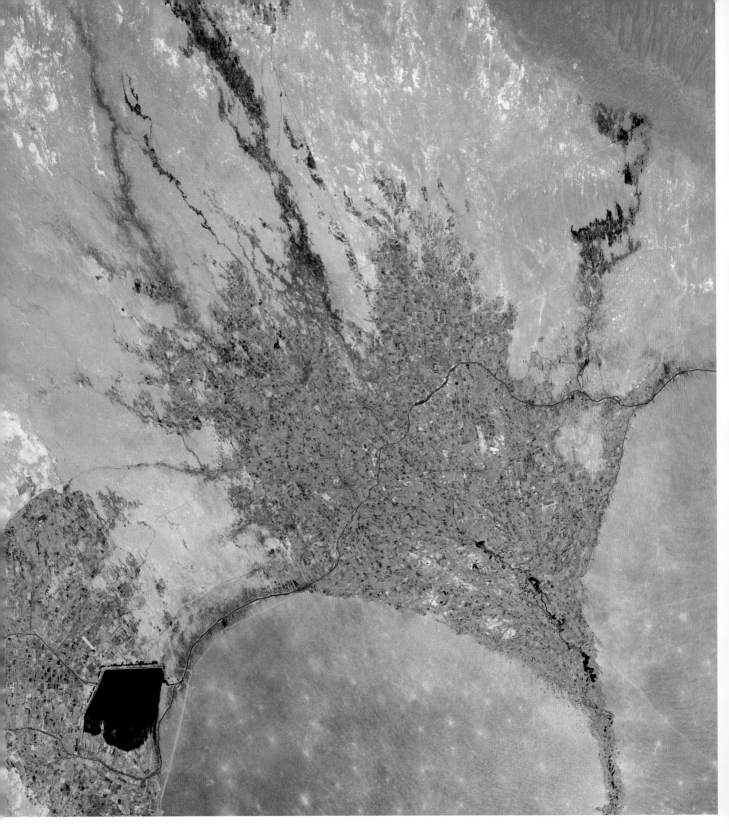

# Turkmenistan: the Murgap River

THE LUSHNESS OF THE ALLUVIAL fan of the Murgap river in southeast Turkmenistan
creates a false impression. Turkmenistan suffers from a severe and increasing water shortage.
More than 90 per cent of the country, comprising 300,000 sq. km/116,000 sq miles, is desert.
Efforts to irrigate it, above all in the shape of Kara Kum Canal, which at 1,375 km/860 miles is
the longest irrigation canal in the world, has exacerbated the problem. Leakage from the canal
brought salt to the surface, accelerating desertification.

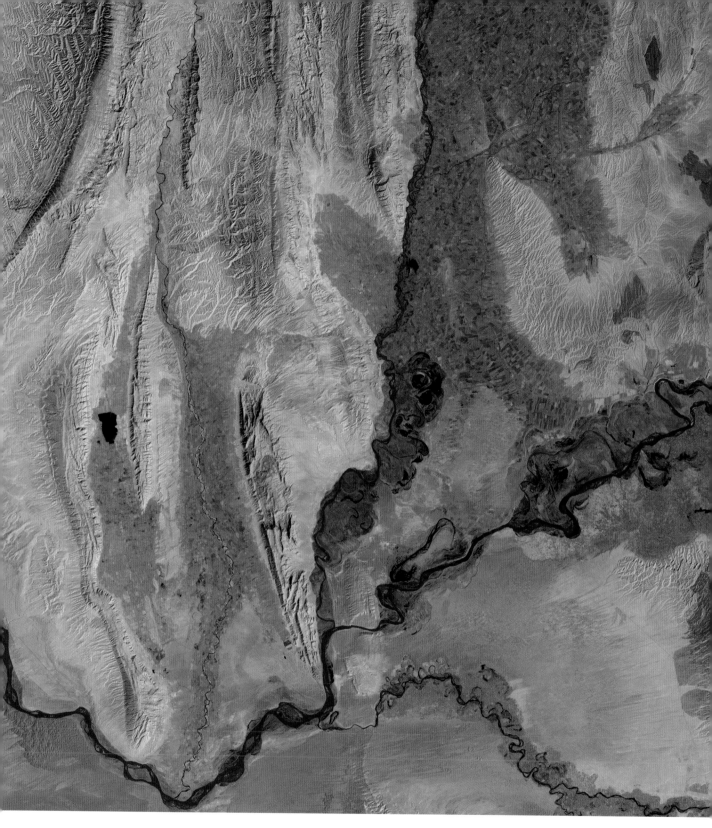

## Tajikstan and Afghanistan: the Oxus River

THE OXUS, MORE GENERALLY known today as the Amudar'ya, is the large river flowing left to right across the foot of the image. The larger of the two rivers joining it from the north is the Vakhsh in Tajikistan, its banks, especially to the east, supporting large agricultural areas, shown in green. Along this stretch of its 2,400 km/1,500-mile course, the Oxus marks the border between Afghanistan to the south and Tajikistan to the north.

83

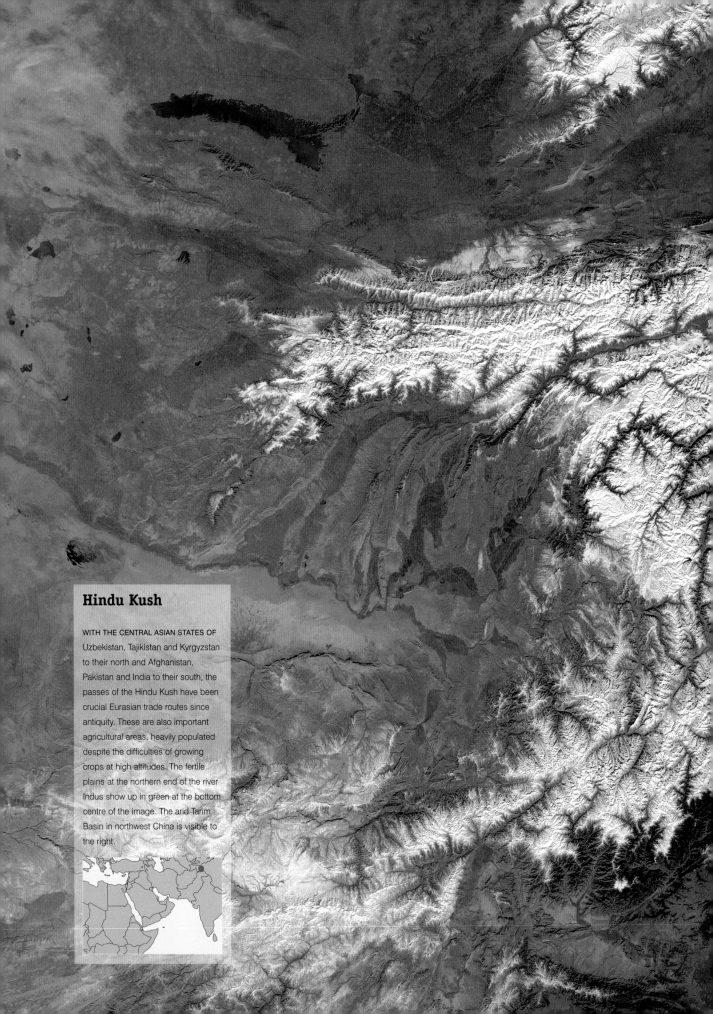

## Hindu Kush

WITH THE CENTRAL ASIAN STATES OF
Uzbekistan, Tajikistan and Kyrgyzstan
to their north and Afghanistan,
Pakistan and India to their south, the
passes of the Hindu Kush have been
crucial Eurasian trade routes since
antiquity. These are also important
agricultural areas, heavily populated
despite the difficulties of growing
crops at high altitudes. The fertile
plains at the northern end of the river
Indus show up in green at the bottom
centre of the image. The arid Tarim
Basin in northwest China is visible to
the right.

# SOUTH & EAST ASIA

South and East Asia is a vast area embracing a huge range of landscapes, cultures, peoples and climates. It contains the two most populous countries in the world – China and India – with 1,237 million and 984 million people respectively. It contains six of the world's ten most densely populated countries, headed by Singapore, with 2,025 people per sq km/5,246 per sq mile, as well as the world's third least densely populated country, Mongolia, which has fewer than two people per sq km/four per sq mile. At 9.6 million and 3.3 million sq km/3.7 million and 1.3 million sq miles, China and India are the world's third and seventh largest countries. Mandarin Chinese, with 874 million speakers, is spoken by more than twice the number of the world's next most widely spoken language, Hindi. Perhaps not surprisingly, the greater metropolitan area of Tokyo, with 31.4 million inhabitants, makes it the largest city in the world. But there are other vast and sprawling cities across the region, many deeply impoverished. Jakarta, New Delhi, Bombay and Calcutta all have populations of more than 13 million.

Verkhoyansk, situated in the vast wilderness forests of Siberia, claims the record for the lowest temperature ever recorded other than at the poles, -68°C/-90.4°F in February 1933. Crossing the continent, some 2,000 km/1,250 miles southeast is Lake Baikal, the world's deepest lake. Continuing in this direction, over the Himalayas, the world's highest plateau, is the Indian subcontinent. Cherrapunji in northeast India holds the record for the greatest annual rainfall (between August 1860 and August 1861) as well for the most rainfall in a single month, an astounding 293cm in July 1861. With average annual rainfall of 487cm, Moulein in Burma is the fourth wettest inhabited place on Earth. In April 1986, hailstones weighing up to 1.02kg/2.25lb fell in Gopalangi, Bangladesh, killing 92 people. Bangladesh also holds the un- happy record of the two most catastrophic storms ever recorded: in 1970, when up to 500,000 people were killed, and in 1991, when 138,000 died.

All the world's ten tallest mountains are in South Asia, in the Himalayas. Eight are in Nepal, including Mount Everest, 8,850m/29,029 ft high, two in Pakistan, including K2, the world's second highest mountain at 8,611m/28,250ft.

Home to the world's oldest continuous civilization, that of China, East Asia is also the site of the world's youngest country, East Timor, internationally recognized only in 2002 after a long and bitter fight for independence from Indonesia.

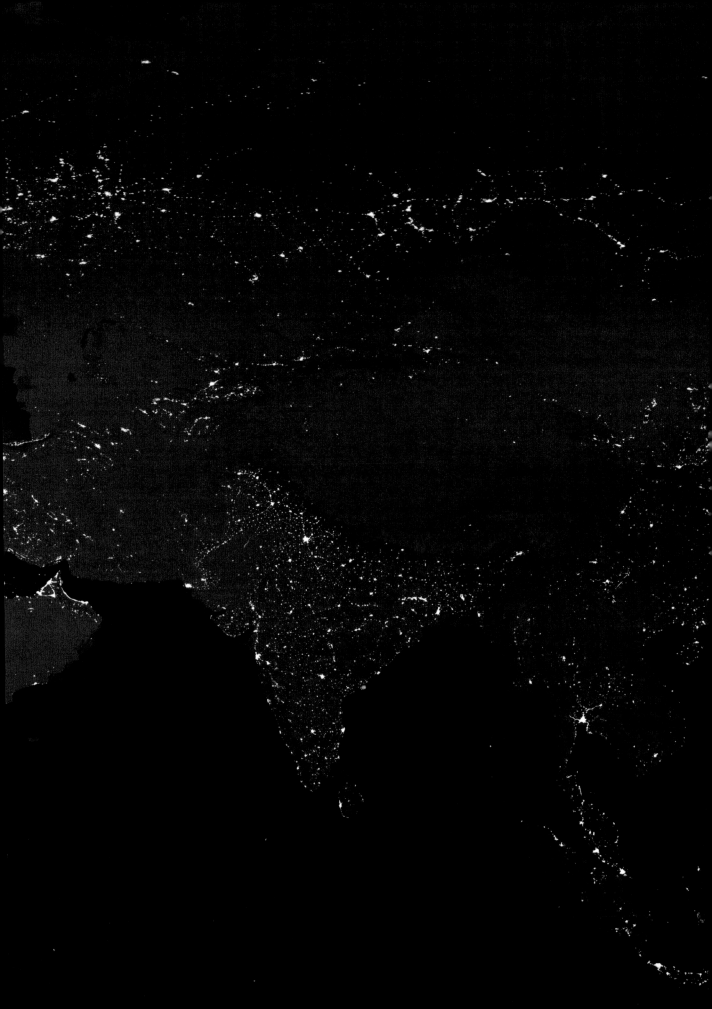

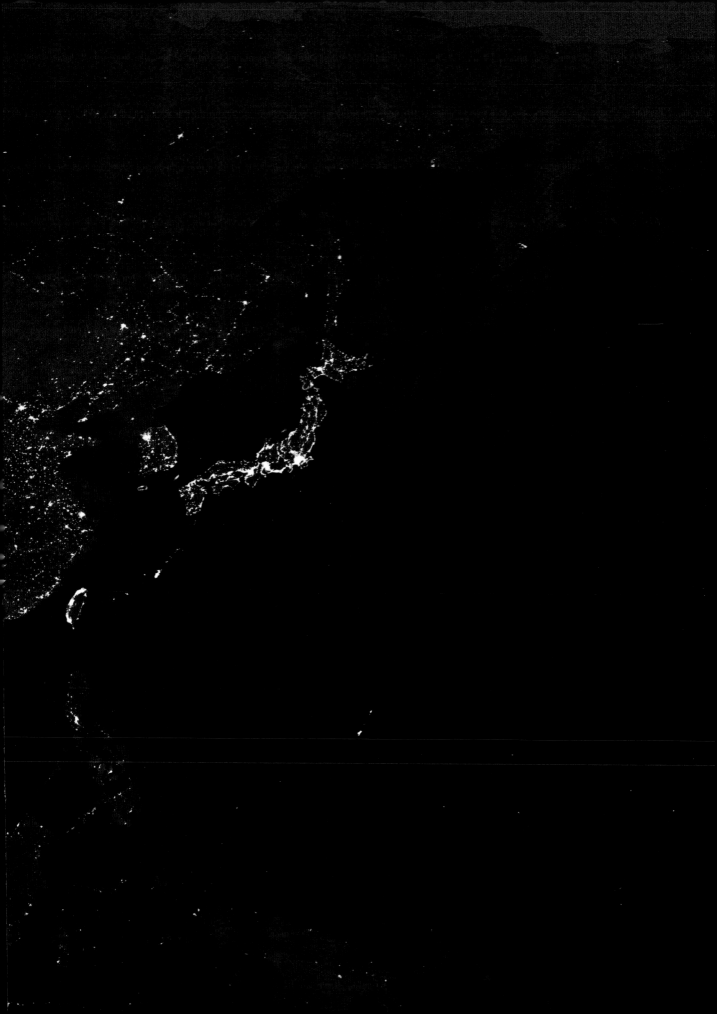

# Pakistan and Iran: Baluchistan

AMONG THE MANY APPLICATIONS of satellite imagery is its capacity to highlight features by enhancing or exaggerating colours. Those in this image of Baluchistan on the Pakistani–Iranian border have been deliberately manipulated to show rock types and formations in the highly deformed collision belt where southeast Eurasia meets the 'Tethyan' micro-plate, an area of numerous geological faults. The result is an abstract mixture of artificial colours and patterns.

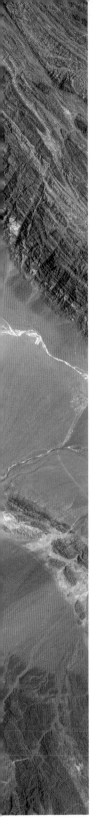

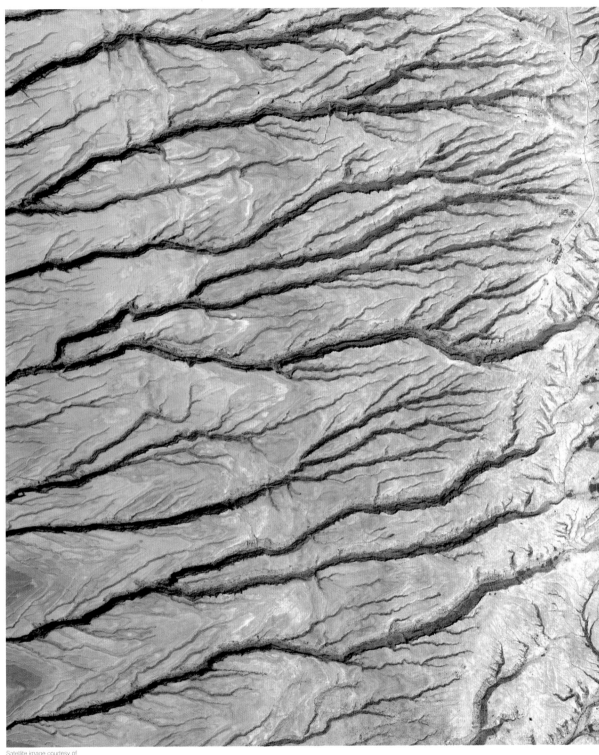

Satellite image courtesy of
Space Imaging Middle East

## Pakistan: Kirthar Range

THESE SHARPLY ETCHED DRAINAGE GULLIES have been carved in the low hills of the Kirthar
Range, where they slope eastward into the fertile Indus Valley of Pakistan's Sindh Province.
Their unusual depth is partly the result of sudden and fast-moving flash floods. The small red
dots that intermittently stud the length of the gullies are vegetation, clinging to life in an
otherwise hostile region. The image shows an area just over 8 km/5 miles north to south.

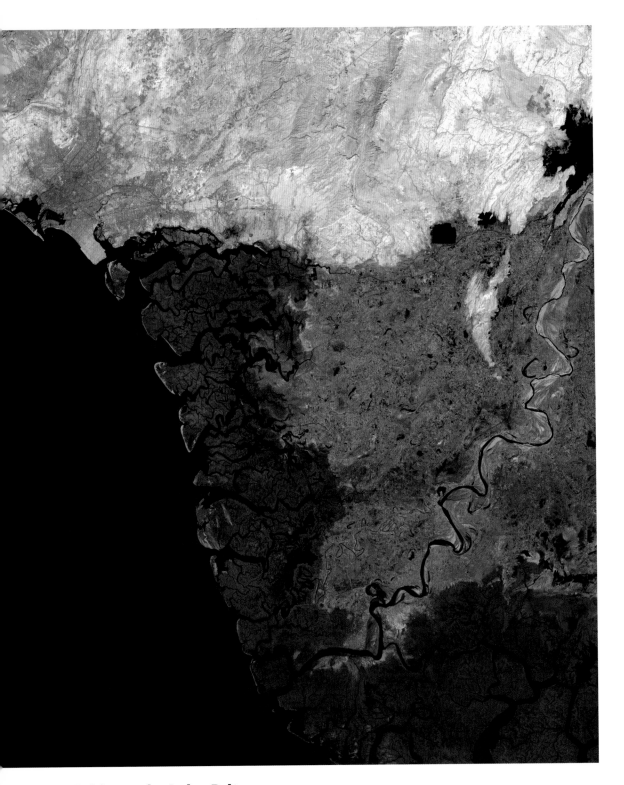

# Pakistan: the Indus Delta

THE DAMAGE DONE TO THE INDUS DELTA has been extensively charted by satellite images. Increased damming of the Indus, the country's principal source of fresh water for agriculture, has significantly reduced its flow. The result has been a gradual encroachment of the sea. These rising levels of salinity have destroyed almost half the delta's once huge mangrove swamps and reduced fish stocks. Karachi, Pakistan's principal port, is northwest of the delta.

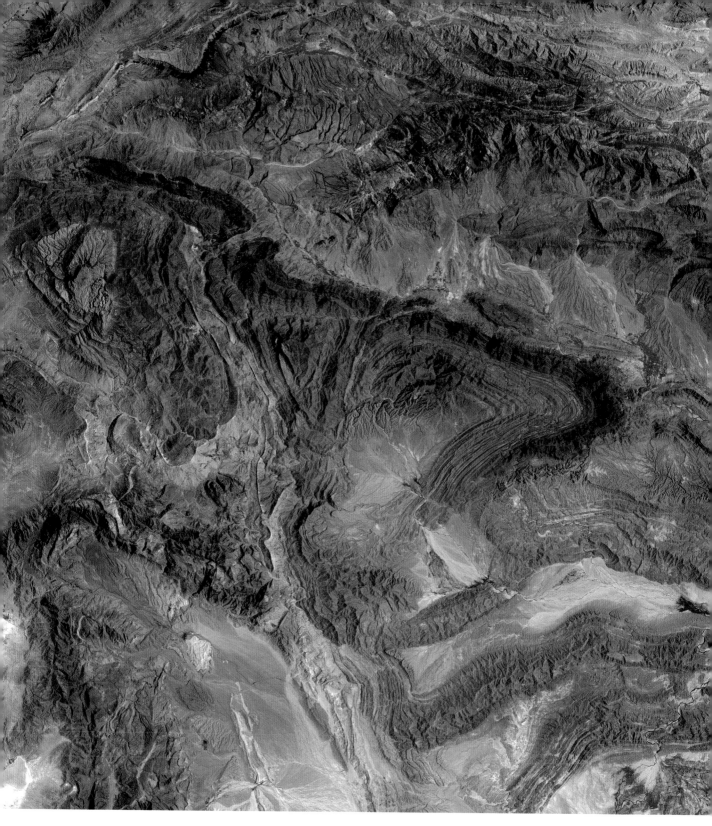

## Pakistan: Northern Baluchistan

THOUGH MANY HUNDREDS OF KILOMETRES from Himalayas proper, this image of Baluchistan in
western Pakistan highlights the immense geological forces unleashed by the collision between
the Indian subcontinent and the main Asian landmass to its north. The snaking green paths,
looking almost like glaciers, show phases of deformation that geologists call 'superimposed
folding', as the land is successively folded. The image contains an area approximately 120km/
75 miles from north to south.

93

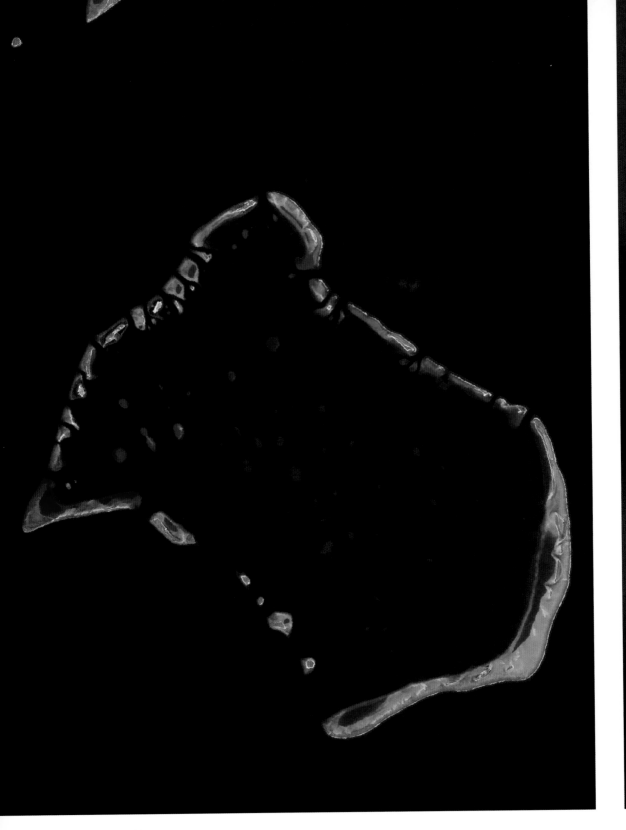

## The Maldives

STRUNG OVER SEVERAL HUNDRED KILOMETRES of the Indian Ocean southwest of India, the
Maldives consist of almost 1,200 islands grouped in twenty-six distinct tropical coral atolls only
one of which is shown in this image. Only 200 of the islands are inhabited. None rises more
than 1.8m/6ft above sea level. Their total population is 286,000. Malé, the capital, has a
population of 81,000. Where fishing was once almost the only activity, today the islands'
economy is dominated by tourism. The red splashes on this image are lush tropical vegetation.

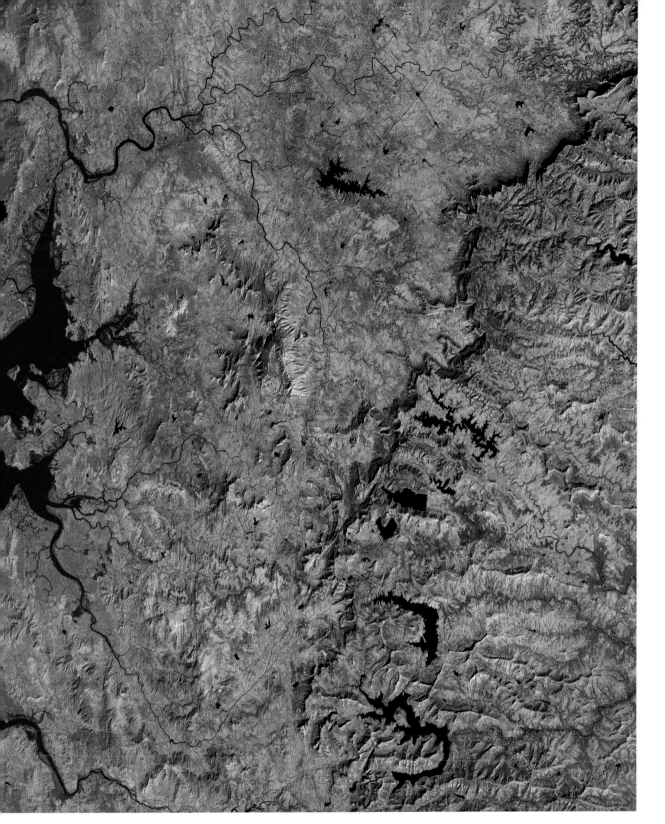

## India: Mumbai (Bombay)

THE ISLAND-CITY OF MUMBAI (Bombay) is towards the upper left-hand corner of this image. Measured by population within its actual city limits, it is the largest in the world, with a population of 12.1 million. Its relatively easy access from the Middle East and Europe, allied to a magnificent natural harbour, have given it a strategic significance for several hundred years. To its south is a heavily indented and richly tropical coast. Inland are the Western Ghats, a range of sharply eroded hills running along much of India's west coast.

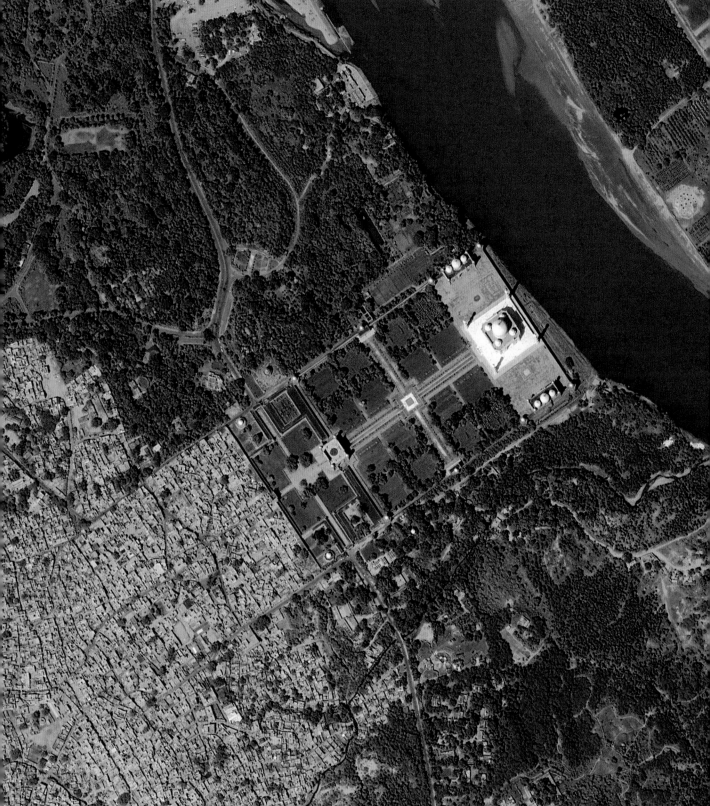

Satellite image courtesy of Space Imaging

# India: the Taj Mahal, Agra

THE TAJ MAHAL, ITS CEREMONIAL GARDENS centred in this image, lies on the banks
of the river Yamuna in Agra, 200 km/124 miles southeast of Delhi. It was built by Shah
Jahan, the greatest of the Mughal emperors of India, in memory of his wife and mother of
his fourteen children, Mumtaz Mahal. The building was completed in 1649. It remains the
supreme example of Mughal architecture, a delicate and precisely balanced structure, at
once serene and commanding.

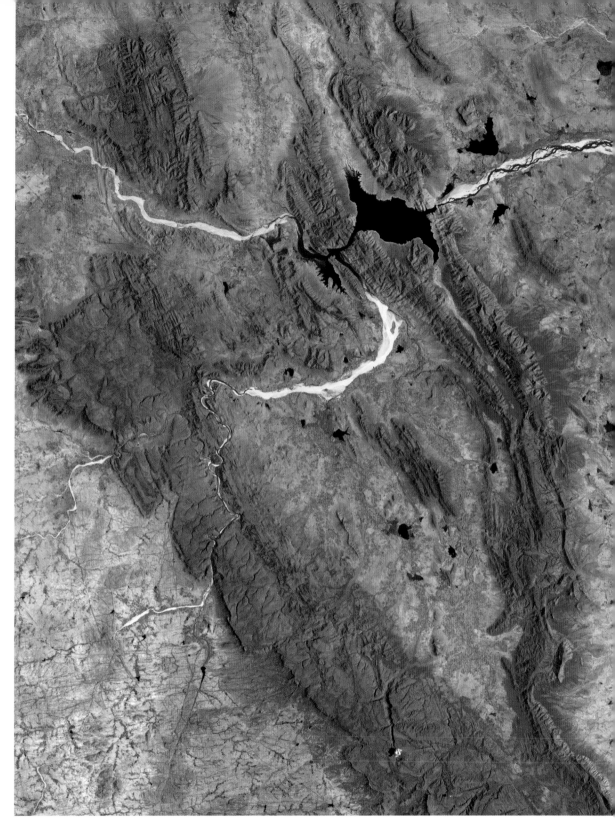

# India: the Velikonda Range

THE VELIKONDA RANGE IS IN ANDHRA PRADESH, in southeast India, about 150 km/93 miles northwest of Madras. It forms a flank of the Eastern Ghats, which run for much of the length of the country's east coast. In this image the range can be seen clearly running from the lower right to the upper left-hand corner. Perhaps as much as 540 million years old, today it is little more than an eroded relic. At the top right is the river Penner, which reaches the coast at Nellore.

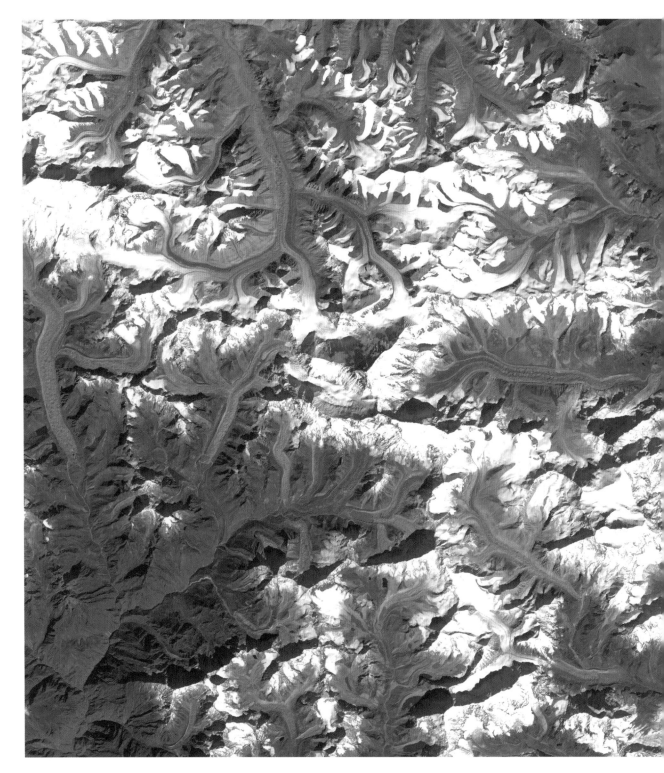

# Nepal and Tibet: Mount Everest

THE HIMALAYAS, WITH THE ASSOCIATED KARAKORAM and Hindu Kush ranges, are the highest mountains in the world and the third-longest chain, extending 3,860 km/2,400 miles from west to east. Mount Everest, the world's highest mountain at 8,850m/29,029ft, lies two-thirds of the way along the Himalayas, towards its eastern end, on the border of Nepal and Tibet. It is clearly shown here, slightly north of the centre of the image, its peak at the apex of the inverted triangle created by its shadow.

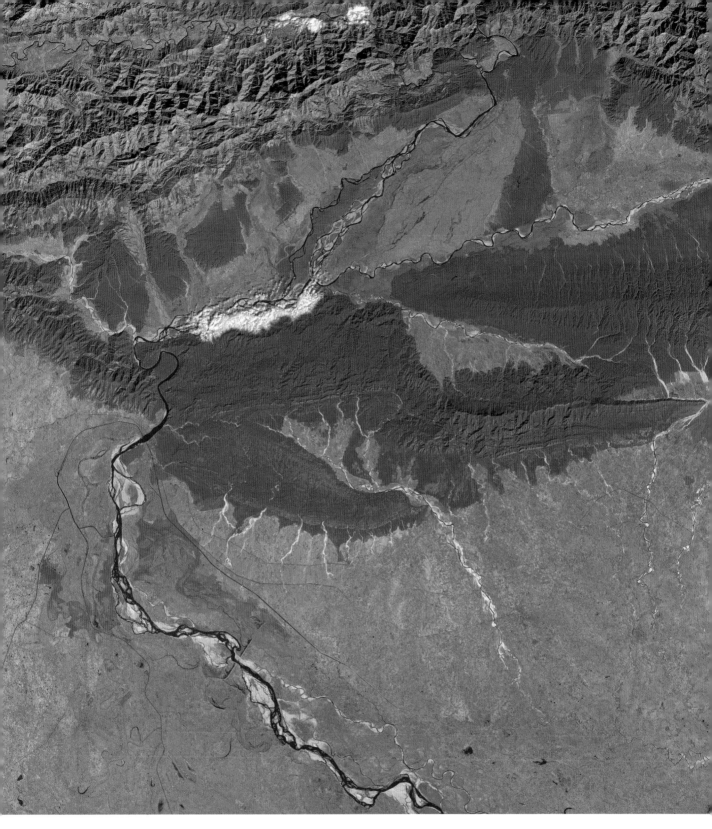

## India and Nepal: the Gandak River

THE GANDAK RIVER TUMBLES SOUTH from the Himalayas through Nepal and into India, where it eventually joins with the Ganga (Ganges). The Himalayas are clearly visible at the north of the image. The dark red bands on their flanks, running across the image, are dense forests. The distinctive patches of white are fogs. As it enters the plains of Uttar Pradesh in northern India, the river slows, splitting into a series of channels and leaving silt deposits, shown as pale blue.

99

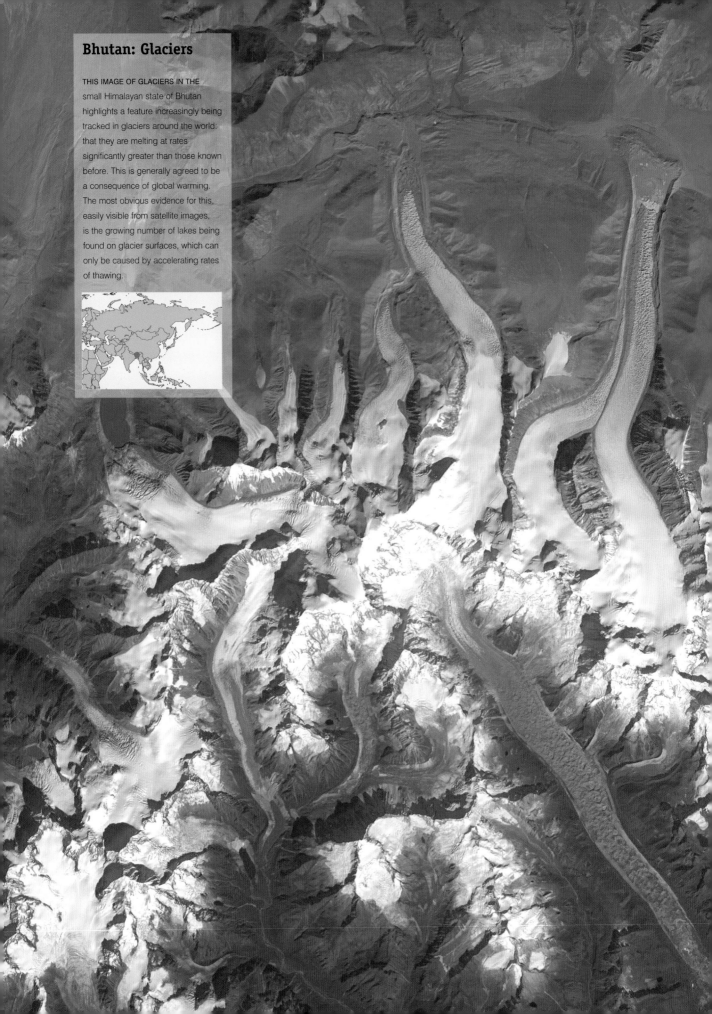

# Bhutan: Glaciers

THIS IMAGE OF GLACIERS IN THE small Himalayan state of Bhutan highlights a feature increasingly being tracked in glaciers around the world: that they are melting at rates significantly greater than those known before. This is generally agreed to be a consequence of global warming. The most obvious evidence for this, easily visible from satellite images, is the growing number of lakes being found on glacier surfaces, which can only be caused by accelerating rates of thawing.

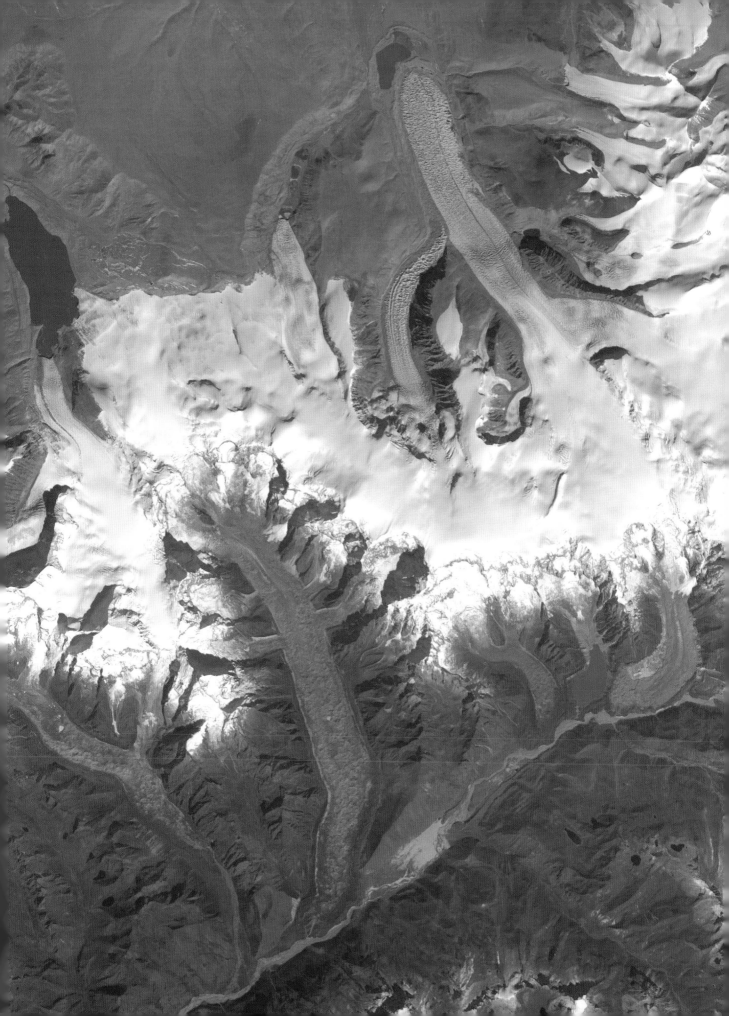

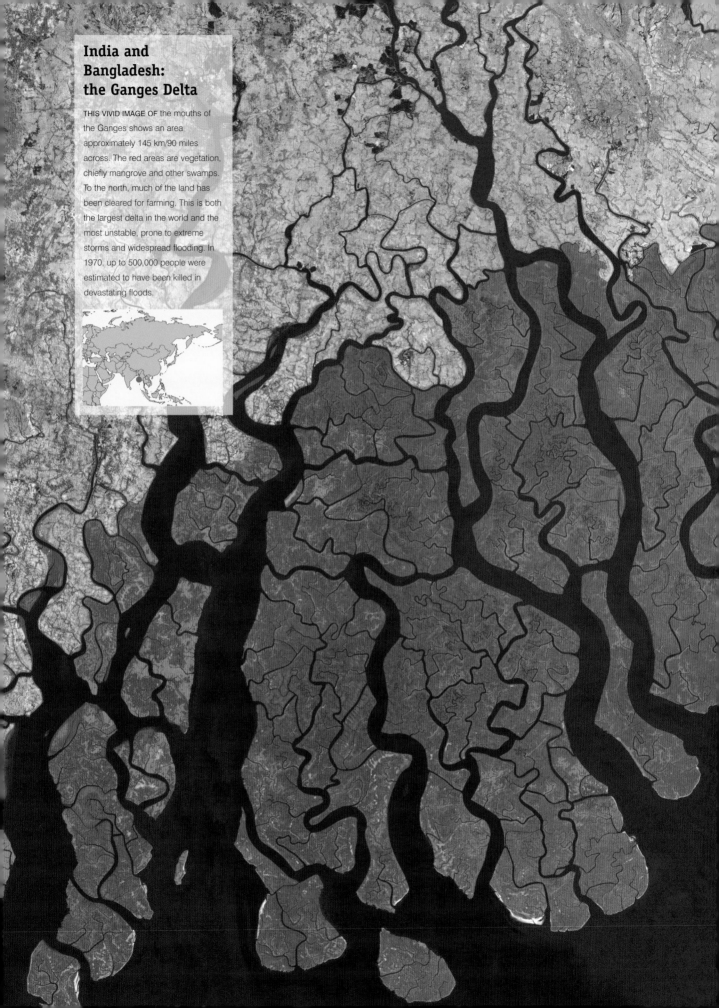

# India and Bangladesh: the Ganges Delta

THIS VIVID IMAGE OF the mouths of the Ganges shows an area approximately 145 km/90 miles across. The red areas are vegetation, chiefly mangrove and other swamps. To the north, much of the land has been cleared for farming. This is both the largest delta in the world and the most unstable, prone to extreme storms and widespread flooding. In 1970, up to 500,000 people were estimated to have been killed in devastating floods.

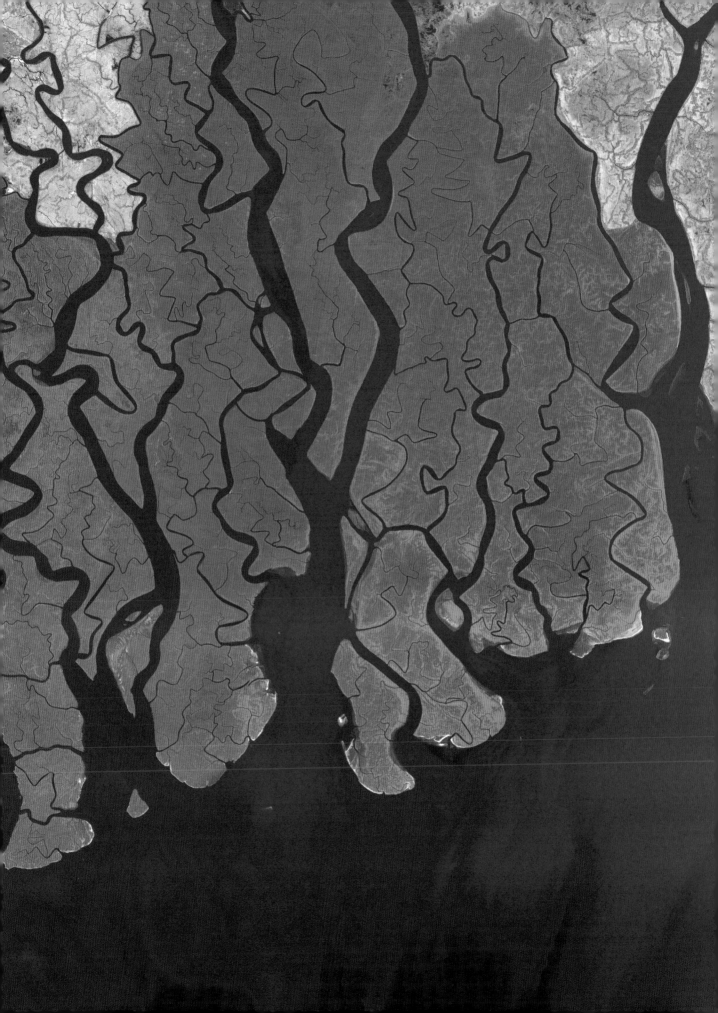

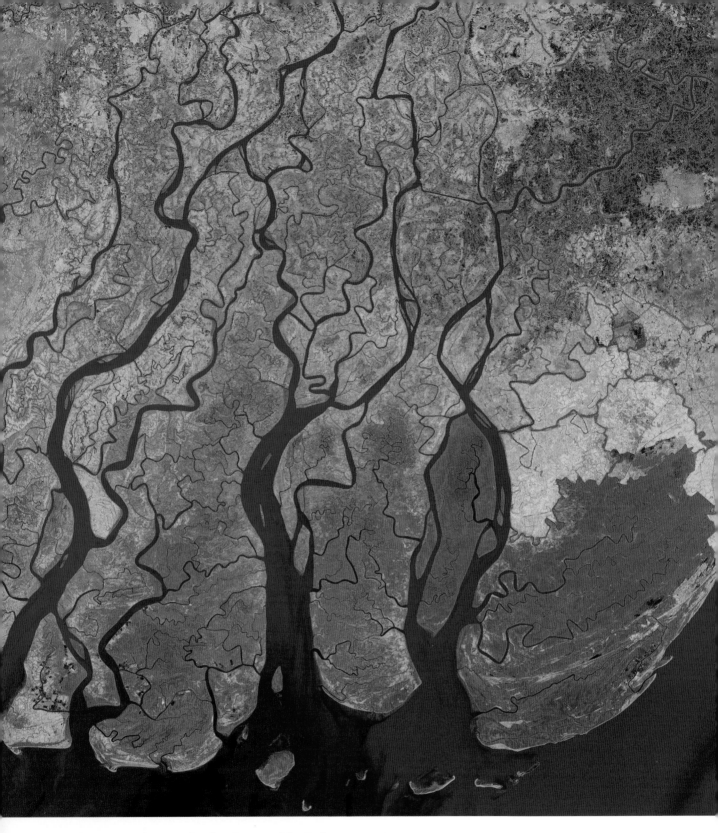

## Myanmar (Burma): the Irrawaddy Delta

THE HUGE IRRAWADDY DELTA IN MYANMAR (Burma) forms a trio with the Ganges Delta in India
and Bangladesh and the Mekong Delta in Vietnam, each fertile and low-lying and, in the case
of the Ganges and Irrawaddy, covered with dense mangrove swamps, shown here as the
bright red patches. It is a shifting landscape of fanlike marshes, oxbow lakes, small islands and
meandering rivulets and streams. The lighter blue areas in the sea are silt-rich water.

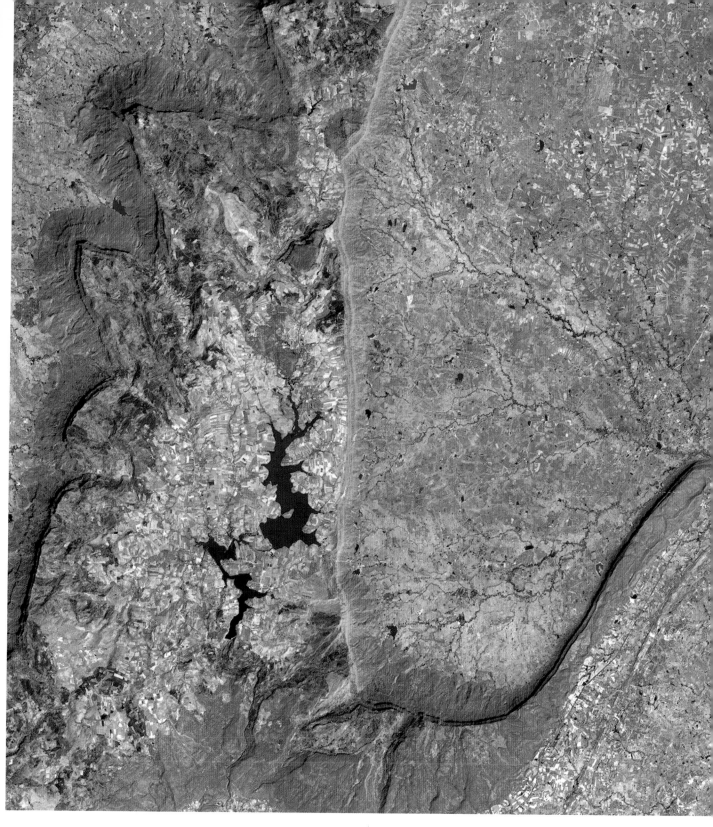

## Thailand: Chaiyaphum Province

THE IRREGULAR SHAPED AREA ON THE LEFT, bounded by red, is a plateau, its walls covered
with thick vegetation. It contains a patchwork of fields, also in red, as well as a number of lakes.
The lower-lying area to the right, marked to the south by an escarpment, is criss-crossed by
rivers. To the upper right is a further concentration of fields. Chaiyaphum Province is in the
fertile centre of Thailand. The image shows an area approximately 45 km/28 miles from
north to south.

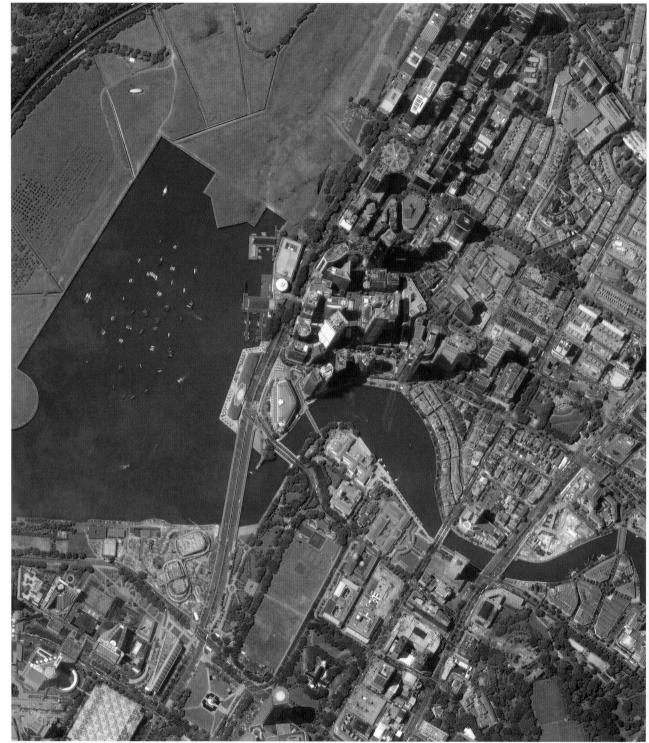

## Singapore

SINGAPORE IS NOT ONLY THE SECOND most densely populated country on Earth, with over 6,000 people per sq km/15,540 per sq mile (and an area of approximately 683 sq km/264 sq miles), it is also one of only two entirely urbanized countries in the world (the other is the Vatican). Officially, every single one of its population of 3.9 million lives in Singapore City. The very model of a modern, thriving international city, Singapore's development since its independence in 1965 has been startling. By 1996, it had become the sixth most prosperous country in the world.

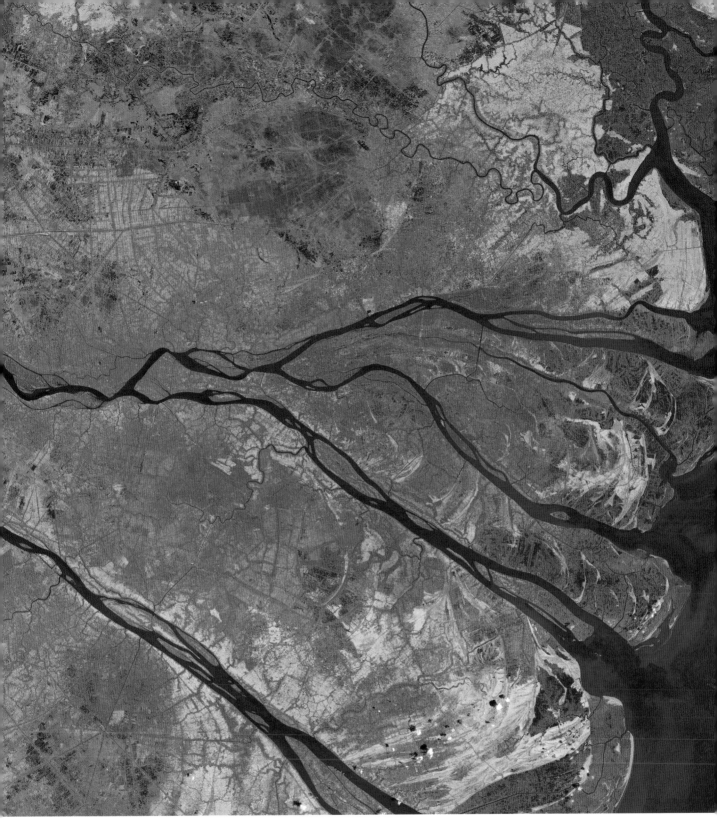

## Vietnam: the Mekong Delta

THE GREAT MEKONG RIVER enters the South China Sea through a maze of tangled channels and small islands. The silt-laden waters, which originate in the Himalayas, have turned the delta into a vast rice-growing area. It is an overwhelmingly agricultural region, with no other industry to speak of, on which 15 million Vietnamese depend. Vegetation on this image is in red. The area shown is approximately 160 km/100 miles from north to south.

107

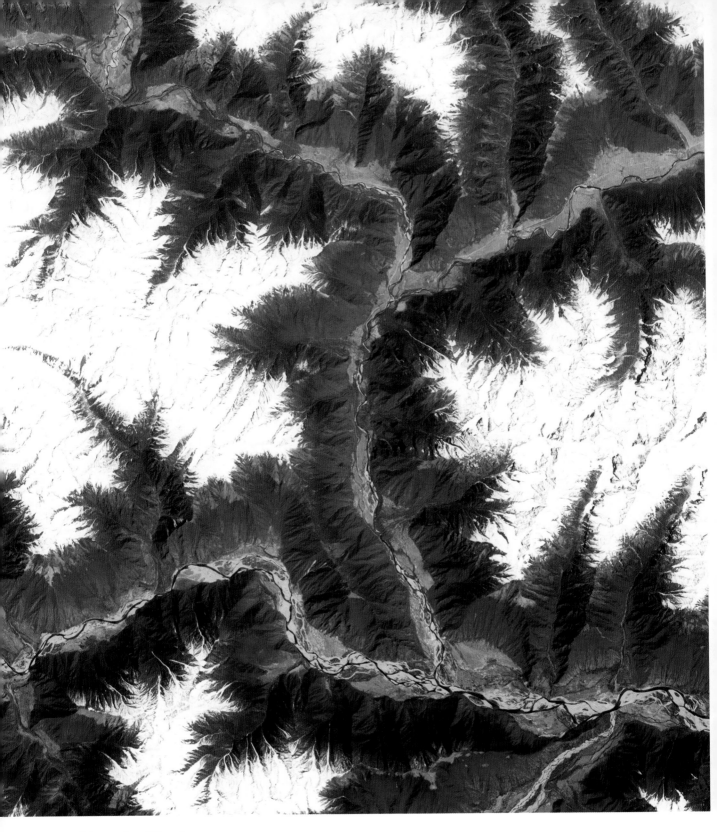

# China: the Himalayas

108    PRACTICALLY THE WHOLE OF TIBET, which has been forcibly incorporated within China since
1950, lies within the Himalayas. This startling image of soaring, snow-capped peaks and
ridges at the eastern end of the mountain range is a remarkable, irregular red-on-white
patchwork. A series of fast-flowing rivers are clearly shown. They are the headwaters of the
Yangtze (Chiang Jang), at 6,450 km/4,000 miles it is the longest river in China and the third
longest in the world.

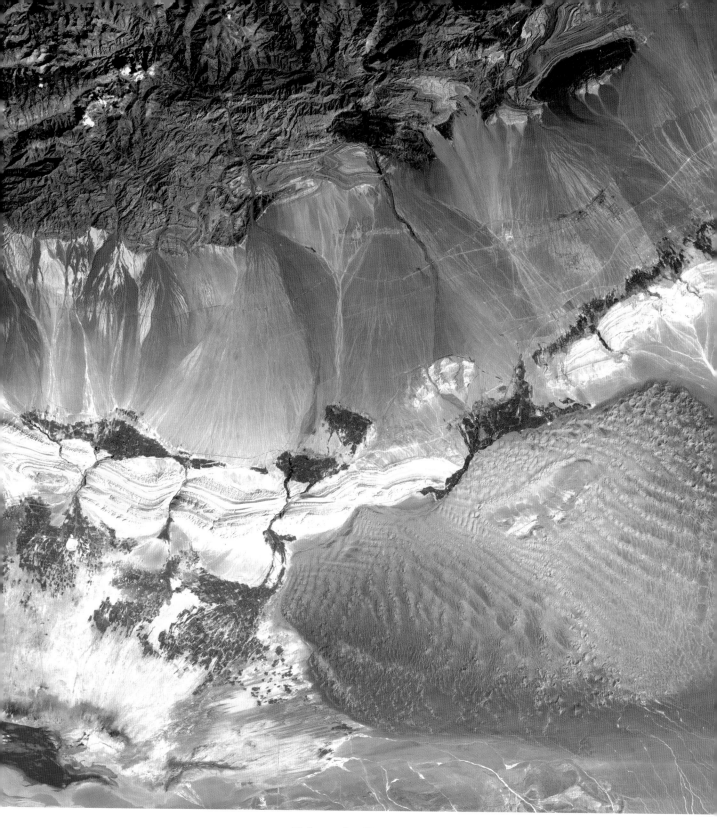

## China: the Turpan Pendi

THE TURPAN PENDI, OR TURFAN DEPRESSION, nestles below the Bogda Mountains, in the upper
half of the image, on the northern rim of the Takla-makan Desert. It is the third lowest place on
Earth, 154m/505ft below sea level. It consists of an unusual mixture of salt and sand dunes.
The saline lake to the lower left is typical, as is the undulating area of sand to the lower right.
The area shown is approximately 130 km/80 miles north to south.

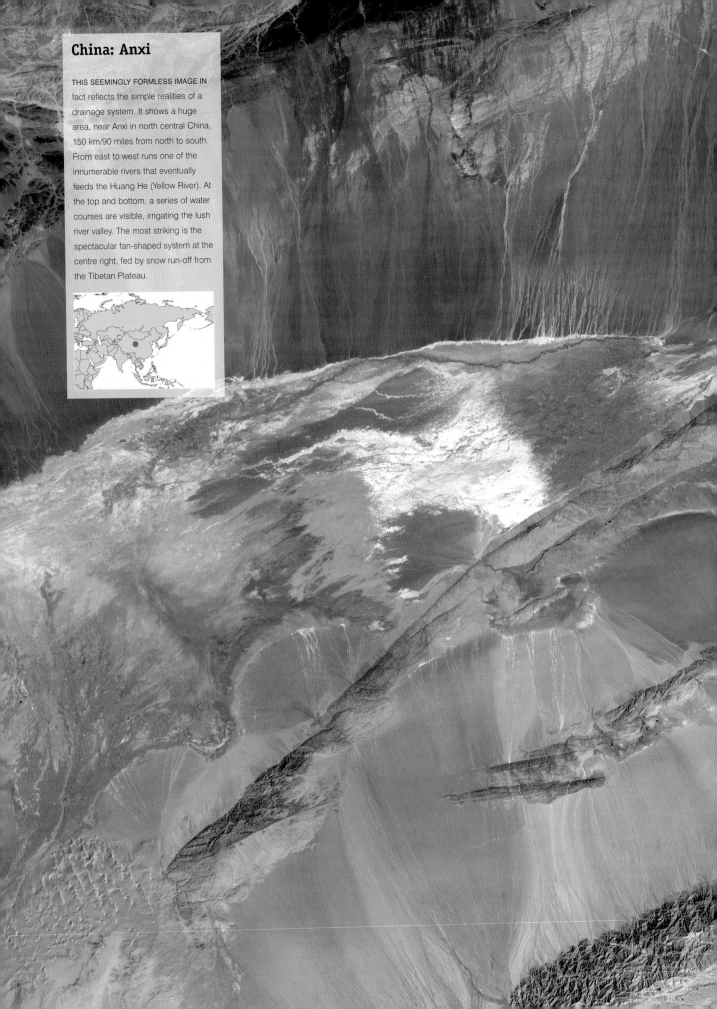

# China: Anxi

THIS SEEMINGLY FORMLESS IMAGE IN fact reflects the simple realities of a drainage system. It shows a huge area, near Anxi in north central China, 150 km/90 miles from north to south. From east to west runs one of the innumerable rivers that eventually feeds the Huang He (Yellow River). At the top and bottom, a series of water courses are visible, irrigating the lush river valley. The most striking is the spectacular fan-shaped system at the centre right, fed by snow run-off from the Tibetan Plateau.

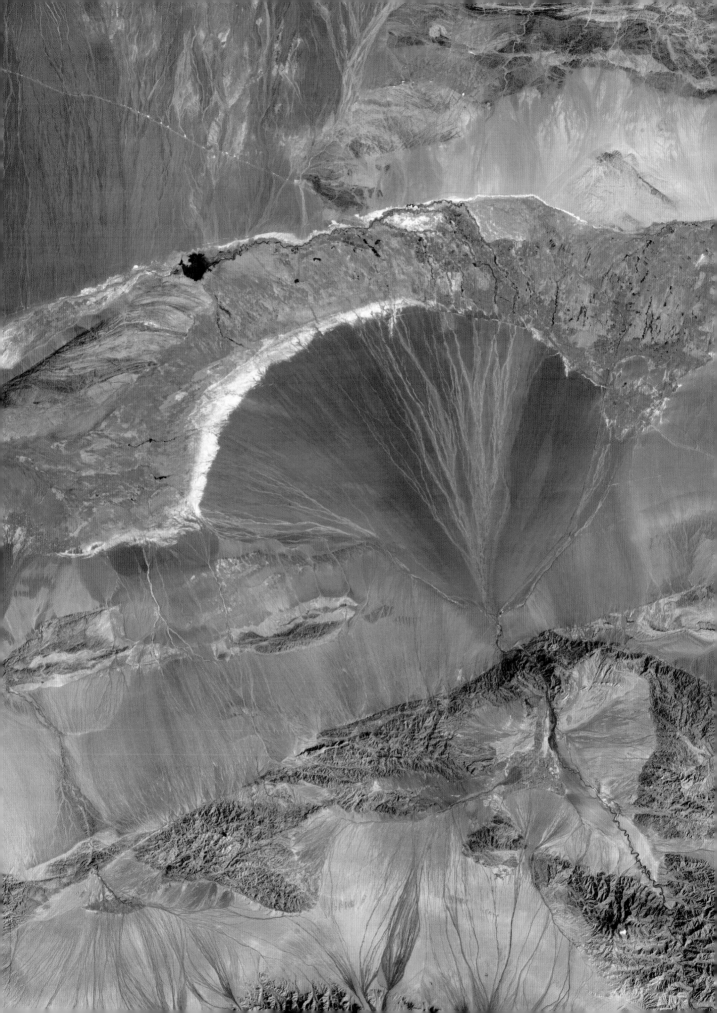

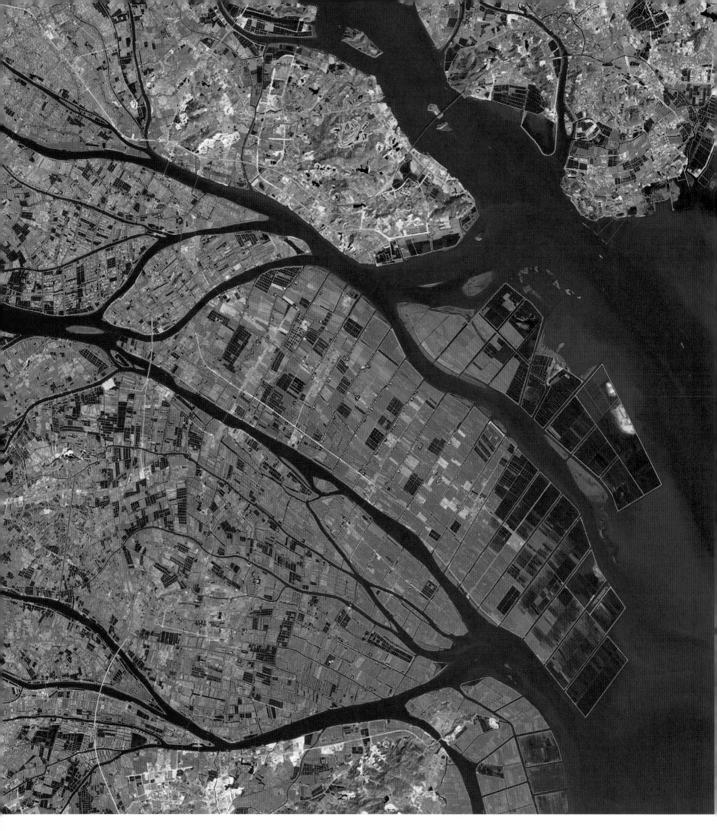

# China: Guangzhou

GUANGZHOU, CAPITAL OF GUANDONG PROVINCE in southern China, is the sixth largest city in China, with a population of more than 3 million, and is a major industrial centre. Located at the mouth of the Pearl River, it is also south China's leading deepwater port. The stimulus to its economic growth has in part come from its proximity to Hong Kong, 60 km/40 miles to its southeast. Unusually, there is substantial agriculture in the city, too. The red squares at the bottom of the image are fields.

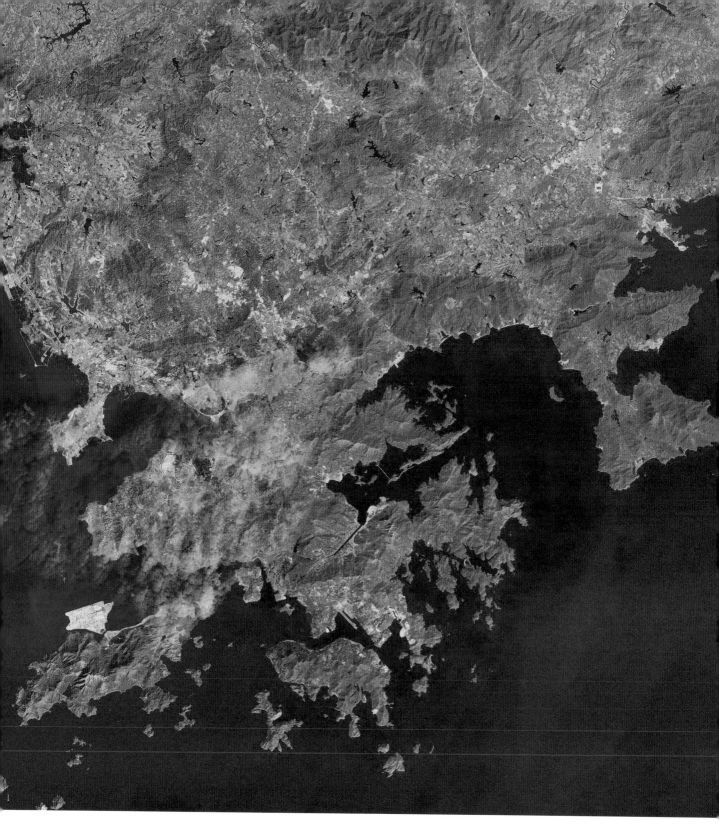

## China: Hong Kong

HONG KONG ITSELF, 'FRAGRANT HARBOUR' in Cantonese, is the large island in the lower centre of this image, just one of the ragged cluster of mountainous islands that make up the Hong Kong Peninsula. It is one of China's principal economic cities, a leading centre of commerce and industry. Though one of the most densely populated cities in the world, 75 per cent of the land area is a conservation area, making Hong Kong province one of the most unspoilt metropolitan areas in Asia.

113

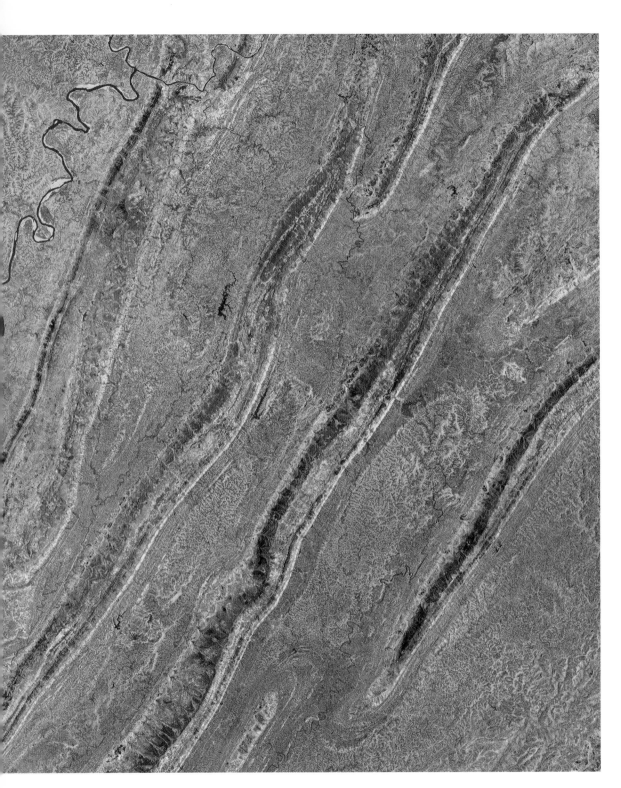

# China: the Sichuan Pendi

THE PROMINENT DIAGONAL RIDGES, outlined are in red, are 'anticlines': areas where the coming together of the Earth's plates has compressed and then forced the crust upwards. Their almost regular saw-tooth edges are entirely typical. The lowland areas between these folds are known as 'synclines' and are frequently the sites of oil or gas deposits. The Sichuan Pendi is in south central China. The area shown on this image is approximately 120 km/75 miles from north to south.

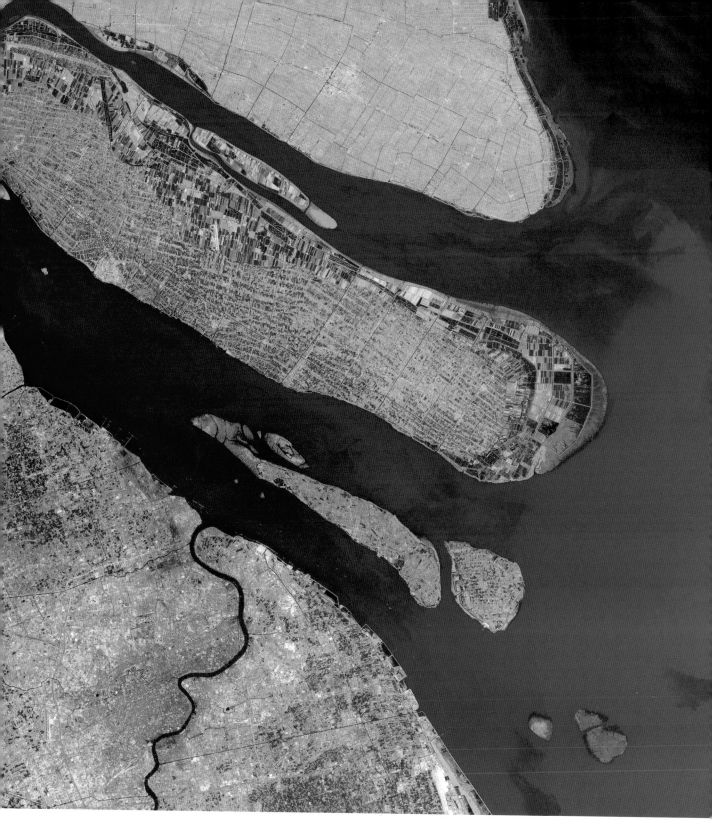

## China: Shanghai

THOUGH NOW CHINA'S LARGEST CITY, with 16.7 million people in its greater metropolitan area, Shanghai was of little significance before the nineteenth century when European penetration began the process that turned it into today's economic powerhouse. It is now China's leading financial centre and a major deepwater port. The city straddles the Huangpu River, visible at the bottom of the image, where it enters the Yangtze/Chang Jiang estuary.

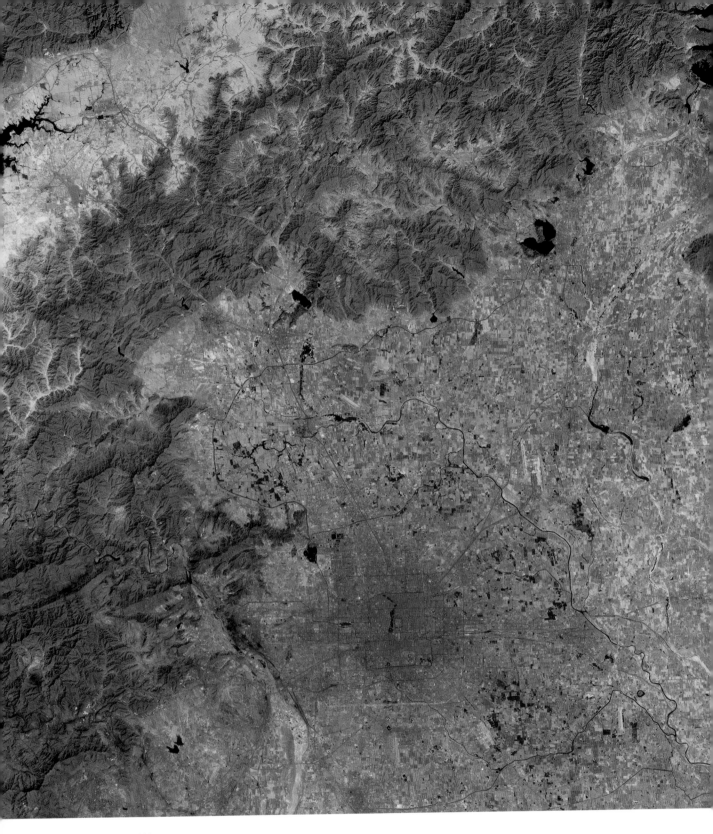

# China: Beijing

THE DRAMATIC LOCATION OF BEIJING, China's capital, is highlighted by this overview of the
city, which shows an area of approximately 120 km/75 miles from north to south. Beijing lies
at the rim of a flat coastal plain and is bounded to the west and north by the rugged Taihang
Mountains, which run diagonally across the image. The city itself is clearly visible in the
lower centre. Dotted around it, and shown in red and light blue, are numerous large areas
of agriculture.

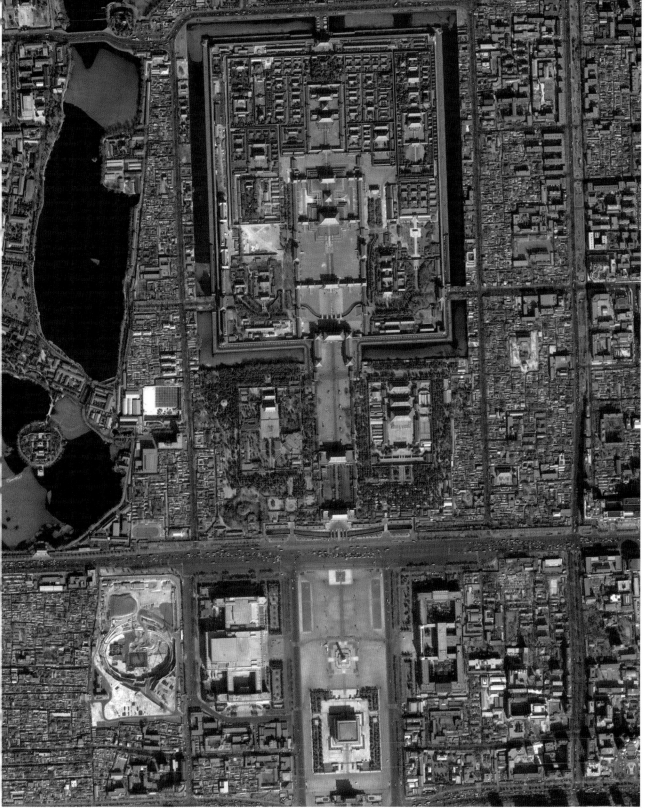

©DigitalGlobe

## Beijing: the Forbidden City

AT THE HEART OF BEIJING IS THE FORBIDDEN CITY, which dominates the upper half of this
image. Completed under the Mings in 1420, it was the epicentre of the country, the formal
residence of the emperor and as such strictly off-limits to all but his inner circle. It is surrounded
by 9m/30ft-high walls that extend for more than 3,350m/11,000ft. To its south is Tiananmen
Square, also laid out by the Mings, and at 44ha/108 acres reputedly the largest square
in the world.

# South Korea: Seoul

SEOUL, CAPITAL OF SOUTH KOREA, lies on the distinctive shallow W-shape formed by the Han-gang River on the right-hand side of this image. It is by far the largest city in the country: the population of its greater metropolitan area is nearly 20 million, just a little under half that of the entire country. To its west is Inch'ŏn, the country's largest port, located at the mouth of the Han-gang. The extensive orange-red areas are forests and the deep purple areas are flooded rice fields.

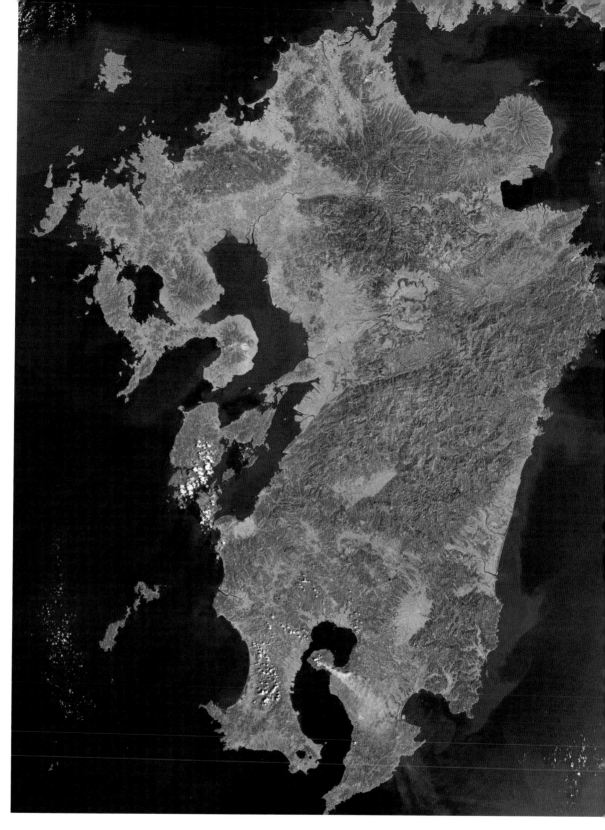

## Japan: Kyūshū

KYŪSHŪ IS THE MOST SOUTHERLY OF JAPAN'S main islands as well as the third largest and most densely populated. Just visible at the top of the image is Honshu, Japan's largest island, separated from Kyūshū by the narrow Shimonoseki Strait. Kyūshū is largely volcanic and mountainous. Towards its centre in the north is Mount Aso, an active volcano which has the world's largest caldera: 50,000 people live inside it. In the south of the island smoke can be seen coming from another volcano, Sakurajima. There are numerous hot springs. Urban areas on this image are pale green. Kyūshū's largest city, on the island's north coast, is Fukuoka.

119

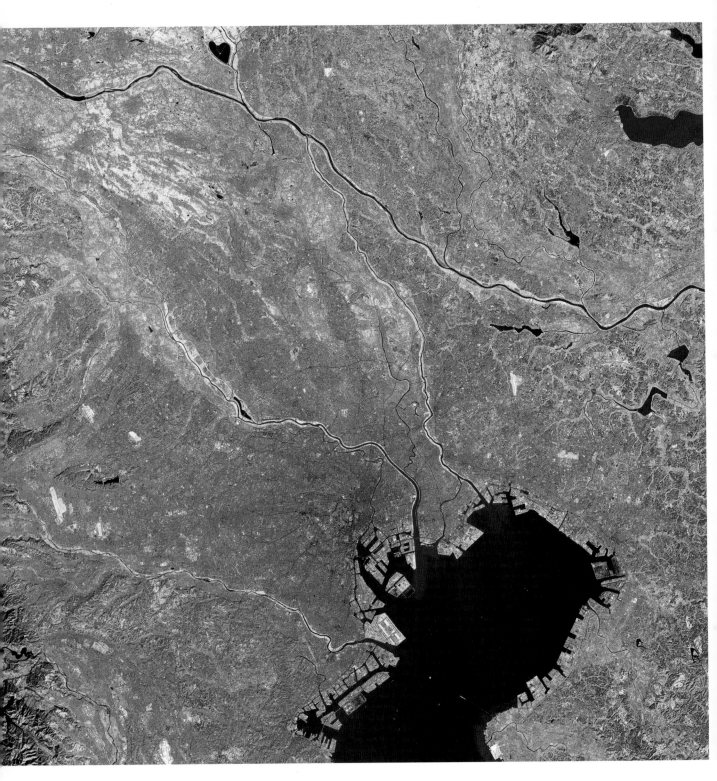

# Japan: Tokyo

THE POPULATION OF THE GREATER METROPOLITAN area of Tokyo, Japan's capital, is
31.4 million, the largest of any city in the world and a quarter of Japan's total population.
Administratively, it comprises twenty-five cities, five towns and eight villages and sprawls over
2,187 sq km/844 sq miles. Even in the eighteenth century, the city, then Edo, had a population
of more than one million. Post-war Tokyo mushroomed, a process paralleling the country's
economic boom. In 1986 alone, property prices in central Tokyo doubled.

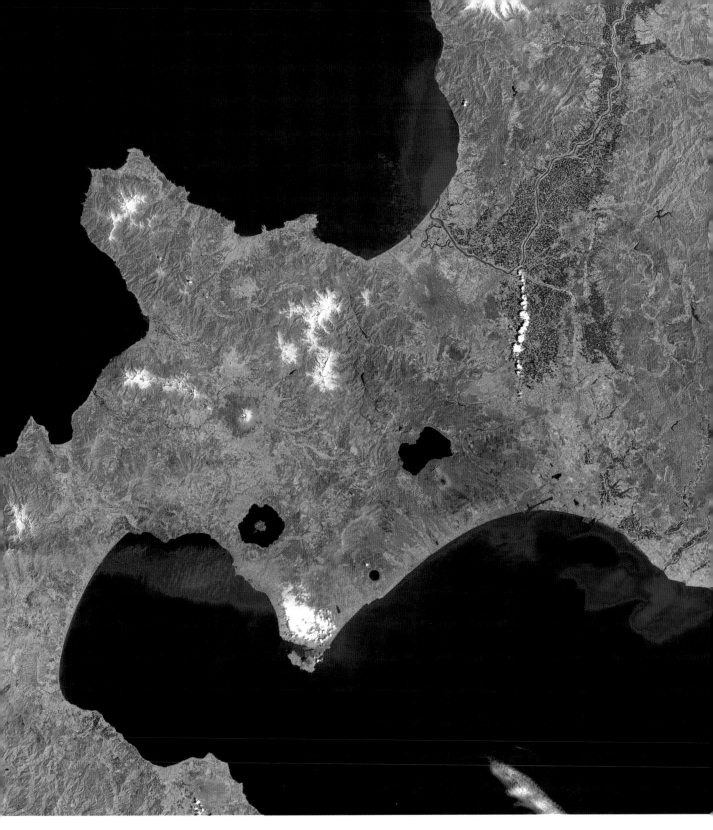

## Japan: Sapporo

THIS IMAGE IS OF THE SOUTHWEST CORNER of Hokkaidō, Japan's most northerly and second largest island. The purple areas in the upper right corner show flooded rice fields which follow the banks of river Ishikari Gawa. Sapporo, the island's largest city and one of the fastest growing in the country is southwest of the river. The rugged volcanic interior of Hokkaidō, parts of it snow covered, including the Yotei-zan volcano in the centre left, is also clearly visible. Despite the often inhospitable terrain, the south of the island is also a major agricultural centre. The image shows an area approximately 230 km/143 miles from north to south.

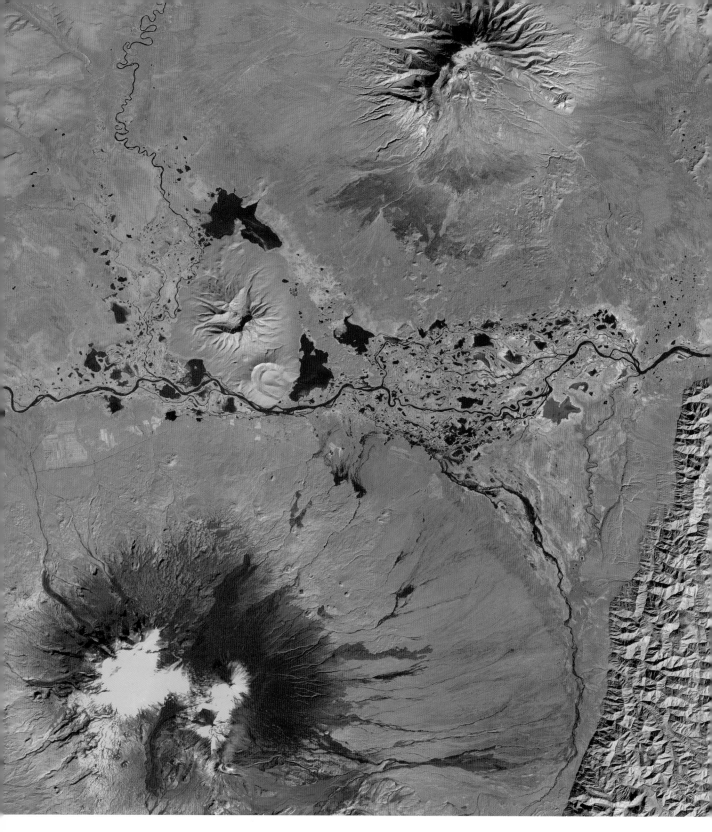

# Russia: Kamchatka, summer

THE MOUNTAINOUS 1,200 KM/750-MILE-LONG Kamchatka Peninsula in eastern Russia juts into the Pacific. Though rich in natural resources, minerals especially, its remoteness and inhospitable terrain have so far restricted their exploitation. Fishing is the main economic activity and more than half the 387,000 population live in the only town of note, Petroplavlosk-Kamchatskiy on the southeast coast. The east coast has twenty-eight active volcanoes; in the peninsula as a whole there are 300 extinct volcanoes.

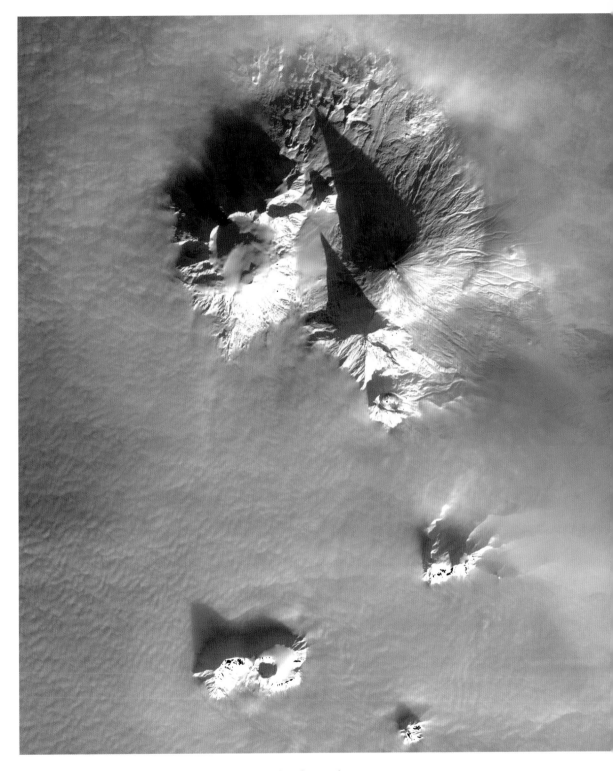

## Russia: Kamchatka, winter

THIS IMAGE SHOWS THE SAME AREA as that on the facing page with the volcanic peaks reaching up above cloud level. At the top is Klyuchevskaya, 4,750m/ 15,584ft high and the largest volcano on Kamchatka. It is located on the eastern ridge on Kamchatka's Pacific coast. Since 2003, the volcano has shown increasing signs of activity. Experts predict that for the first time since the 1920s a prolonged period of volcanic activity can be expected. To its south is the smaller volcano of Bezymianny, which is also becoming active again. A small plume of ash is visible at its summit.

123

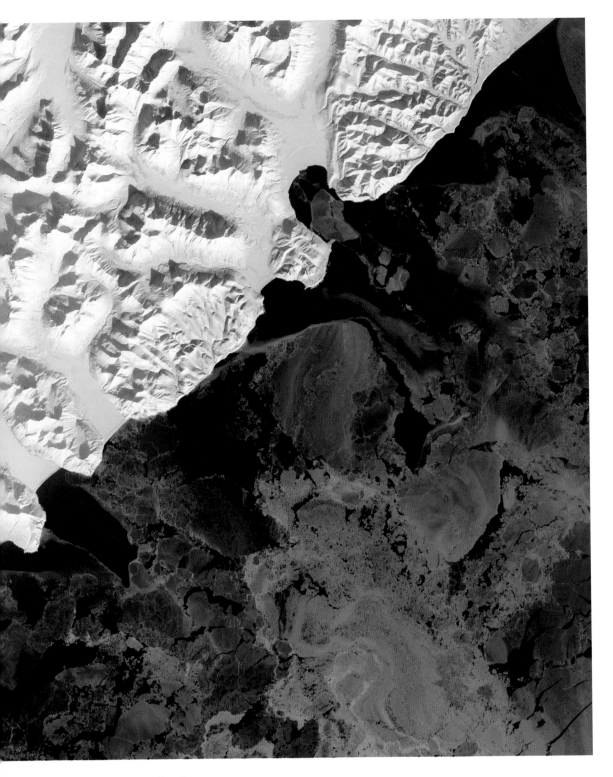

# Russia: Kamchatka

IN CONTRAST TO THE RELATIVELY SHELTERED west coast of Kamchatka, which faces the Sea of Okhotsk, the east coast, facing the Bering Sea, is rugged and exposed. Though south of the Arctic Circle, winters here are fierce and numerous glaciers fill the region's mountain valleys. In this image of the very northeast tip of the peninsula, blue glacier-ice can be seen swirling into the Bering Sea. The image shows an area approximately 25 km/15 miles from north to south.

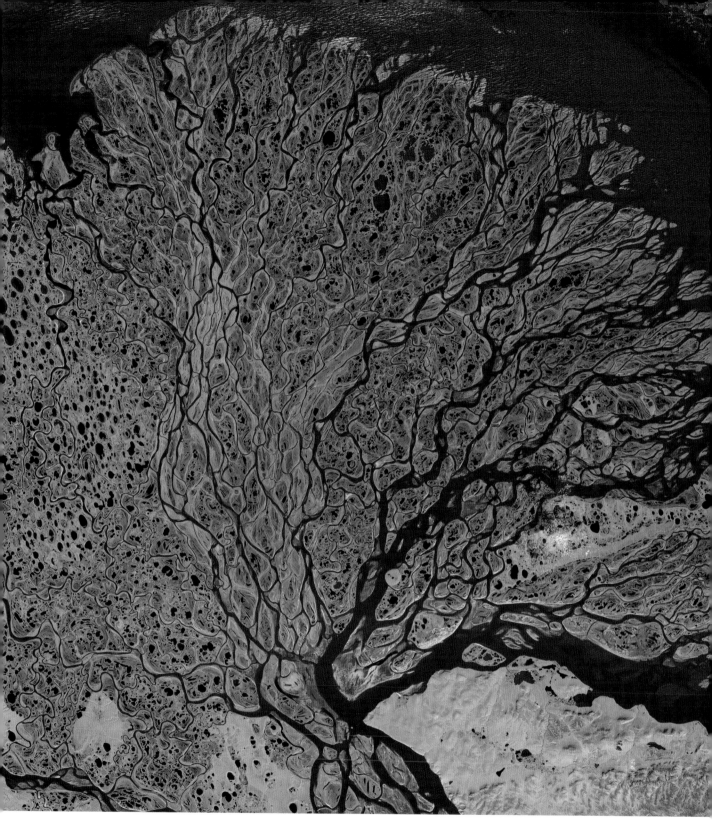

## Russia: the Lena Delta

THE ABSTRACT BEAUTY OF THE LENA DELTA in Siberia is vividly captured here. The Lena is
the tenth-longest river in the world, running north 4,400 km/2,730 miles from southern
Siberia to the Arctic Ocean. The delta is 400 km/250 miles wide. This image shows an area
approximately 160 km/100 miles from north to south. For nine months of the year, it is a frozen
wasteland. Between July and September the delta is transformed into lush wetland
supporting many species of animals.

125

# AFRICA

Geography has not been kind to Africa. Though the world's second largest continent, with a total land area of 30 million sq km/11.6 million sq miles, and home to almost 800 million people, its coastline is smaller in proportion to its landmass than that of any other continent. One consequence is that Africa has relatively fewer natural harbours than the world's other continents. Inevitably, this has tended to inhibit contact with it. At the same time, though it has many rivers, which in theory aid access to the interior, few are easily penetrated from the sea. Much of the continent's interior is plateau land stretching almost to the coast. As they near the sea, rivers such as the Congo plunge through a series of dramatic falls that make navigation impossible.

To the north, along the Mediterranean coast and in the Nile valley, the story is very different. These were areas that shared in and, in the case of Egypt, contributed decisively to the development of the civilizations of the ancient world. But even here they are the victims of geography. Immediately to their south is the Sahara, at 9.1 million sq km/3.5 million sq miles the largest desert in the world, an almost trackless wasteland of sand and rock. About 6,000 years ago the region was still fertile but once desertification began it continued remorselessly. Today, the Sahara is advancing southward at up to 5.5m/18ft a day. Not surprisingly, the countries of the region are among the least densely populated in the world.

Allied to its vast size and the prevalence of tropical disease in sub-Saharan Africa, the consequence of these geographical realities was to seal off much of Africa from contact with the outside world at least until the nineteenth century. Catching up has proved persistently difficult. Six of the poorest countries in the world are African, the list headed by Sierra Leone and Burundi. In Botswana, which tops the list, average life expectancy is thirty-two. In Niger the literacy rate is less then 14 per cent.

Africa boasts the longest river in the world, the Nile, which runs northwards for 6,863 km/4,265 miles from Lake Victoria, itself the third-largest lake in the world, to the Mediterranean. Its highest mountain, standing almost astride the equator, is Mount Kilimanjaro in Tanzania, 5,895m/19,340ft high. Its lowest point is Lac Asal in Djibouti, 153m/502ft below sea level.

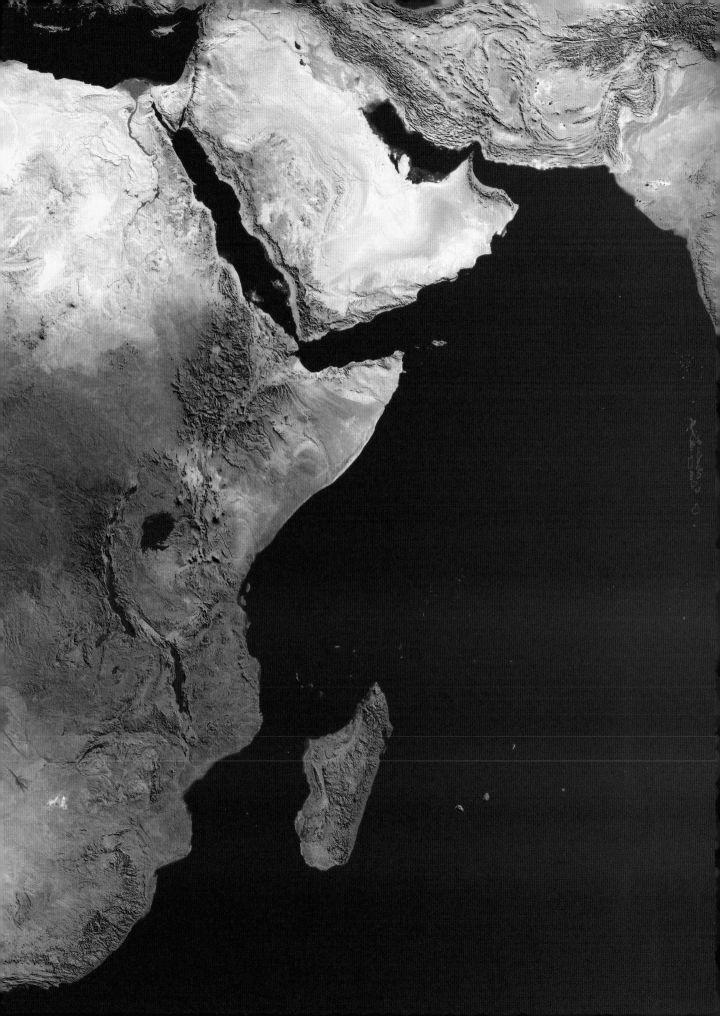

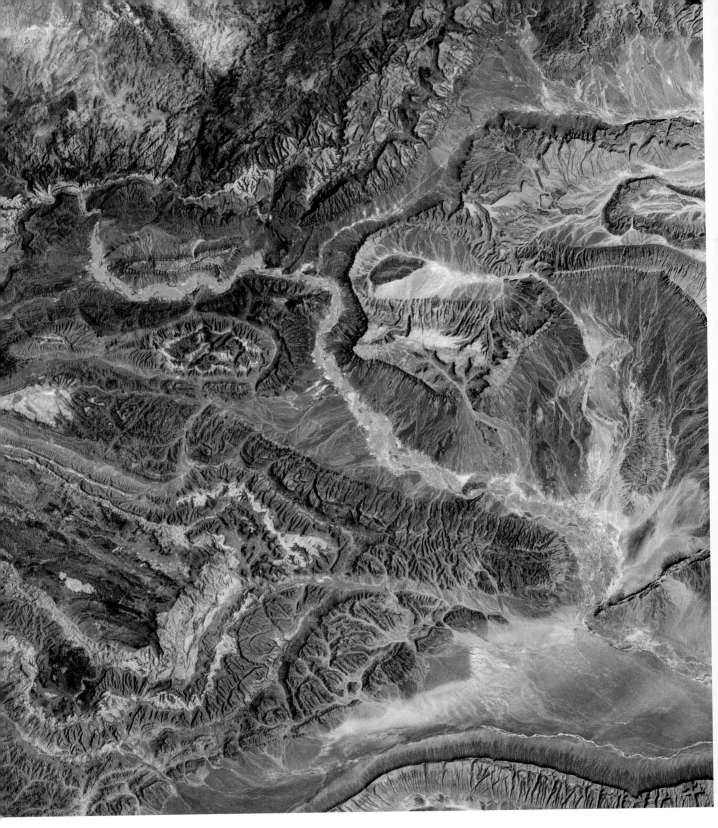

## Morocco: the Southern Anti Atlas Mountains

130

THE ATLAS MOUNTAINS STRETCH across Morocco, following the line of the Atlantic coast. The colours in this image have been deliberately exaggerated to highlight different rock types and formations. Among the most obvious is in the centre left, fringed in pale green. This is an 'anticline', where the rocks have been forced upwards, in effect folding them. The vivid green snaking across the image is vegetation along a river. The image shows an area approximately 120 km/75 miles from north to south.

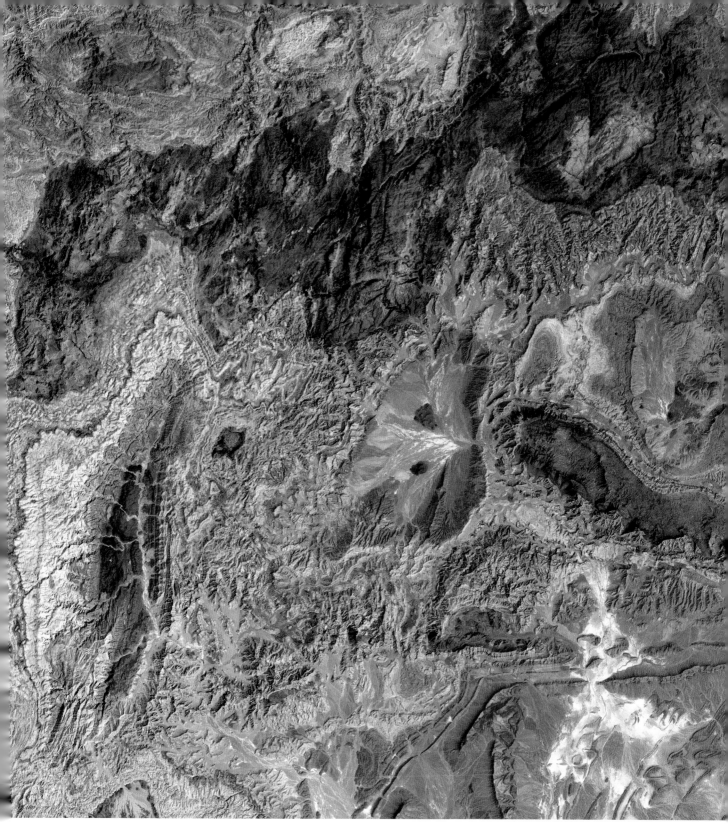

## Morocco: the Anti Atlas Mountains

AS IN THE PREVIOUS IMAGE, the colours here have been manipulated and enhanced to highlight
the complex geological structure of the region. This shows an area, approximately 120 km/
75 miles from north to south, of the Anti Atlas in the southwest of Morocco, where the
mountains tail off towards the borders of Western Sahara and Algeria. The dark green at the
top of the image is an anticline. Below it, in purple, are a series of 'synclines', where the rocks
have been folded downwards.

131

## Mauritania: sand dunes

132

THE HYPNOTIC PATTERN OF THIS IMAGE consists of linear sand dunes. Dunes of this type, in parallel ridges, sometimes several kilometres wide though always longer than they are wide – 100 km/60 miles is not unusual – cover more of the Earth's sand deserts than any other type. That they are formed by wind is agreed; how the process works is not. Opinions divide between whether a prevailing wind blowing from one direction, or winds blowing from more than one direction are responsible.

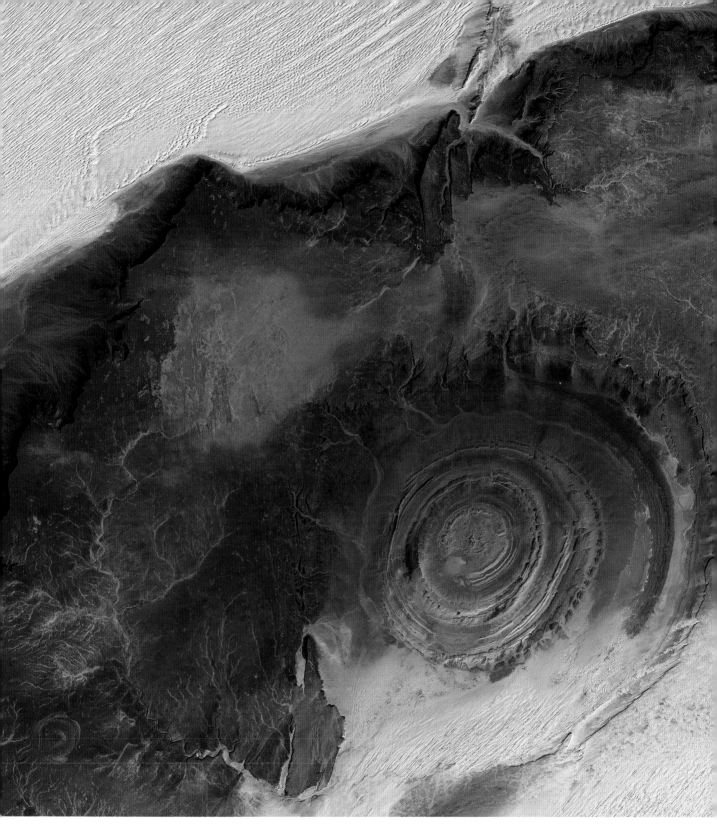

## Mauritania: the Richat Structure

THOUGH IT RESEMBLES AN IMPACT CRATER, which it was originally thought to be, the Richat Structure in the Maur Adrar Desert in central Mauritania was formed when a volcanic dome hardened and was eroded, exposing its onion-like layers of rock. It has long been a landmark for orbiting spacemen, a conspicuous bull's-eye in an otherwise featureless expanse of desert. It has a diameter of almost 50 km/30 miles. The sparseness of its meagre vegetation, shown in green, is apparent.

133

# Algeria: Star Dunes, Grand Erg Oriental

THE GRAND ERG ORIENTAL, which extends south across eastern Algeria, is the second largest sea of sand in the Sahara, behind only the Libyan Desert. It is a featureless, low-lying area. As this remarkable image demonstrates, so-called star, or 'pyramid', dunes predominate, individual mounds of sand as opposed to the linear dunes found elsewhere in the Sahara. There is some evidence that they are produced by winds blowing from several different points. The image shows an area approximately 60 km/ 36 miles from north to south.

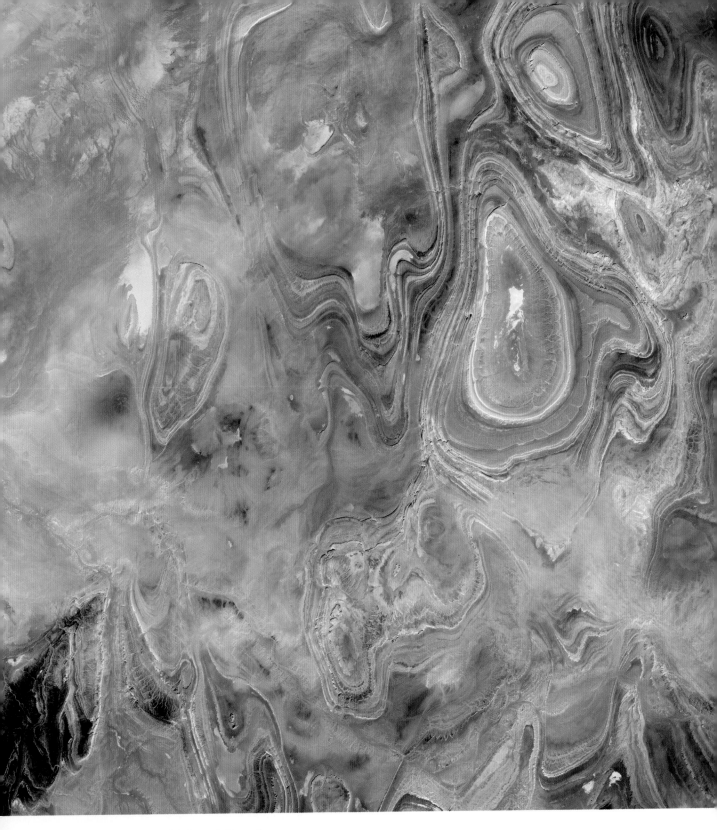

## Algeria: the Sebkha Mekerghene

136    THE NEAR-PSYCHEDELIC EFFECT of this image, with its attenuated, multilayered swirls and
loops, is partly the result of using deliberately rich and distorted colour values to show up
geological features and partly created by these features themselves. The circular formations
are a series of synclines and anticlines, depressions and elevations in the Earth's crust whose
origins can be dated to 300 million years ago. The light blue patches are saltpans. The area
shown is approximately 120 km/75 miles from north to south.

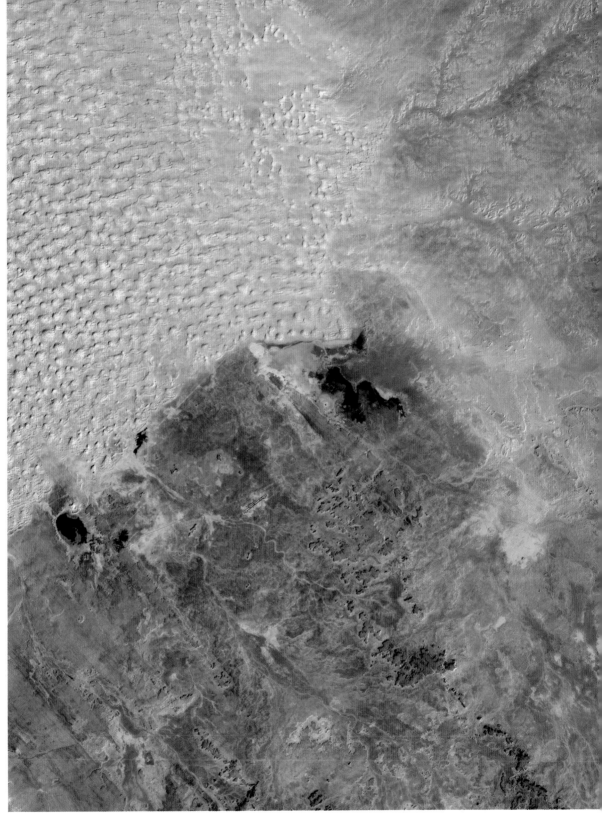

## Libya, Algeria and Tunisia:
## Ghadames and the Grand Erg Oriental

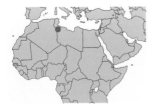

THREE CLASSIC DESERT LANDSCAPES are shown on this image, approximately 120 km/75 miles
from north to south, of the Grand Erg Oriental: rocky, in the predominantly red and orange area
at the bottom and the greener areas in the top right; stony, in the low-lying plains within the
rocky areas; and sandy, in the top left-hand corner. The gullies in the top right are dried up
water-courses, evidence of higher rainfall as little as 7,000 years ago. The turquoise patches at
the bottom are saltpans.

137

# Libya:
# the Murzūq Basin

THE AREA SHOWN HERE OF southwest
Libya is immense, well over 860 km/
540 miles from west to east. The
Murzūq Basin itself is the huge,
roughly circular area of sand in the
lower centre left. It is surrounded to
its west and north by a gently sloping
sandstone escarpment. The
distinctive, inkstain-like, black area in
the top right is volcanic basalt, thrown
out by a series of small volcanoes,
their cones stilll visible. The black-
purple smear below it, slanting
southwest, is a deposition from a
plume of wind-blown volcanic debris.

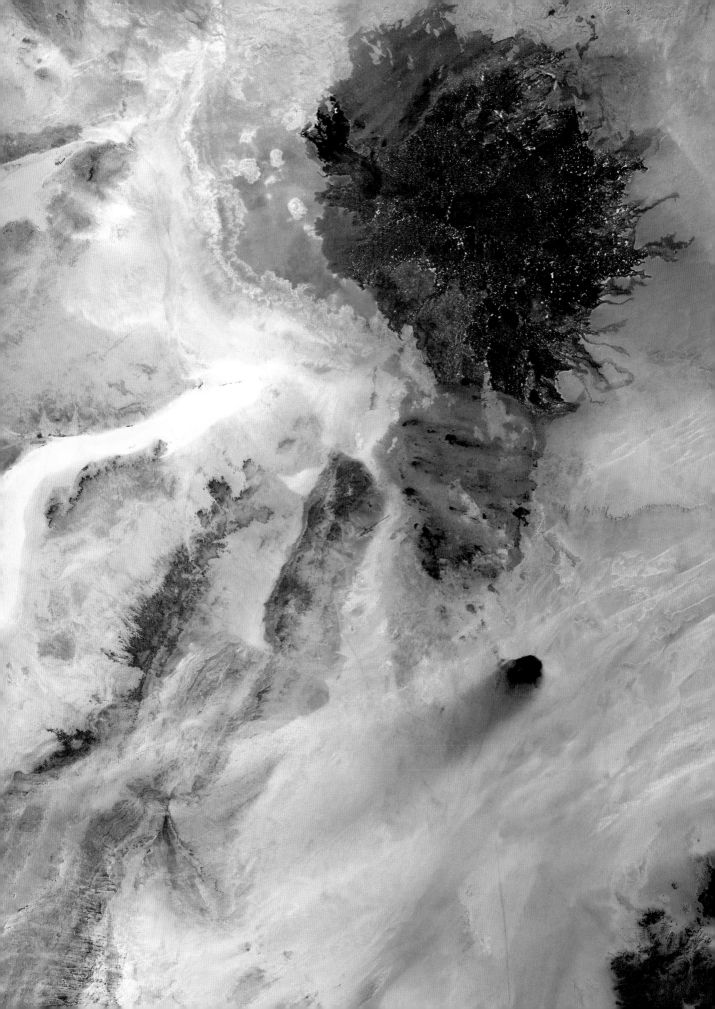

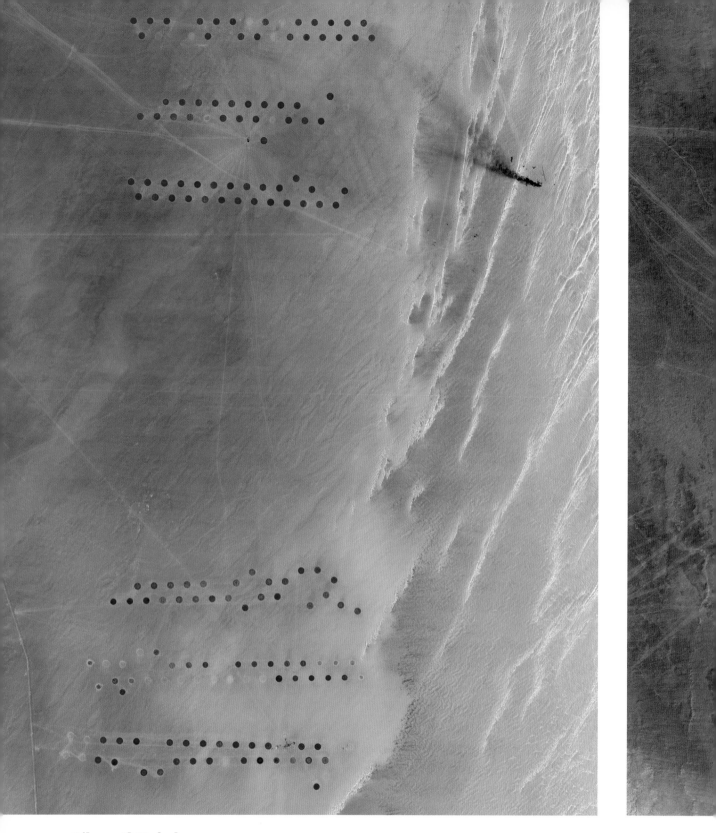

# Libya: Al Kufrah

AL KUFRAH, DEEP IN THE SANDY WASTES of eastern Libya, is the site not just of significant oil reserves – the black smoke in the upper right-hand corner is gas burn-off from an oilwell – but also of huge underground water reservoirs, a legacy of the much wetter climate of the Sahara after the last Ice Age. The red dots at the top and bottom of the image are circular fields, each about 1 km/0.6 miles across, their vegetation shown in red, watered from these reservoirs using centre-pivot irrigation systems.

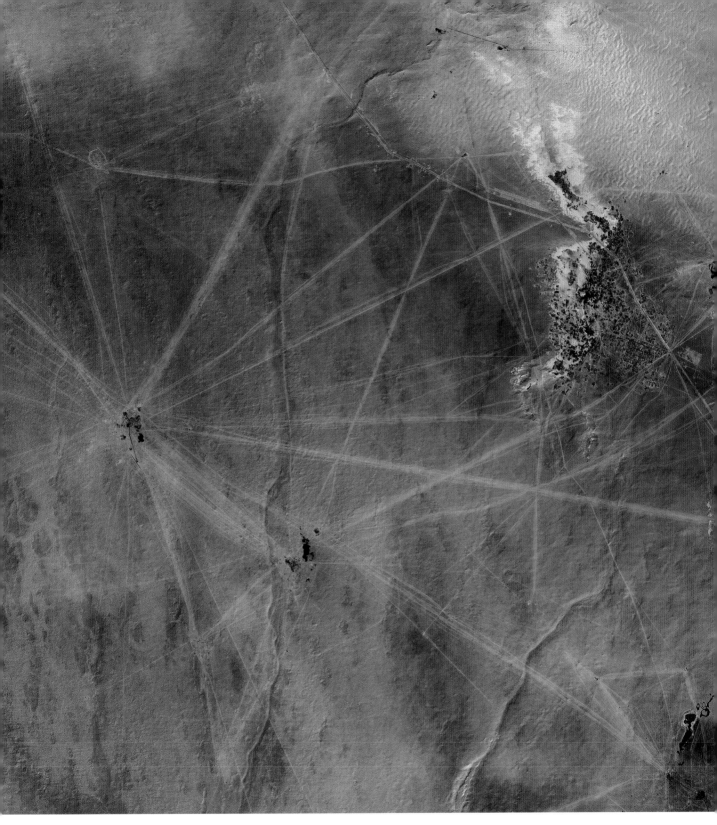

## Libya: Awjilah

OIL DOMINATES LIBYA'S FRAIL ECONOMY, accounting for 95 per cent of all its hard-currency earnings. The country is the largest oil producer in Africa, ahead of Nigeria and Algeria, with 36 billion barrels of proven oil reserves, the eighth-largest in the world and 3.5 per cent of the world total. There are fourteen main oilfields. It is widely believed that the country contains significant undiscovered extra reserves and that perhaps only 25 per cent of its total oilfields have been discovered. This image shows a network of vehicle tracks linking oilwells in the rocky plains of Ajdabiya Province in the northeast.

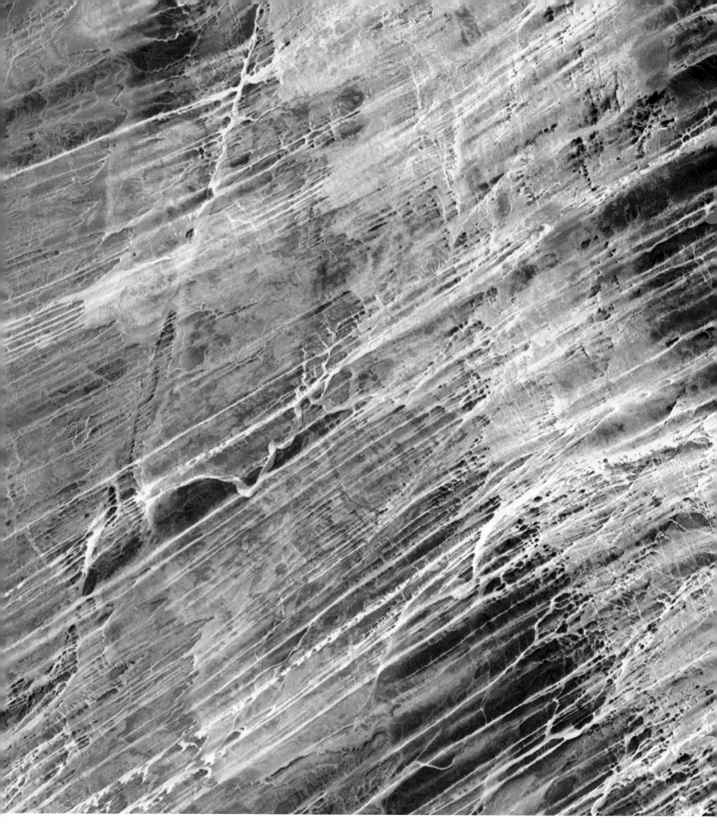

## Libya, Niger and Chad: the Central Sahara

142

SANDWICHED BETWEEN THE HOGGAR Mountains to the west in Algeria and the higher Tibesti range to the east in northern Chad, the image shown here covers almost the precise junction of Libya, Niger and Chad. Unlike the great sand seas to the north, this region of the Sahara, though no less arid, is predominantly rocky. The bedrock has a pronounced north-south sweep. The fine yellow lines are streaks of sand. The area shown is approximately 80 km/50 miles from north to south.

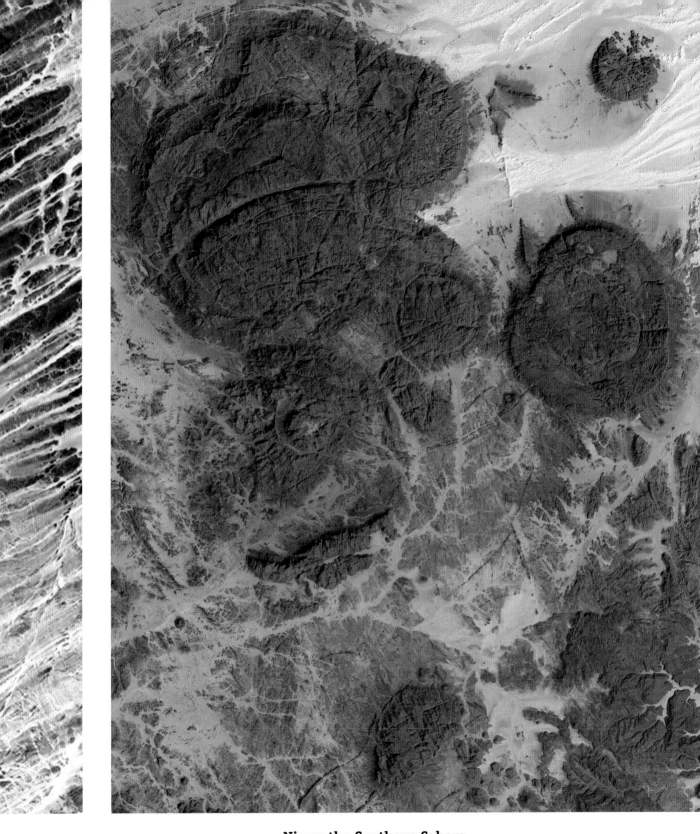

## Niger: the Southern Sahara

LANDLOCKED NIGER IS ONE OF THE POOREST countries in the world. Four-fifths of the country is desert. Of its 1.27 million sq km/0.49 million sq miles, only 660 sq km/255 sq miles are irrigated. Even in the relatively fertile south, subsistence agriculture prevails. This image, about 120 km/75 miles north to south, shows a composite of igneous landforms with volcanic rock (in red), sand (in yellow in the upper right-hand corner) and dried-up watercourses (in the lower right). A river gorge cutting east west through the volcanic rock in the top left forms the northern edge of a spectacular, near perfectly circular ring dyke some 50 km/ 30 miles in diameter.

143

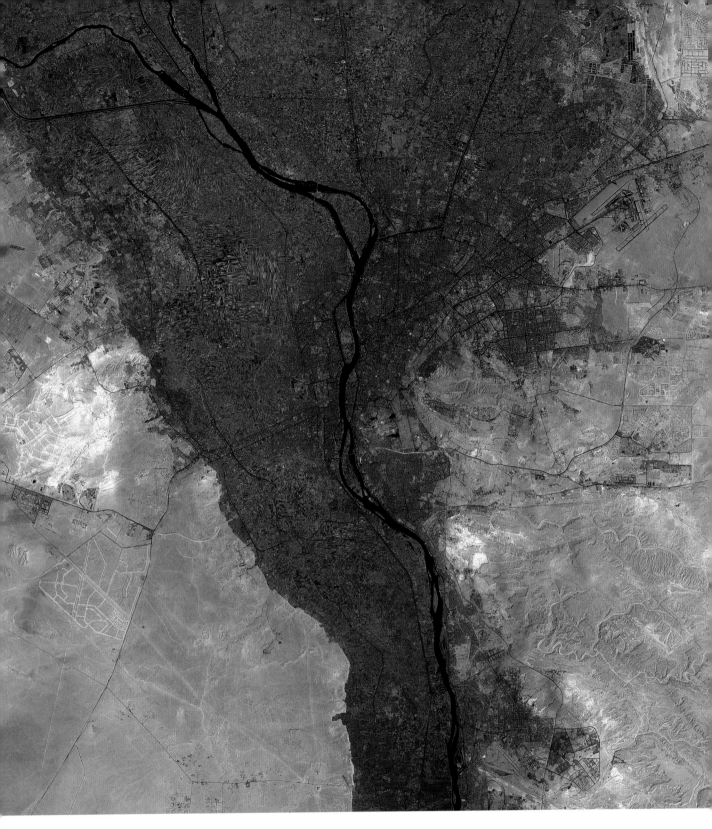

# Egypt: Cairo

144

**THE SPRAWL THAT IS CAIRO**, capital of Egypt and, with a population of nearly 12 million, easily the largest city in Africa, lies just south of the Nile Delta, clearly visible on this image. The bulk of the city lies on the east bank of the Nile, though it has expanded northwards over the last hundred years. The green areas are cultivated land, watered by the Nile. Memphis, the ancient capital of the Lower Nile, is to the southwest, near the pyramids.

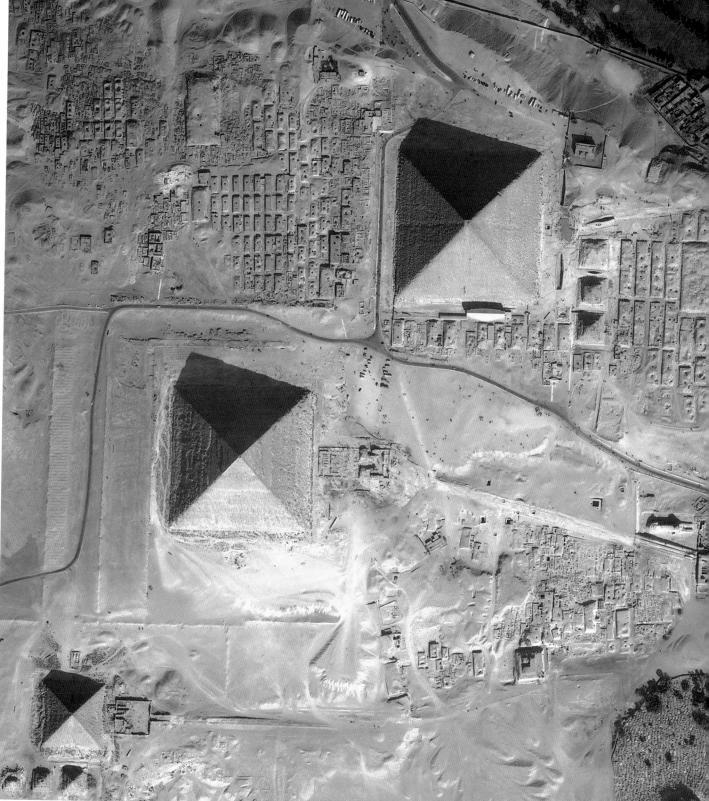

©DigitalGlobe

# Egypt: the Pyramids

OF THE PYRAMIDS OF GIZA, the Great Pyramid, at the upper right of this image, is the most celebrated. Built by Cheops *c.* 2590 BC, it is the only one of the Seven Wonders of the World to have survived. When completed, it stood 146m/480ft high and for forty-three centuries was the tallest structure on Earth, though it has lost approximately 9m/30ft over the years. The pyramid in the centre is that of Khafre and the smaller one at the bottom that of Menkaure.

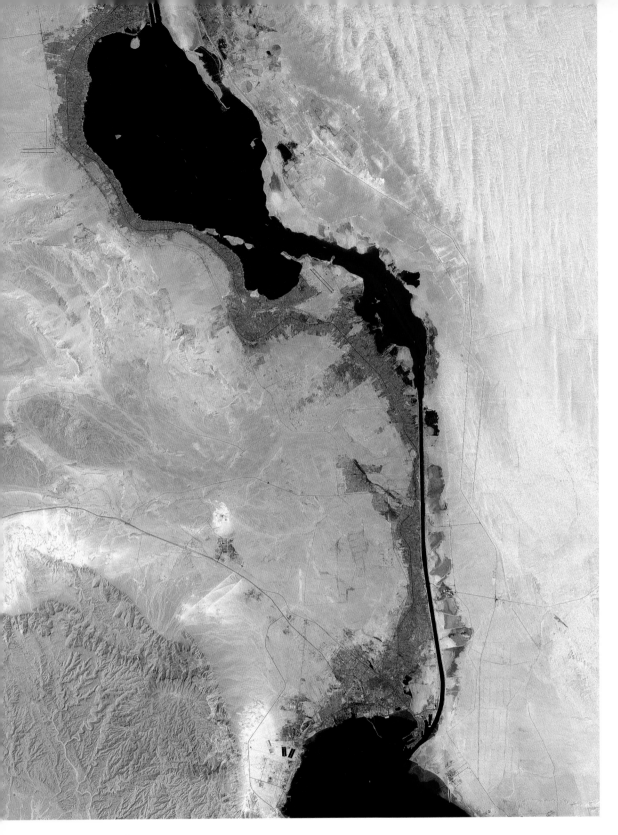

# Egypt: Suez

THE PORT OF SUEZ lies at the southern end of the Suez Canal, here clearly visible as it runs
north–south between the Red Sea and the Little Bitter Lake, one of several natural waterways
incorporated into the canal by its nineteenth-century French engineers. From here, the canal
continues northward to the Mediterranean, which it enters at Port Said. The canal marks the
precise division between Africa, to the west, and Asia, to the east.

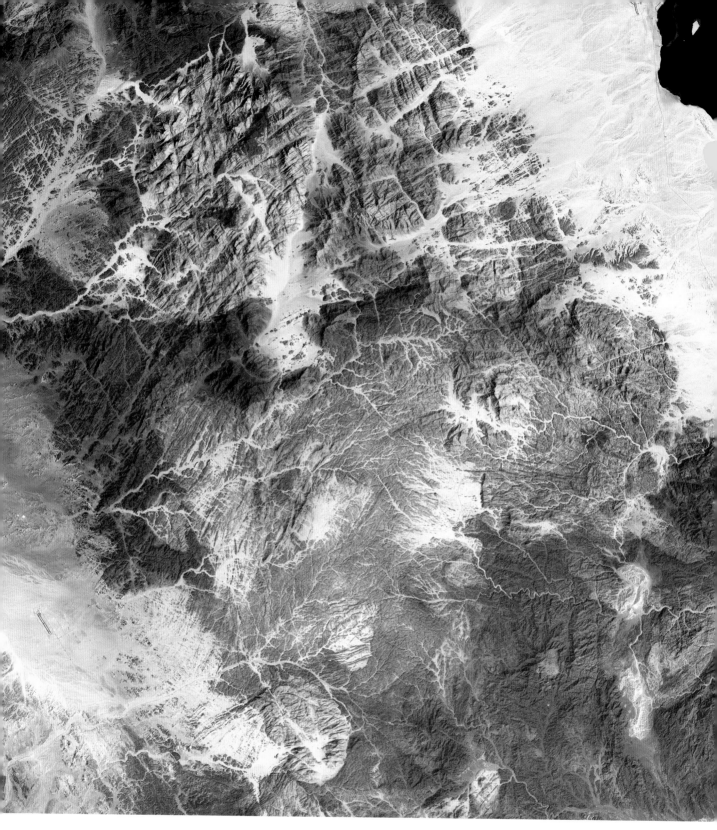

## Egypt: the Red Sea Coast

THE RED SEA, JUST VISIBLE in the upper right-hand corner, marks the division between two of the world's 'plates', rigid landmasses floating in permanent if scarcely perceptible motion on the Earth's mantle. Africa and most of the seas around it forms one, the Arabian Peninsula another. As Arabia drifted away from Africa, the rocks on the margin between them were stretched, producing the southeast-northwest grain visible in the top right-hand corner.

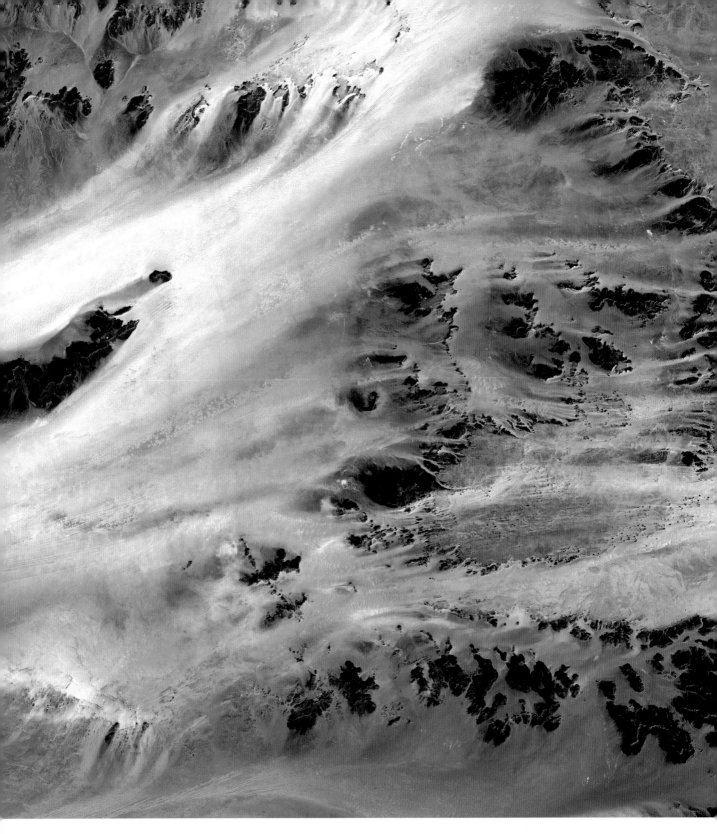

## Chad: the Southern Sahara

THIS IMAGE IS OF THE SAHARA in northeast Chad, near the Terkezi Oasis, close to the border with Sudan. The area it shows is approximately 100 km/60 miles from north to south. What looks almost like a wide, multicoloured waterfall sweeping diagonally from right to left is in fact windblown sand, shown in various shades of white, yellow and orange. It is interspersed with sharp outcrops of rock. The abrasive effect of windblown sand produces heavy and rapid erosion.

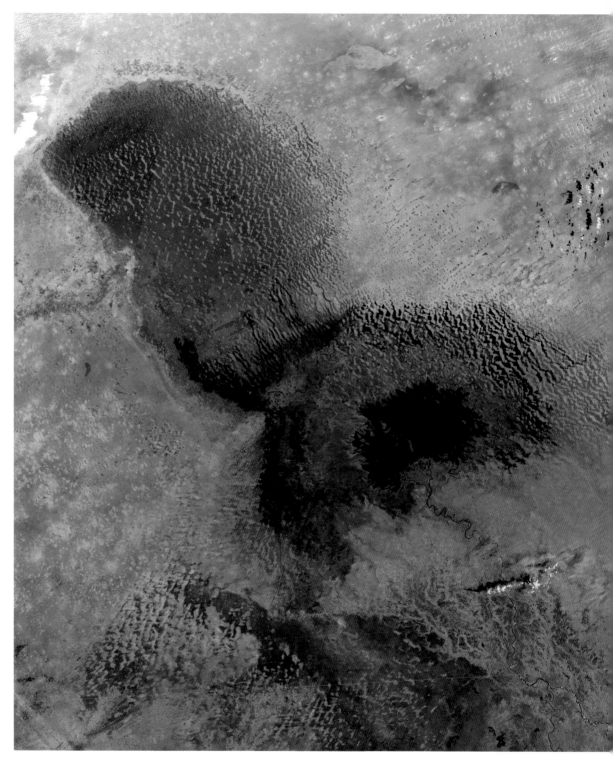

## Chad, Nigeria and Cameroon: Lake Chad

LAKE CHAD IS THE ONLY SIZEABLE BODY of water in the Sahara yet for forty years it has shrunk dramatically through a combination of drought and extensive use of it for irrigation. The rippled green and brown areas to the north and northwest of the lake indicate its former extent. Nonetheless, as the green vegetation around it shows, the lake is still the site of extensive wetlands. The area shown on this image is vast, approximately 325 km/200 miles from north to south.

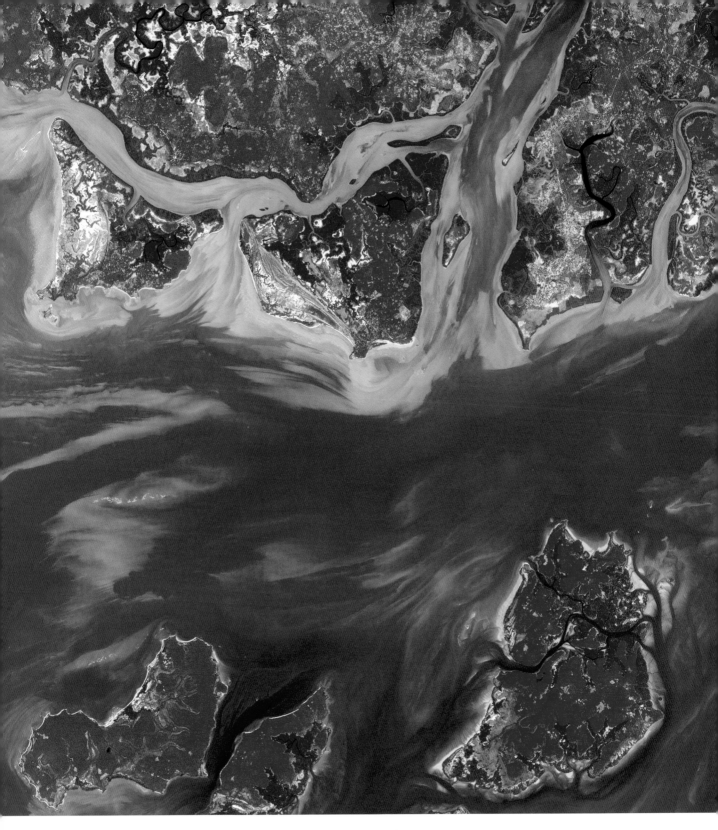

# Guinea Bissau: coastline and the Bijagós Archipelago

THE BRIGHT REDS AND BLUES in this false-colour composite image of part of the coastline of Guinea Bissau are deliberate, intended to highlight how silt is deposited as it is washed into the shallow waters off the coast by the Geba and other rivers. The paler blue shows these silt deposits. The vivid reds reveal the dense vegetation typical of the tropics. The islands at the bottom of the image are part of the Bijagós Archipelago.

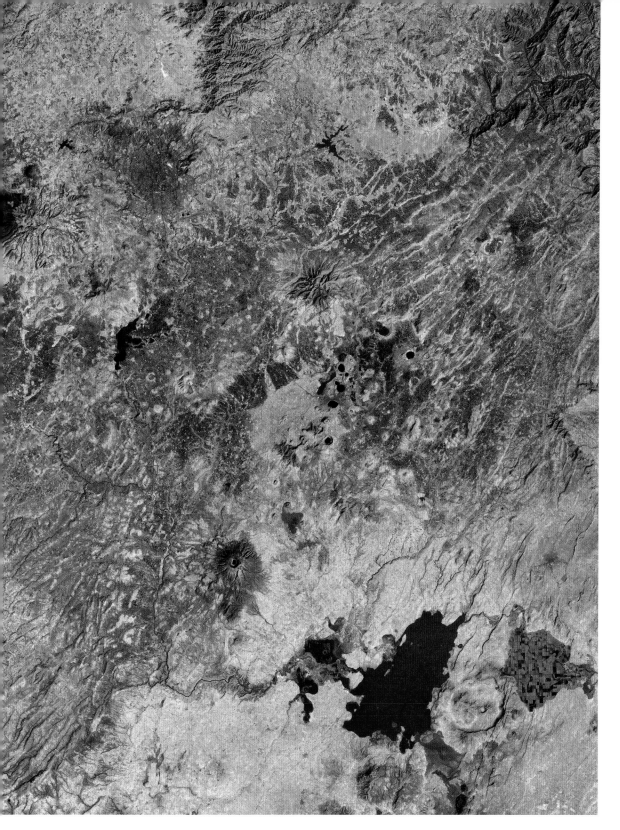

©DigitalGlobe

# Ethiopia: Addis Ababa

154    ADDIS ABABA IS THE GREY AREA in the top left-hand corner of this image, ringed to its north
by fields, shown in red. It is the capital of Ethiopia, heart of the country's government and
administration and the country's principal communications hub. The population is 2.1 million.
The city lies at an average elevation of 2,440m/8,000ft in the well-watered Ethiopian highlands.
The area was once actively volcanic and a number of small volcanic cones are visible here.
Lake Ziway lies in the bottom right.

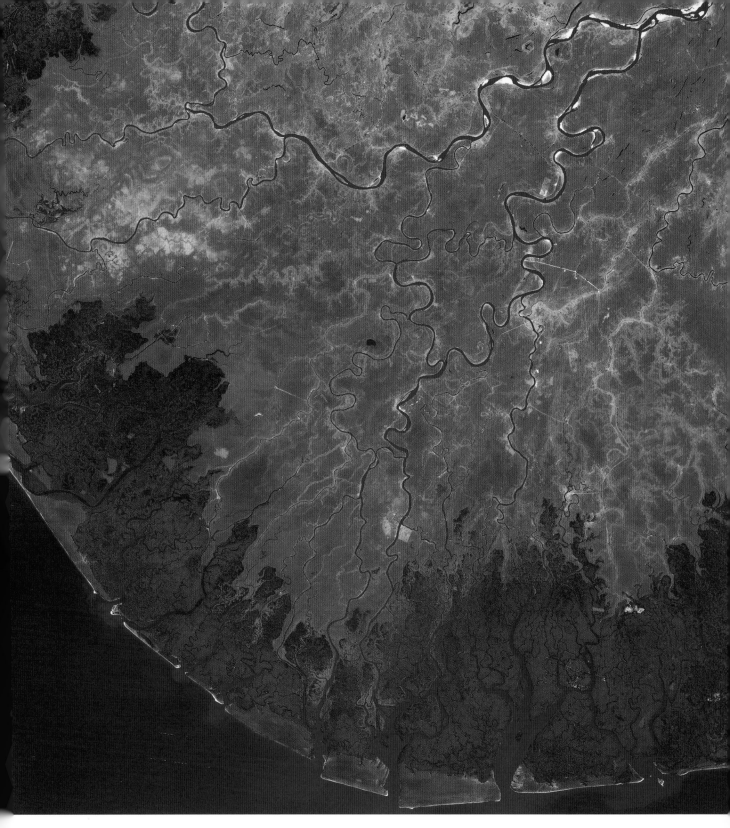

## Nigeria: the Niger Delta

THE NIGER DELTA is one of the most varied and remarkable ecosystems in the world, a complex and fragile mix of wetlands, swamp forests and mangrove swamps. It is one of the wettest places on Earth, with average annual rainfall in places of up to 400cm/157in. Already most of the delta's rainforests have been destroyed, and further irreparable damage seems certain as it is the site of the country's largest oil and gas reserves. The image shows an area approximately 110 km/66 miles from north to south.

153

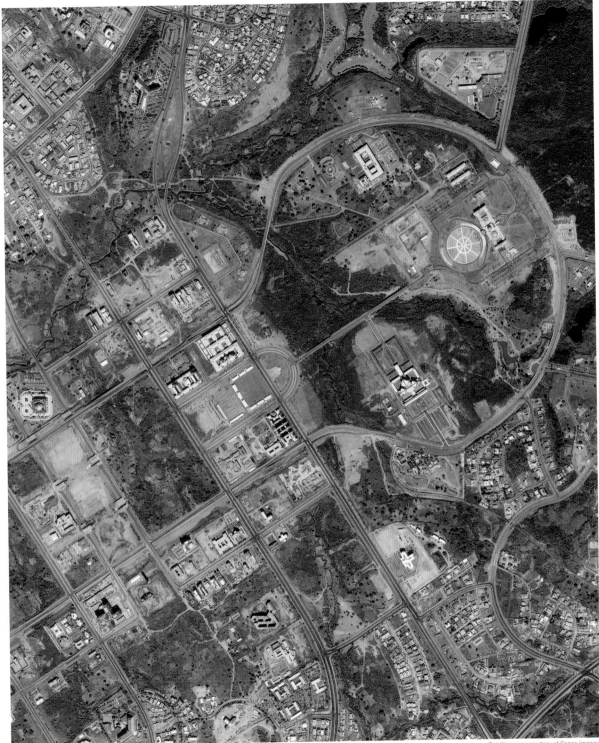

Satellite image courtesy of Space Imaging

# Nigeria: Abuja

ABUJA, CAPITAL OF NIGERIA and located in almost the exact geographic heart of the country, north of the confluence of the Benue and Niger rivers, is a rarity in Africa: a city purpose built as a capital. The decision to build the city was taken in 1976. The city, which became Nigeria's capital in 1991, is still small, covering an area of only 250 sq km/96 sq miles. The area shown here, about 4 km/2.5 miles from north to south, shows the government district.

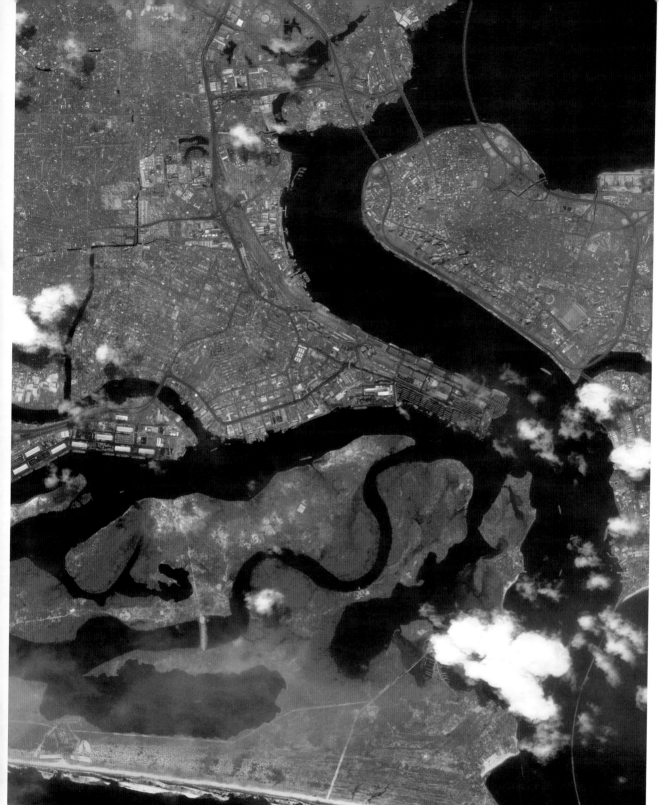

## Nigeria: Lagos

LAGOS IS IN THE SOUTHWEST CORNER of Nigeria and faces the Bight of Benin. It is the largest city in Nigeria, with a population of 10 million, as well as the country's leading economic and industrial centre and the site of its chief port. From Nigeria's independence in 1960 to 1991, it was also the capital of Nigeria. The heart of the city lies on the peninsula pointing to the upper left-hand corner. The image shows an area of approximately 10 km/6 miles from north to south.

151

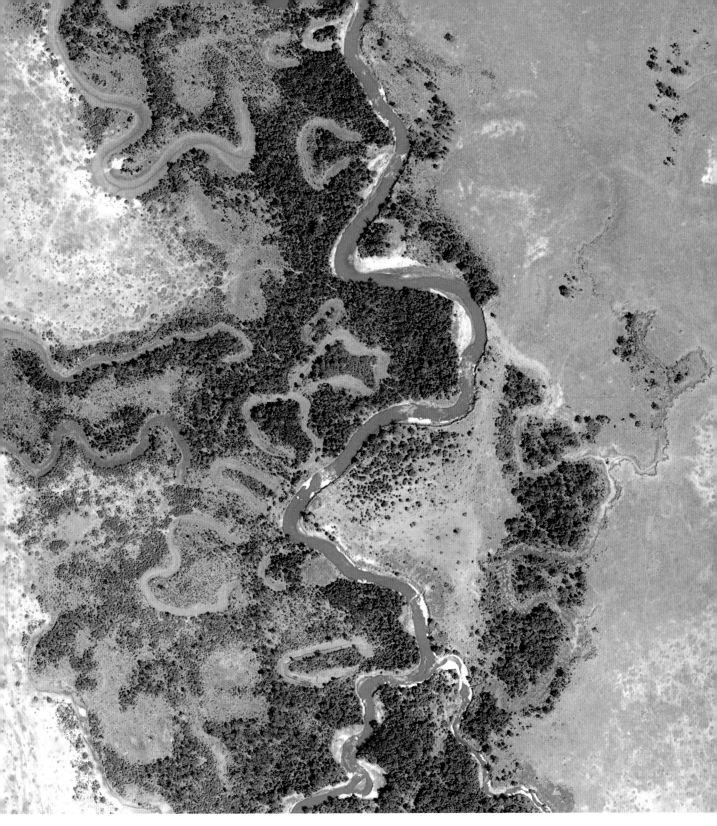

## Kenya: the Masai Mara

THE MASAI MARA GAME RESERVE is in western Kenya on the border with Tanzania and is the
most famous of the country's wildlife parks. It covers 1,510 sq km/583 sq miles of gently rolling
hills and woodland and contains sizeable numbers of animals, including up to half-a-million
wildebeest, who migrate north in June from Tanzania's Serengeti Plain. The image here shows
a 2.5 km/1.5 mile section of the meandering Mara River, in green, with numerous oxbow lakes.

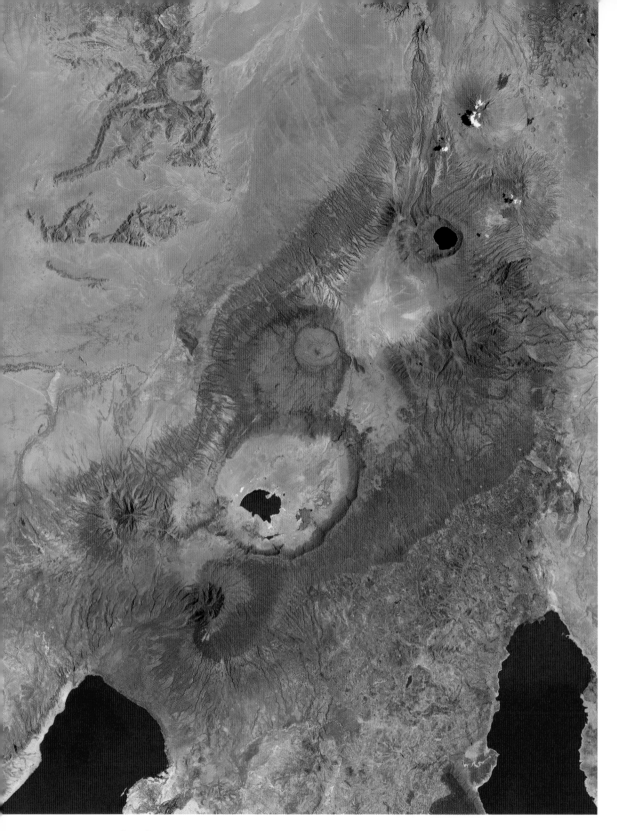

## Tanzania: the Ngorongoro Crater

THE 3,188M/10,456FT-HIGH Ngorongoro Crater in Tanzania's Serengeti National Park is a dormant volcano whose collapsed crater, or 'caldera', is the largest in Africa. It covers 260 sq km/ 100 sq miles and is 610m/2,000ft deep. The crater is visible, a small lake in its centre, in the lower half of the image. Two smaller volcanoes lie to its north. The red areas around all three are dense vegetation. Lake Eyasi is at the bottom left, Lake Manyara at the bottom right.

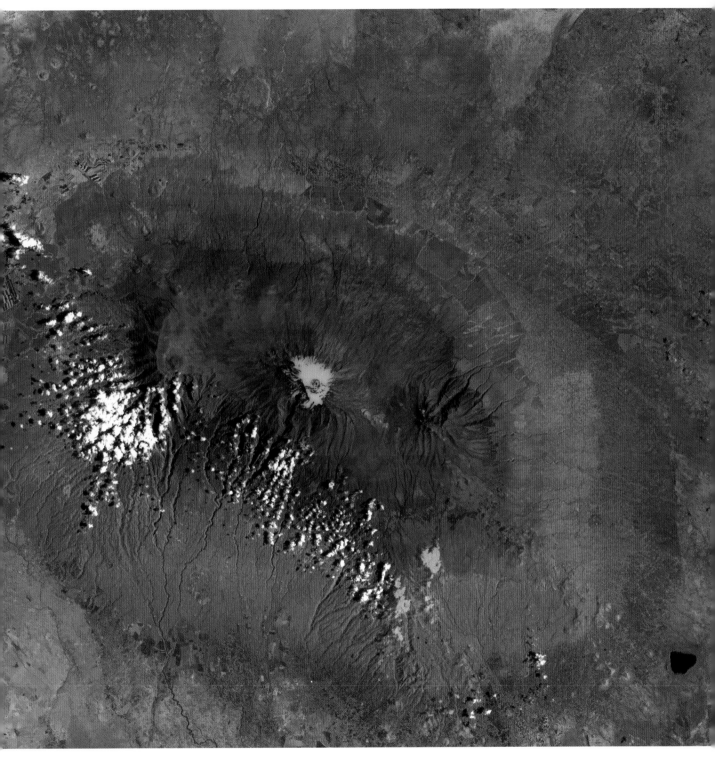

## Kenya and Tanzania: Mount Kilimanjaro

MOUNT KILIMANJARO LIES ALMOST EXACTLY on the Kenya–Tanzania border, which runs
diagonally across this image from top left to bottom right. The mountain, an extinct volcano,
has two peaks. The higher, Uhuru, at 5,895m/19,340ft the highest point in Africa, is easily seen,
its permanent snow-capped peak shown in pink. The lower, Mawenzi 5,354m/17,564ft, is just
visible to the right. The vivid red areas on the lower slopes are areas of natural and managed
forest and coffee plantations.

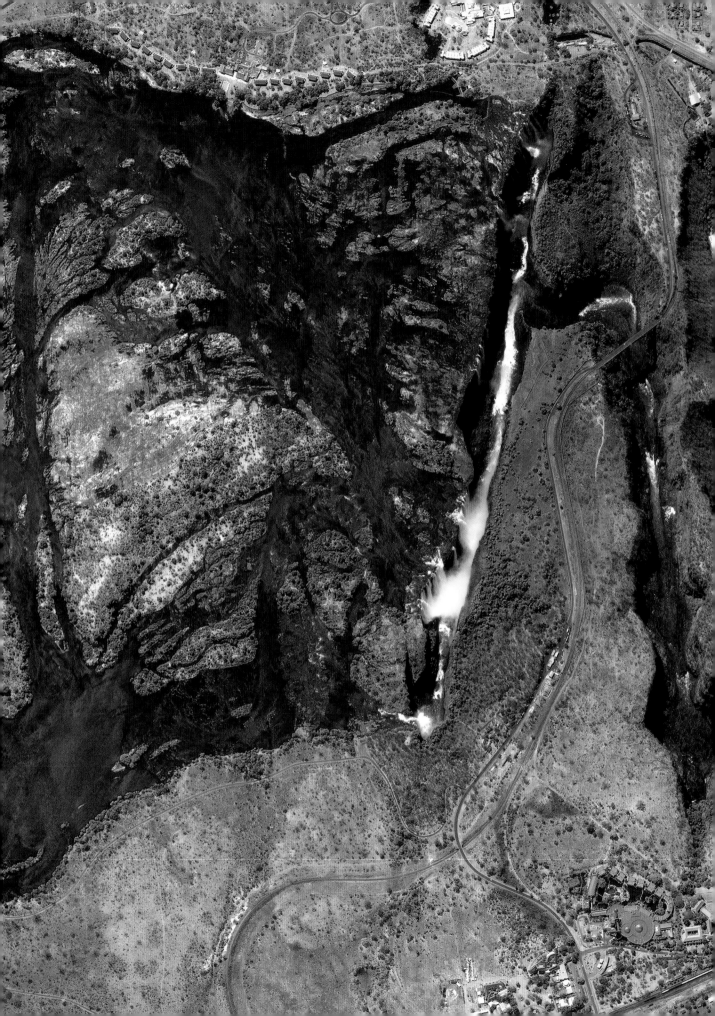

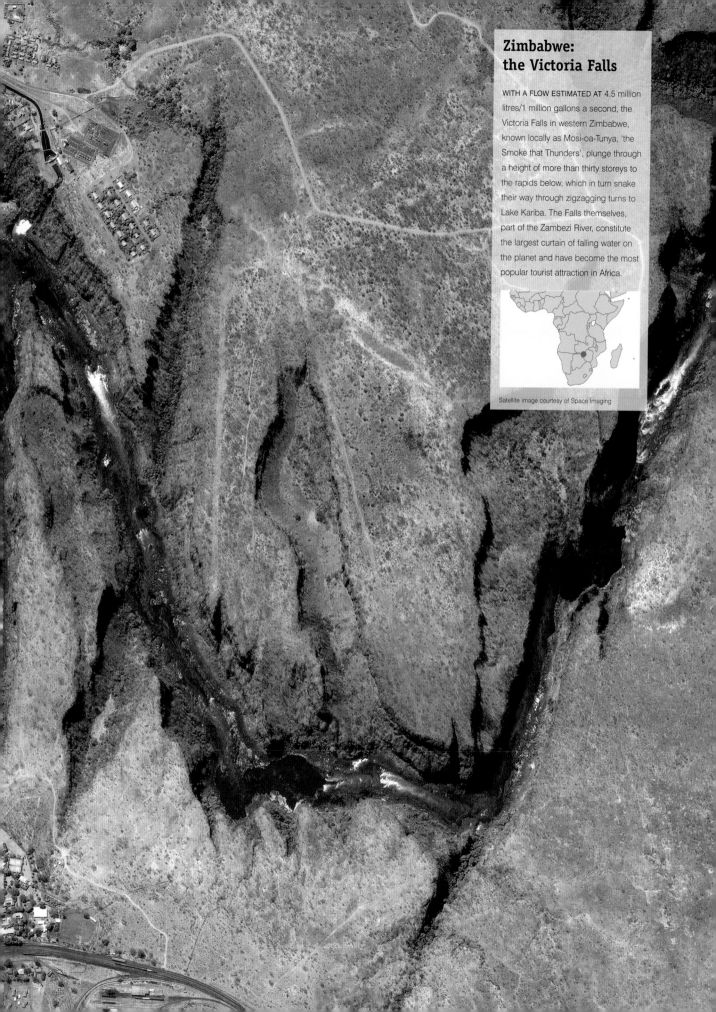

# Zimbabwe: the Victoria Falls

WITH A FLOW ESTIMATED AT 4.5 million litres/1 million gallons a second, the Victoria Falls in western Zimbabwe, known locally as Mosi-oa-Tunya, 'the Smoke that Thunders', plunge through a height of more than thirty storeys to the rapids below, which in turn snake their way through zigzagging turns to Lake Kariba. The Falls themselves, part of the Zambezi River, constitute the largest curtain of falling water on the planet and have become the most popular tourist attraction in Africa.

Satellite image courtesy of Space Imaging

# Namibia: the Ugab River

THE UGAB, WHICH RUNS from the highlands of western Namibia to the Atlantic, precisely reflects the arid conditions of Namibia. Depending on the rains, it flows above ground for only a few days a year: it is otherwise entirely subterranean. Nonetheless, this elusive waterway supports a varied and delicate ecosystem, allowing a wide variety of plants and animals to survive. The most spectacular are the black rhino and the desert elephant, which in the dry season regularly travel 70 km/43 miles between waterholes.

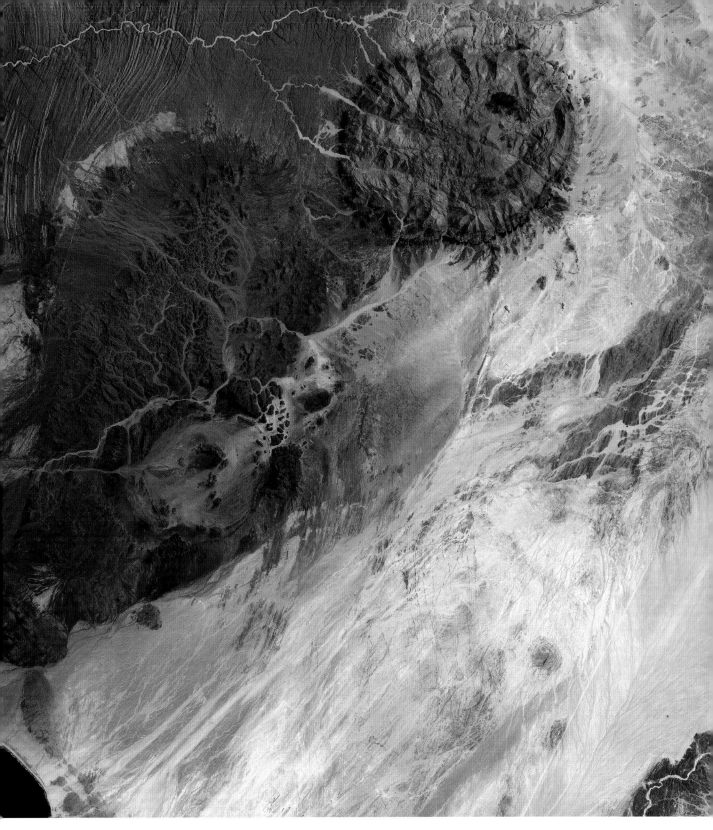

## Namibia: the Brandberg Massif

THE BRANDBERG MASSIF IS THE CIRCULAR formation in the upper right-hand corner of the
image. It is a vast lump of granite that punched through the Earth's crust 120 million years ago
and towers over the Namib Desert to the south. A ring of dark and steep-sided rocks encircles
it. To its southwest is an older and more eroded granite intrusion. To the north, running through
heavily eroded rocks, the Ugab river can be seen.

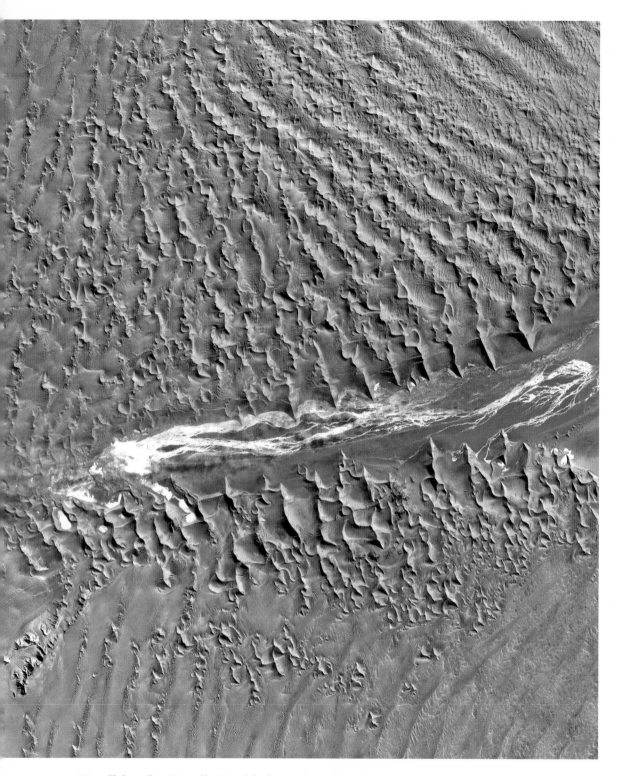

## Namibia: the Namib-Naukluft National Park

EXTENDING MORE THAN 49,000 sq km/18,900 sq miles, the Namib-Naukluft National Park is
the largest game park in Africa and the oldest desert on Earth. This is one of the world's most
extraordinary environments: arid yet teeming with life sustained by early morning fogs that roll
in off the Atlantic. In places, the sand dunes are more than 300m/1,000ft high. Their distinctive
orange colour is a sign of age. Because the iron in the sand oxidises, the richer the colour, the
older the dune. A largely dry water-course bisects the image.

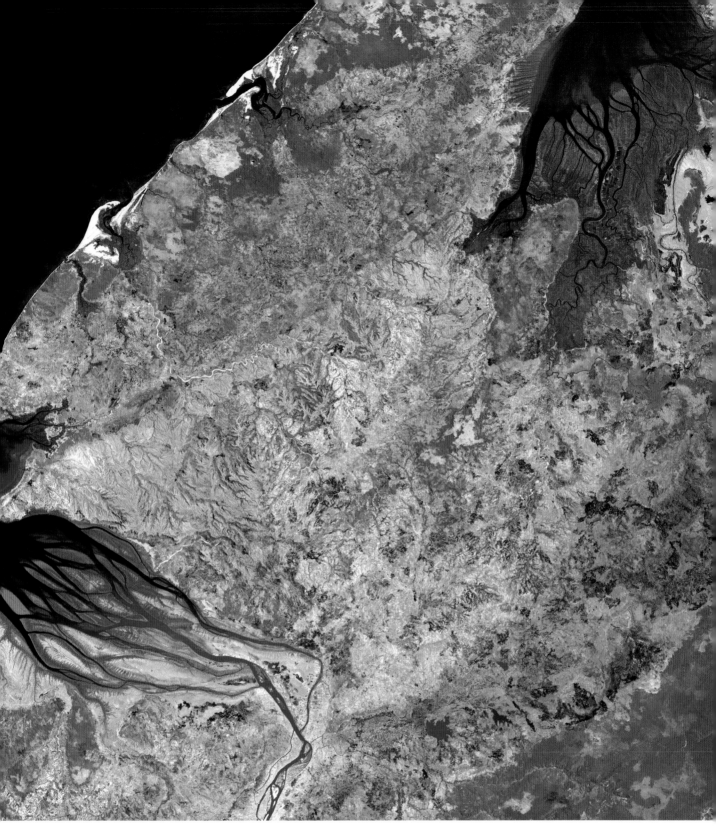

## Madagascar: the northwest coast

THE RED AREAS ON THIS false-colour image are healthy vegetation, with the mangrove swamps in and around the two river mouths (top right and lower left) particularly conspicuous. The extensive green areas are dry vegetation. The paler blue colours in both rivers are silt deposits. Satellite images of this kind are invaluable in tracking environmental change and degradation. The image shows an area of approximately 80 km/50 miles from north to south.

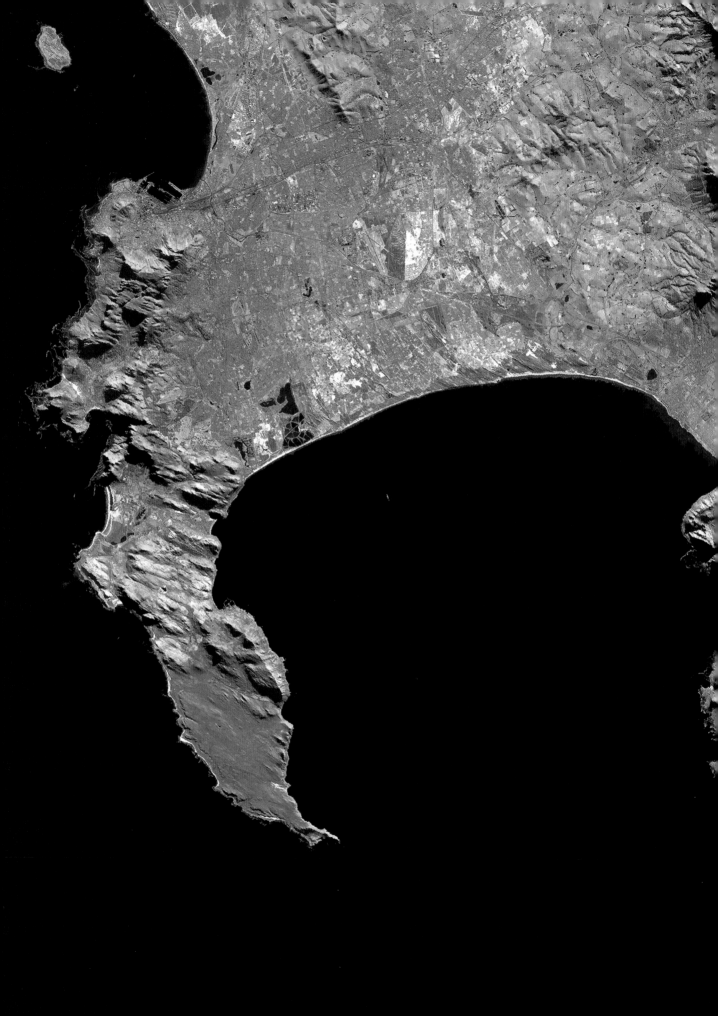

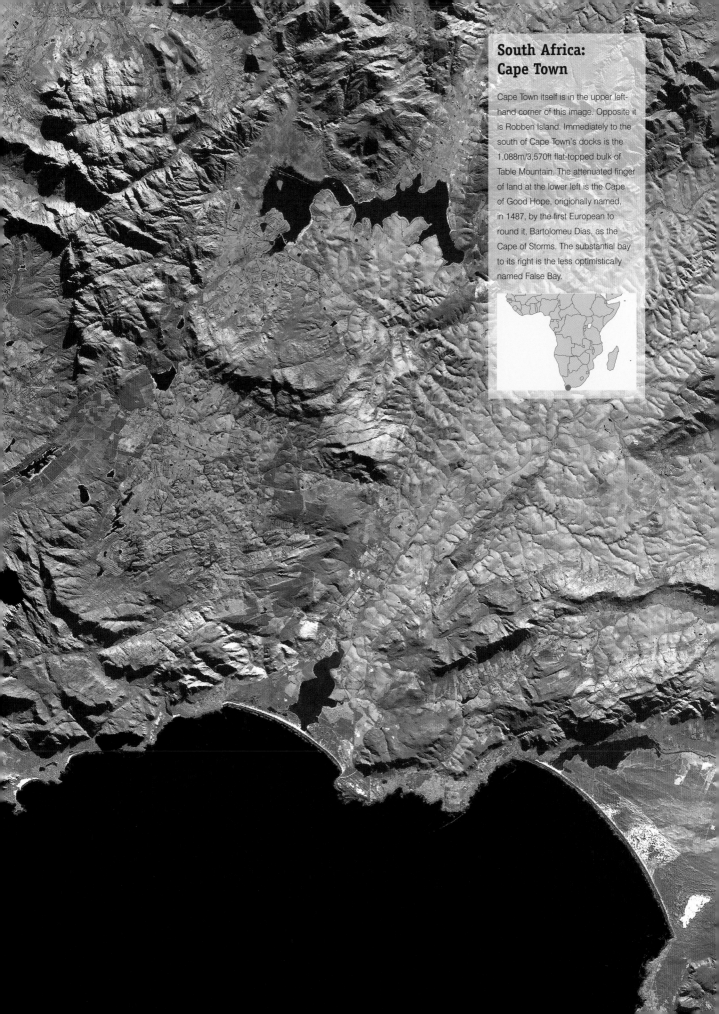

## South Africa: Cape Town

Cape Town itself is in the upper left-hand corner of this image. Opposite it is Robben Island. Immediately to the south of Cape Town's docks is the 1,088m/3,570ft flat-topped bulk of Table Mountain. The attenuated finger of land at the lower left is the Cape of Good Hope, originally named, in 1487, by the first European to round it, Bartolomeu Dias, as the Cape of Storms. The substantial bay to its right is the less optimistically named False Bay.

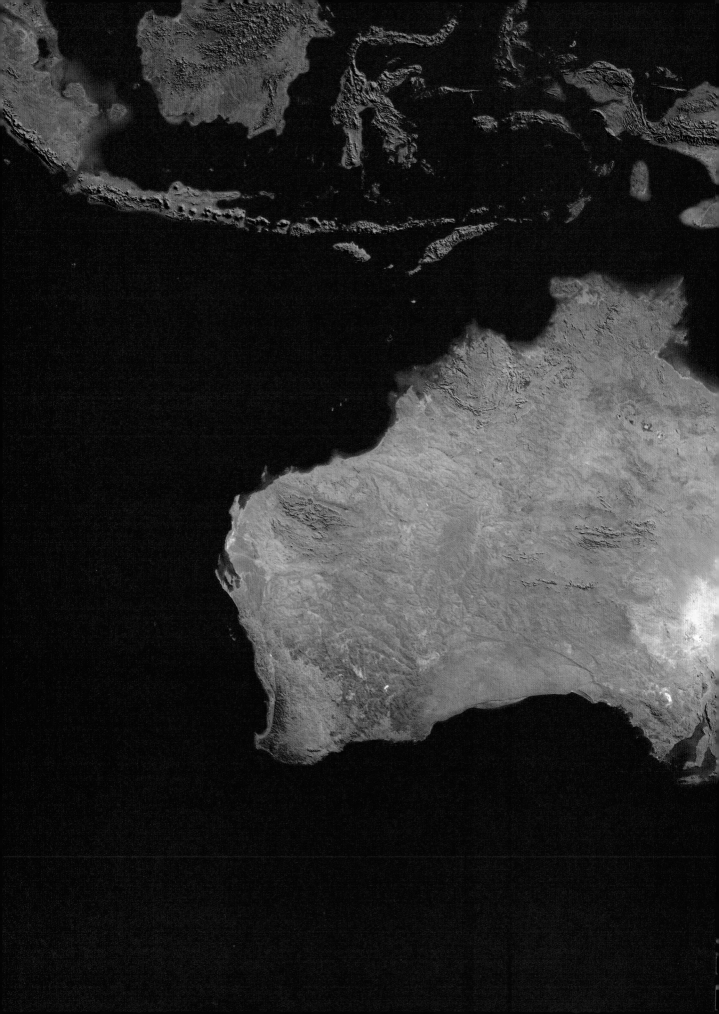

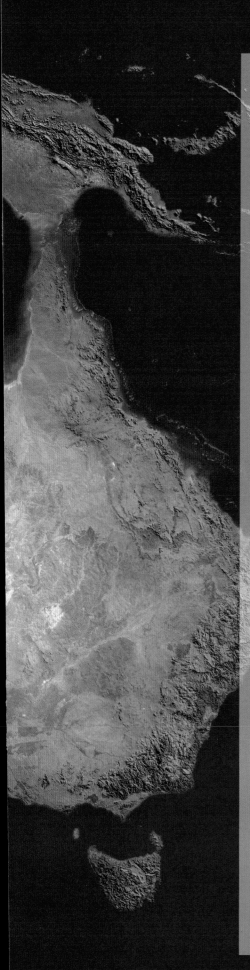

# AUSTRALIA / OCEANIA

If there has long been confusion whether Australia is the world's smallest continent or its largest island, today it is generally accepted that Australia, along with Papua New Guinea to the north, New Zealand to the southeast and the thousands of small coral atolls and volcanic islands that lie scattered across the South Pacific together comprise a single continent: Australia/Oceania. With a land area of 8.1 million sq km/3.13 million sq miles and a population of 31 million, it is still the world's smallest continent as well as its least populous. (By comparison, South America, the next least populous continent, has a population of 342 million).

Australia is by far its largest landmass. At 7.6 sq million km/2.9 million sq miles it is the sixth largest country in the world. It is also the flattest and most arid, worn smooth by 3,000 million years of erosion. Uniquely, it has no major river systems, a fact which made its exploration slow and often fatal. Much of the vast interior is not only uninhabited but uninhabitable, a trackless waste of desert stretching for thousands of miles. As a result, 70 per cent of the population live in the country's ten largest cities. Most are in the southeast and on the coast. That said, there are some variations of climate and terrain. The tropical northeast has the oldest rainforests in the world, while running almost the length of the east coast is a substantial mountain chain, the Great Dividing Range. It highest peak, Mount Kosciuszko, is 2,230m/7,316ft. The northeast coast also boasts the 2,012 km/1,250-mile long Great Barrier Reef, the world's largest coral formation.

New Zealand, 2,400 km/1,490 miles away, is strikingly different. Both the North and South Islands are rugged, the former largely volcanic, the latter actively mountainous. The great chain of mountains which runs more or less along the core of the South Island, the Southern Alps, are almost comparable in scale to Europe's Alps. There are wide variations in climate between the two islands, with the South Island, no more than 2,400 km/1,490 miles from Antarctica, significantly cooler. Both islands have extensive grazing lands: New Zealand's population of 3.8 million is outnumbered twenty to one by sheep.

The islands of the South Pacific are divided into three groups: Melanesia, which includes Fiji, Vanuatu, the Solomon Islands and New Caledonia; Micronesia, which includes the Marshall Islands, Micronesia itself, Guam, Saipan and the Northern Mariana Islands; and Polynesia, which includes French Polynesia, the Marquesas, the Cook Islands, Easter Island, Pitcairn and Tuvalu.

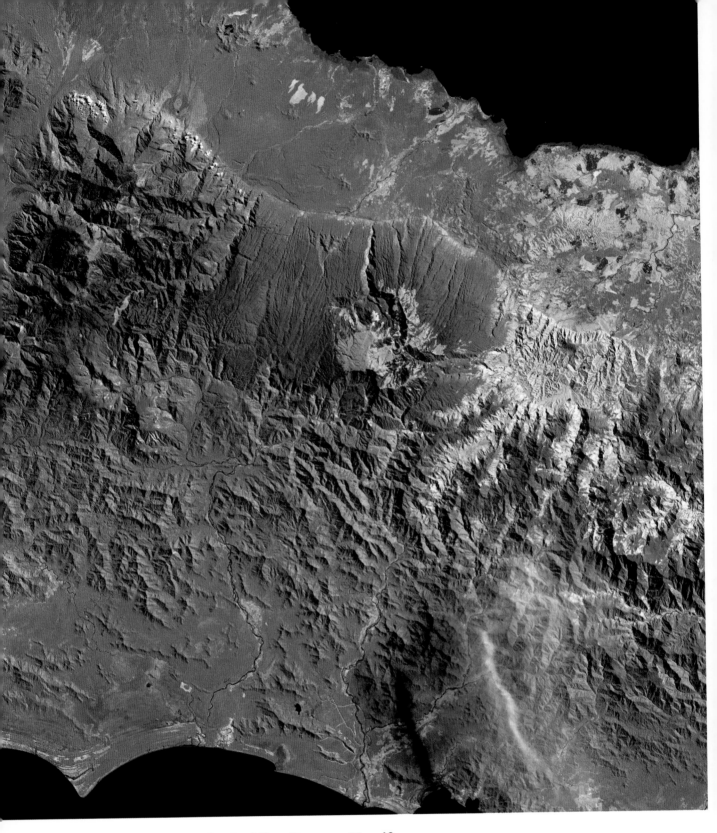

## Papua New Guinea: the Suckling-Dayman Massif

THE SUCKLING-DAYMAN MASSIF runs along the spine of southeast Papua New Guinea, its flanks dipping gently to the sea in the north, south and east. Mount Suckling, at 3,676m/12,060ft its highest point, is the prominent, fractured-looking structure towards the upper left-hand corner. The blue patches at its summit, as elsewhere on the image, are bare rock. Vegetation is in red; the bright red fringe along the north coast marks mangrove swamps.

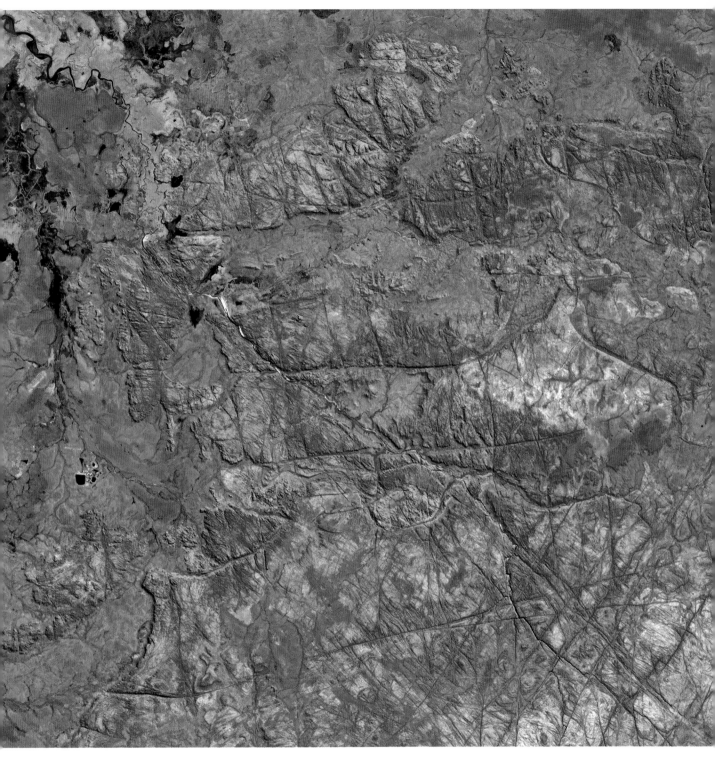

## Australia: Arnhem Land

THE STARK AND ERODED PLATEAU of Arnhem Land, its rocky surface etched by fault lines, lies at the far north of the Northern Territory. Beyond the escarpment at the left, which runs broadly north–south, is Kakadu National Park. The dark blue areas at the top of the image and at the centre left are vegetation burnt by recent bush fires. The irregular red shapes in the top left-hand corner are vegetation growing on the banks of a river. The image shows an area approximately 90 km/54 miles from north to south.

171

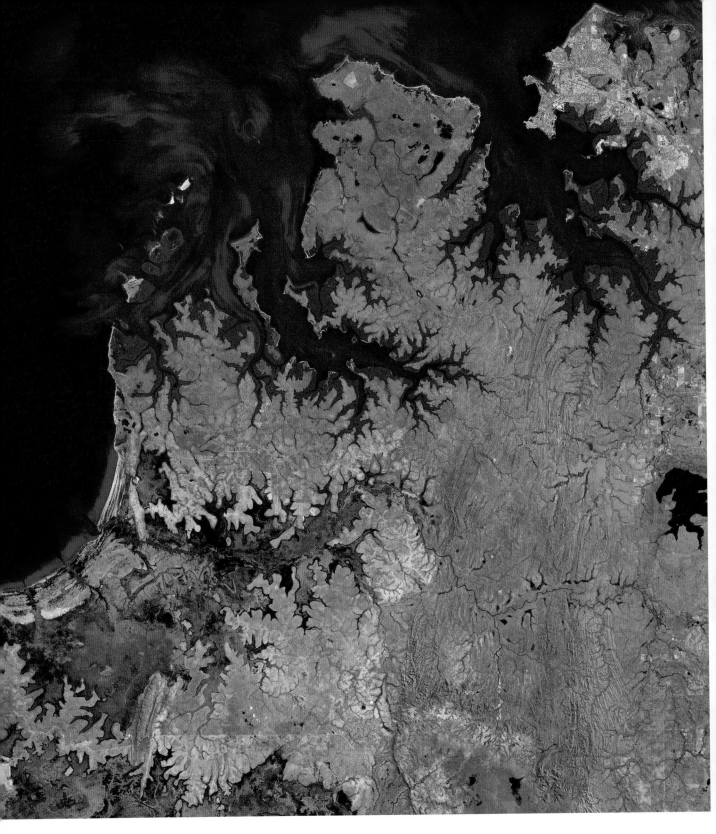

## Australia: Darwin

DARWIN, CAPITAL OF THE NORTHERN TERRITORY, is in the upper right-hand corner of the image. The city was named after Charles Darwin, in 1839, when its harbour, Port Darwin, was discovered during a further voyage of HMS *Beagle*, the ship on which Darwin had made his momentous voyage around the world some years earlier. Though this image was taken near the end of the wet season, the great masses of green are relatively dry vegetation. The vivid reds on and near the coast are mangrove swamps.

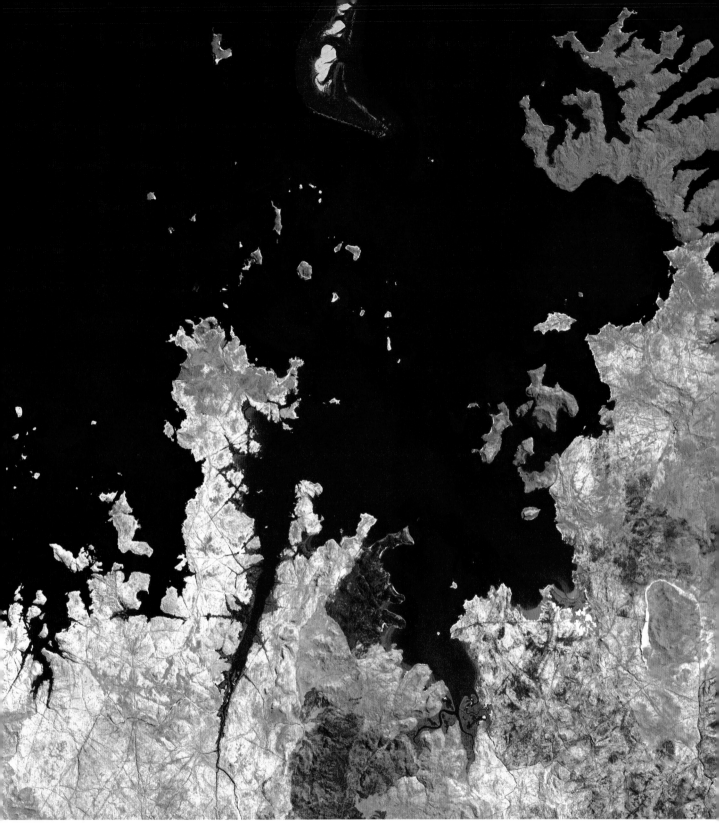

## Australia: Admiralty Gulf

ADMIRALTY GULF LIES AT THE NORTHEAST tip of the Bonaparte Archipelago, the jagged, island-studded coastline which runs for almost 480 km/300 miles along the shore of northwest Australia. The colours in this image have been enhanced to highlight different rock formations and the very sharp transitions between them, particularly those in orange and dark purple in the lower centre and bottom right-hand corner. Vegetation, most often growing in the many faults in the rocks, is shown in green.

173

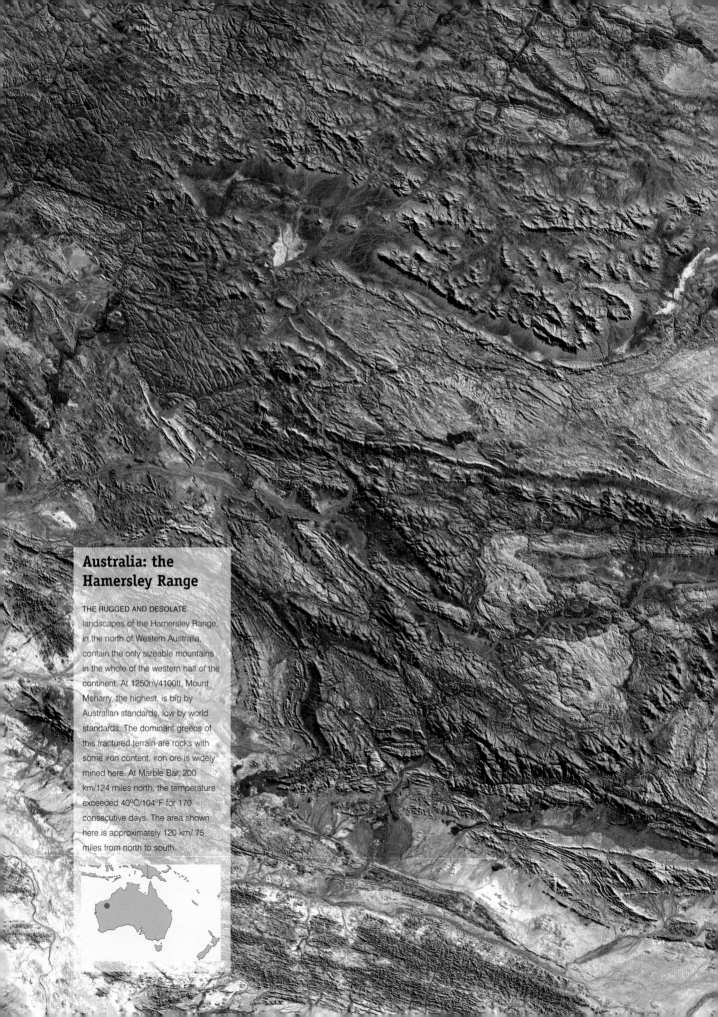

## Australia: the Hamersley Range

THE RUGGED AND DESOLATE landscapes of the Hamersley Range, in the north of Western Australia, contain the only sizeable mountains in the whole of the western half of the continent. At 1250m/4100ft, Mount Meharry, the highest, is big by Australian standards, low by world standards. The dominant greens of this fractured terrain are rocks with some iron content, iron ore is widely mined here. At Marble Bar, 200 km/124 miles north, the temperature exceeded 40ºC/104ºF for 170 consecutive days. The area shown here is approximately 120 km/ 75 miles from north to south.

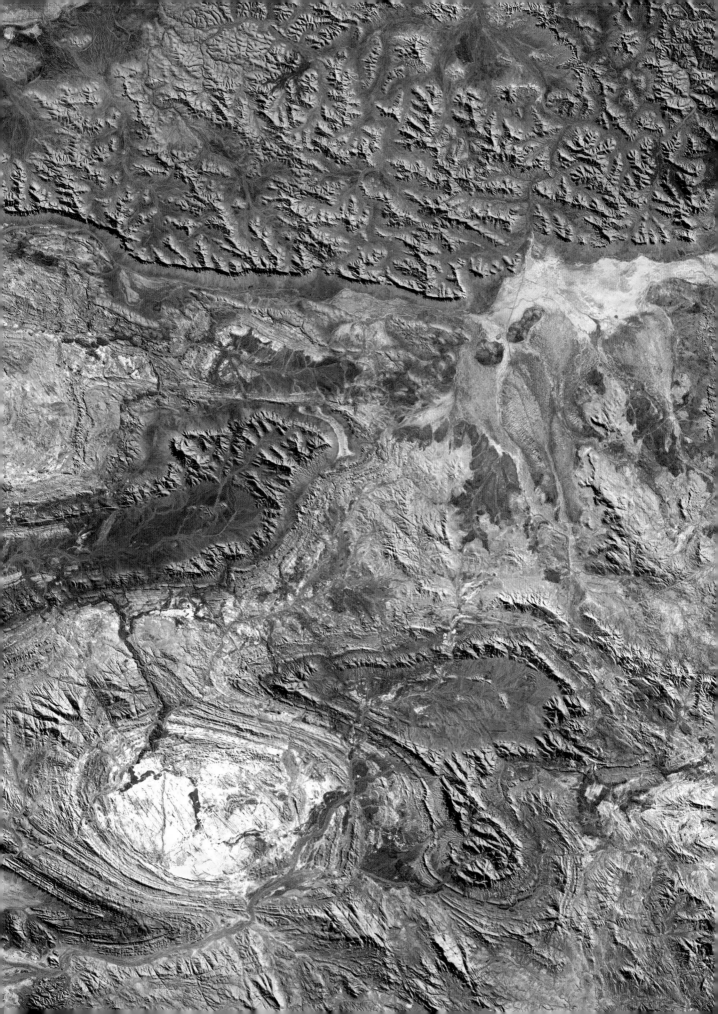

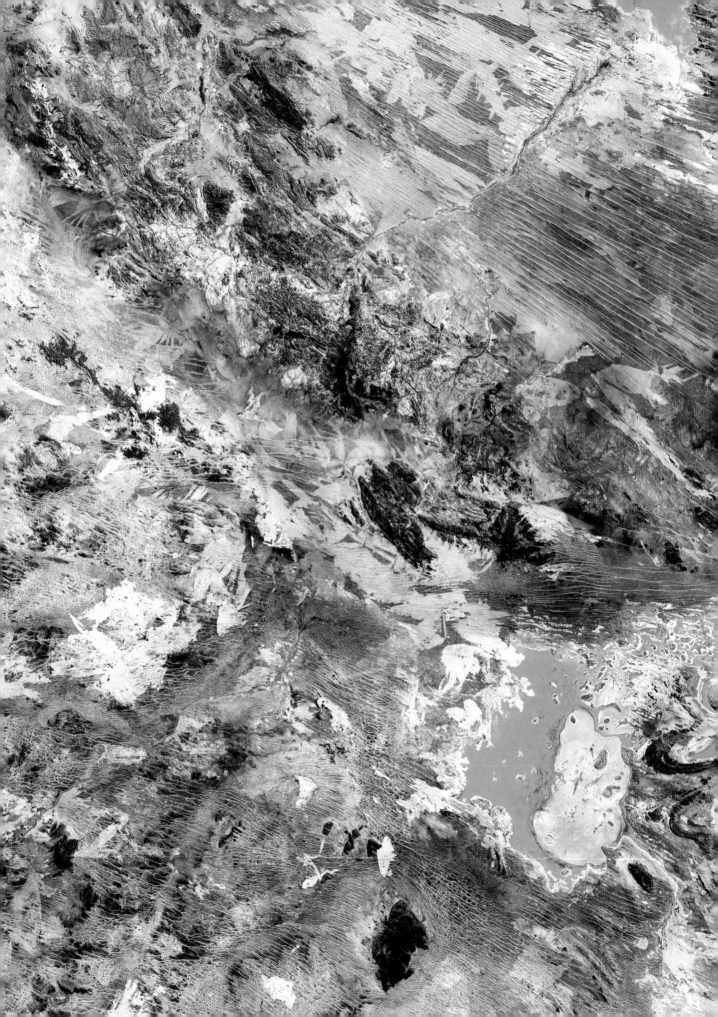

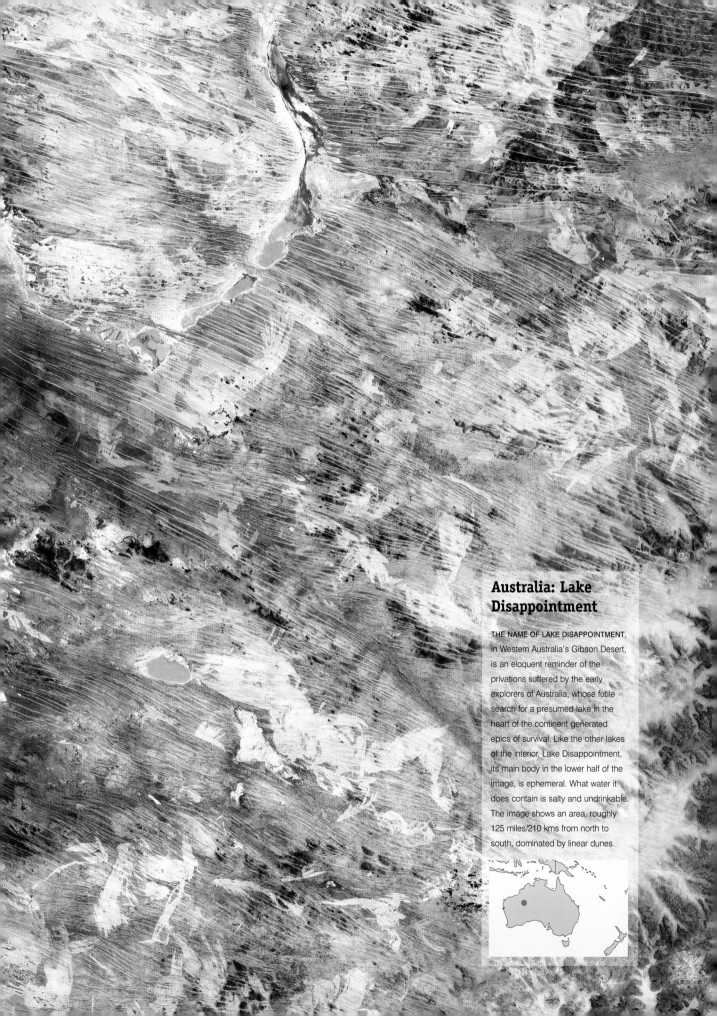

## Australia: Lake Disappointment

THE NAME OF LAKE DISAPPOINTMENT, in Western Australia's Gibson Desert, is an eloquent reminder of the privations suffered by the early explorers of Australia, whose futile search for a presumed lake in the heart of the continent generated epics of survival. Like the other lakes of the interior, Lake Disappointment, its main body in the lower half of the image, is ephemeral. What water it does contain is salty and undrinkable. The image shows an area, roughly 125 miles/210 kms from north to south, dominated by linear dunes.

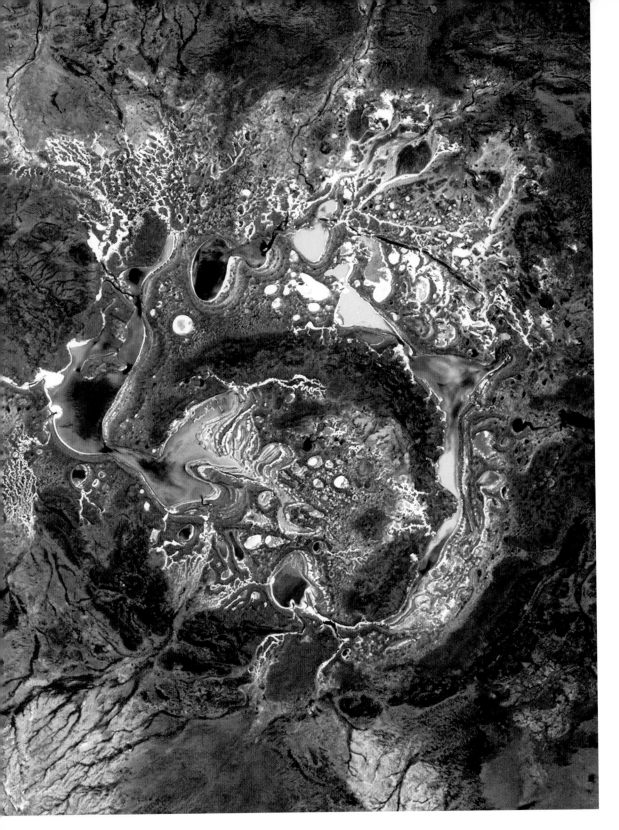

## Australia: Shoemaker Crater

THE SHOEMAKER CRATER lies in the arid heart of Western Australia. It is an impact structure, created about 1.7 billion years ago by a meteorite and is the oldest known such meteorite crater in Australia. It measures approximately 30 km/18 miles across. Its core is surrounded by a dark, crescent-shaped ring of rock. The globular-looking splashes of green and yellow are salt-encrusted seasonal lakes, rarely containing more than a few metres of water.

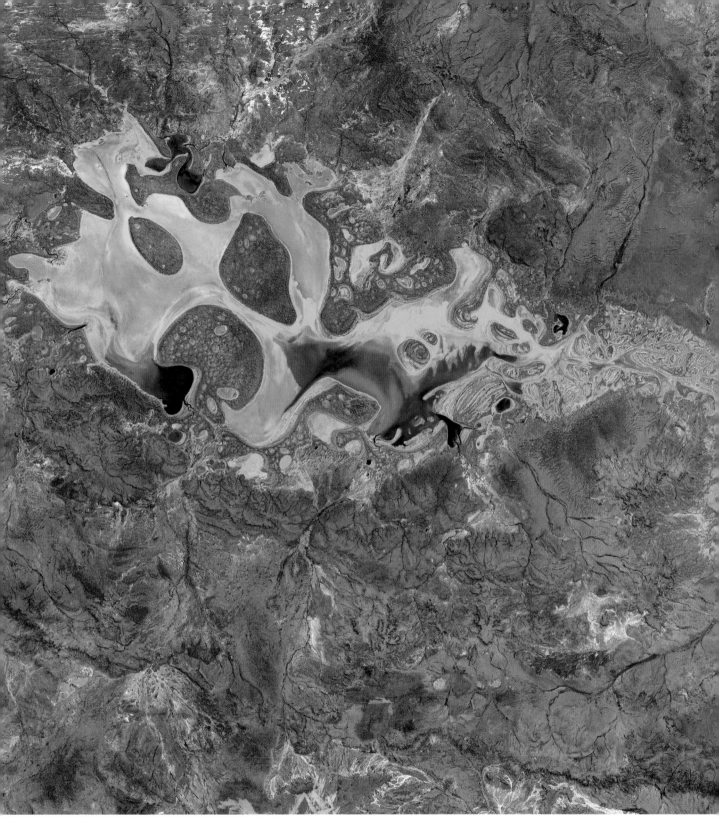

## Australia: Lake Carnegie

SOUTH OF THE GREAT SANDY DESERT and north of the Great Victoria Desert, Lake Carnegie
is one of a number of seasonal lakes that lie scattered across the empty wastes of Western
Australia. It is filled only during rare periods of significant rainfall. In many years, it consists of
little more than a muddy, island-studded marsh. The shallowest water is pale blue on this
image, deeper water as dark blue. The image shows an area approximately 100 km/
60 miles from north to south.

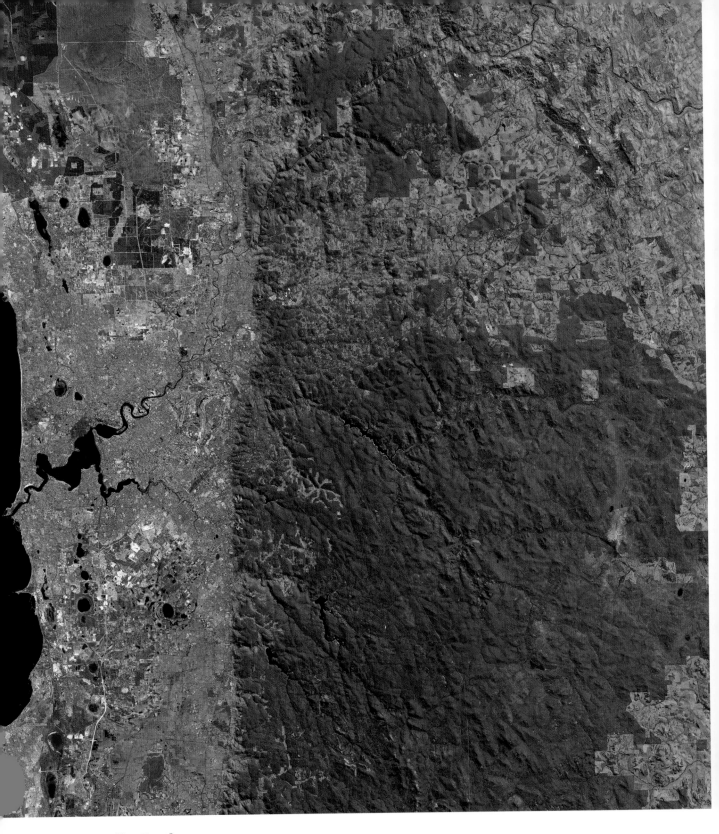

# Australia: Perth

PERTH, IN WESTERN AUSTRALIA, is the most isolated city in the world. The nearest major population centre is Adelaide, 3,220 km/2,000 miles to the east. The city and its suburbs are shown in pale grey on the left-hand side of the image. The thin dark strip on the extreme left is the Indian Ocean. The centre of Perth is on the Swan River, the more northerly of the two shown here. Inland is the steep escarpment of the Darling Range.

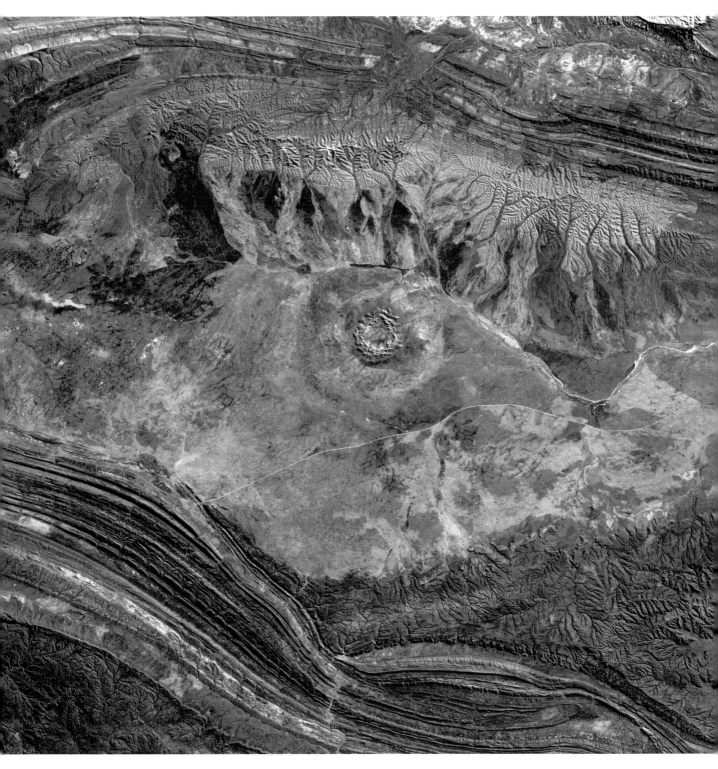

## Australia: Gosse's Bluff Crater

THE REMAINS OF A HEAVILY ERODED impact crater are in the centre right of the image. It lies
in Australia's Northern Territory south of the Macdonnell Ranges, also shown here. The total
diameter of the crater is about 18 km/12 miles, that of the more conspicuous centre crater
about 3.2 km/2 miles. It was created about 140 million years ago by a comet or asteroid
probably about 1km/0.6 miles across. The impact released about one million times more
energy than the Hiroshima atomic bomb.

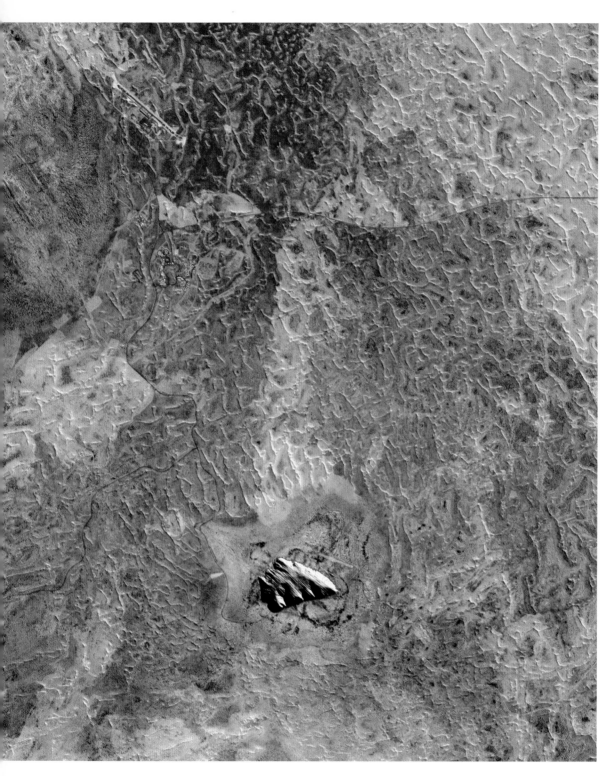

# Australia: Uluru (Ayer's Rock)

ULURU, THE ABORIGINAL NAME for what is still more generally known as Ayer's Rock, lies in the remote southwest of the Northern Territory, roughly in the centre of Australia, in the flat wastes of the Uluru-Kata Tjuta National Park. It is clearly shown in the lower centre of this image. The nearest town of any size is Alice Springs, 440 km/273 miles to the northeast. The squat silhouette of Uluru is instantly recognizable and has made it the country's best-known natural landmark.

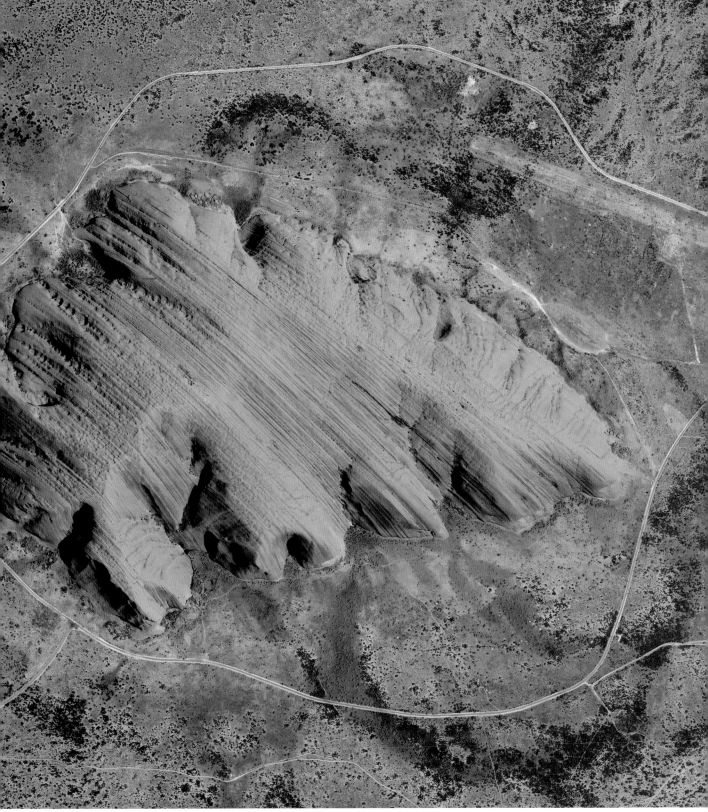

## Australia: Uluru (Ayer's Rock)

ULURU IS THE WORLD'S LARGEST MONOLITH. Approximately 3.6 km/2.25 miles long and
2km/1.25 miles wide, it rises 348m/1,140ft above the surrounding plain. Its perimeter
is 9 km/5.6 miles around. Like an iceberg, only a portion of the rock is visible: it is believed
to extend 2.5 km/1.5 miles underground. Uluru consists of mineral-rich sandstone, which at
dawn and dusk glows red, though its natural rust colour is due to oxidation. The rock has
sacred importance for the Anangu aboriginals.

183

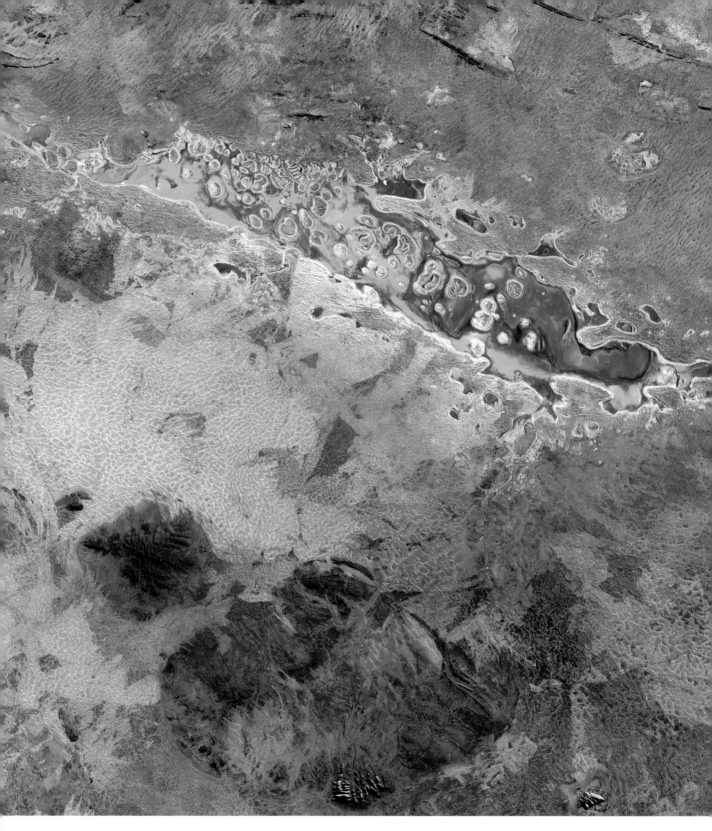

# Australia: Lake Amadeus

THE SHALLOW WATERS OF LAKE AMADEUS, the glistening, seemingly translucent blue slash in the upper half of the image, is rich in salts that have been leached out of the underlying sediments. When dry, the lake bed is transformed into a brilliant sheet of white salt crystals. The sand dunes to the north of the lake are linear, running southwest–northeast; those to the south are more complex forms, the result of topography and different sand types. At the bottom right-hand corner, Uluru (see preceding page) and the Olgas are visible.

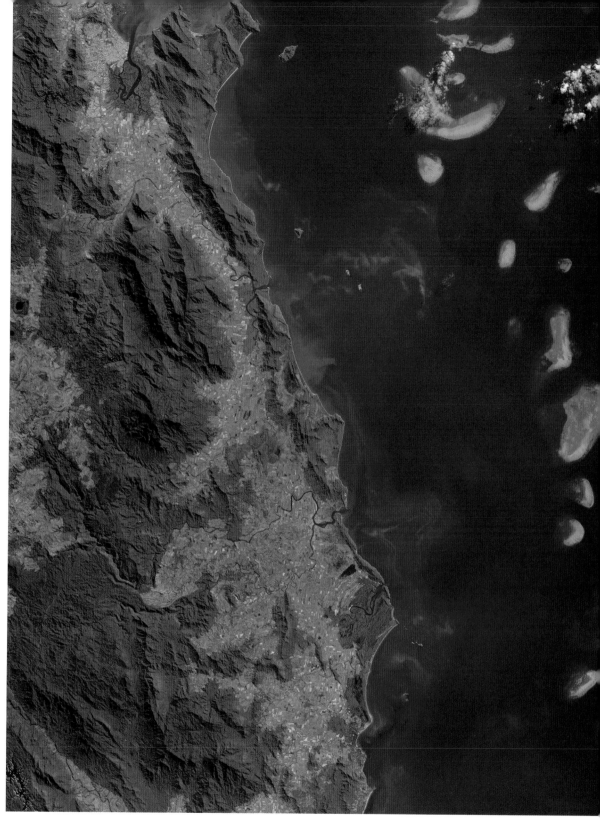

## Australia: Cairns and the Great Barrier Reef

EXTENDING MORE THAN 2,012KM/1,250 MILES along the east coast of Australia, the Great Barrier Reef is the world's most extensive coral formation and the biggest structure made by living organisms. In the north, the reef is nearly continuous and lies an average of 50 km/31 miles offshore; in the south, it is more intermittent and in places as far as 300 km/186 miles offshore. Only a small fraction of the Great Barrier Reef is shown here. The pale blue area in the top left-hand corner is the town of Cairns.

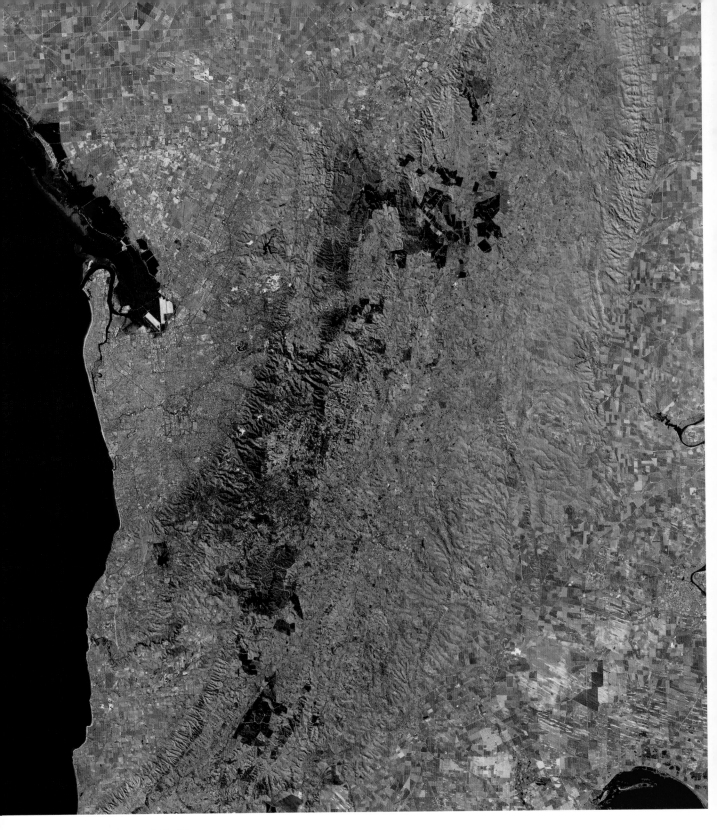

# Australia: Adelaide

EVEN AMONG AUSTRALIAN CITIES, Adelaide's setting is remarkable. It is backed to the east by the Mount Lofty Range and looks out over the Gulf of St Vincent. The city is the capital and chief port of South Australia and has a population of just over one million. With one of the most temperate climates of any of Australia's cities, the city's hinterland, especially to the north, is prime agricultural land. This image shows an area of approximately 120 km/75 miles from north to south.

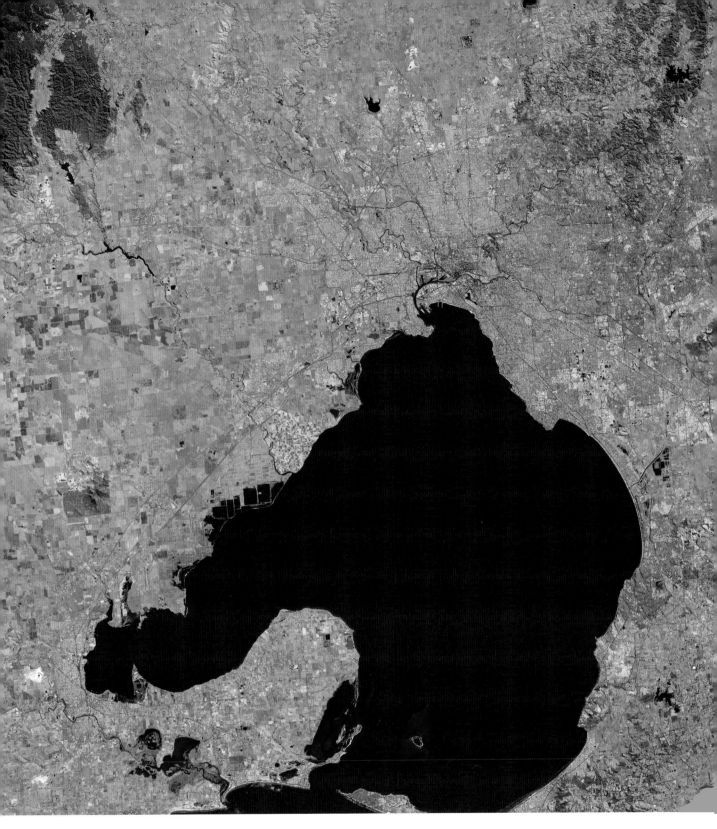

## Australia: Melbourne

MELBOURNE, SHOWN HERE IN THE CENTRE RIGHT of the image, is Australia's second city, rivalling Sydney in size and cultural sophistication. It is the capital of Victoria and a major financial and industrial centre as well as the country's largest port. Its population is 3.16 million and the greater metropolitan area covers 8,800 sq km/3,400 sq miles. It is located at the northern end of Port Philip Bay; the city centre straddles the Yarra River.

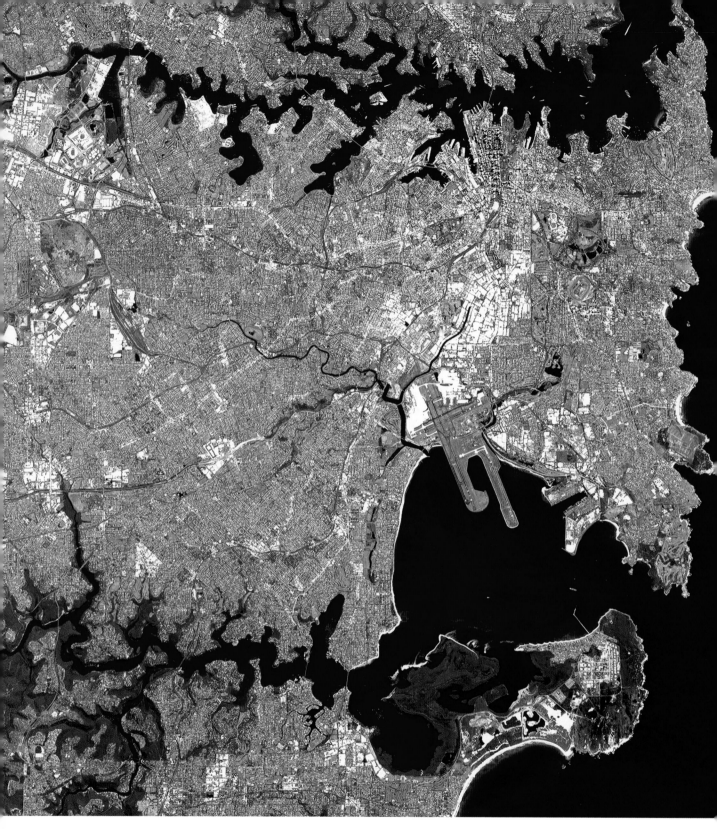

# Australia: Sydney

WITH A POPULATION OF OVER 4 MILLION, Sydney is Australia's biggest and most cosmopolitan
city. It lies around the largest natural harbour in the world, the long and irregularly shaped finger
of water in the upper half of the image. The lower harbour, Botany Bay, now the site of Sydney
airport, is where Captain Cook landed in April 1770, the first known landing by Europeans on
the east coast of Australia. To the south again, the Royal National Park is visible, one of a
series of extensive parks surrounding the city.

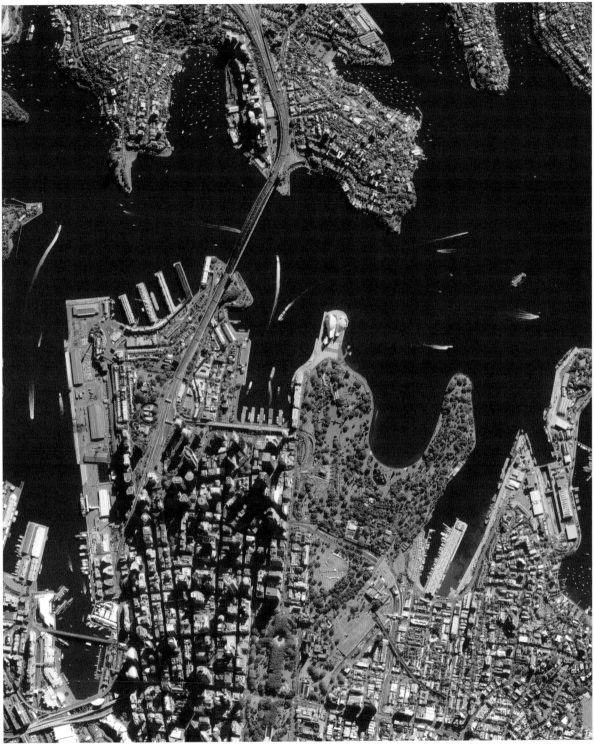

Satellite image courtesy of Space Imaging

## Australia: Central Sydney

PARKS AND WATER DOMINATE central Sydney, one of the world's most vibrant cities and certainly among its most dramatically located. In the centre of the image and projecting into the harbour is the city's most famous landmark, the Sydney Opera House, completed after years of delay and controversy in 1973. Below the Opera House stretch the Botanic Gardens. Boats skim across the harbour. To the left is the Sydney Harbour Bridge, opened in 1932.

189

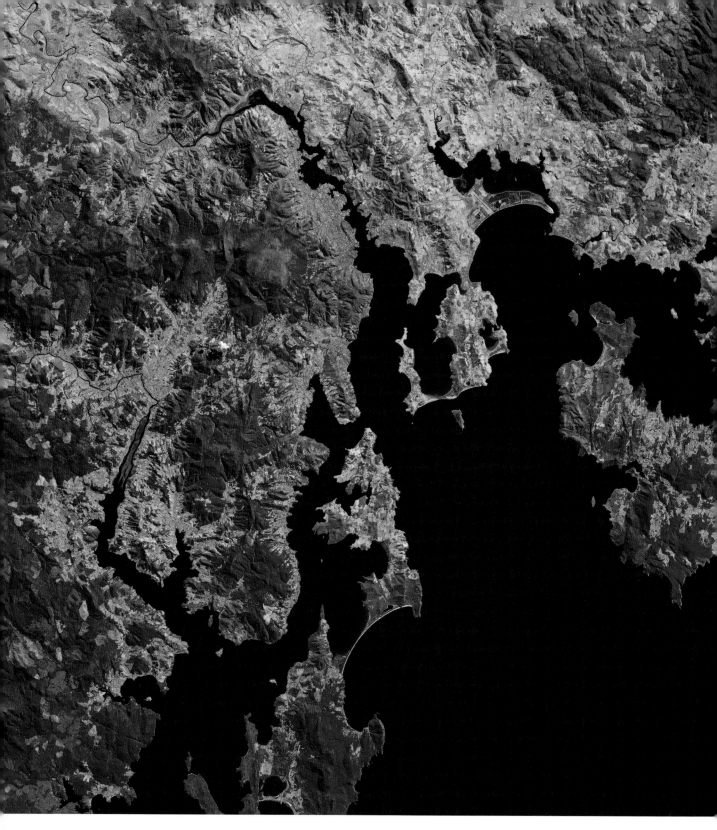

## Tasmania: Hobart

HOBART, CAPITAL OF THE ISLAND state of Tasmania, lies in the upper centre of the image along the Derwent River, itself one of many inlets and estuaries at the head of Storm Bay in the southeast of the island. Immediately to its west, its flanks here in red, its summit in green, is Mount Wellington, 1,470m/4,825ft high. Hobart's dramatic location results in a series of microclimates, which produce considerable variations within the city. The area shown is approximately 100 km/60 miles from north to south.

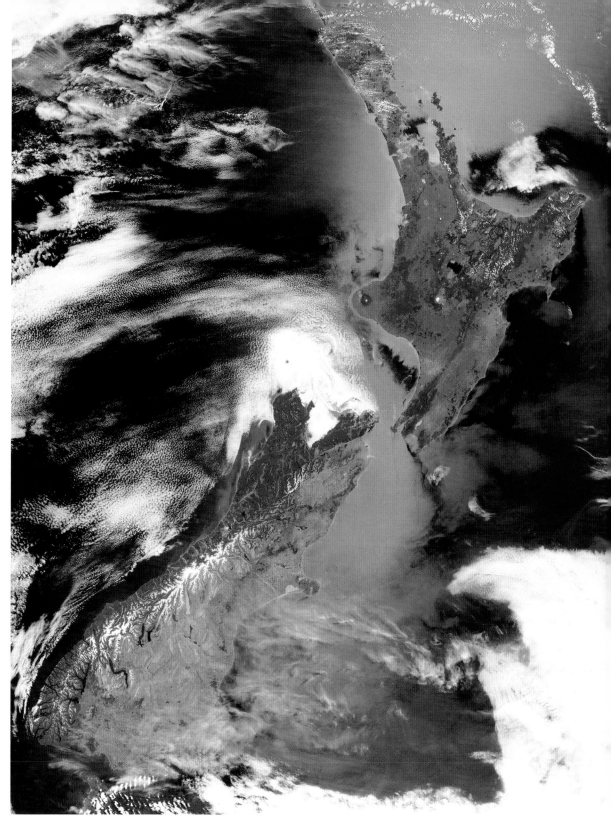

## New Zealand

THIS IS A RARE AND STUNNING true-colour view of New Zealand, captured on a nearly cloud-free day. Both the North and South Islands are shown with exceptional clarity. The snow-capped Southern Alps and their many lakes are especially well represented. New Zealand, 2,400km/ 1,490 miles southeast of Australia, enjoys the distinction of being the last major temperate landmass on Earth to have been settled, probably about AD 850, when it was first reached by Polynesians.

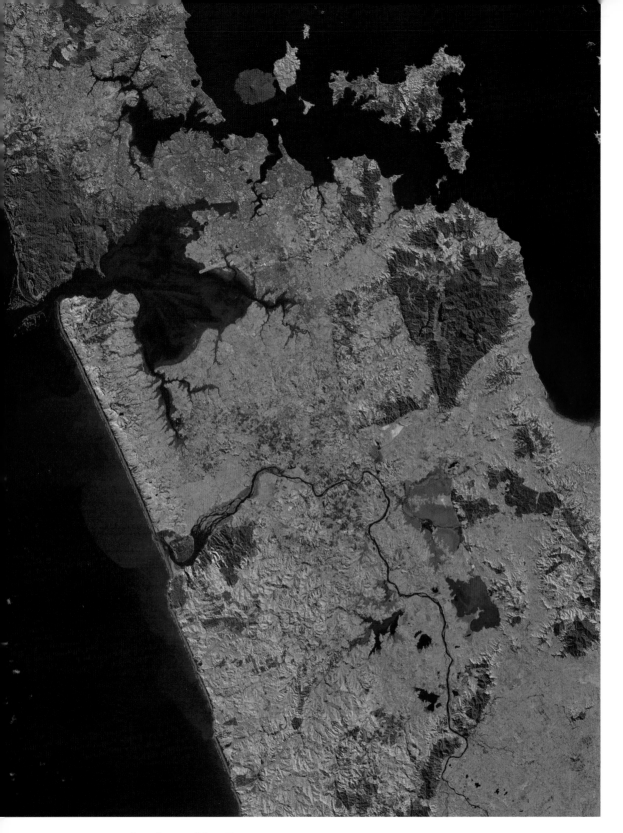

# New Zealand: Auckland

THOUGH WELLINGTON, AT THE SOUTHERN tip of North Island, is the country's capital, Auckland,
located three-quarters of the way up North Island, is by far the country's largest and most
sophisticated city. It lies on an isthmus with a substantial natural harbour giving on to Hauraki
Bay. The city is clearly visible here in blue towards the upper left-hand corner of the image. Its
population and that of its many suburbs is just under 1 million.

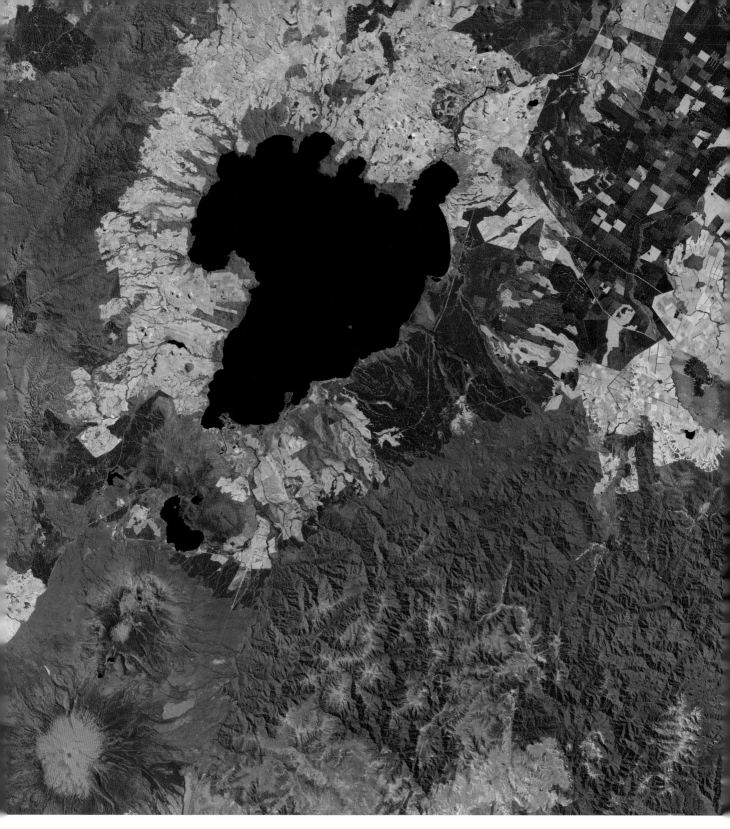

## New Zealand: Lake Taupo

THE 500M/1,900-FT DEEP LAKE TAUPO in the upper part of this image is the crater of a dormant
volcano which last erupted in AD 181, before the arrival of people to the islands. It lies in
almost the exact centre of New Zealand's North Island, part of the belt of volcanoes stretching
across it. To the south, their snow-capped peaks in bright pink, are three smaller volcanoes.
From north to south they are: Tongariro, Ngauruhoe and Ruapehu. The area of the image is
approximately 90 km/54 miles from north to south.

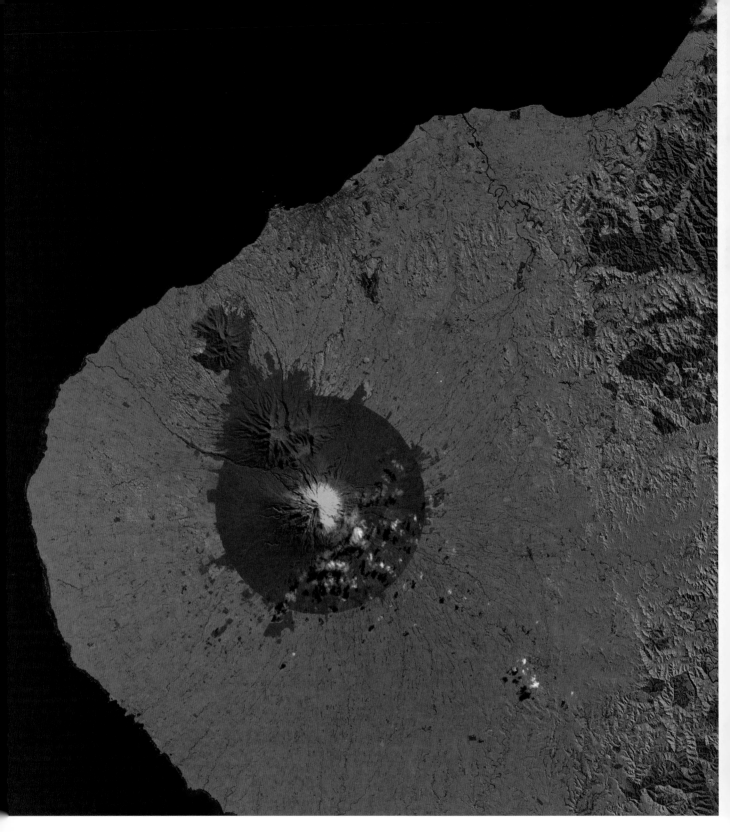

## New Zealand: Mount Taranaki

194    MOUNT TARANAKI, ITS SNOW COVERED PEAK in vivid blue in this image, is on the southwest
tip of the North Island. It is an extinct volcano and since 1881 along with two neighbouring
volcanoes to its north, Kaitake and Pouakai, both clearly visible, has been a national park,
whose limits extend 9.6 km/6 miles from the summit, hence its curiously precise circular
shape. Below the treeline, all of it is densely forested. The volcano is 2,518m/8,259ft high.

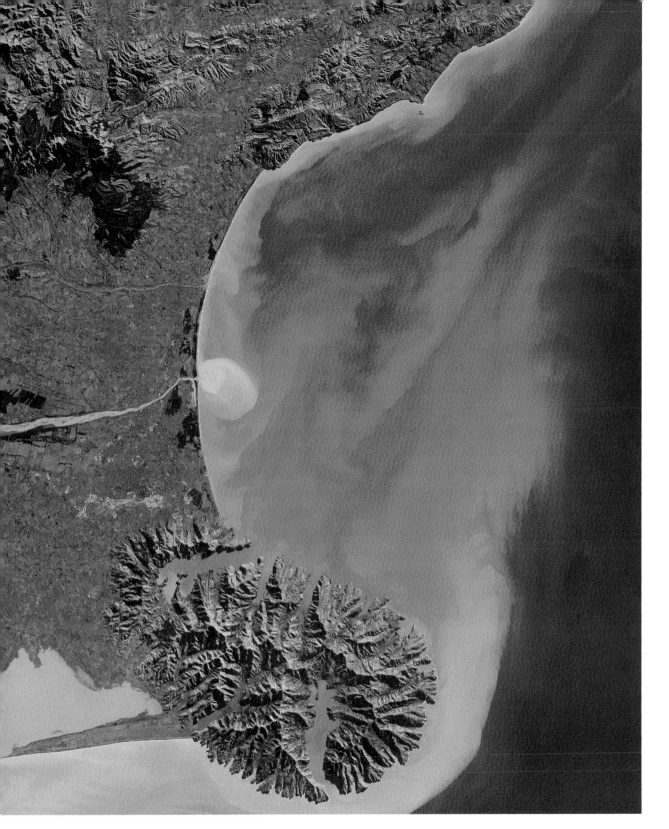

## New Zealand: Christchurch

**LOCATED ON THE EAST COAST** of New Zealand's South Island, Christchurch was established by English settlers in 1850. Today, it is the second largest city in New Zealand. It lies slightly north of the dominant feature on this image, the two dramatically eroded volcanos that jut into the Pacific creating a series of natural harbours. The largest harbour, just south of Christchurch, is Lyttleton, the city's port. To the northwest, the foothills of the Southern Alps, the largest mountains in Australasia, are visible, with sediment from their erosion being transported into the ocean.

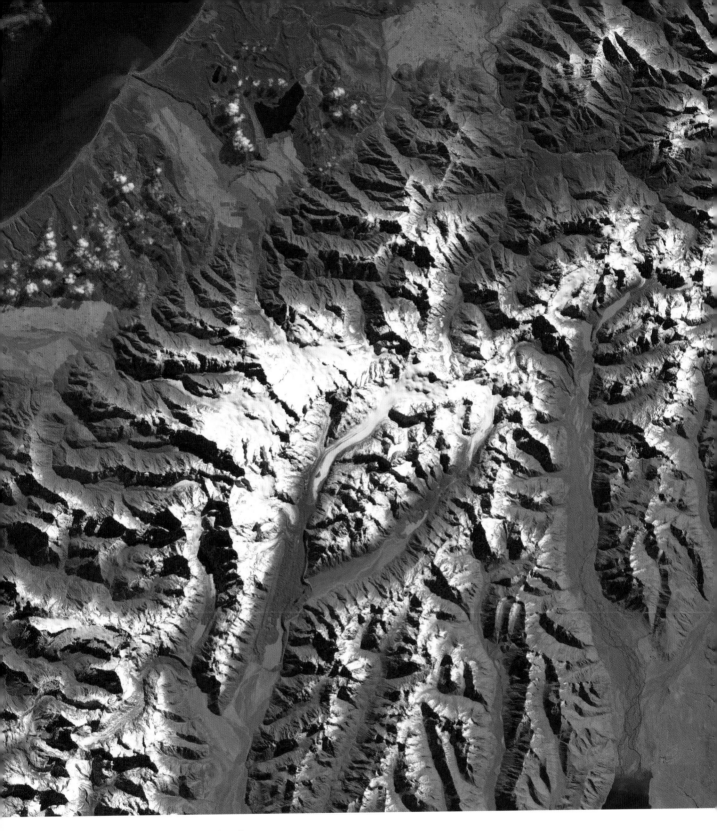

# New Zealand: Mount Cook

196    AT 3,753M/12,313FT, MOUNT COOK, in the centre of this image, is the highest mountain in New Zealand. It lies halfway along the Southern Alps of the South Island. Today, it is part of the Aoraki Mount Cook National Park, which contains more than 140 peaks higher than 2,000m/6,500ft and seventy-two glaciers. The mountains form a natural barrier between east and west, hence the lushness of the western rim, with high rainfall from the prevailing westerly winds, and relative aridity in the areas to the east.

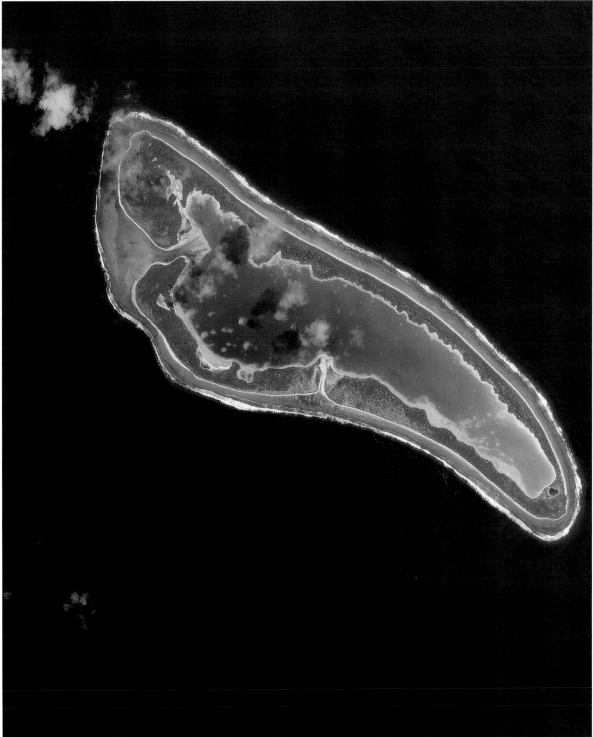

Satellite image courtesy of Space Imaging

## Kiribati: Nikumaroro Island

NIKUMARORO ISLAND IS AN UNINHABITED, low-lying coral atoll built on a submerged volcanic chain and surrounded by reefs. It lies in the Phoenix Group, which today is part of the Republic of Kiribati in the southwest Pacific. The island, once known as Gardner Island, is little more than 1.6km/1 mile long. It has been suggested that it was here that the American aviator Amelia Earhart was forced to ditch during her 1937 attempt to fly around the world. At the time, her disappearance galvanized the world's press.

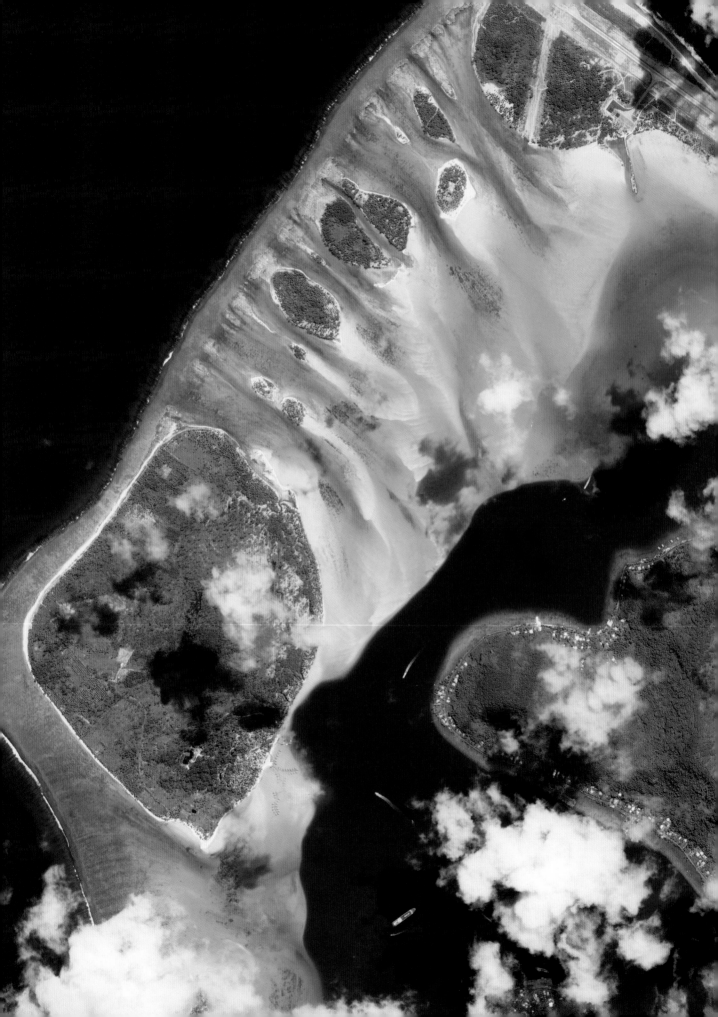

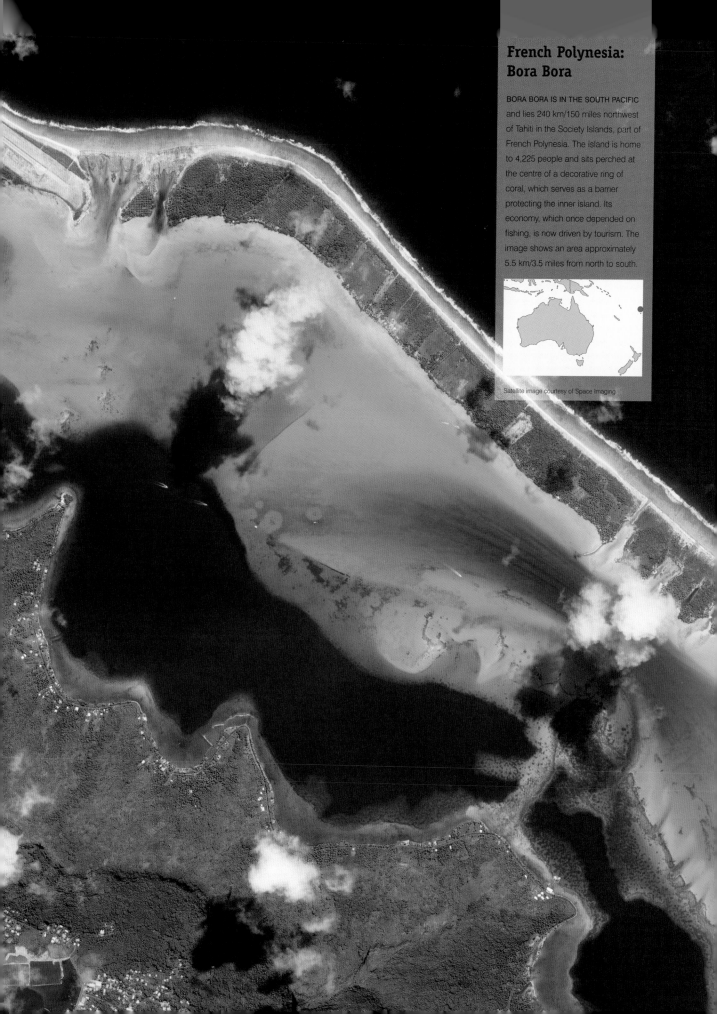

# NORTH AMERICA

Together, Greenland, Canada, the United States and Mexico cover an area of more than 24 million sq km/9.2 million sq miles. Canada and the United States are respectively the second and fourth largest countries in the world. There the similarities between them end. Where Canada, very slightly larger than the USA, has a total population of 30.5 million, the USA has a population of 281 million. Not surprisingly, population density in Canada is among the lowest in the world, at slightly less than eight people per square mile. In fact, with the overwhelming majority of Canadians living in the south of the country, the majority of the country is effectively unpopulated. Most of the north is a vast, empty Arctic wasteland. Greenland, the largest island in the world (Australia aside), presents an even more extreme case. 80% is uninhabited ice cap, leaving it with a population density of substantially less than one person per square mile, easily the lowest in the world.

Yet with 50 per cent of the population of the United States living in cities of more than one million people, it, too, has huge areas that are sparsely populated. The neighbouring states of Montana, Wyoming and North and South Dakota are the size of France, Germany, the Low Countries and Switzerland combined yet their total population is a quarter that of Paris. By contrast the combined greater metropolitan area of New York and Philadelphia has a population of more than 30 million.

The United States has a huge range of landscapes and climates, from Arctic to sub-tropical. In general, the east is wetter and more fertile, the west drier and more arid. The deserts of Nevada, Arizona and California, for example, average less than 12.5cm/5in of rain a year. The heavily wooded Pacific northwest is the exception to this rule, with substantially higher rainfall than any other part of the country.

The most obvious geographical features are two mountain ranges, the Appalachians in the east and the much younger and hence less eroded Rockies in the west, which continue north almost as far as Alaska. Between them are the Great Plains, vast areas of largely flat grasslands extending across the heart of the country.

The longest river is the Mississippi, at 5,971 km/3,731 miles, the fourth longest in the world, the heart of a complex system of waterways that runs broadly north–south almost from the Great Lakes to the Gulf of Mexico. The highest mountain is Mount McKinley in Alaska, 6,194m/20,322ft high. The lowest point of the country is Death Valley, in California, 86m/282 ft below sea level and also the hottest place on the continent.

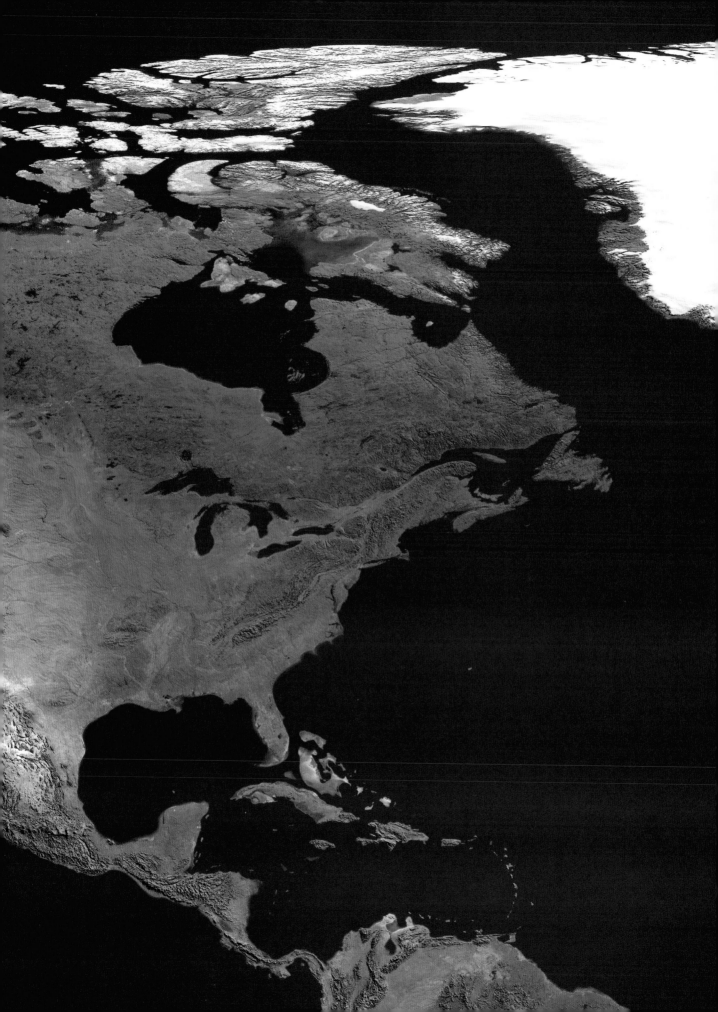

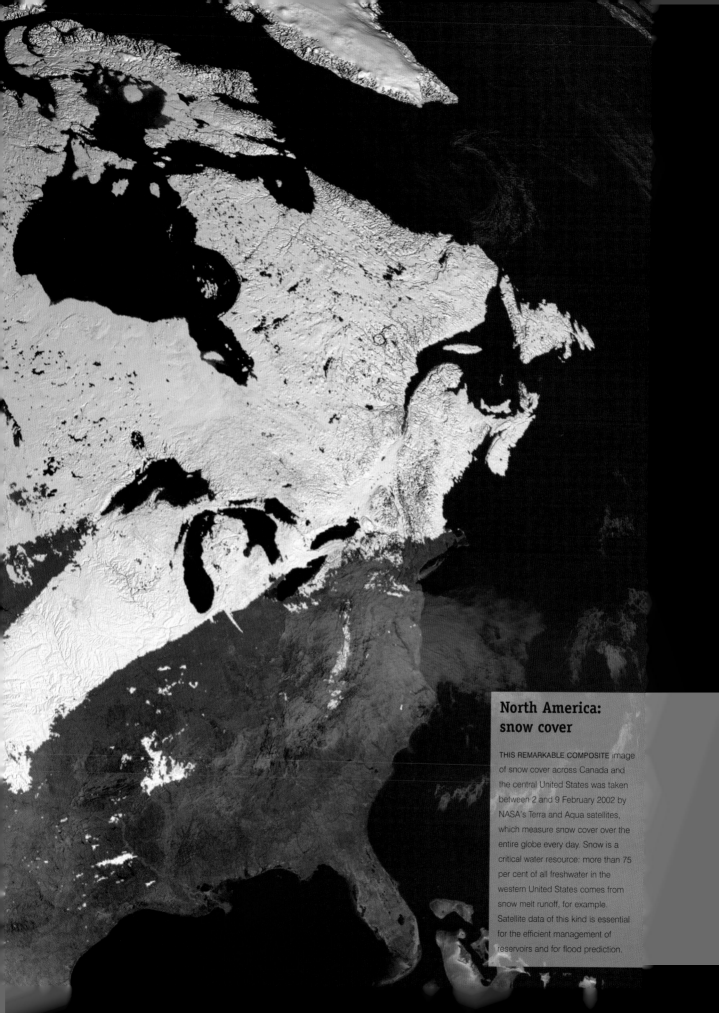

# North America: snow cover

THIS REMARKABLE COMPOSITE image of snow cover across Canada and the central United States was taken between 2 and 9 February 2002 by NASA's Terra and Aqua satellites, which measure snow cover over the entire globe every day. Snow is a critical water resource: more than 75 per cent of all freshwater in the western United States comes from snow melt runoff, for example. Satellite data of this kind is essential for the efficient management of reservoirs and for flood prediction.

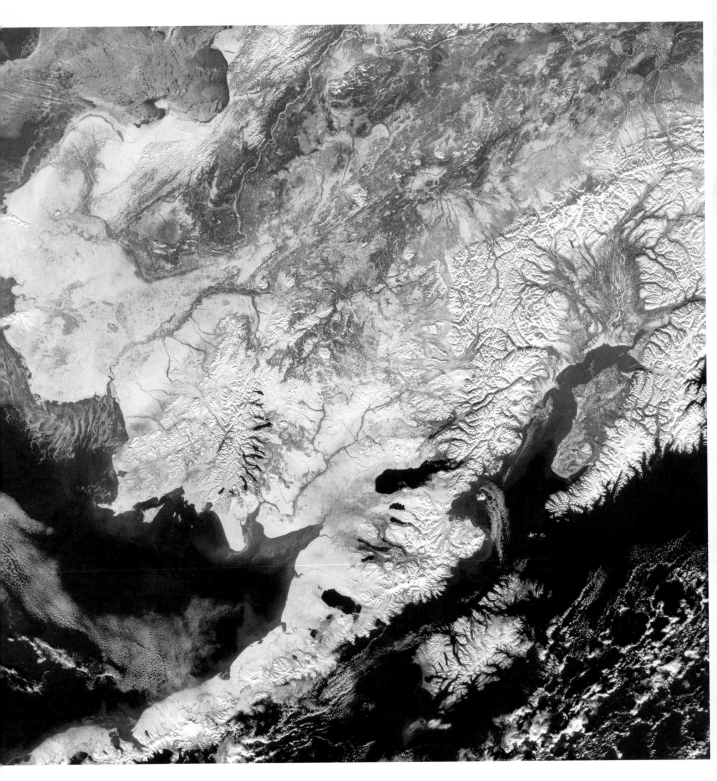

# United States: Alaska

THIS RARE CLOUD-FREE VIEW of Alaska was taken in early November 2001 and clearly shows the onset of winter over the immense, largely empty region. In the lower left, the Alaska Peninsula stretches into the Pacific. The most unusual feature is at the upper right. In a delicate blue, against the rugged white backdrop of the Alaska Range, Mount McKinley, at 6,194m/ 20,322ft the highest mountain in North America, casts its massive shadow in the fading daylight.

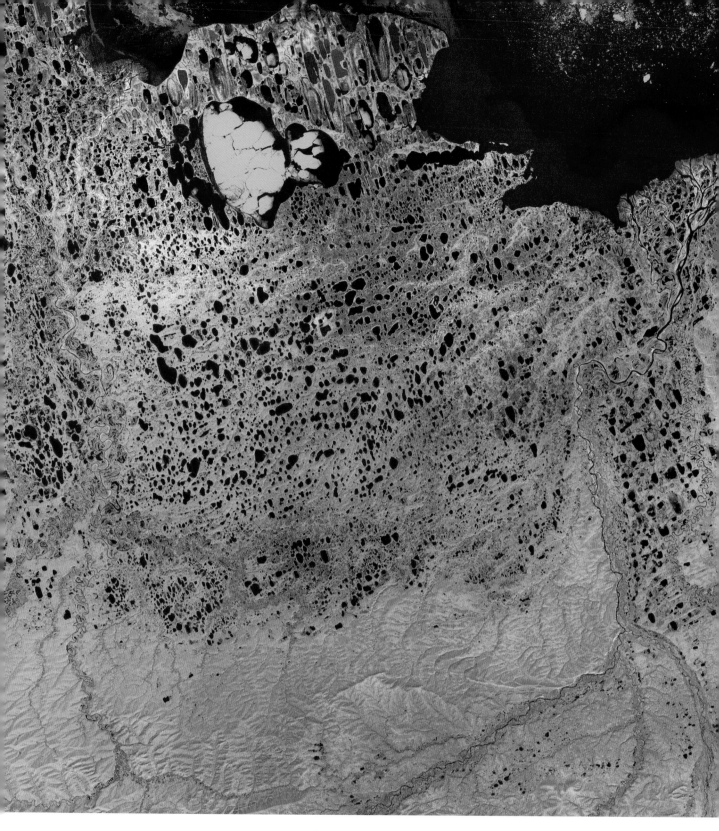

## United States: Alaska and the Beaufort Sea coast

THE AREA SHOWN ON THIS IMAGE of Alaska's north coast, which faces the Beaufort Sea, part of the Arctic Ocean, is substantial, approximately 200 km/120 miles from north to south. The image was taken in the region's brief summer. The iceberg-studded Beaufort Sea is visible at the top. The pink areas below it, interlaced with hundreds of small lakes, are marshy tundra. The green band at the bottom is sparse and hardy vegetation.

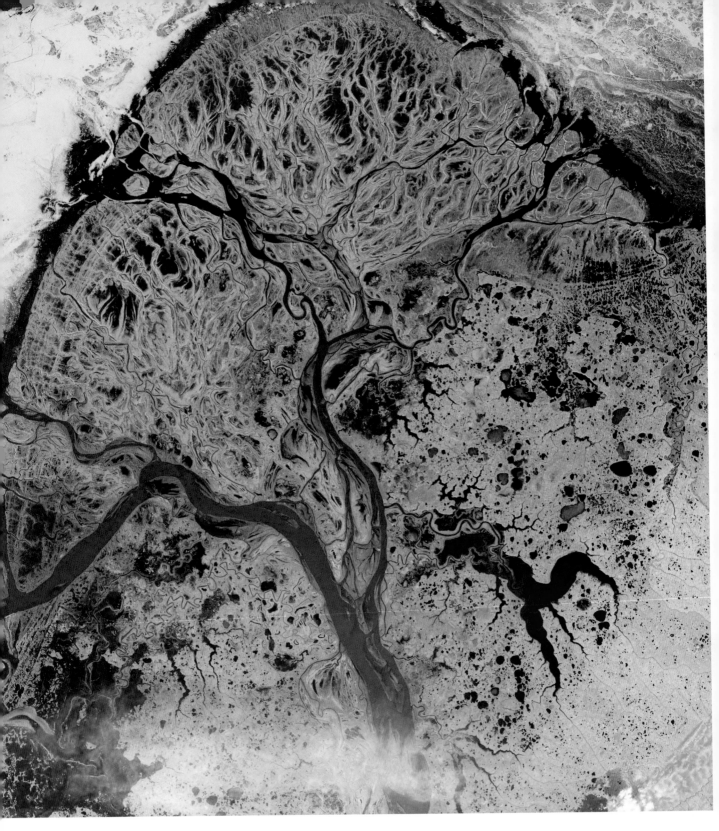

# United States: the Yukon Delta, Alaska

ALASKA'S YUKON RIVER RISES HIGH in the Mackenzie Mountains, a northern extension of the
Rockies and flows north and west 3,185 km/1,980 miles to the frigid Bering Sea. Its delta is
huge – the image shows an area approximately 100 km/60 miles from north to south – and
is defined by an intricate maze of small lakes and waterways. Despite the hostility of the terrain,
wildlife abounds. The white areas at the top of the image are sheet ice.

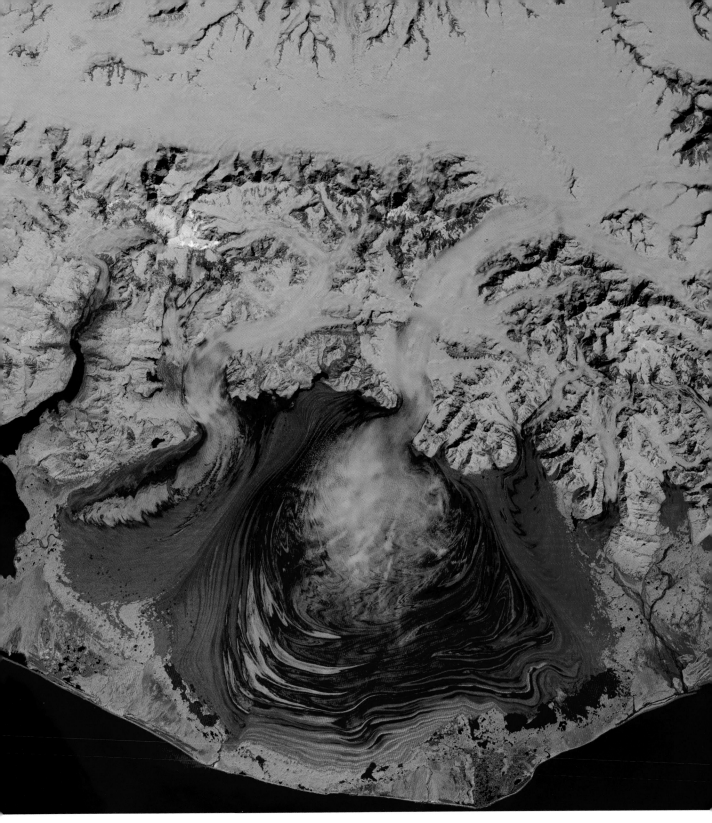

## United States: the Malaspina Glacier, Alaska

MALASPINA GLACIER IS THE LARGEST GLACIER in Alaska. It consists in fact of two glaciers, Agassiz glacier to the left and Seward Glacier to the right. The latter is a classic example of a 'piedmont' glacier, in which the ice is squeezed through a narrow mountain valley on to a broad plain below, where, no longer confined, it spreads itself into a wide lobe-like form. Seward Glacier is 65 km/40 miles wide and 45 km/28 miles long, extending almost to the sea.

209

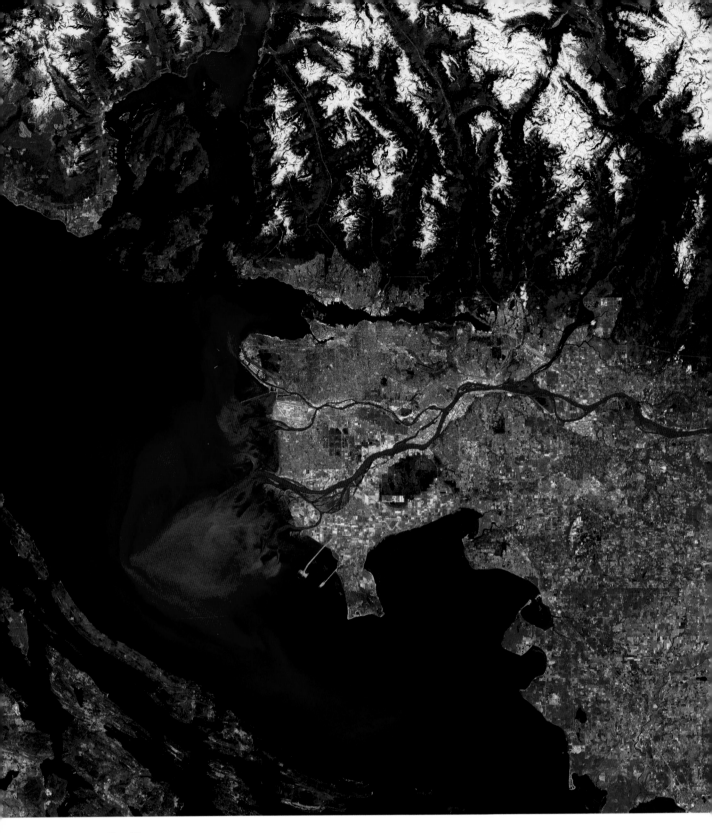

# Canada: Vancouver

VANCOUVER, IN BRITISH COLUMBIA, is the only city of note on Canada's west coast.
It has a population of just under half a million. It lies almost exactly in the centre of this image
on the Fraser River, which splinters into a series of channels before flowing into the Strait of
Georgia. Vancouver's Pacific location makes it the most temperate Canadian city; its natural
harbour is ice-free year-round. North of the city are peaks of the Coast Range; opposite, the
numerous islands lying off Vancouver Island.

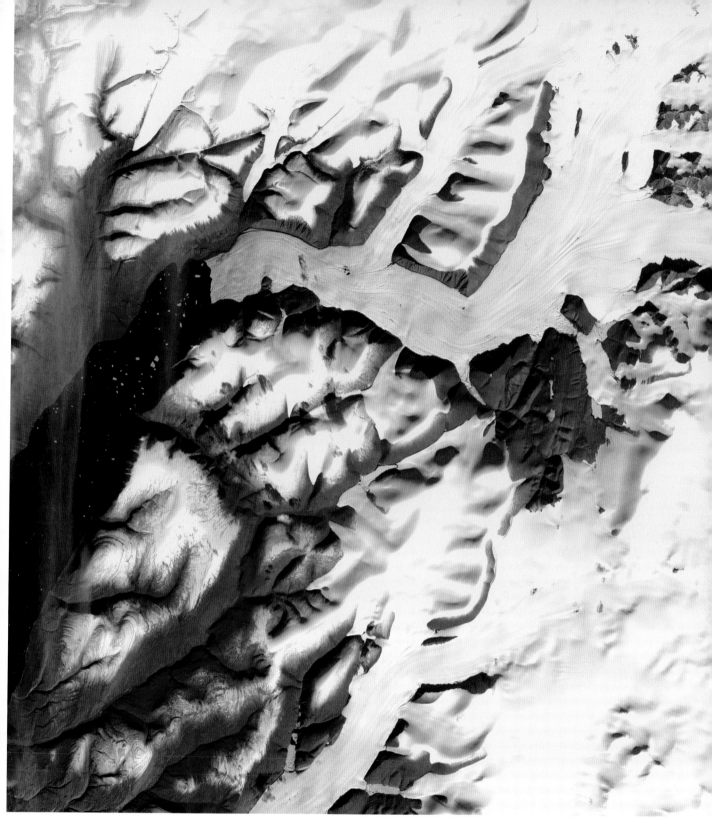

## Canada: Ellesmere Island

THE NORTHEAST TIP OF ELLESMERE ISLAND is the most northerly point in Canada, located deep within the Arctic Circle. It is a land dominated by ice and rock, a polar desert with almost no rainfall. Sparse vegetation and low temperatures allow only small populations of the hardiest animals to survive. The image covers an area approximately 50 km/30 miles from north to south and clearly shows two of the many glaciers that flow into the sea, where they break apart to form icebergs.

211

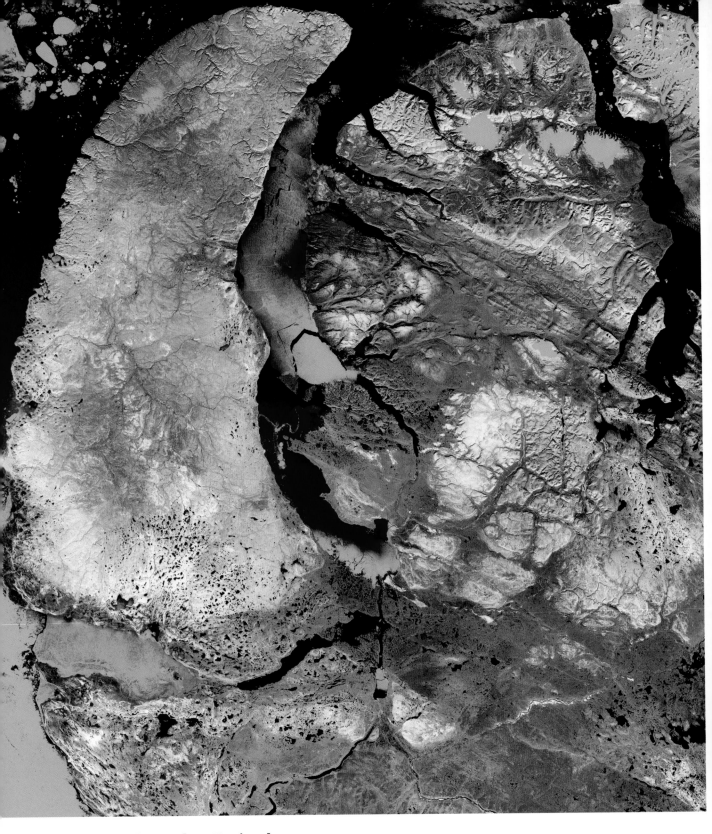

# Canada: the Brodeur Peninsula

BRODEUR PENINSULA IS THE GREAT claw-like shape on the left-hand side of this image. It lies at the northwest tip of Baffin Island, to which it is joined at its very south by a narrow land bridge, shown here with ice in the surrounding waters even in summer. To its north is Lancaster Sound, the eastern end of the ice-clogged Northwest Passage. The area shown here is huge and extends for approximately 390 km/245 miles from north to south.

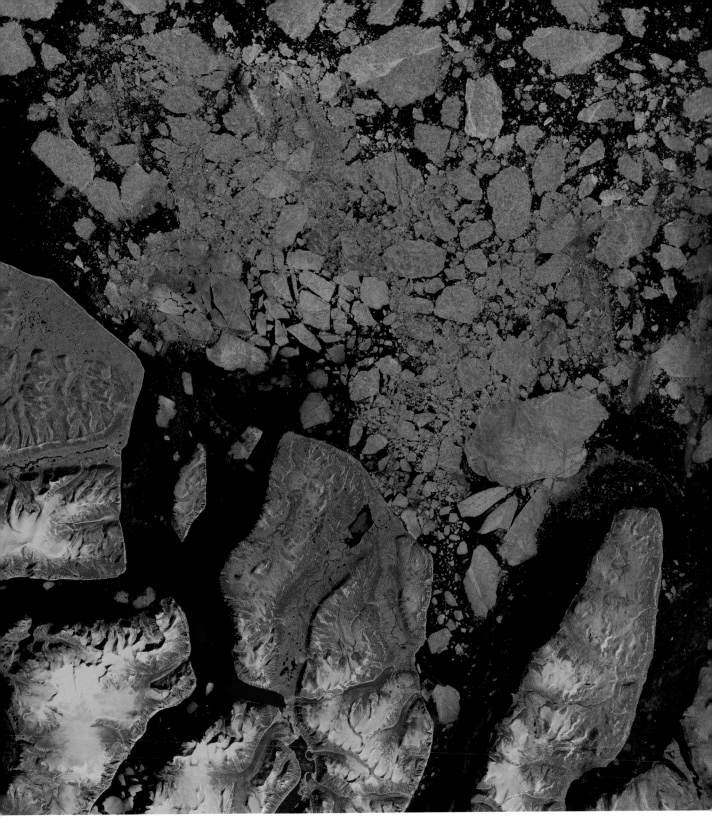

## Canada: Baffin Island, East Coast

THE WHOLE OF THE MOUNTAINOUS east coast of Baffin Island, which faces the Davis Strait and Baffin Bay, is indented with deep, fjord-like inlets, eroded both by the actions of glaciers and by the pounding of the sea. Snow and ice in this image, including numerous icebergs, are shown in light blue. Vegetation, growing only in the more sheltered spots, is in green. The area shown here is approximately 100 km/60 miles from north to south.

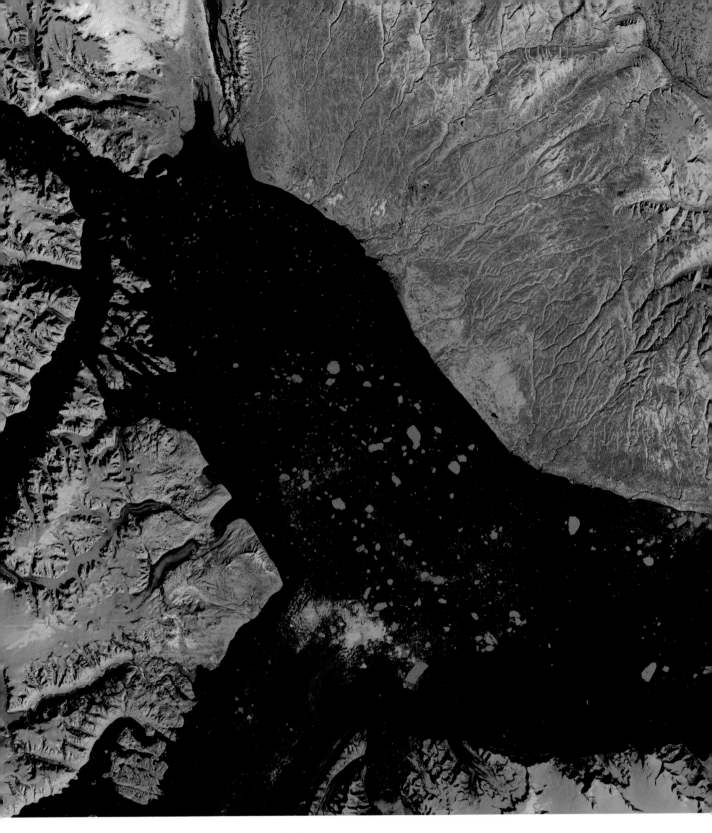

# Greenland: Jameson Land and Hall Bredning

214    APART FROM A FEW COASTAL AREAS, Greenland is geographically considered part of North
       America. At 2,175,600 sq km/840,004 sq miles, it is the largest island in the world. This image
       shows a rare, nearly snow free part of the island, home to musk ox, polar foxes, geese and
       many arctic birds. Other than along a narrow strip of its west coast, Greenland is almost
       entirely covered by ice, in places 3 km/1.8 miles thick, which accounts for 10 per cent of
       the world's fresh water. This image shows an area approximately 150 km/90 miles from
       north to south.

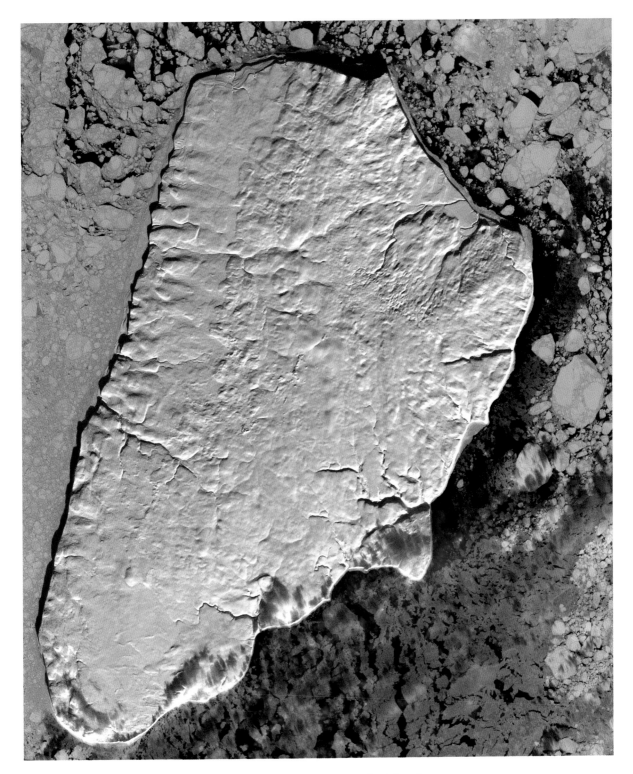

## Canada: Akpatok Island

SOME 43 KM/27 MILES LONG and 24 km/15 miles wide, Akpatok Island lies in Ungava Bay in the Hudson Strait in northern Québec. It rises almost sheer out of the sea, with cliffs that soar to between 150–245m/500–800ft and make the island accessible only by air. Its last Inuit inhabitants left in 1900, though it remains a traditional hunting ground for Inuit attracted by its walruses and whales. The gauzy red patterns at the bottom of the image are clouds.

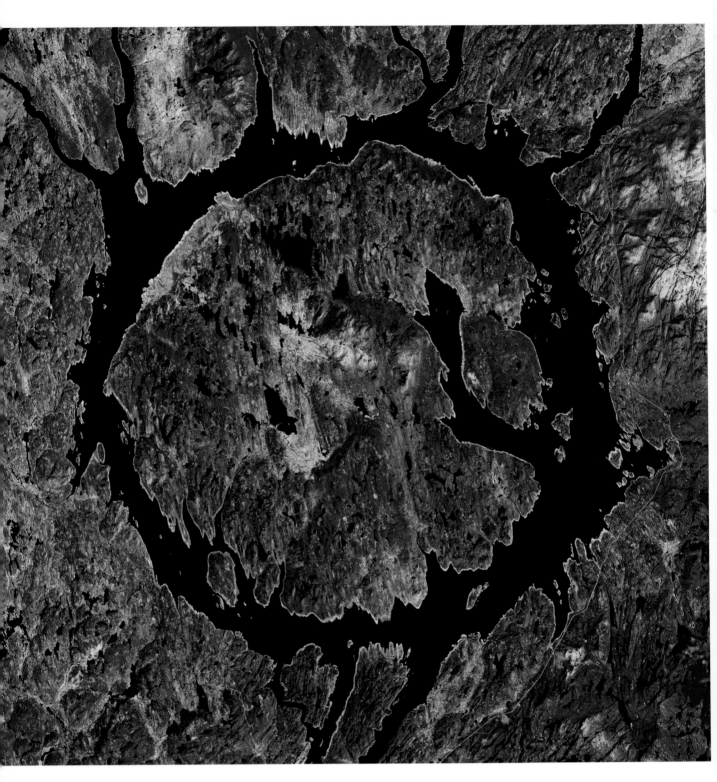

# Canada: Lake Manicouagan

LAKE MANICOUAGAN IN QUÉBEC is an impact structure created when an asteroid, perhaps 5 km/3 miles across, plunged to Earth about 210 million years ago. The resulting explosion is estimated to have led to the loss of 60 per cent of all life on Earth. The central area of land is a classic example of a rebounding uplift, after millions of tonnes of material were suddenly removed during the impact. The crater has a diameter of 70 km/43 miles.

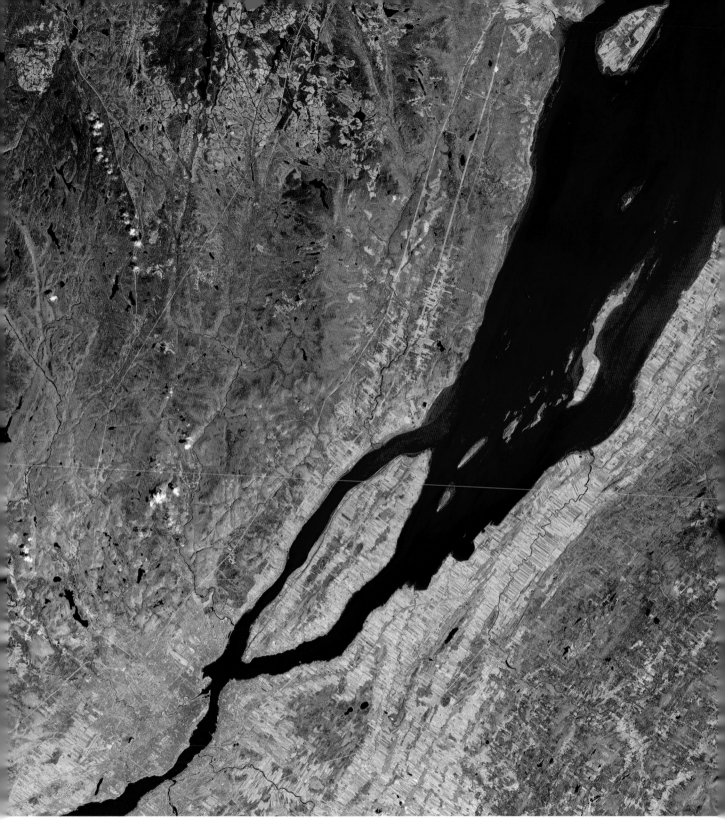

## Canada: Québec and the St Lawrence River

FIRST PENETRATED BY FRENCH EXPLORER Jacques Cartier in 1535, the St Lawrence, which runs
in a bold blue slash diagonally across this image, leads deep into Canada from the Atlantic.
Québec City is located just below the largest island shown here, where the river narrows
dramatically (*kebek* is the Algonquian for 'narrow passage'), and is the capital of the Province
of Québec. It was founded in 1608 by Samuel de Champlain and remains the most French-
minded city in the country.

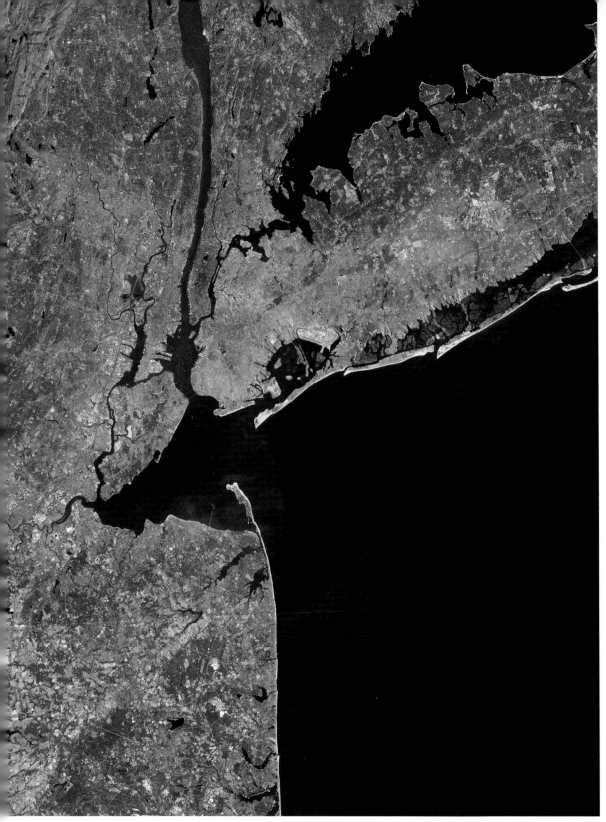

## United States: New York City

URBAN AREAS ARE SHOWN IN GREY on this false-colour image, vegetation in red. Manhattan, the heart of New York, is the thin finger of land in the upper left centre. It is bounded by the Hudson River to the west and the East River to the east. Central Park is clearly visible. Long Island is to the right of New York, running towards the top right-hand corner; Newark, New Jersey is to its left. To the south, running north–south, stretch a series of built-up resorts on the Atlantic coast.

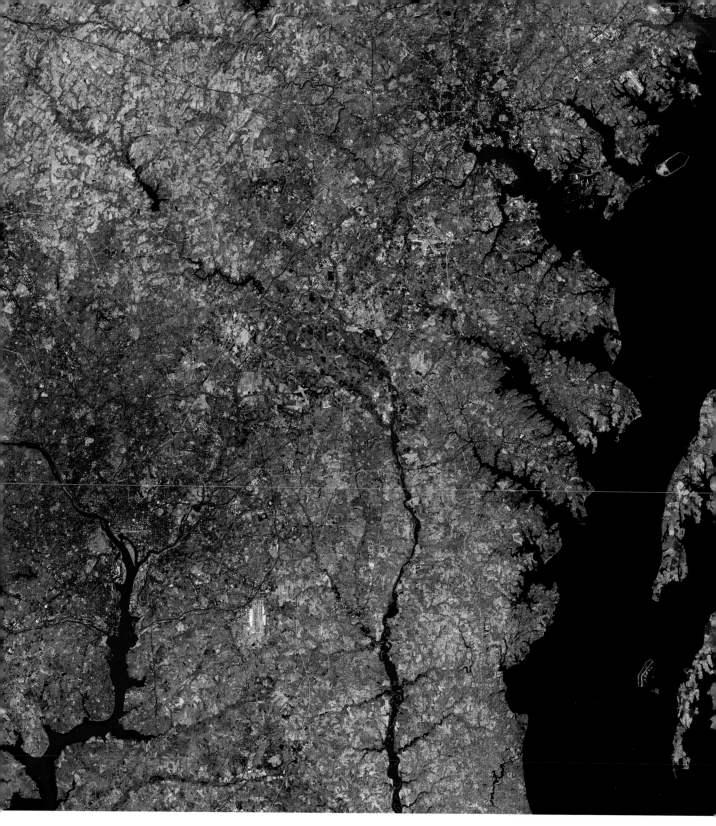

## United States: Washington DC and Baltimore

WASHINGTON DC, FEDERAL CAPITAL of the United States, is the dense blue mass in the lower
left centre of the image. It lies on the steep-sided and twisting Potomac, which snakes up from
the lower left-hand corner and marks the division between Virginia on the left and Maryland on
the right. The broad black band on the right is Chesapeake Bay, in reality more a deeply
fissured inlet than a bay. Almost at its head on its left bank is Baltimore.

219

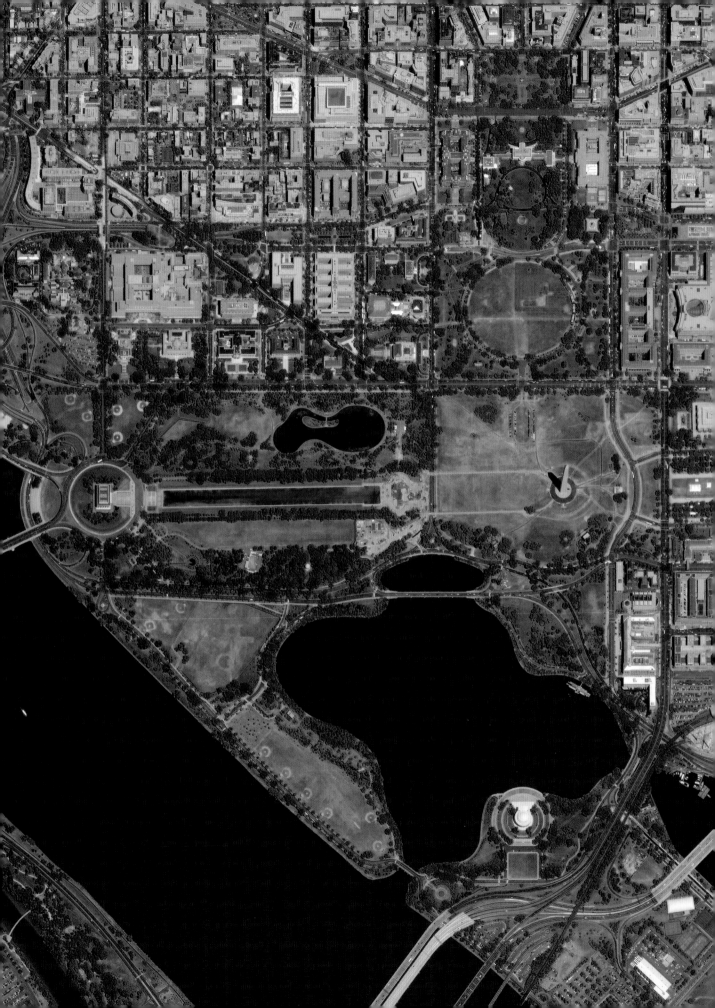

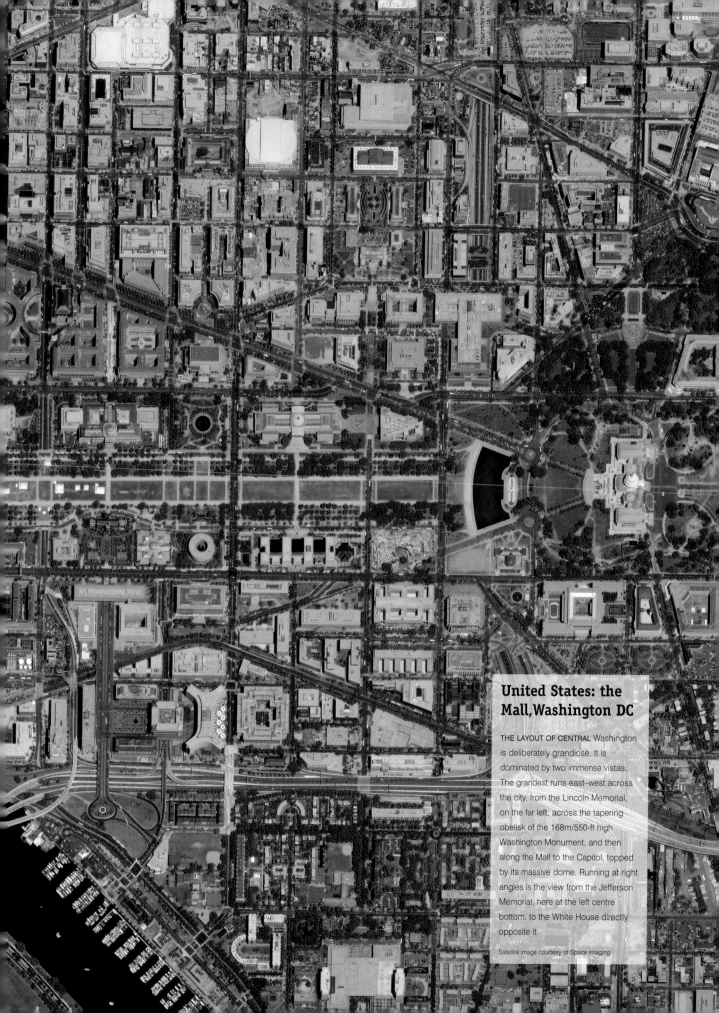

## United States: the Mall, Washington DC

THE LAYOUT OF CENTRAL Washington is deliberately grandiose. It is dominated by two immense vistas. The grandest runs east–west across the city, from the Lincoln Memorial, on the far left, across the tapering obelisk of the 168m/550-ft high Washington Monument, and then along the Mall to the Capitol, topped by its massive dome. Running at right angles is the view from the Jefferson Memorial, here at the left centre bottom, to the White House directly opposite it.

Satellite image courtesy of Space Imaging

# United States: Miami and the Everglades

MIAMI, THE LARGEST CITY IN FLORIDA, is in the lower right corner, bisected by numerous canals and facing a series of small islands. Miami Beach is easily visible as the thin white strip running almost exactly north–south. Running diagonally southeast and northwest, the Miami Canal can also be clearly seen. The dark area on the left of the image is the edge of the Everglades National Park, dark because the park is mostly waterlogged marshland, which reflects little electromagnetic radiation.

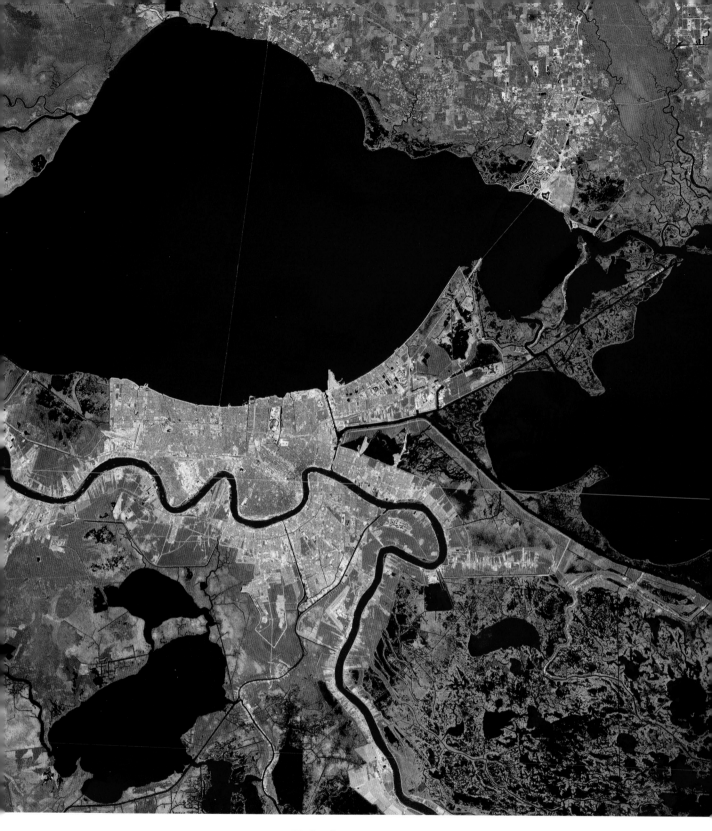

# United States: New Orleans and Lake Pontchartrain

LAKE PONTCHARTRAIN IS THE LARGE, almost circular body of water in the upper centre of the image, while New Orleans is the pale blue-grey area immediately to its south. The city centre lies between the irregular U shape made by the Mississippi, the dark blue line that meanders diagonally to the bottom right-hand corner. Damming of the Mississippi north of New Orleans has prevented vital silt from reinforcing the river delta, with the result that the city is slowly sinking into the Gulf of Mexico.

223

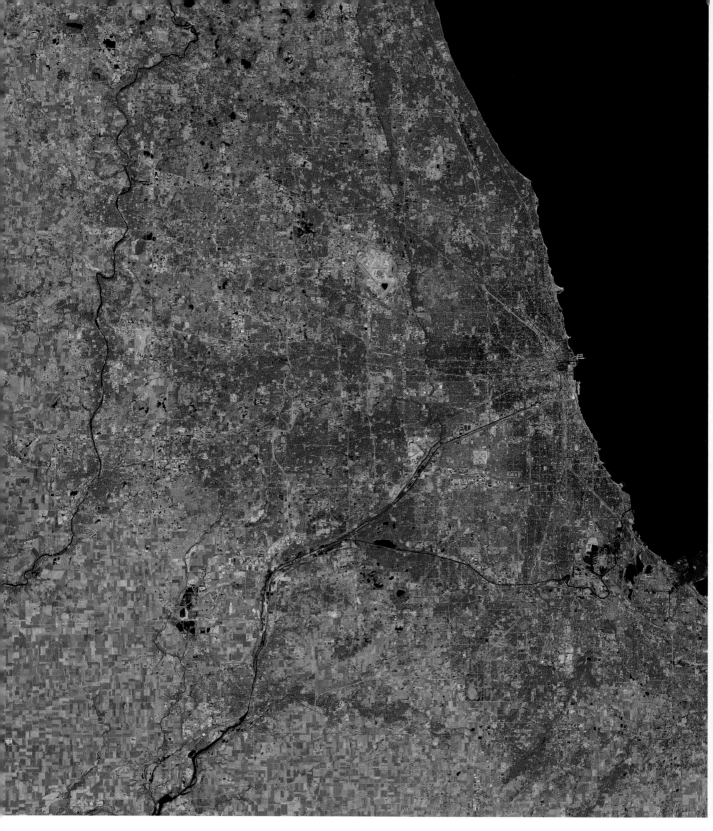

# United States: Chicago

EXTENDING 35 KM/22 MILES along the southwest shore of Lake Michigan, Chicago is home to 7.7 million people and, surrounded by a vast belt of suburbs, sits in the centre of a metropolitan area of more than 8 million people. It is the third-largest city in the United States and a major industrial, financial and transport centre. The thin line that runs into the centre of the city from the southwest is the Chicago Sanitary and Ship Canal.

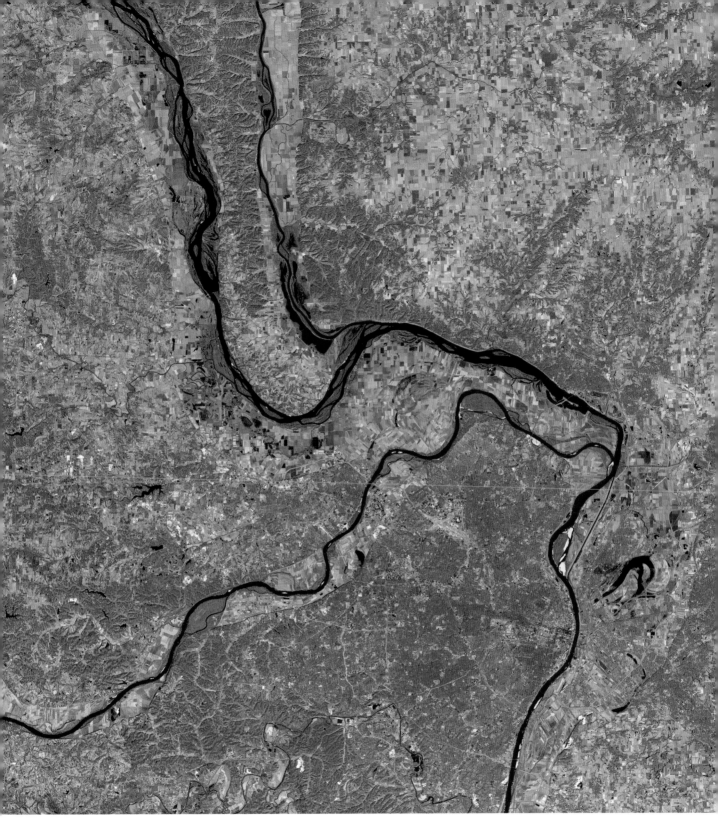

## United States: St Louis

ST LOUIS LIES JUST BELOW one of the great river junctions of America, where the Mississippi, at the upper left, the Illinois, at the centre left top, and the Missouri, at the lower centre left, meet before flowing south to New Orleans and the Gulf of Mexico as the Mississippi. The land to the right of the image is the state of Illinois, that to the left the state of Missouri. Reduced vegetation and tree cover enhances the rivers flood plains. The area shown on the image is approximately 100 km/60 miles from north to south.

225

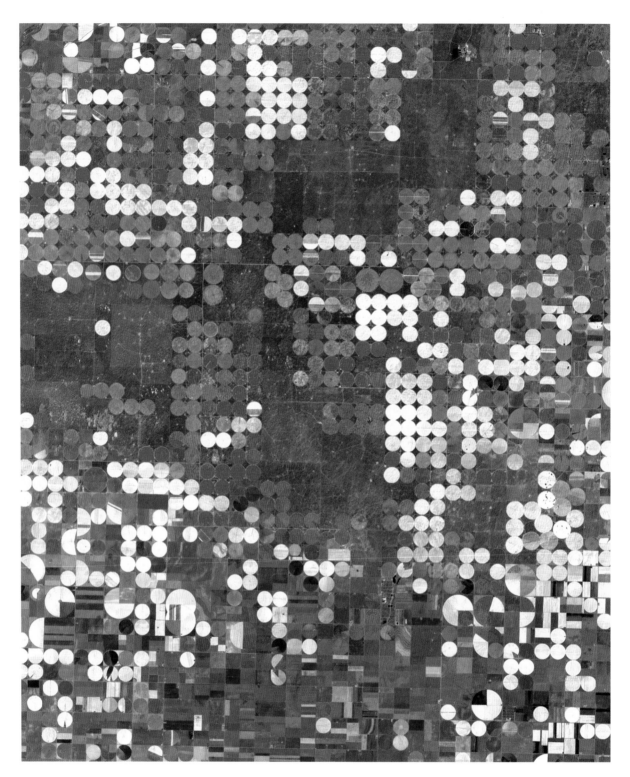

## United States: Garden City

THIS APPARENTLY BIZARRE IMAGE shows irrigated fields, each about 1 km/0.6 mile across, outside Garden City in southwest Kansas. All are irrigated using centre-pivot systems, hence their characteristic circular shapes, each representing one field. The red circles are healthy vegetation, the paler circles harvested crops. The adoption of centre-pivot irrigation from the 1970s onwards has transformed this area of the state. What were typical shortgrass prairies are now highly productive agricultural areas, growing corn, wheat and sorghum.

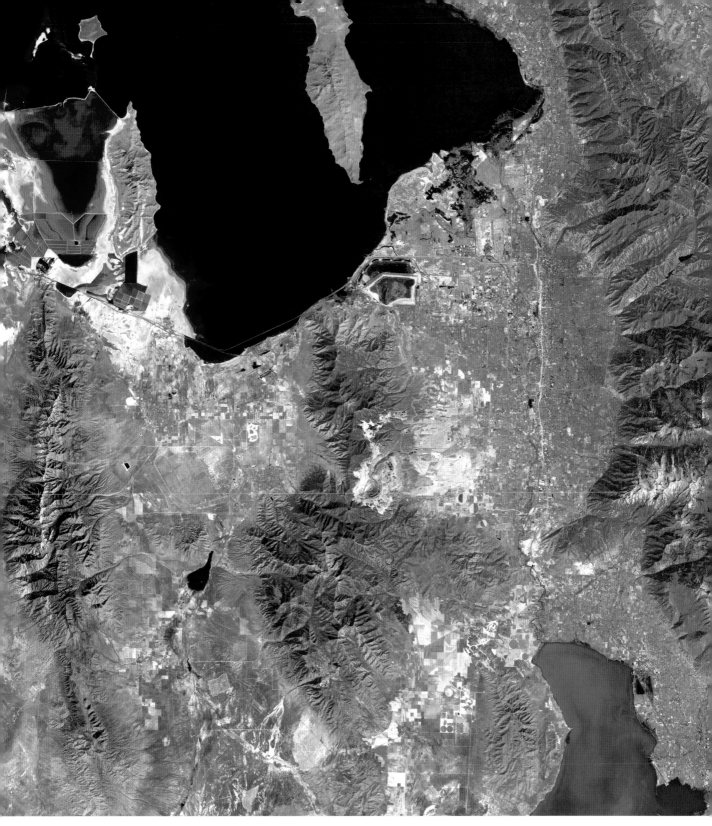

## United States: Salt Lake City

THE GREAT SALT LAKE IN UTAH SITS AT THE TOP of this image; the pale blue and turquoise areas
to the left are shallows. The furrowed green landscape running north–south on the right of the
image are a portion of the Wasatch Mountains. To their left, in a broad valley, is Salt Lake City
itself, shown in grey-blue. 32 km/20 miles southwest of the city, looking like an impact crater, is
the Bingham Canyon Copper Mine, the world's largest open-pit excavation. Utah Lake is in the
lower right-hand corner.

# United States: the Columbia Plateau

THE COLUMBIA PLATEAU EXTENDS over 500,000 sq km/193,000 sq miles of eastern Washington, eastern Oregon and western Idaho. This image shows a small area of it in Oregon, approximately 60 km/37 miles from north to south, with the Owyhee River running through it. Geologically, it is interesting as a giant lava field, in parts 3,048m/10,000ft thick, the whole formed in the last 17 million years as a result of a series of immense volcanic eruptions.

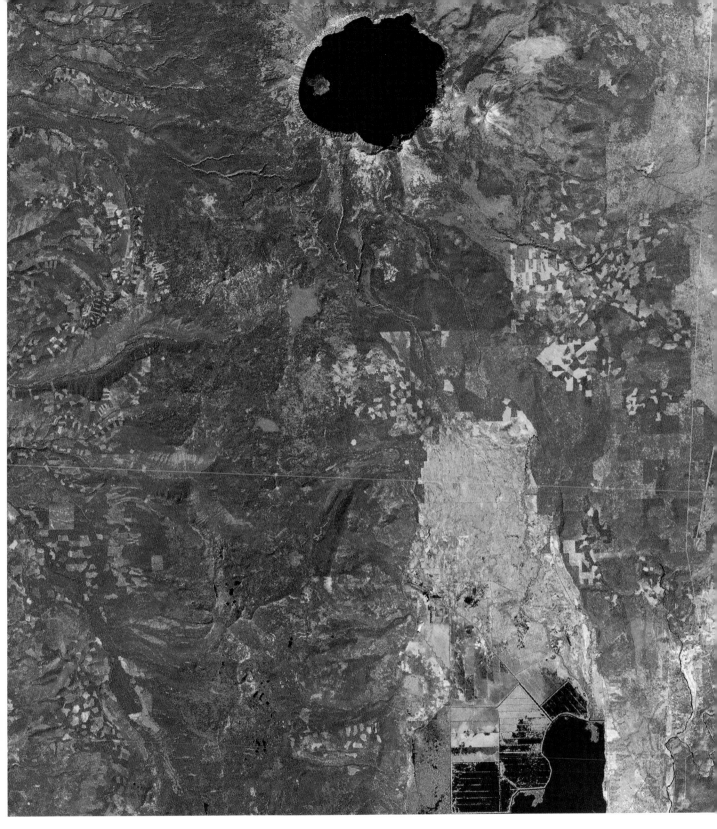

# United States: Crater Lake

AS ITS NAME IMPLIES, CRATER LAKE in western Oregon is formed from a volcano, which last erupted 7,000 years ago. Technically, such formations are known as caldera. The lake, 10 km/6.2 miles across, is famous for the brilliant blue of its water and its exceptional clarity – it is often possible to see 30m/100ft into the lake. At 592m/1,943ft , it is also the deepest lake in the United States. Wizard Island, at the western edge of the lake, was formed from a later volcanic eruption.

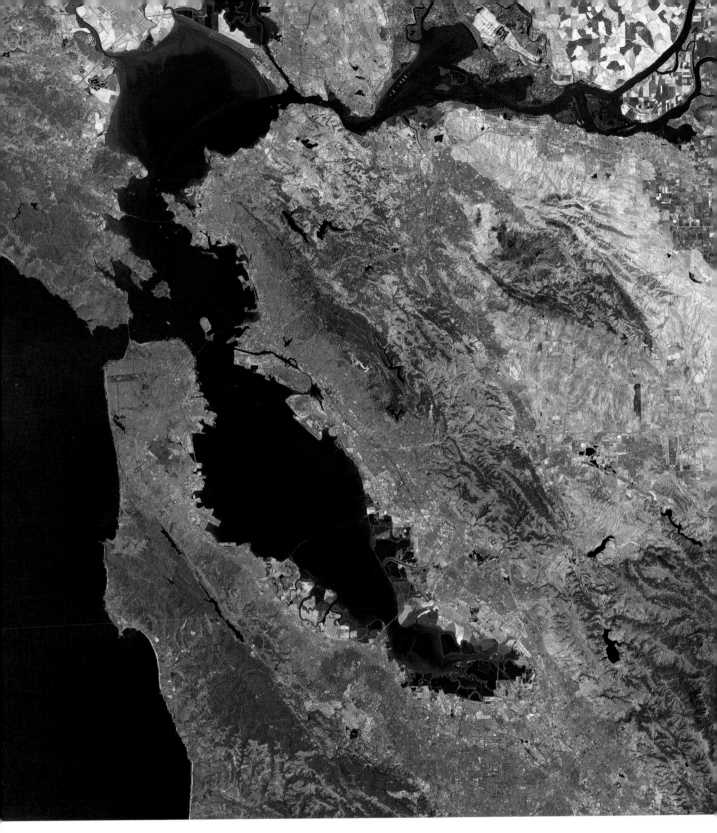

# United States: San Francisco Bay

SAN FRANCISCO LIES AT THE UPPER LEFT centre of the image at the northern tip of the
prominent peninsula that divides the Pacific, to the left, from San Francisco Bay, to the right.
Facing the city to the east is Oakland; at the southern end of the Bay is San José. Together
they make up the greater metropolitan area of San Francisco, with a population of just over
4 million. Just visible, and linking San Francisco over the entrance to the bay with Sausalito,
is the Golden Gate Bridge.

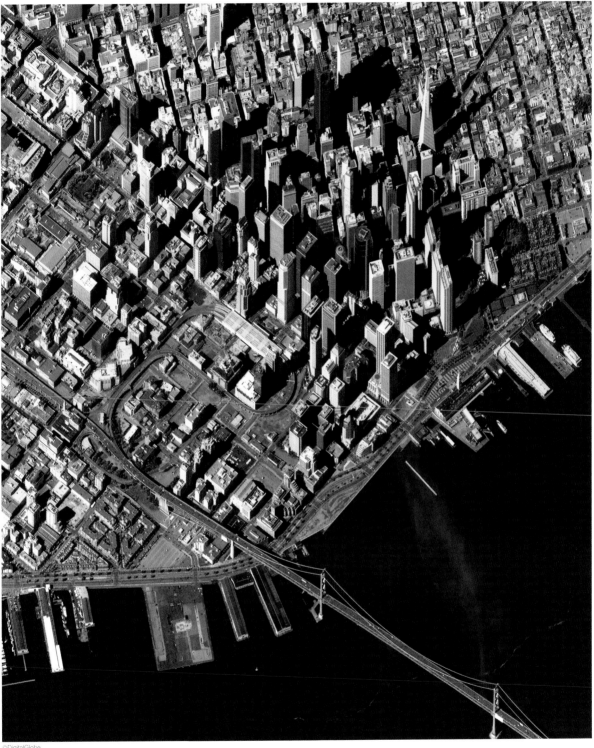

©DigitalGlobe

## United States: Downtown San Francisco

THIS EXCEPTIONAL VIEW of San Francisco's business district has been deliberately slanted 42 degrees to provide a sense of perspective. Despite its size and prosperity, San Francisco, like Los Angeles, lies on the San Andreas Fault. In April 1906, the city was all but destroyed by a severe earthquake, felt as far away as Nevada, and the fires that broke out in its wake. The bridge at the bottom of the image is the Bay Bridge, opened in 1936 and linking the city with Oakland.

# United States: Yosemite National Park

232     **YOSEMITE NATIONAL PARK** is among the most spectacular natural landscapes in America, a
remarkable, precisely preserved region of towering mountains, Alpine-like meadows and
thundering waterfalls. It is in the upper half of this image, in southern California, close to the
border with Nevada, and to the left of the prominent lake – Mono Lake – in the upper right-hand
corner. Running north–south through the image are the snow-capped peaks of the Sierra
Nevada mountain range.

## United States: El Capitan, Yosemite National Park

EL CAPITAN, WHICH DOMINATES this image, is the largest exposed granite monolith in the world. It soars 1,100m/3,600ft above the north side of Yosemite Valley, in the heart of Yosemite National Park. To Native Americans, it is the 'Shooting Star'. It is a classic example of the effects of glacial erosion. Where the softer rocks of the valley floor were swept smooth by glacial action, the all-but-indestructible granite of El Capitan was left intact.

233

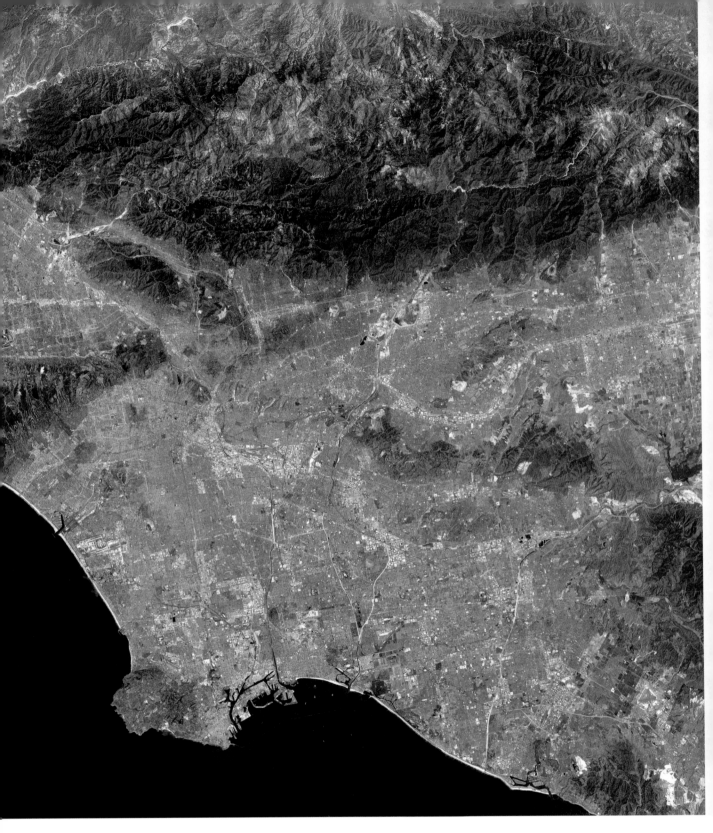

# United States: Los Angeles

234    THE VAST URBAN SPRAWL that is Los Angeles is well captured in this image of the southern
Californian city. While the city itself has a population of 3.7 million, making it the second largest
in the United States, the population of the greater metropolitan area is 16.7 million. Downtown
Los Angeles is centred on the paler area, running broadly east–west, directly north of the city's
port, Long Beach. Directly north again is Hollywood. Beverly Hills, the world's most expensive
residential area, is slightly southwest of the Hollywood hills.

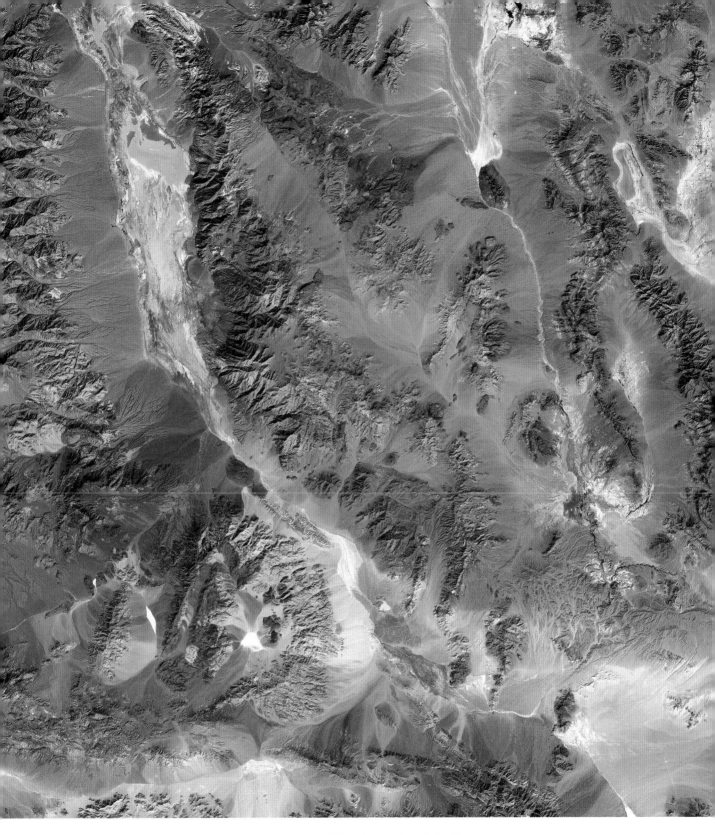

## United States: Death Valley

DEATH VALLEY, ON THE EASTERN BORDER of southern California, was named by prospectors who crossed it during the 1849 California Gold Rush. It is a broad valley, easily visible here as the prominent blue scar running from top left to bottom right, hemmed in to the east by the Amargosa Range and to the west by the Panamint Range. Its lowest point is 86m/282ft below sea level. Death Valley holds the record for the highest temperature recorded in the United States: 56.6°C/134°F on 10 July 1913.

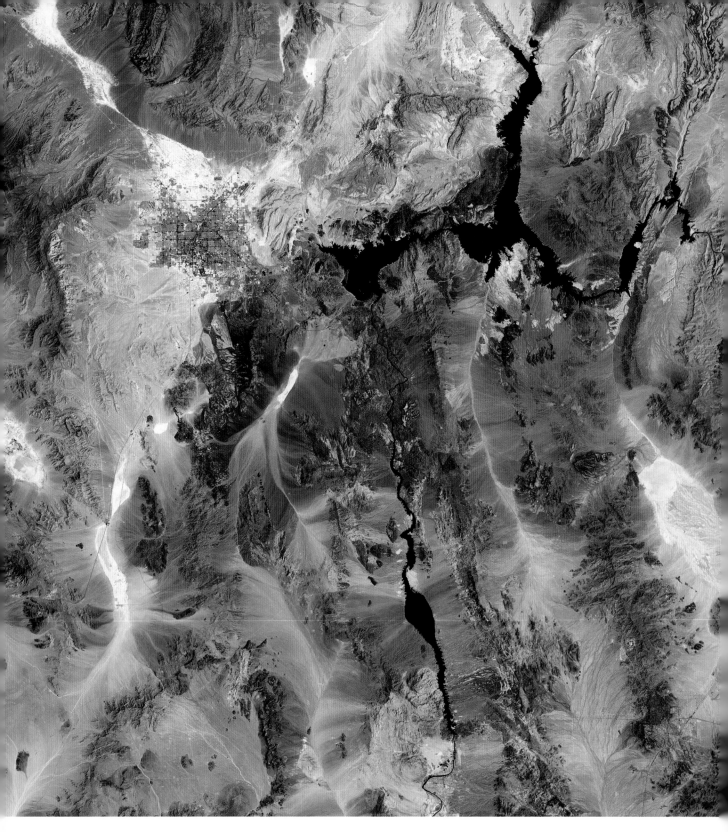

# United States: Lake Mead

236     LAKE MEAD, THE IRREGULARLY SHAPED body of water in the upper centre of the image, shown
here in black, is the largest man-made lake in the world. It was created when the Hoover Dam,
originally known as the Boulder Dam, was built on the Arizona–Nevada border between 1930
and 1936. It is fed principally by the Colorado River, just visible, as it exits the Grand Canyon
(see page 238), as a green and pinkish line on the right of the image. The green mass to the
left of Lake Mead is Las Vegas.

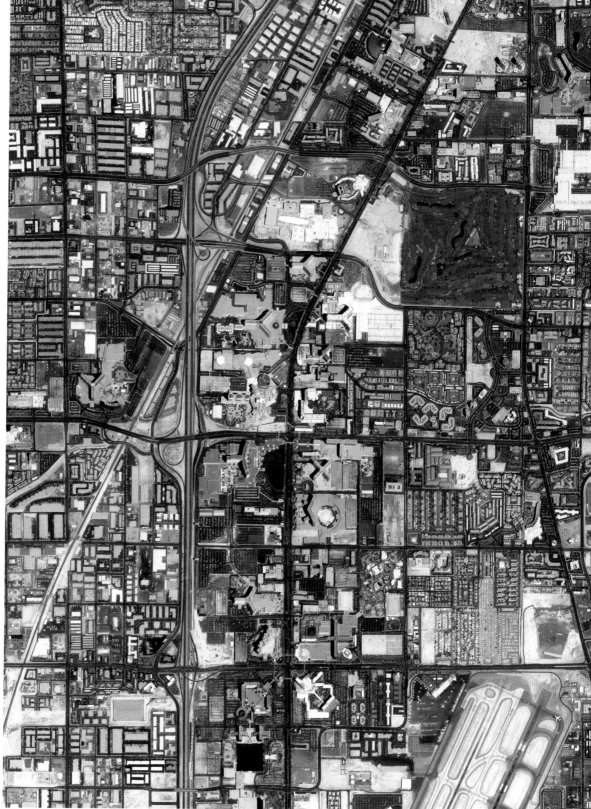

Satellite image courtesy of Space Imaging

# United States: Las Vegas

LAS VEGAS, THE FASTEST-GROWING urban area in the United States, was transformed by
gambling, legalized in Nevada in 1931, and airconditioning. Set in one of the driest areas in
the world, where summer temperatures regularly exceed 40°C/104°F, from the 1940s it rapidly
developed as a major centre of gambling and prostitution. Its lavish casinos on its Strip, the
darker road running up the centre of the image and then bending right became bywords for
ostentation. Today Las Vegas has more than 88,000 hotel rooms

237

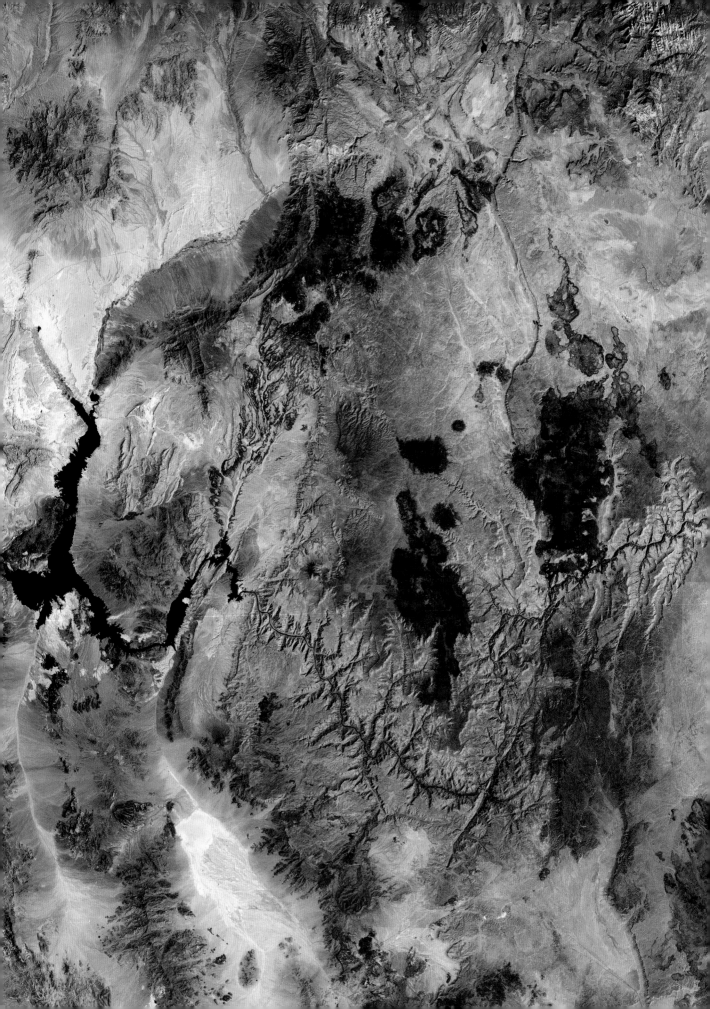

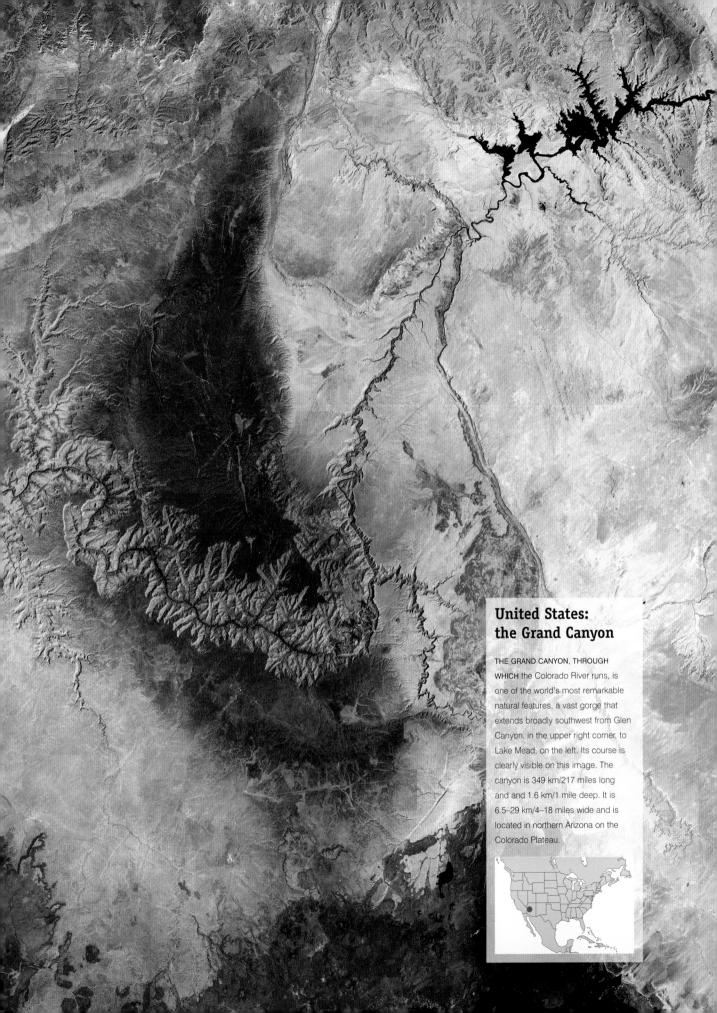

## United States: the Grand Canyon

THE GRAND CANYON, THROUGH WHICH the Colorado River runs, is one of the world's most remarkable natural features, a vast gorge that extends broadly southwest from Glen Canyon, in the upper right corner, to Lake Mead, on the left. Its course is clearly visible on this image. The canyon is 349 km/217 miles long and and 1.6 km/1 mile deep. It is 6.5–29 km/4–18 miles wide and is located in northern Arizona on the Colorado Plateau.

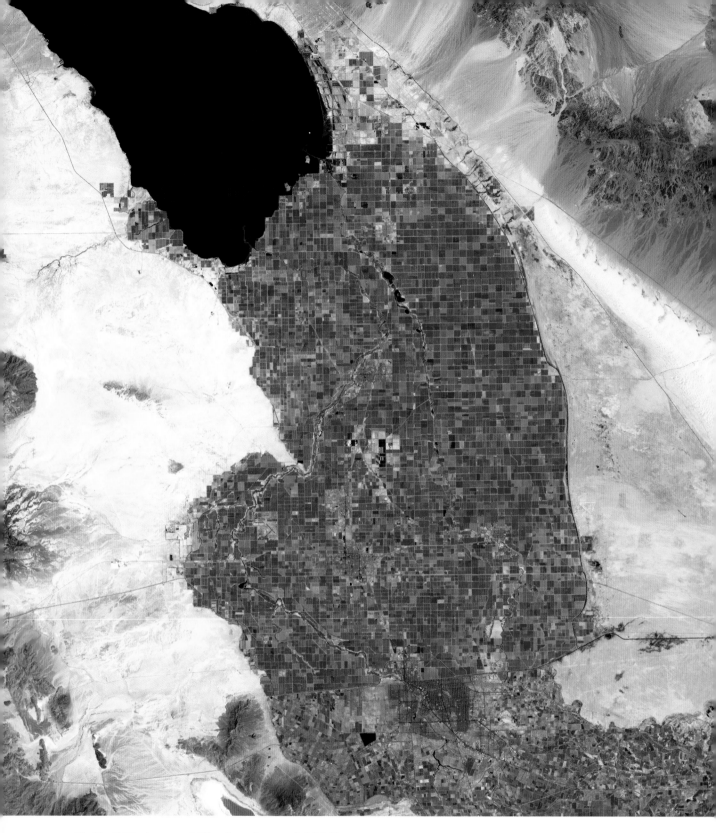

# United States and Mexico: Imperial Valley

240     IMPERIAL VALLEY, ON THE BORDER of California and Mexico, represents a triumph of American
ingenuity over nature. At more than 70m/200ft below sea level, it is among the lowest and
hottest points in the world. Summer temperatures exceed 46°C/115°F. Yet irrigated by water
diverted from the Colorado River – not to be confused with the lifeless Salton Sea in the north
of the image – it has been made fertile. The red squares are vegetation, productive in America,
arid in Mexico.

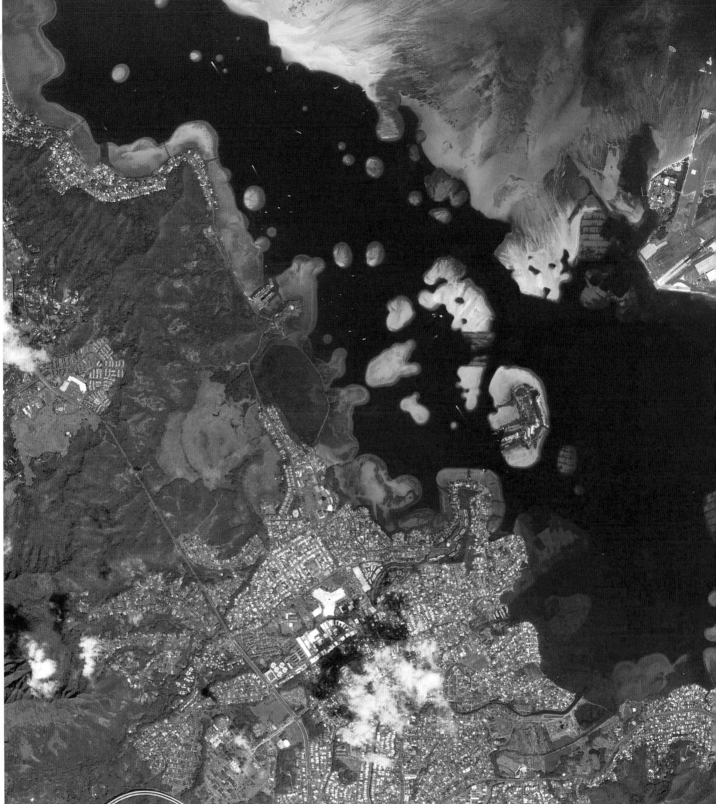

# United States: Oahu, Hawaii

Oahu may not be the largest of the Hawaiian chain but, as the site of the state's capital, Honolulu, the largest city of Hawaii, it is the economic, administrative and tourist focus of the islands and a major Pacific crossroads. This view, which shows an area approximately 8 km/5 miles from north to south, is of Kaneohe, on the island's east coast, and the shallow waters of the adjacent Kaneohe Bay.

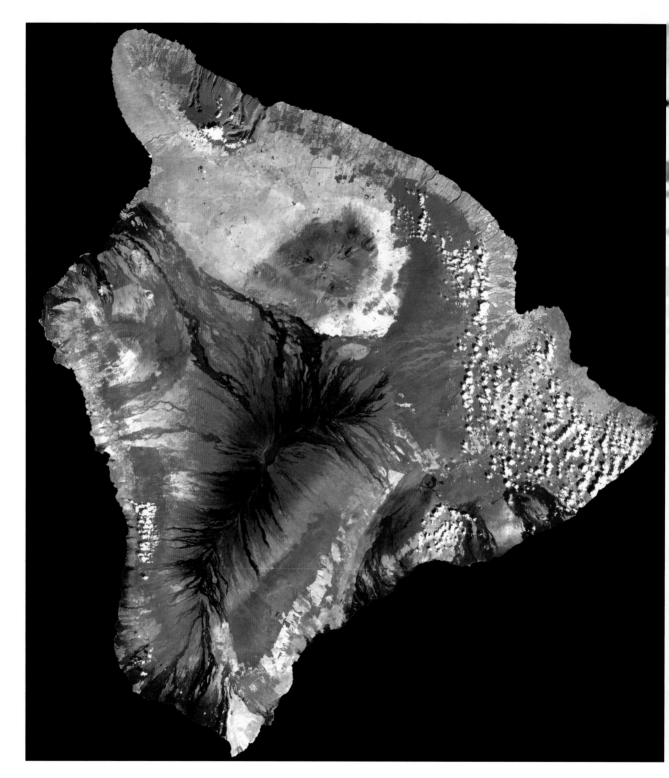

## United States: Hawaii

HAWAII IS THE MOST EASTERLY of the Hawaiian chain in the central Pacific, the world's longest island-chain with 132 islands extending 2,430 km/1,520 miles northwest–southeast across the Pacific. The main group, the state of Hawaii itself, consists of eight islands, which each include the summit of one or more volcanoes. On Hawaii, there are five volcanoes: of the two active ones Kilauea on the southeast coast is the most active volcano on Earth. A thin plume of smoke from its summit is just visible in this image.

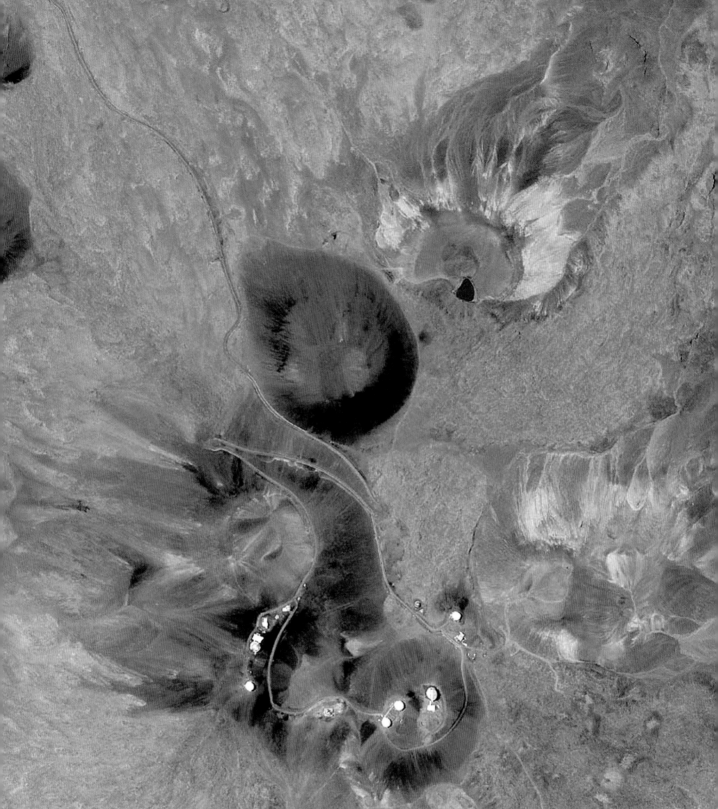

## United States: Mauna Kea Observatory

MAUNA KEA IS A DORMANT VOLCANO near the north coast of Hawaii, last thought to have erupted 3,500 years ago. Its lava-strewn summit, 4,205m/13,800ft high, is the highest point in the Pacific. Rising above the island's usual cloud base, its atmosphere is exceptionally dry. It is also well away from population centres, so there is little or no light pollution. Since the 1960s, these conditions have made Mauna Kea ideal for the world's leading ground-based observatory, with thirteen main telescopes operated by astronomers from eleven different countries.

243

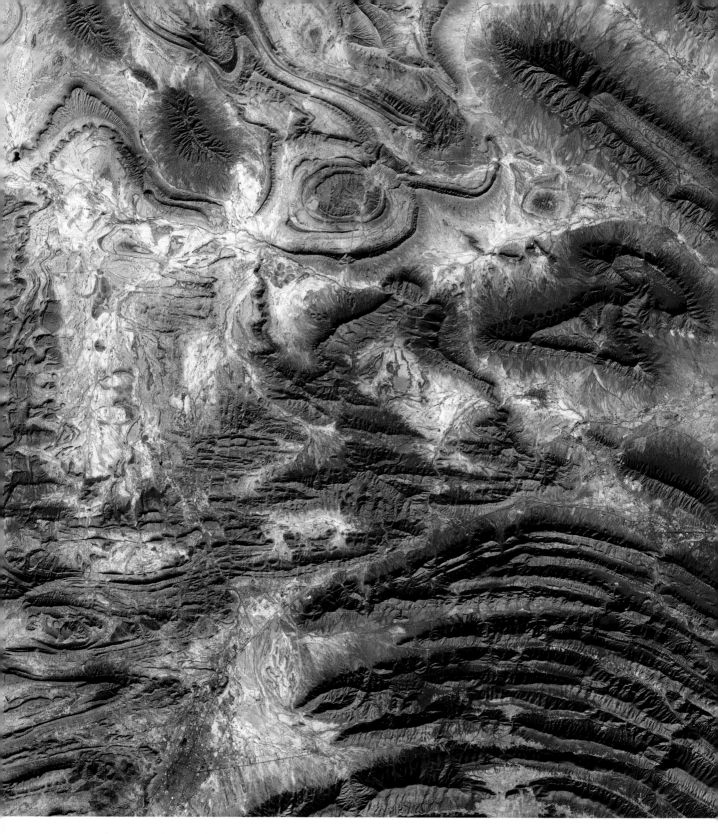

# Mexico: Northern Sierra Madre Oriental

244

THIS VIEW, SHOWING AN AREA approximately 100 km/60 miles from north to south, is of the Eastern, or Oriental, Sierra Madre Range, the eastern edge of the vast and inhospitable central Mexican plateau. The landscape in this sparsely populated region varies from hot and densely overgrown seaward slopes to the arid mountains of the interior. The Sierra Madre Oriental extends for 1,130 km/700 miles parallel to the north–south coast of the Gulf of Mexico.

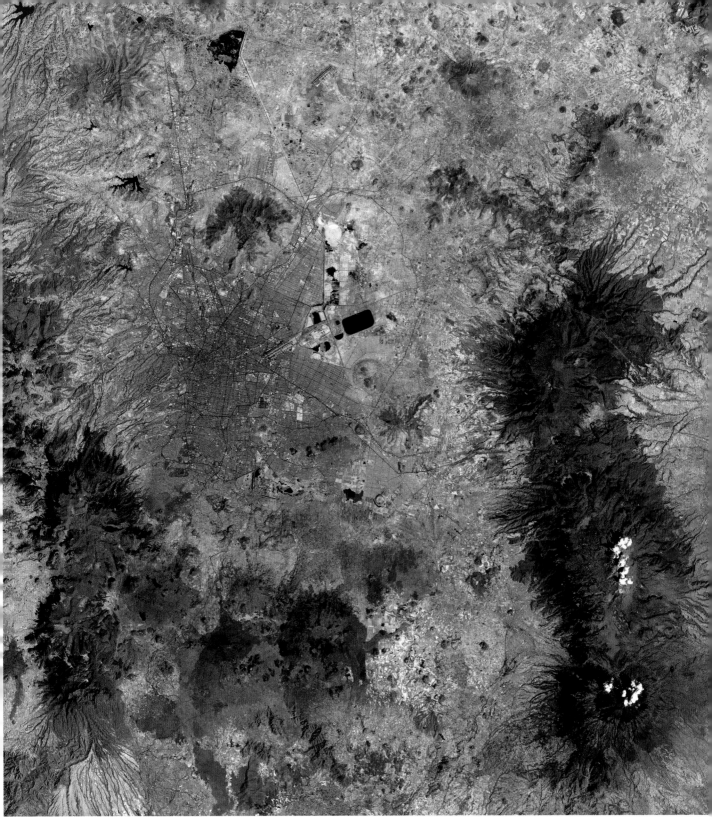

## Mexico: Mexico City

AT AN AVERAGE ELEVATION of 2,200m/7,200ft, Mexico City is the highest major city in the world. It extends over 3,800 sq km/1,467 sq miles and has a population of 15.6 million. Its demand for water, at 60,000 litres/13,200 gallons per second, is exhausting the city's prime water source – an underground lake on which the city rests. As a result, Mexico City is slowly sinking: over the last hundred years, it has sunk by 7.5m/25ft.

245

# SOUTH AMERICA

The two great landmasses that are the Americas are linked by only the slenderest of landbridges, 80 km/50 miles wide at its narrowest in Panama. To the north are the lush forests and mountains of tropical Central America, to the east the great arc of the island-studded Caribbean. Though only the fourth-largest of the continents, embracing an area of 17.8 million sq km/6.9 million sq miles and accounting for 11.9 per cent of the world's landmasses, much of South America's remote interior was first fully mapped only from the 1970s when satellite-borne radar was used to penetrate the cloud cover.

South America, joined to Central America only three million years ago, presents a remarkable range of landscapes and climates. The most striking feature is the contrast between the huge rainforests that extend across Brazil, the continent's largest country (and the world's fifth largest), and the arid mountain chain, the Andes, that hugs the entire length of South America's west coast. At 7,250 km/4,500 miles, the Andes are easily the longest mountain range in the world, rising at their highest to more than 6,800m/22,500ft. They are the site of the world's highest navigable lake,

home of the potato, a plant well adapted to poor soils and high altitudes. In combination with the cold air generated by the north-flowing Humboldt Current, the Andes have created one of the driest climates in the world. The town of Arica in northern Chile has average annual rainfall of less than 10mm/0.5in. Further south in the Atacama Desert, there has been no measurable rainfall for 400 years.

The Andes are also the source of the Amazon, at 6,450 km/4,010 miles the world's second longest river and the largest rain basin in the world, draining an area of 7 million sq km/2.7 million square miles. It flows westward to the Atlantic through the world's largest rainforest. Though approximately 10 per cent of these forests have been lost to systematic deforestation, they still account for around one-third of all the world's rainforests.

To the south are the pampas of central Argentina and Uruguay, a vast area of rich and fertile grassland and the site since the nineteenth century of a series of immense cattle ranches or estancias. Further south still, the continent tapers to a point amid the icy windswept wastes of Tierra del Fuego.

Titicaca, 4,000m/13,000ft high and straddling the border of Bolivia and Peru, as well as of the world's highest railway, which climbs 4,843m/15,885ft from the Peruvian capital, Lima, to Huancayo. They are also the original

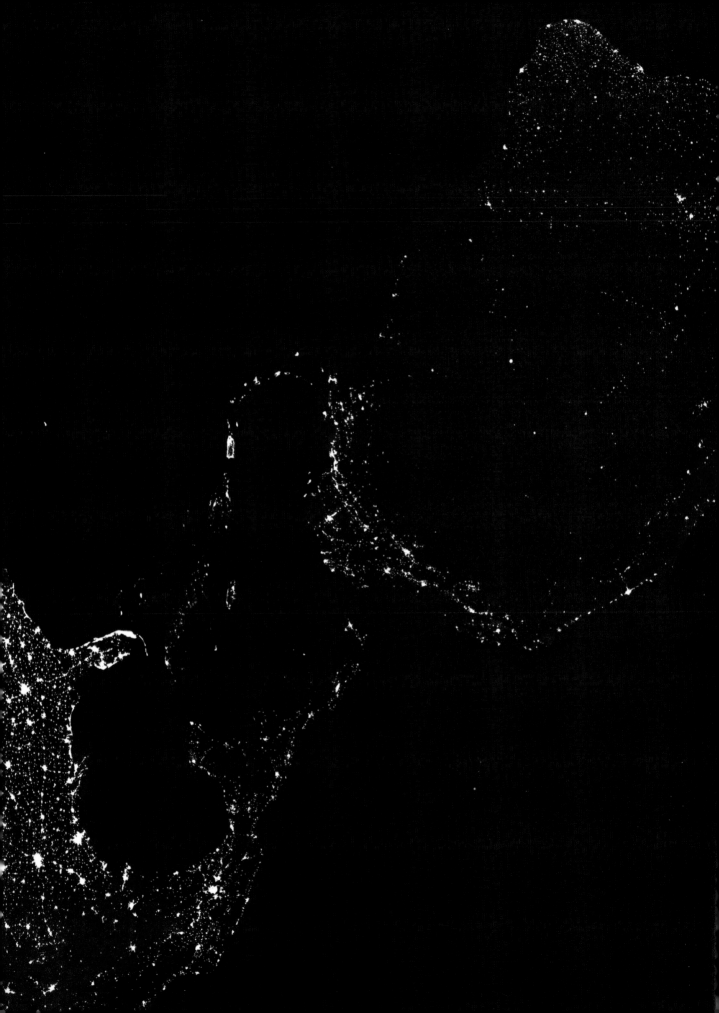

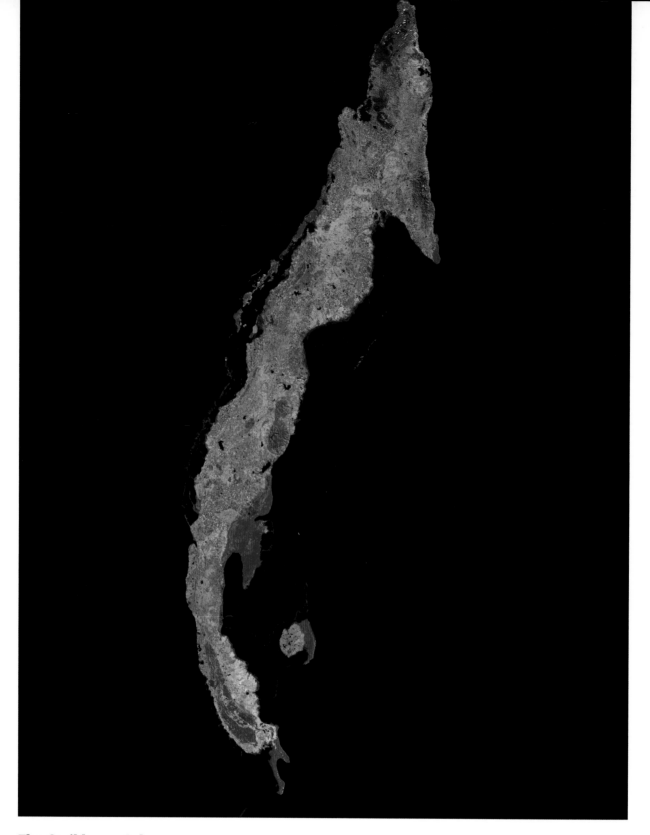

## The Caribbean: Cuba

CUBA, THE 'PEARL OF THE CARIBBEAN', is the largest island in the group, an attenuated
finger of land 1,260 km/782 miles long and only 32 km/20 miles wide at its narrowest. No part
of it is more than 80 km/50 miles from its sea. Hardly surprising, at 5,500 km/3,417 miles its
coastline is disproportionately long. Cuba is predominantly low-lying and fertile; only the rugged
southeast is mountainous – on this image shown at the top centre. Havana, the capital, is on
the northwest coast, shown bottom left.

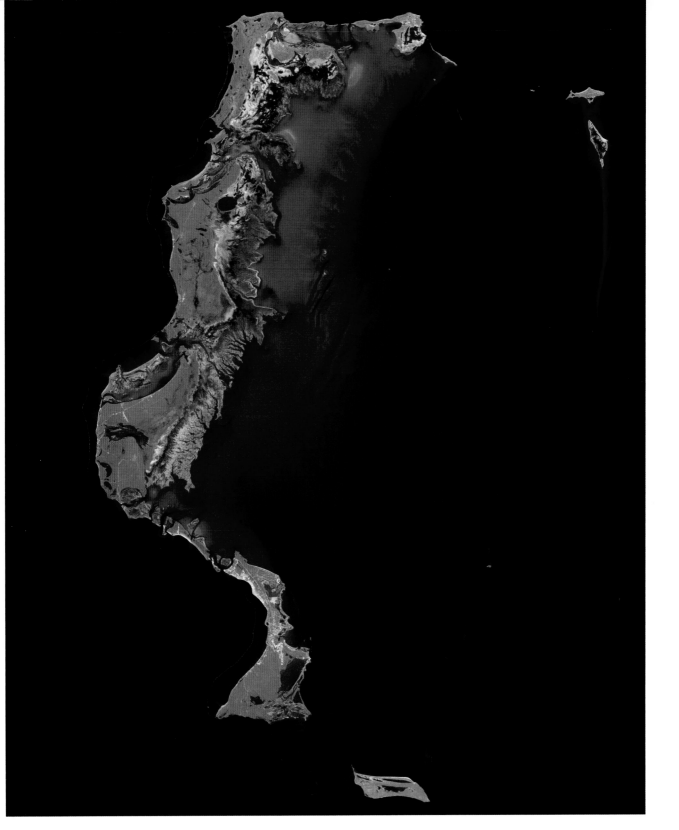

## The Caribbean: the Turks and Caicos Islands

THE TURKS AND CAICOS are the most easterly of the untidy straggle of islands that extend
southeast from the Bahamas. They consist of up to forty islands and cays – small, low-lying
islands of sand and coral. Only eight are inhabited by a population numbering just under
20,000. The highest point in the islands is 49m/160ft. There are extensive marshes and
mangrove swamps along the north shore, shown here in red. North on this image is on the left.

251

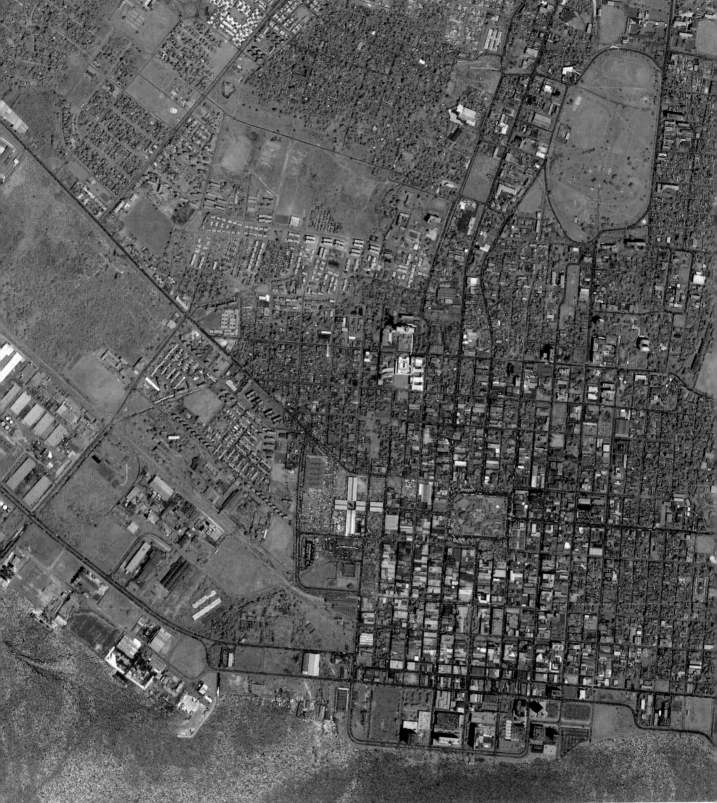

# Jamaica: Kingston

252 THE LOWER HALF OF THIS IMAGE, approximately 4 km/2.5 miles from north to south, shows the waterfront of downtown Kingston, capital and largest city of Jamaica and, with a population of 650,000, one of the largest cities in the Caribbean. Kingston is the administrative and financial centre of the island as well as its principal port. Its harbour, sheltered by a long peninsula, is one of the finest in the region. The large oval in the upper right is the National Heroes Park.

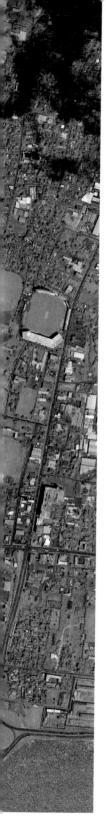

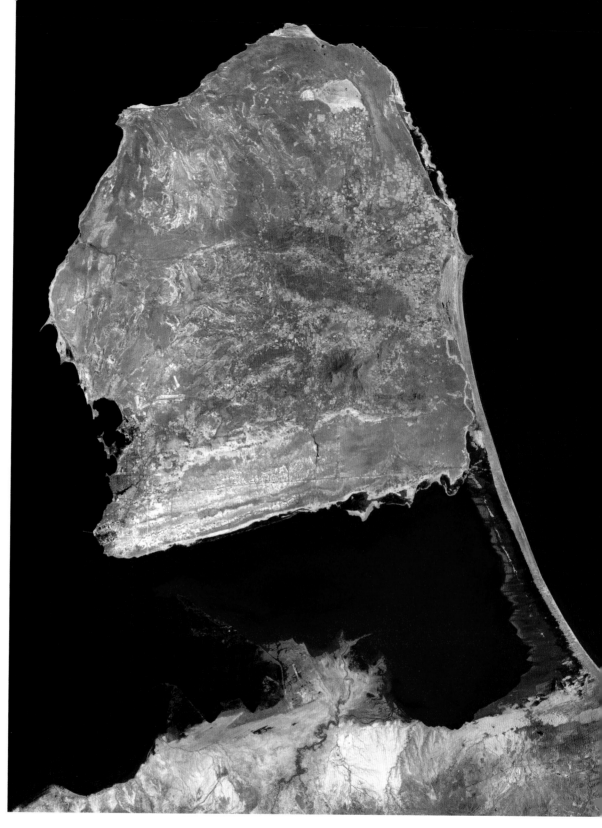

# Venezuela: the Peninsula de Paraguaná

THE NARROW ISTHMUS OF MÉDANOS, which links the Peninsula de Paraguaná to the Venezuelan
mainland, is young geologically, created only about 10,000 years ago. Until then, Paraguaná
was just one of the many islands that stud the Venezuelan coast. Along the peninsula's
southern coast there are a series of oil refineries. Sandy beaches lie along the coasts and have
become the focus of a thriving tourist trade. The silty, shallow water south of the peninsula
shows clearly.

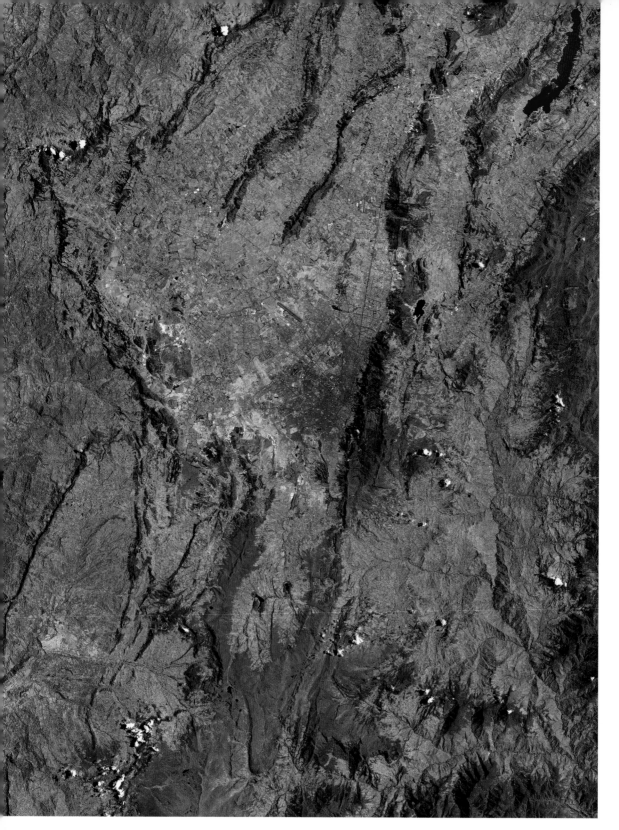

## Colombia: Bogotá

SPACIOUS AND ELEGANT BOGOTÁ, the 'Athens of America' in the words of the nineteenth-century natural scientist Humboldt, lies high in the northern reaches of the Andes between the Cordillera Central and Cordillera Oriental, the latter clearly visible on the right. The average elevation of the city, shown here as the dense blue mass in the centre of the image, is 2,610m/8,560ft. Bogotá is the capital of Colombia and has a substantial population of six million. The image covers an area of approximately 100 km/62 miles from north to south.

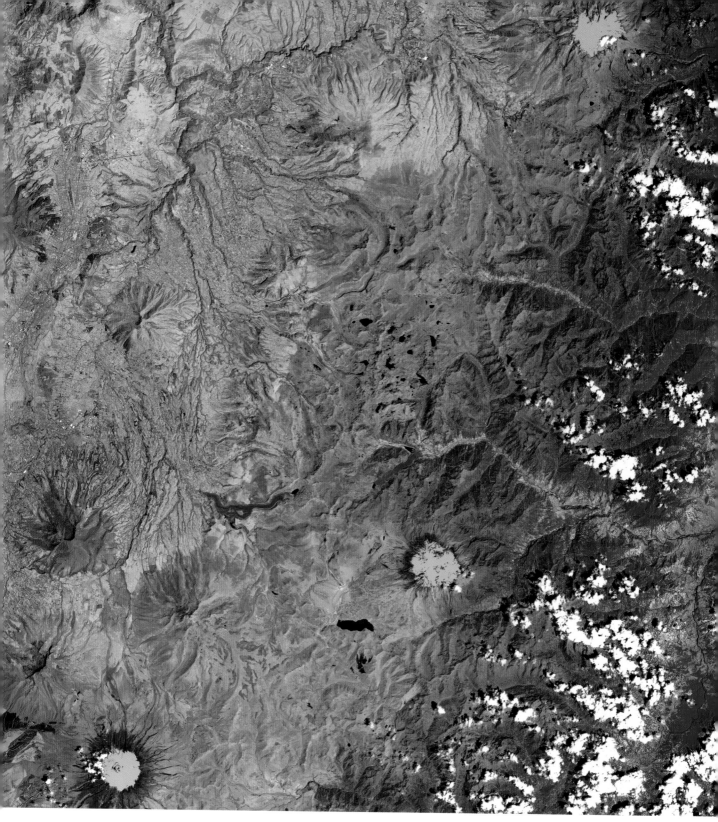

## Ecuador: Quito

QUITO, THE CAPITAL OF ECUADOR and like Bogotá, in the northern Andes, is visible here as the pale blue area, running north–south, in the upper left centre of the image. The region is highly volcanic. In this image alone there are more than a dozen volcanoes, with the snow-capped summits of the three highest, shown in bluey-green, easy to see. From north to south they are: Cayambe 5,790m/18,996ft; Antisana 5,704m/18,710ft; and Cotopaxi 5,896m/19,343ft, the world's second-highest active volcano.

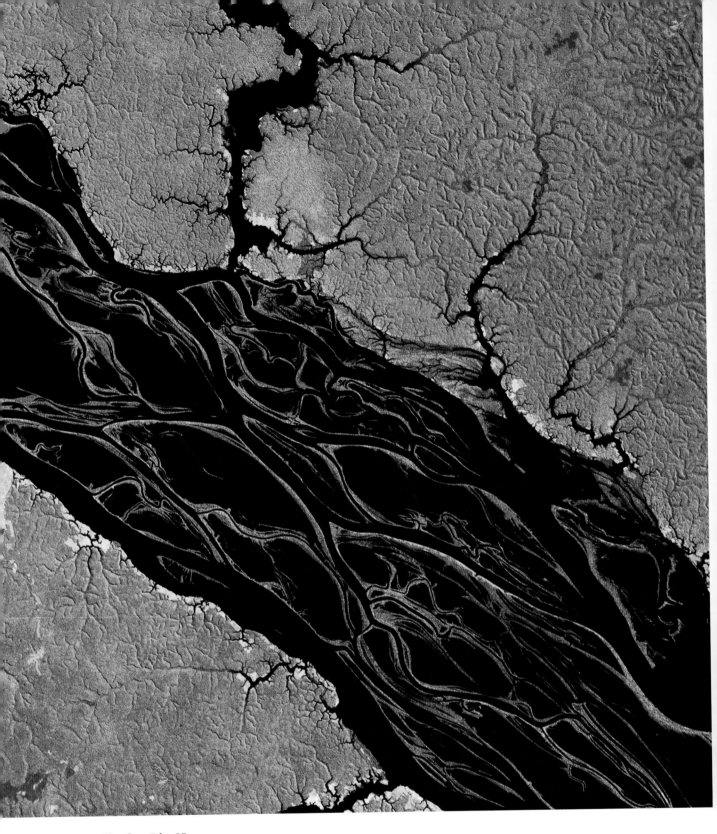

## Brazil: the Rio Negro

THE RIO NEGRO, HERE APPROPRIATELY SHOWN IN BLACK, is so named because of the high levels of tannin it contains. The curious orange-red ribbons in the river are levées, many of which are entirely flooded when the river is at its peak between November and April. In the lower left is a small area of the Jaú National Park, at 22,650 sq km/8,750 sq miles the largest protected tropical rainforest in South America.

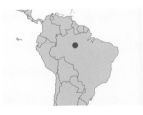

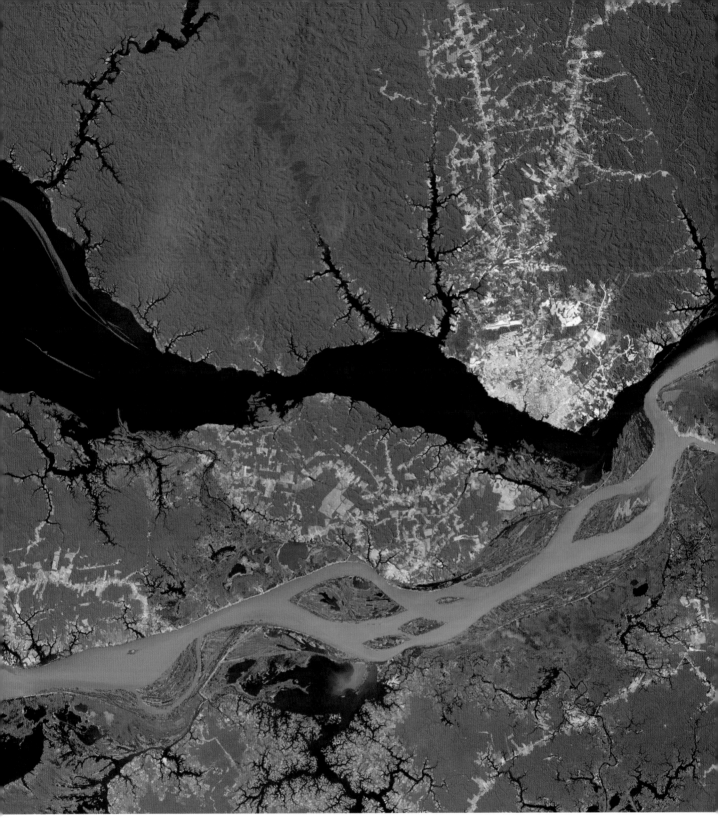

## Brazil: Manaus

THE RIO NEGRO, AT THE CENTRE LEFT, is the largest of the Amazon's tributaries, flowing 2,300 km/1,429 miles from Colombia to the Amazon. At the confluence of the Rio Negro and Amazon is Manaus, capital of the state of Amazonas and shown here as the pale blue-grey area in the centre right. Where the Rio Negro appears black on this image, the Amazon, running along the bottom of the image, is light blue, its silt-rich waters reflecting radiation as measured by the satellite more effectively and hence appearing lighter.

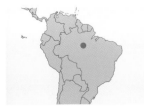

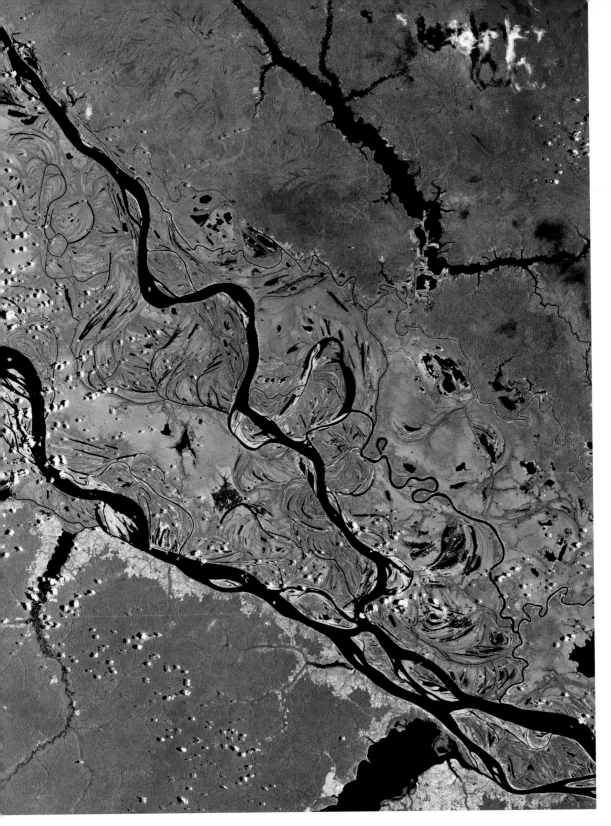

# Brazil: Tefé

TEFÉ, IN BRAZIL'S AMAZONAS REGION, and the capital of the Massive Province, lies in the lower right-hand corner and is just visible in pale blue. The lower of the two rivers, in black, running diagonally across the image, is the Amazon itself; to its north is the Japurá, one of the Amazon's many tributaries. To the north again is Lake Amanã. The Amazon Plain here is an intricate mosaic of forest, scrub, marshes and lakes, all prone to annual flooding.

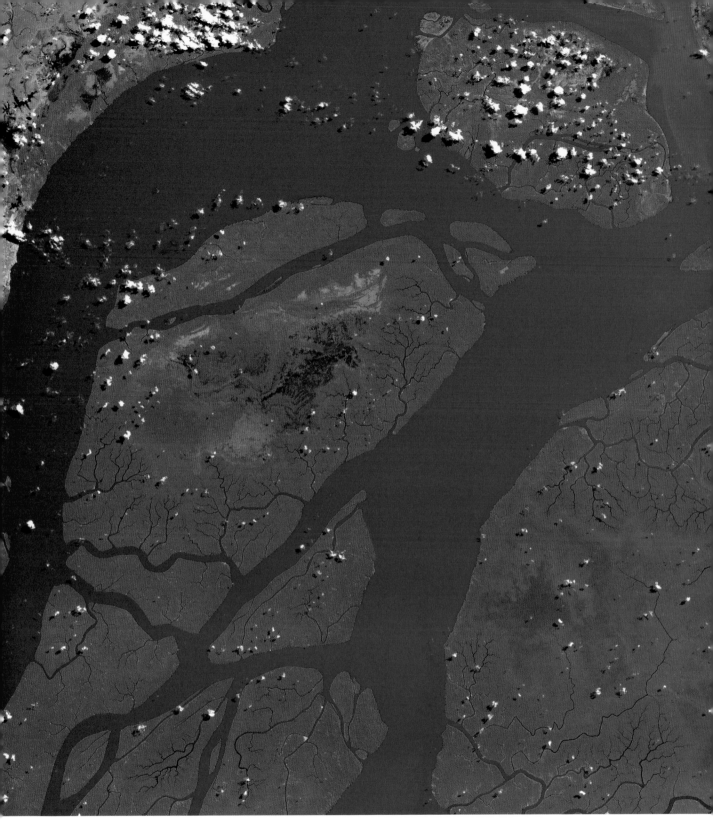

## Brazil: the mouth of the Amazon

'THE GRANDEUR OF THIS RIVER is admirable', reported a seventeenth-century explorer of the Amazon, 'for, like a king over all others, it guards its gravity with measured steps'. Its vast mouth, shown here, includes the second-largest island in South America, the Marajó, a part of which is shown on the right of the image. All the red areas are forest; the green patch in the upper left, site of the town of Macapá, is savannah.

259

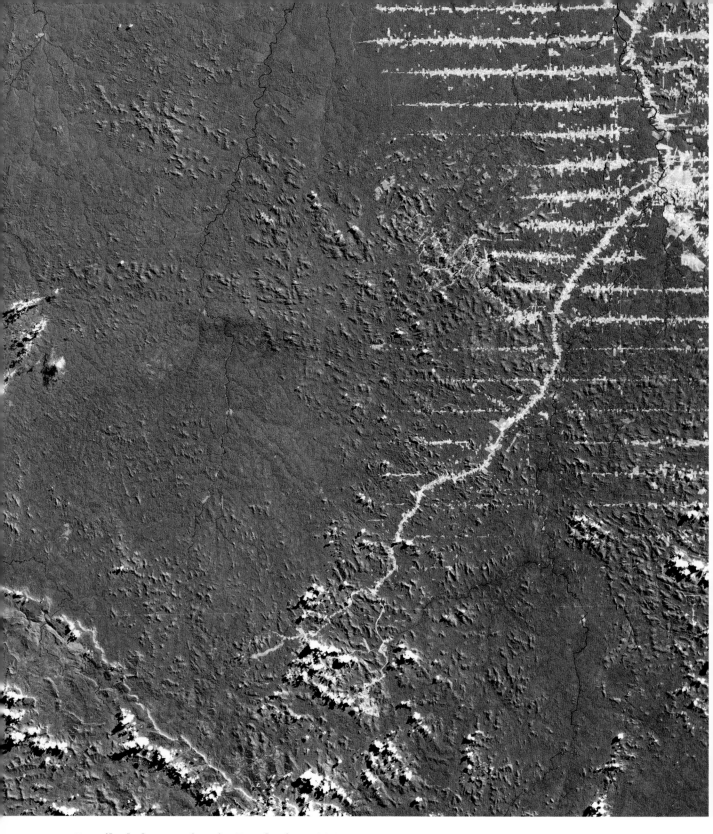

# Brazil: deforestation in Rondovia, 1984

THE AREA SHOWN ON THIS and the facing page is identical. It lies near the south of the
Amazon rainforest in Rondovia, close to Brazil's border with Bolivia, and covers approximately
100 km/60 miles from north to south. The images chart with alarming precision the
deforestation of the Amazon Basin. This image was taken in May 1984, the image opposite in
September 2001. The red areas are forest; the pale areas are cleared land.

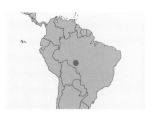

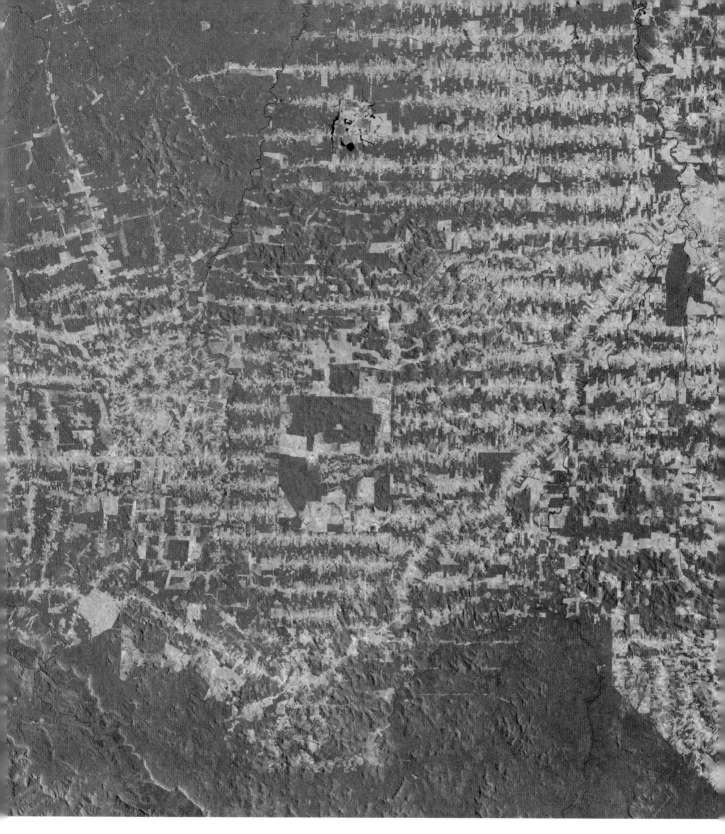

## Brazil: deforestation in Rondovia, 2001

DEFORESTATION TYPICALLY INVOLVES CUTTING roads through the rainforest. From them, subsidiary roads are made, creating the characteristic 'fishbone' or 'feather' pattern seen here. Where on the previous image only the outlines of the process are visible, here vast areas have been destroyed. Brazil has 3.6 million sq km/1.4 million sq miles of tropical rainforest, 30 per cent of the world's total. Though rates of deforestation have slowed, 15,000 sq km/ 5,800 sq miles are cleared every year.

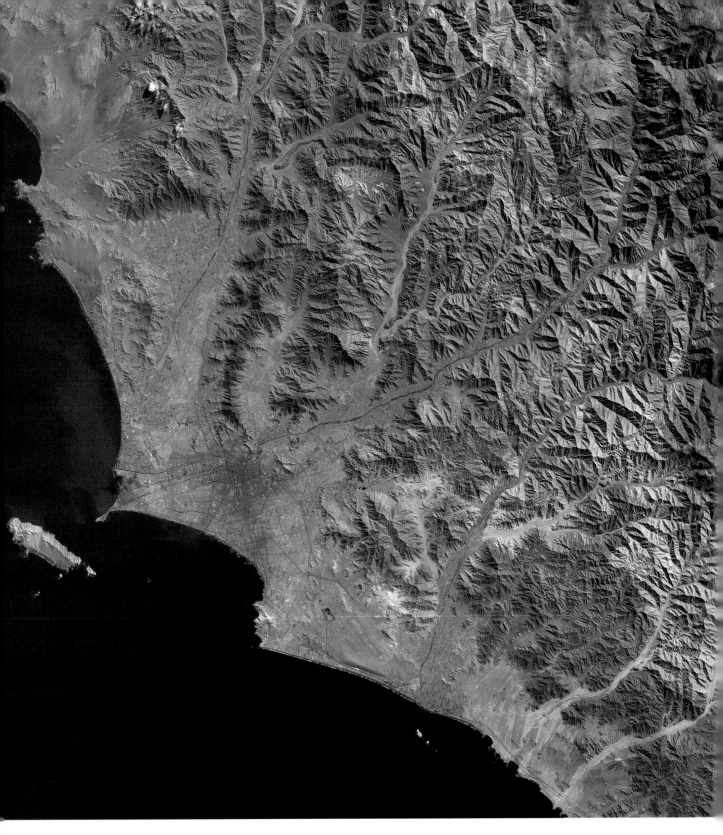

# Peru: Lima

WITH BOGOTÁ AND MEXICO CITY, Lima, capital of Peru, was one of the three great cities of Spain's New World empire. In the seventeeth and eighteenth centuries, it was the capital of the Vice-Royalty of Peru and unrivalled in South America in importance and wealth. Today, it is a substantial modern city of 6.6 million people. It lies in the shadow of the Andes, which tower behind it. The city itself can be seen in the lower left centre of the image with its port, Callao, facing the small offshore island.

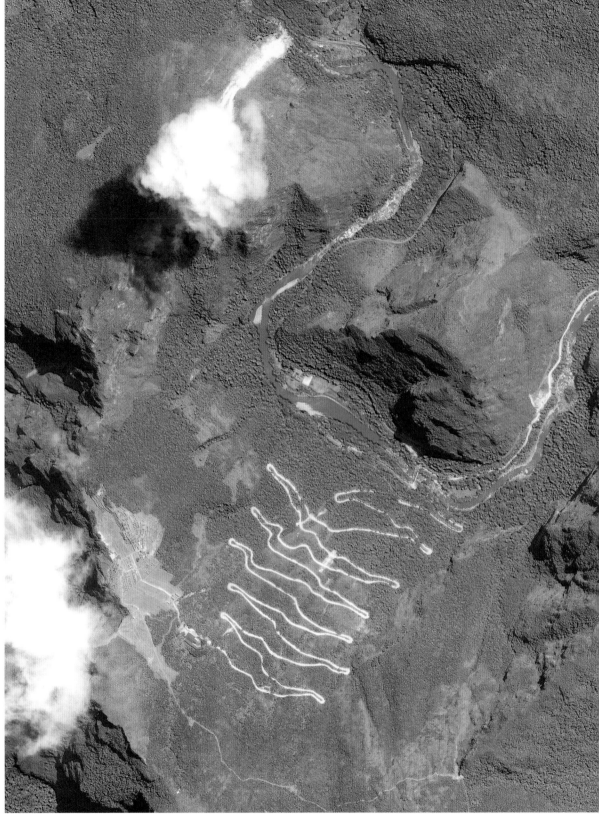

Satellite image courtesy of Space Imaging

## Peru: Machu Picchu

THOUGH ONLY 80 KM/50 miles from Cuzco, the great Inca fortress of Machu Picchu was never found by the conquistadors and later Spanish settlers of South America. Rediscovered in 1911, it is the most complete example of a pre-Columbian city on the continent. The site itself covers 13 sq km/5 sq miles, its massive dry-stone buildings linked by 3,000 stone steps. Machu Picchu nestles under the substantial peak in the right centre of the image and is reached by the vertiginous zig-zagging road in the lower centre.

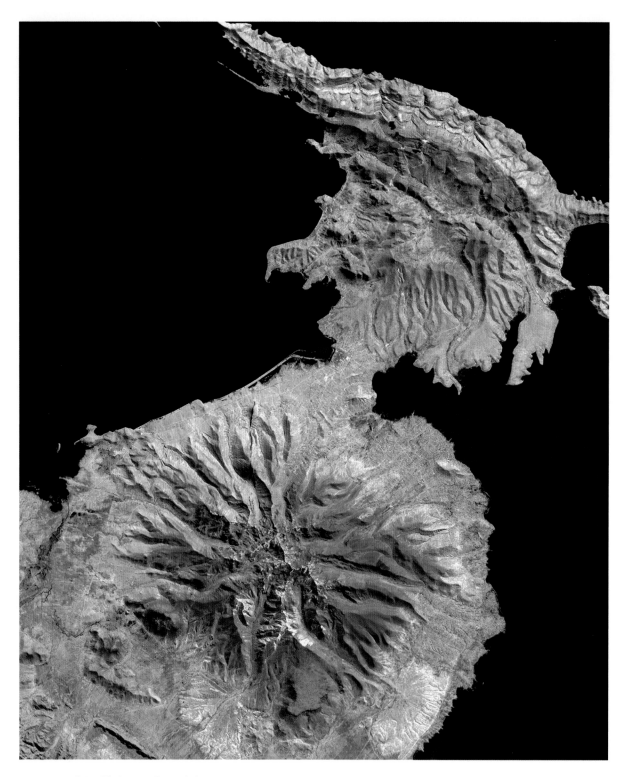

# Peru and Bolivia: Lake Titicaca

IF SMALL BY WORLD STANDARDS, at 8,300 sq km/3,200 sq miles Lake Titicaca is nonetheless the largest lake in South America. At more than 4,000m/13,000ft it is also the highest navigable lake in the world. The tip of the peninsula at the top of the image is in Bolivia; all the land below it is in Peru. The heavily eroded near-circular mountain in the lower half is an ancient volcano. The image shows an area approximately 50 km/30 miles from north to south.

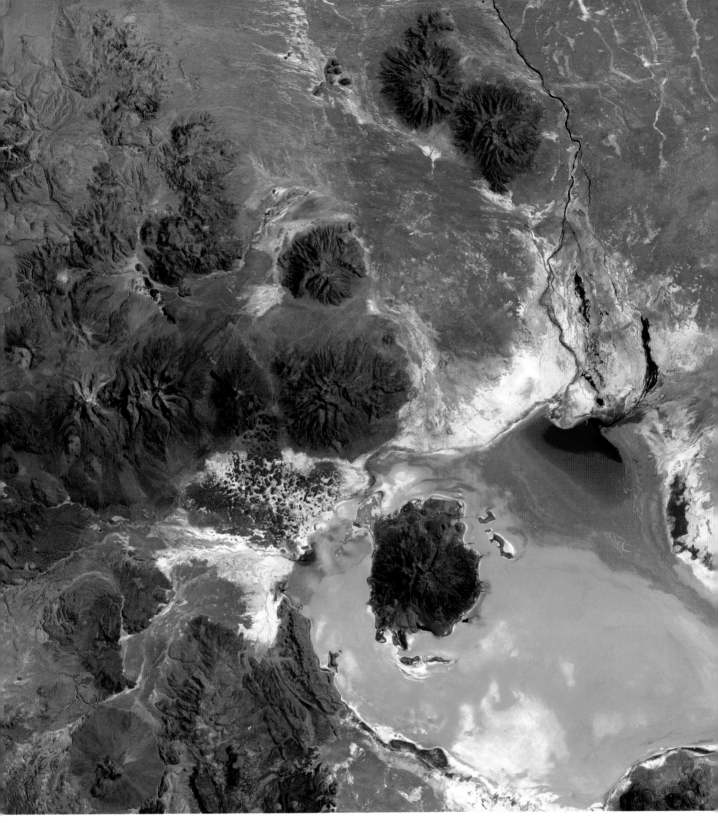

## Bolivia: Laguna de Coipasa

LAGUNA DE COIPASA IS IN SOUTHWEST BOLIVIA, close to the border with Chile. It is a salt lake, prone to heavy evaporation in the dry climate of the Bolivian Plateau, and lies at an altitude of 3,680m/12,070ft. The blue areas, largest at the north, are salt flats. Running into it from the north is a small river, the Lauca, itself frequently prone to dry out. A number of volcanoes are also visible.

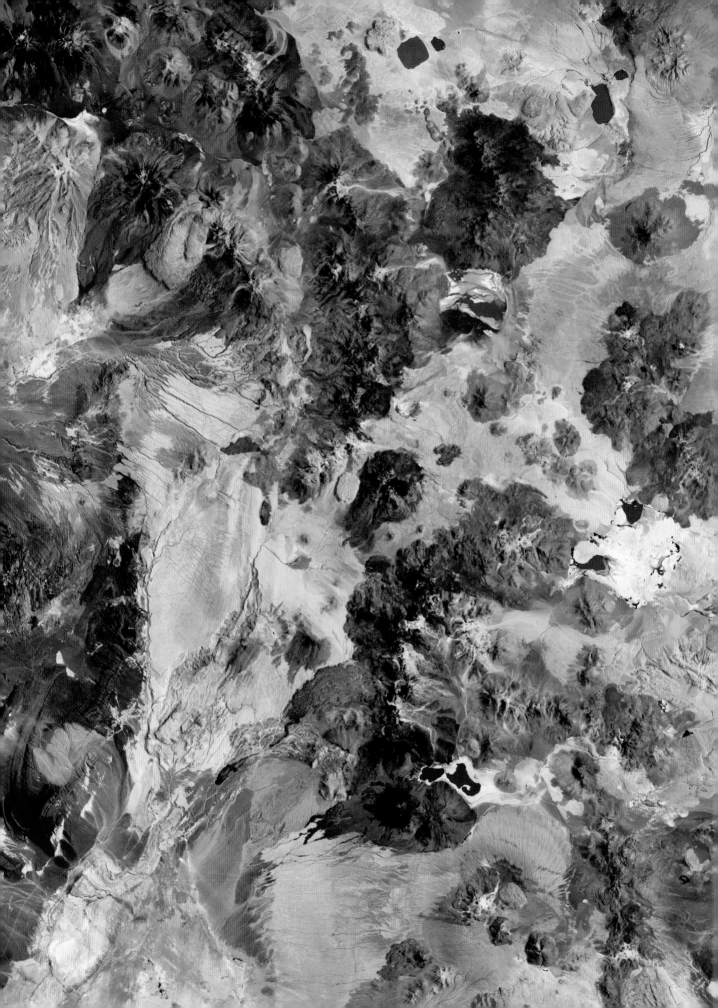

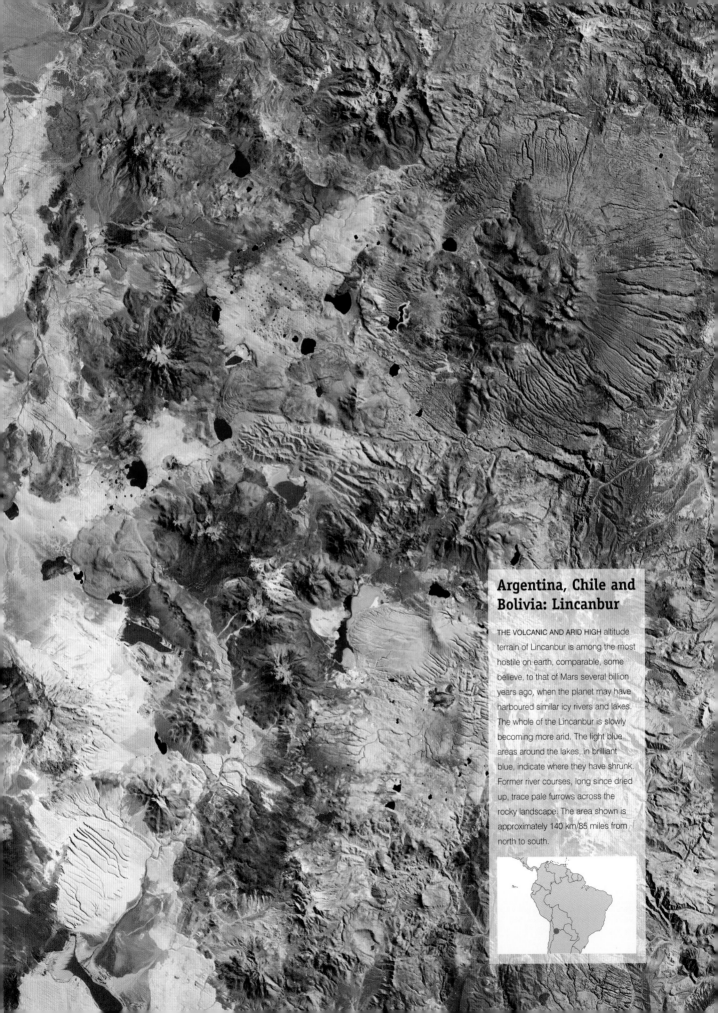

## Argentina, Chile and Bolivia: Lincanbur

THE VOLCANIC AND ARID HIGH altitude terrain of Lincanbur is among the most hostile on earth, comparable, some believe, to that of Mars several billion years ago, when the planet may have harboured similar icy rivers and lakes. The whole of the Lincanbur is slowly becoming more arid. The light blue areas around the lakes, in brilliant blue, indicate where they have shrunk. Former river courses, long since dried up, trace pale furrows across the rocky landscape. The area shown is approximately 140 km/85 miles from north to south.

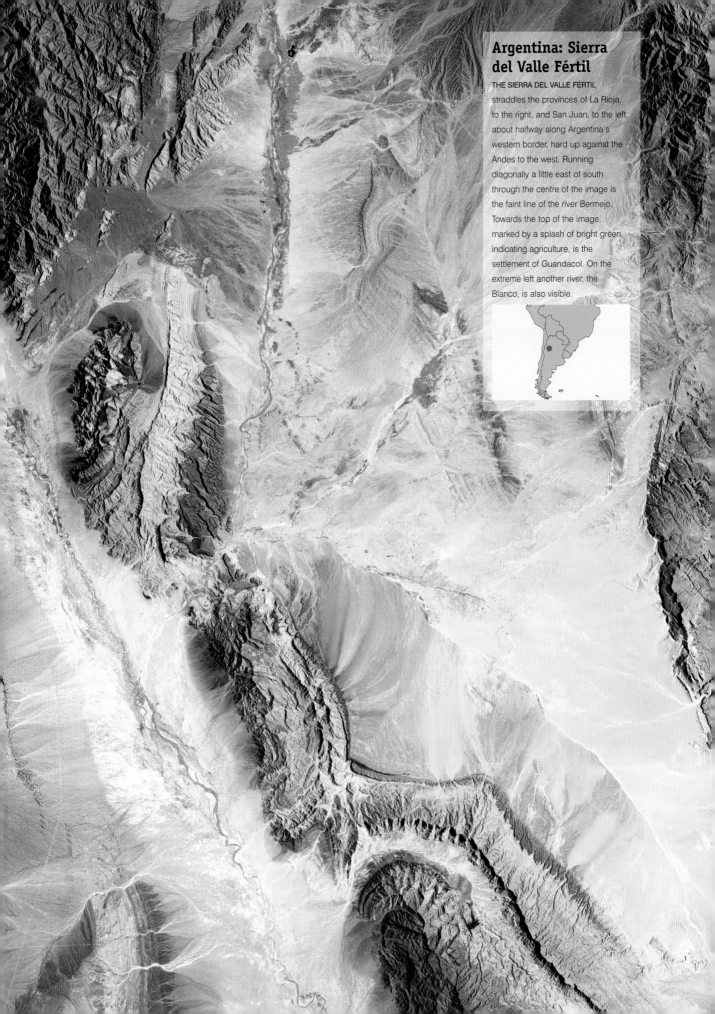

## Argentina: Sierra del Valle Fértil

THE SIERRA DEL VALLE FÉRTIL straddles the provinces of La Rioja, to the right, and San Juan, to the left, about halfway along Argentina's western border, hard up against the Andes to the west. Running diagonally a little east of south through the centre of the image is the faint line of the river Bermejo. Towards the top of the image, marked by a splash of bright green, indicating agriculture, is the settlement of Guandacol. On the extreme left another river, the Blanco, is also visible.

## Bolivia: deforestation

THE STARTLING GRID PATTERNS and thin red and green rectangles of this image of western Bolivia starkly chart deforestation in the country's rainforests. What was once virgin forest has been systematically cleared for use as farm and grazing land. Of the original forest on this image, which extends approximately 45 km/27 miles from north to south, all that remains are the areas shown in dark red. The lighter red areas are vegetation, the green ones other farms and settlements.

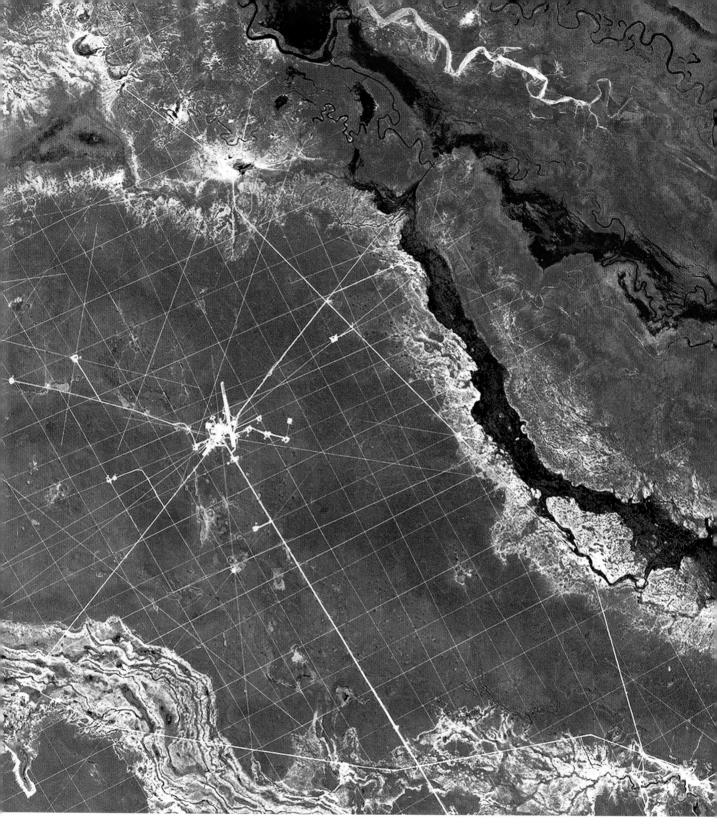

## Argentina: seismic survey lines

THE CURIOUS LINES ON THIS IMAGE of flat grassland in northern Argentina, close to the border with Paraguay, were created by a seismic survey, used in oil and gas exploration in an attempt to determine the structure of the rocks beneath the surface. The ground is vibrated, or explosions detonated, with the sound 'reflections' reaching a receiver at different times. The objective is to locate folds where oil or gas may have been trapped. Grid lines ensure optimum coverage.

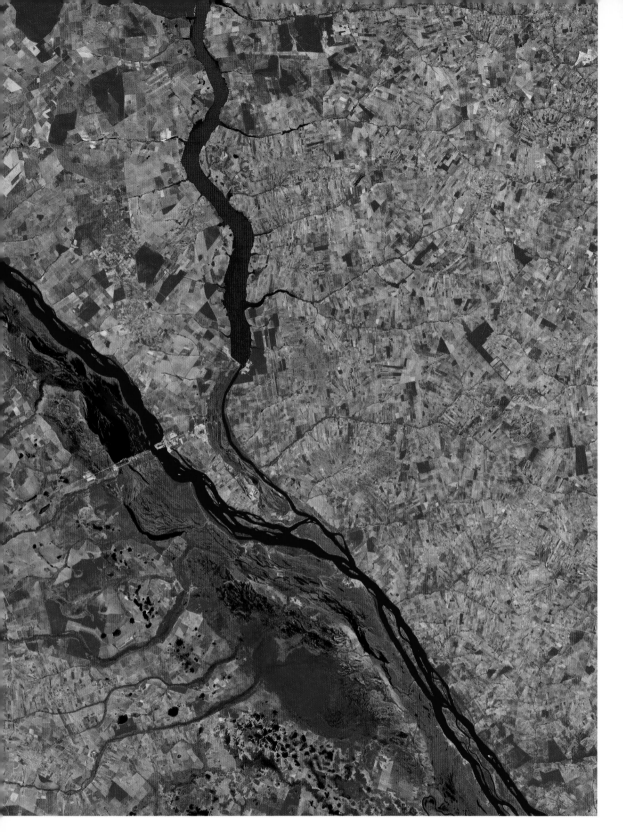

## Brazil: the Paraná and Paranapanema Rivers

**NORTH ON THIS IMAGE OF BRAZIL'S** Paraná and Paranapanema rivers is on the left. The Paraná is to the left, the Paranapanema at the top. Just before their confluence, the massive dam being built across the Paraná is visible in pale blue. The project has been mired in controversy since its start in the 1970s. It has run years behind schedule and massively over budget. As well as huge environmental damage, it is estimated the electricity eventually produced will be the most expensive in Brazil.

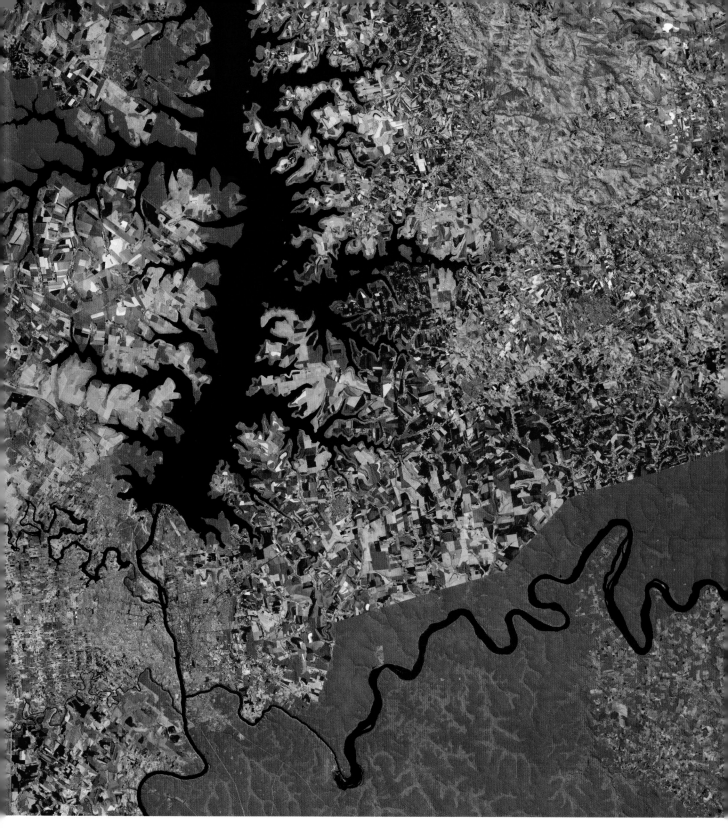

## Brazil, Argentina and Paraguay: the Iguaçu Falls

THE IGUAÇU FALLS ARE ON THE IGUAÇU RIVER, the vivid blue line meandering horizontally across the foot of the image, which here marks the border between Brazil, to the north, and Argentina, to the south. The Falls themselves begin where the river narrows. There are 275 falls over 5 km/3.1 miles. Some plunge hundreds of feet; others cascade down a series of smaller steps before joining the south-flowing Paraná in Argentina. The dark blue body of water to the north is a reservoir, created by damming the Paraná.

273

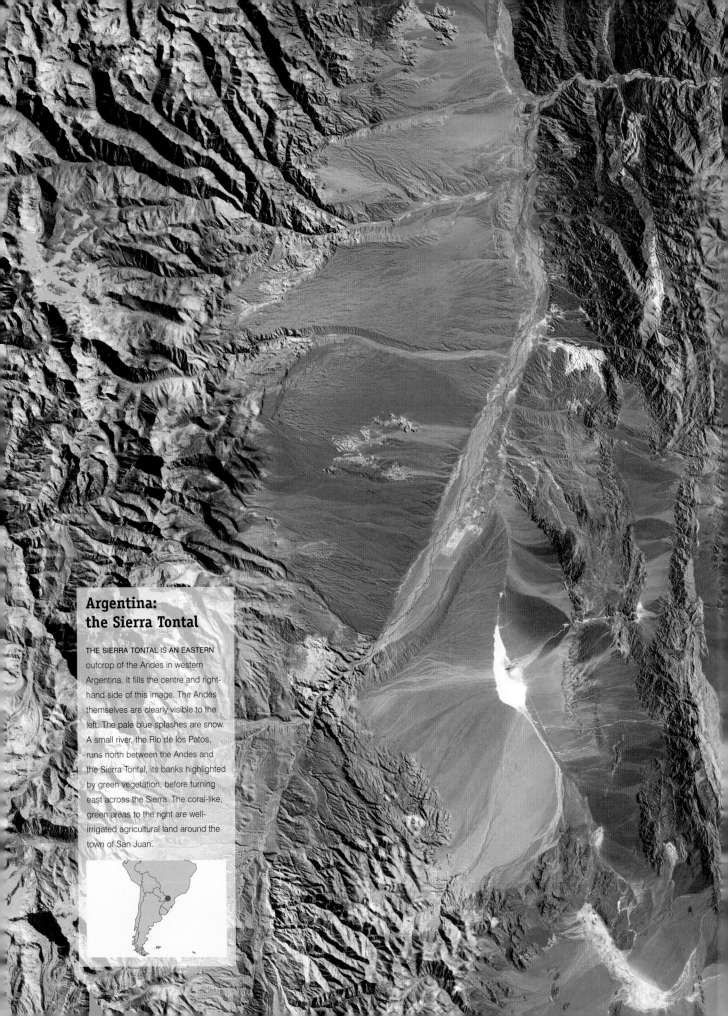

## Argentina:
## the Sierra Tontal

THE SIERRA TONTAL IS AN EASTERN
outcrop of the Andes in western
Argentina. It fills the centre and right-
hand side of this image. The Andes
themselves are clearly visible to the
left. The pale blue splashes are snow.
A small river, the Rio de los Patos,
runs north between the Andes and
the Sierra Tontal, its banks highlighted
by green vegetation, before turning
east across the Sierra. The coral-like,
green areas to the right are well-
irrigated agricultural land around the
town of San Juan.

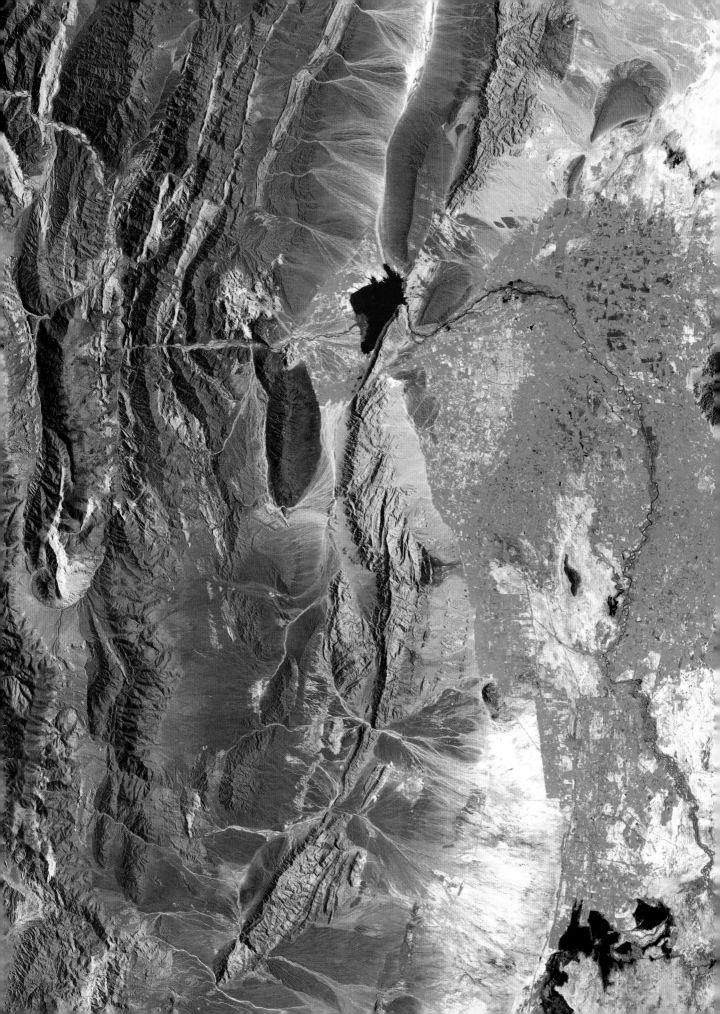

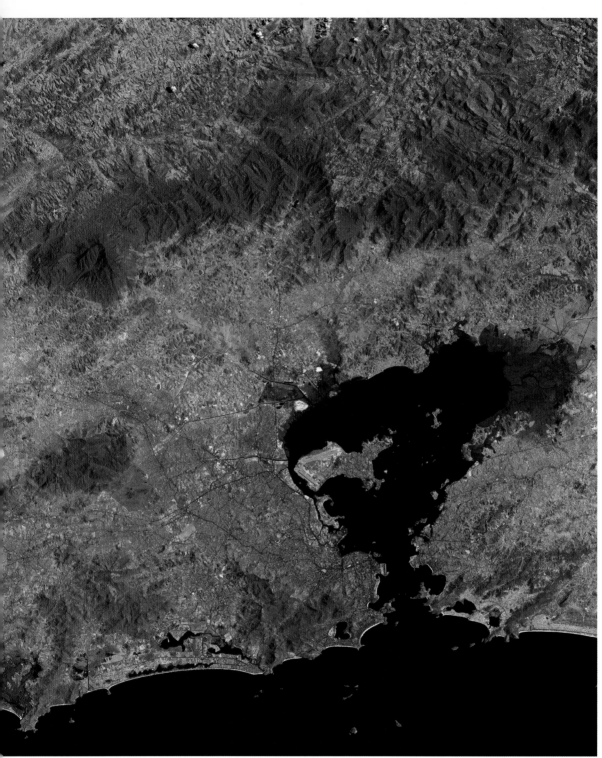

# Brazil: Rio de Janeiro

RIO DE JANEIRO, THE LARGEST CITY IN BRAZIL, hugs the western shore of Guanabara Bay, whose narrow entrance is guarded by steep mountains. With the mountains that loom over the city to the north, it makes for one of the world's most dramatically sited cities. The large island in the bay is Governor's Island, site of the city's airport. Among the city's many exotic attractions are its 72 km/45 miles of white sandy beaches. At the western entrance to the Bay is Copacabana; just to its left is Ipanema.

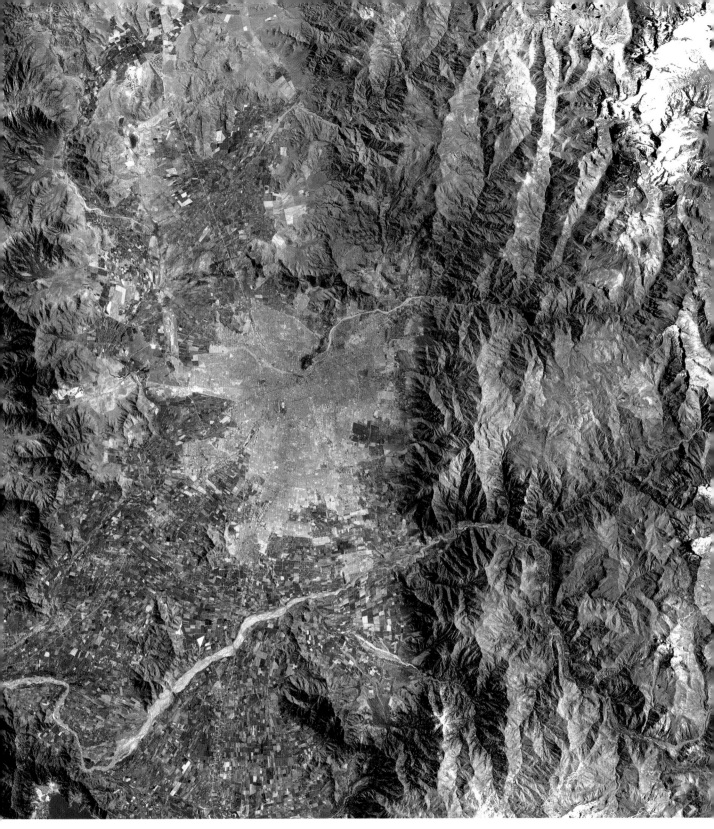

# Chile: Santiago

SANTIAGO, CAPITAL AND LARGEST CITY OF CHILE, is the irregularly shaped smear of blue-grey
in the centre of the image. With a population of 5.1 million, it is the political, commercial and
financial heart of the country. It lies in a broad and fertile valley, at an average elevation of
520m/1,700ft and bounded to the east by the snow-capped Andes. The Mapocho River, just
visible on this image, flows through Santiago's heart. The area shown on this image is
approximately 100 km/60 miles from north to south.

277

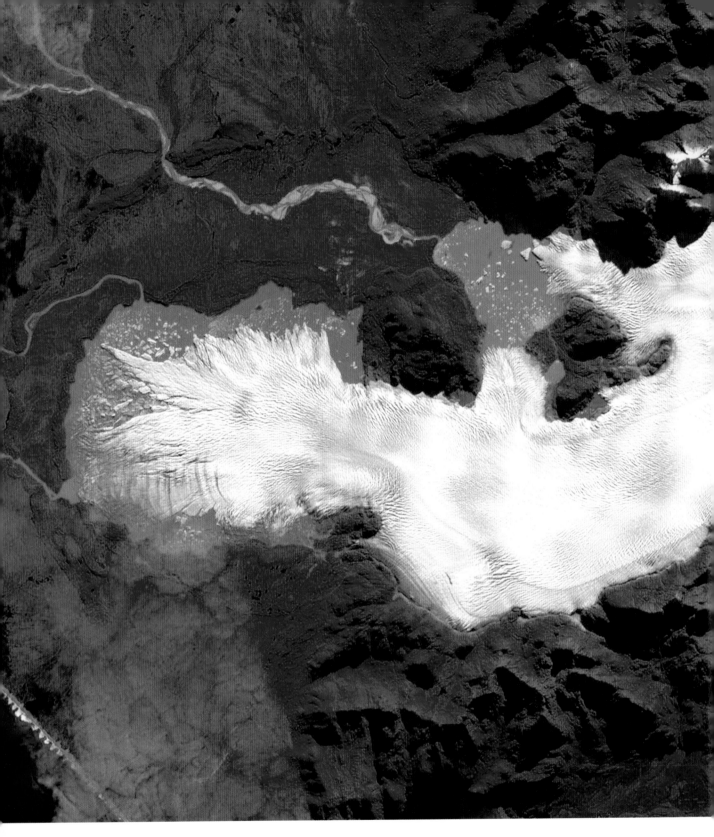

# Chile: Patagonia

WIND, RAIN AND COLD MAKE PATAGONIA, in the far south of South America, one of the bleakest spots on Earth. This image of a glacier shows an area approximately 20 km/12 miles from north to south. As with glaciers across the world, this one is shrinking, the result of global warming. The milky green areas at its foot and sides are silt-rich pools of water. To the right of the image are a series of parallel valleys cut by the glacier before it receded.

## Chile: Wellington Island

THE SHATTERED CHILEAN COAST SPLINTERS into thousands of barren and icy islands as it nears Cape Horn, the southernmost point of South America. This image, which shows an area approximately 250 km/155 miles from north to south, is of part of Wellington Island, the second-largest island in Chile. The fjord-like channels here are not simply the result of erosion by winds and waves but of a fault network created by an oblique collision between South America and the Pacific plate to the west.

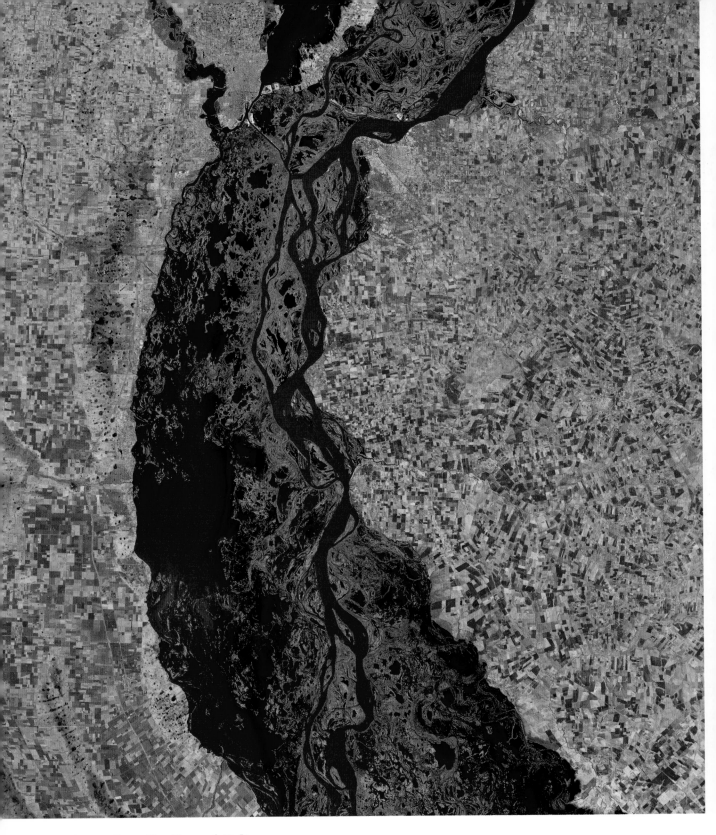

# Argentina: the Paraná Delta

THE HUGE PARANÁ RIVER, which rises in Brazil and flows south into Argentina, reaches the Atlantic Ocean about 32 km/20 miles north of Buenos Aires. Its Delta is a huge forested marshland, a vast labyrinth of densely overgrown islands and narrow channels in the fertile plains that surround the Argentinean capital. The great sweep of the Delta and its numerous islands are immediately visible here. The area of the image is approximately 120 km/75 miles from north to south.

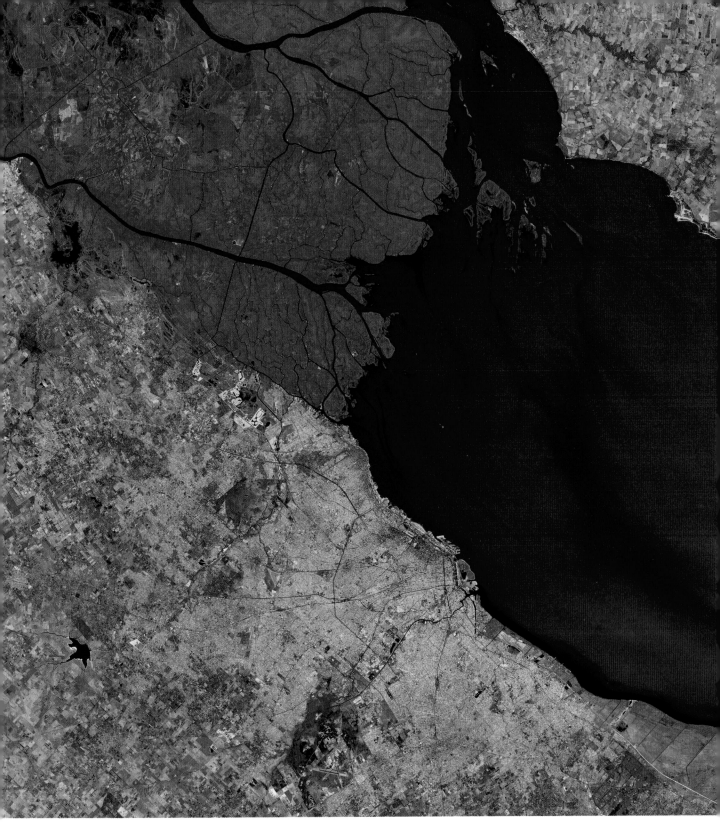

## Argentina: Buenos Aires

**AS WITH MOST OF THE LEADING CITIES** of South America, Buenos Aires, the blue-grey sprawl in the lower centre of the image, was founded by the Spanish conquerors of the continent in the sixteenth century. Buenos Aires has been the capital of Argentina since independence from Spain in 1816. It lies on the south bank of the Rio de la Plata, the broad estuary of the Paraná, whose delta is in the upper left. By any standard, it is a huge city, with a population of 11.25 million.

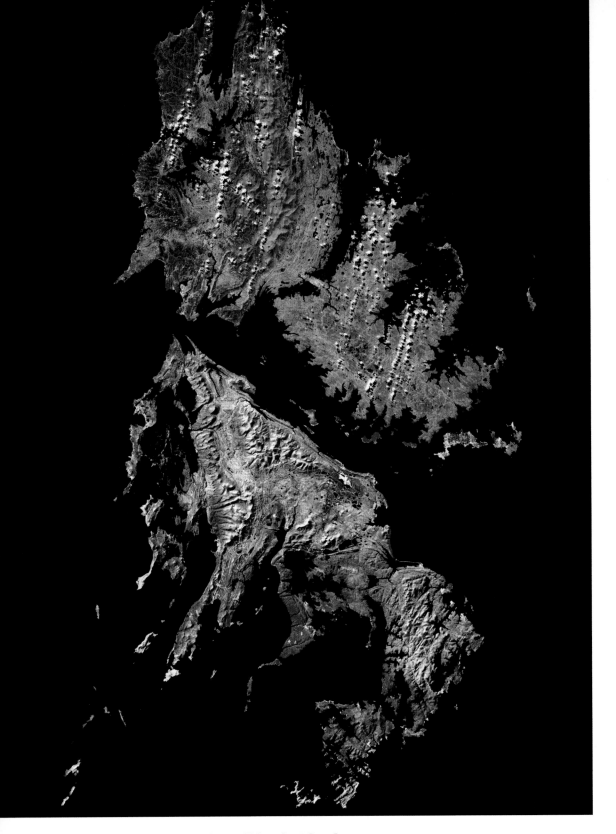

## The South Atlantic: the Falklands Islands

THE SOGGY WASTES OF THE GALE-BATTERED Falkland Islands, deep in the South Atlantic, consist of two main island groups divided by Falkland Sound. West Falkland is largely uninhabited. Likewise, Lafonia, the southern half of East Falkland and connected to it only by a narrow isthmus, is desolate and marshy. The bulk of the island's 2,500 inhabitants live in and around the capital, Port Stanley, in the northeast, which is shown at the top left of this image, because north is to the left.

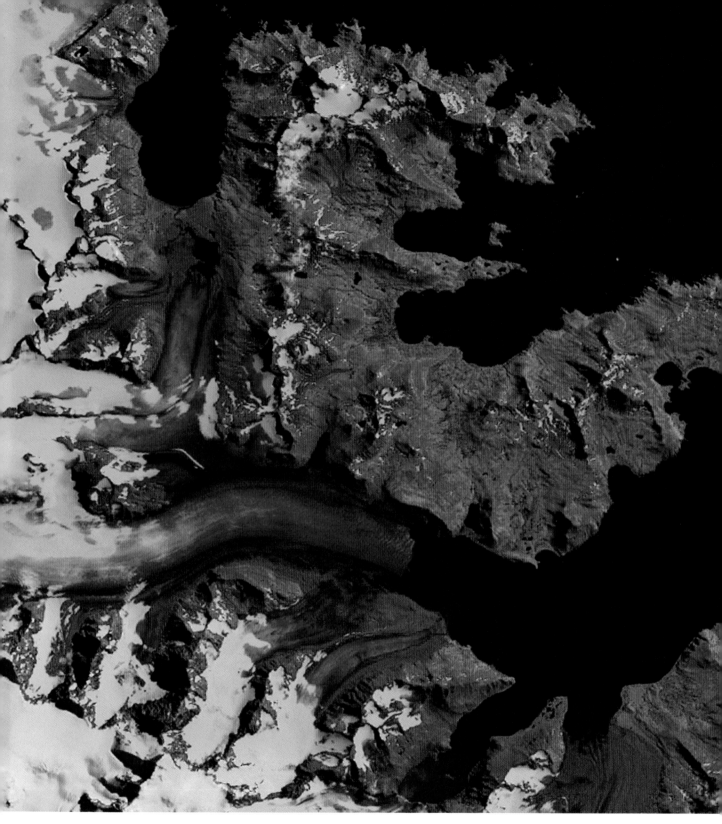

## South Georgia

SOUTH GEORGIA, DEEP IN THE SOUTH ATLANTIC, is among the most desolate spots on Earth, a wasteland of rock and ice. This image of its north coast shows one of its many glaciers. The blue-white areas are snow and ice; the red ones are alpine tundra. The green fringes on parts of the coast are sparse vegetation. The U-shaped bays in the upper half of the image were carved by glaciers. The image shows a small area, only 22 km/13 miles from north to south.

283

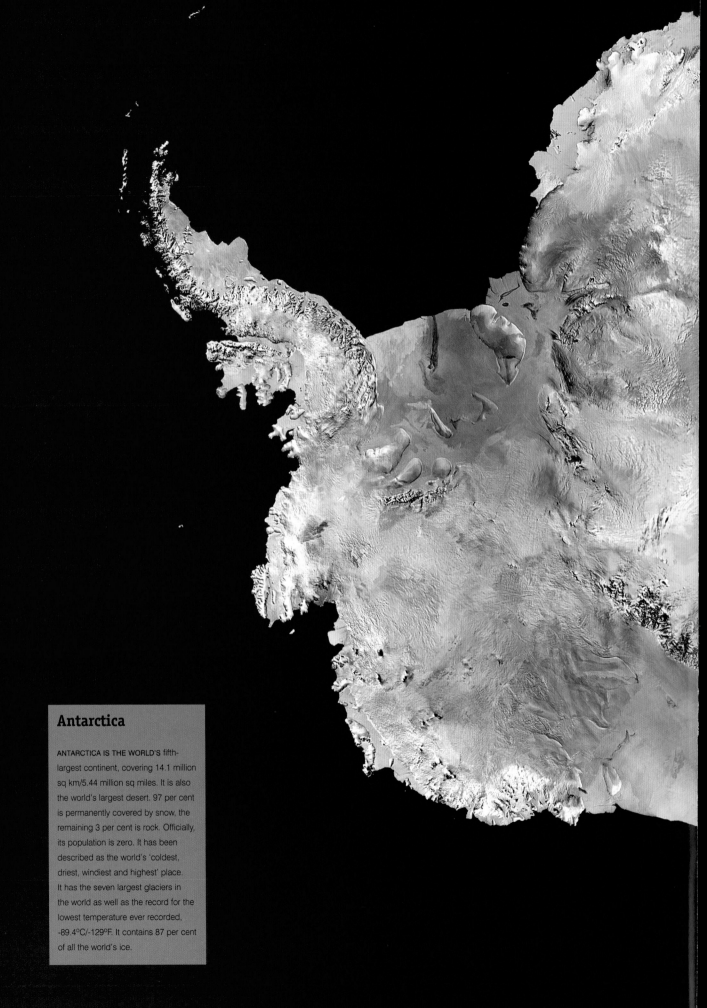

# Antarctica

ANTARCTICA IS THE WORLD'S fifth-
largest continent, covering 14.1 million
sq km/5.44 million sq miles. It is also
the world's largest desert. 97 per cent
is permanently covered by snow, the
remaining 3 per cent is rock. Officially,
its population is zero. It has been
described as the world's 'coldest,
driest, windiest and highest' place.
It has the seven largest glaciers in
the world as well as the record for the
lowest temperature ever recorded,
-89.4ºC/-129ºF. It contains 87 per cent
of all the world's ice.

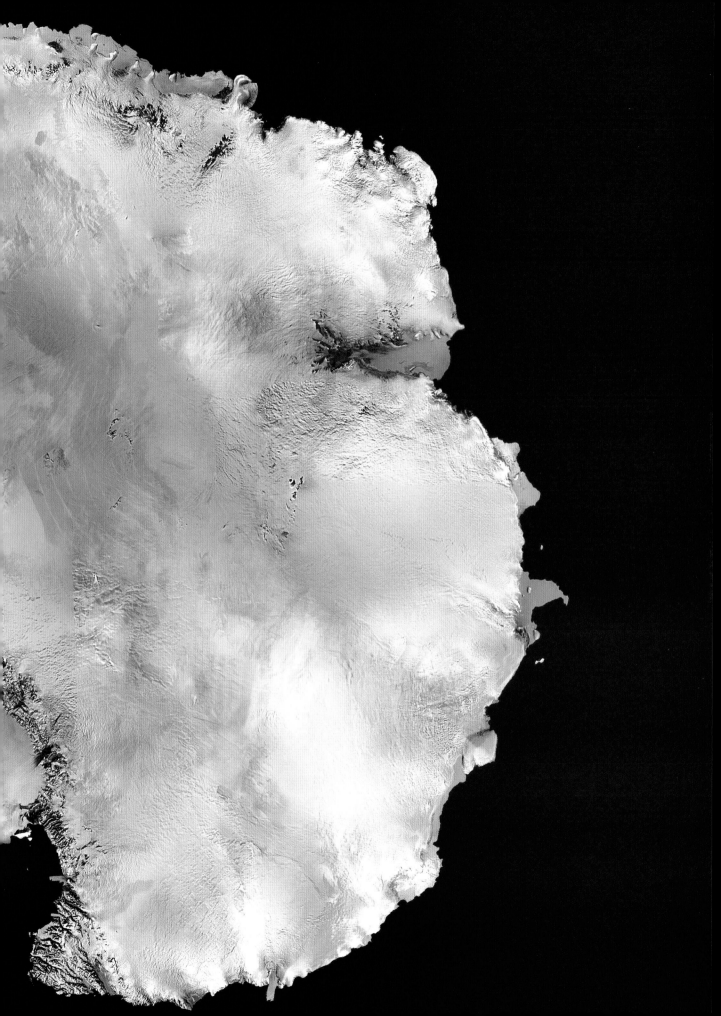

# place index